The World Atlas of
Football Stadiums

First published in the United States of America in 2025 by
Rizzoli Universe, a Division of
Rizzoli International Publications, Inc.
49 West 27th Street
New York, NY 10001
www.rizzoliusa.com

Copyright © 2025 Quarto Publishing plc

All rights reserved. No part of this publication may be reproduced, stored in a retrieval system, or transmitted in any form or by any means, electronic, mechanical, photocopying, recording, or otherwise, without prior consent of the publishers.

ISBN: 978-0-7893-4582-0
Library of Congress Control Number: 2024945005

Printed in Huizhou, Guangdong, China
TT/May/2025
2025 2026 2027 2028 / 10 9 8 7 6 5 4 3 2 1

For Rizzoli
Publisher: Charles Miers
Editor: Klaus Kirschbaum
Assistant Editor: Emily Ligniti
Managing Editor: Lynn Scrabis

The authorized representative in the EU for product safety and compliance is Mondadori Libri S.p.A., via Gian Battista Vico 42, Milan, Italy, 20123, www.mondadori.it

Conceived, designed, and produced by
The Bright Press, an imprint of the Quarto Group,
1 Triptych Place, London SE1 9SH,
United Kingdom.
T (0)20 7700 6700
www.quarto.com

Publisher: James Evans
Editorial Director: Isheeta Mustafi
Commissioning Editor: Caroline Elliker
Art Director: James Lawrence, Emily Nazer
Cover Design: Emily Nazer
Senior Editor: Joanna Bentley
Project Editor: Julie Brooke
Design: JC Lanaway, Marcia Pedraza
Picture Research: Kathleen Steeden
Production Controller: George Li

Visit us online
Instagram.com/RizzoliBooks
Facebook.com/RizzoliNewYork
Youtube.com/user/RizzoliNY

Front cover photo: Ronnie Schmutz/Unsplash. Back cover photos: background Shutterstock/Nick Ledzinskiy, top Shutterstock/ju.hrozian, middle CucombreLibre CC BY 2.0, bottom natea23mv.

The World Atlas of Football Stadiums

1000 iconic grounds & their stories

JOHN GILLARD

with
JOSEPH O'SULLIVAN
NEEL SHELAT

foreword by
JOHN HARKES

CONTENTS

Foreword 6
Introduction 8

NORTH AMERICA AND THE CARIBBEAN
10

1

CENTRAL AND SOUTH AMERICA
54

2

EUROPE
106

3

AFRICA AND THE MIDDLE EAST
240

ASIA
276

AUSTRALASIA
312

Index 324
Picture Credits 334
Author Biographies 336

Foreword

As the first American to play in the Premier League for Sheffield Wednesday, I often look back at my time at Hillsborough with immense pride and gratitude. To step onto that pitch, to wear the blue and white stripes of Wednesday, and to represent both my country and the passionate supporters of this historic club—those are moments that will stay with me forever.

Hillsborough isn't just a stadium. It's a place where dreams are made and heartbreaks are endured. I remember the first time I walked through the tunnel; the sound of the crowd, the weight of history, and the energy of the supporters—there was nothing quite like it. To say that it was overwhelming would be an understatement. It was humbling, it was exhilarating, and it was everything I had hoped for in my football career.

Every player can tell you about the stadiums that are special to them, and I had the privilege of playing in some of the most iconic grounds in the world: Stadio Olimpico in the World Cup, the famous Anfield of Liverpool, the old Wembley Stadium. But Hillsborough was special. It was a place where you knew you were part of something much bigger than yourself. The stadium itself, with its famous clock, and storied history, is a symbol of the city of Sheffield and of the thousands of fans who have filled those stands through the years.

For me, Hillsborough represented the next step in my journey. It was where I truly realized and appreciated the unique nature of English football and the culture that surrounds it. The level of passion, commitment, and pride shown by the fans was something I'd never experienced before, and it left an indelible mark on me both as a player and as a person.

The significance of Hillsborough extends beyond the matches played within its walls. It's a testament to the resilience and spirit of the Sheffield Wednesday supporters, whose loyalty has never wavered. As I reflect on my time there, I realize how much it shaped not just my career, but my love for the game itself. It's a place that represents the soul of football—a place where every match is a story, every cheer a memory, and every player leaves a piece of themselves on the pitch. I'm proud to have been a part of that story—a story that is played out in a myriad of ways in the extraordinary, iconic, and much-loved stadiums in this book.

John Harkes
SHEFFIELD WEDNESDAY 1990–93
US MEN'S NATIONAL TEAM 1987–2000

Foreword

Introduction

It was the walk to the stadium I remember the most. Strolling alongside a brick wall that housed what felt like a glorious mystery. The chatter and buzz of the crowds all heading in the same direction; flags and scarves everywhere, blue-and-white striped replica jerseys like deck chairs on Brighton Beach. And through the old metal turnstiles—the towering cylindrical kind—the stadium unfurled before me. I'd never seen so many people in one place. The pitch seemed to be a sacred area, empty, awaiting something special. I was hooked before a ball was kicked.

Stadiums hold so many memories and emotions. They bring together communities, harbor rivalries and friendships, create magical moments and heartbreaking losses. This book seeks to draw out the stories from the world's greatest stadiums, from the biggest leagues to the smallest corners of the footballing world. Stadiums have been chosen for their richness of fan experience; whether it be the glorious atmosphere, the beautiful game, the architecture, the incredible surroundings, the history, or the magical journey to the stadium. No two are ever the same, and each one offers something unique, sometimes surprising. You will find extremes of the footballing spectrum: from the

Koh Panyee Floating football field in a Thai fishing village, to the futsal pitch in the middle of a Rio favela, to the state-of-the-art metallic Bernabeu with its layers of retractable pitches. Both women's and men's football are celebrated, from the early years of women's football on the college campus fields of America, shared with other sports, to Sydney's Accor Stadium, where 75,784 fans looked on as Spain lifted the 2023 Women's World Cup trophy.

This book tours the globe spanning every region, running west to east, from North America to Australasia. You may find a stadium that sparks your imagination enough to visit, or even tour a country with ground-hopping as the focus, soaking up the culture along the way. Or simply sit back, dip in, and discover something new.

The Goldstone Ground in Brighton, United Kingdom, where my journey began is now a retail park. The club's new home took over a decade to rise and sits within the beautiful hills of the South Downs National Park, but that's another story. One you can find within the pages of this book.

→ Fans wait for the gates to open at Burnley FC's Turf Moor ground, England.

Introduction

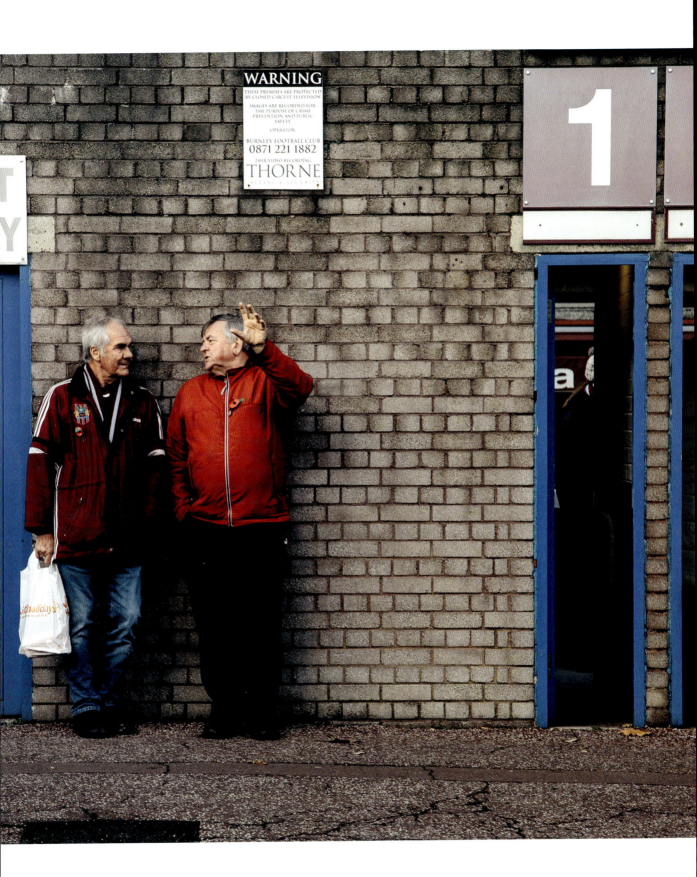

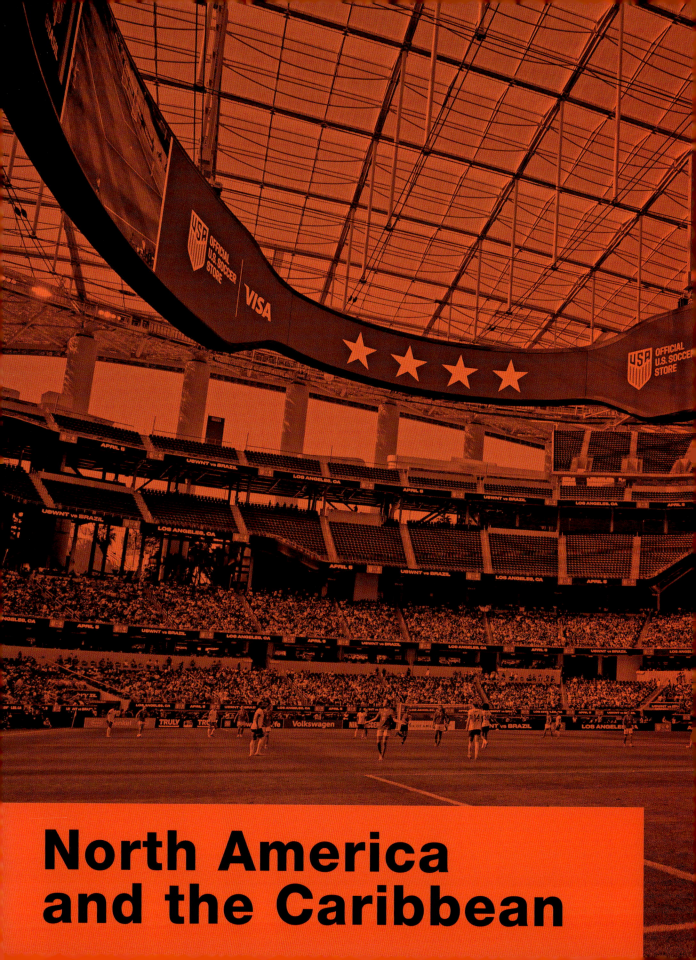

North America and the Caribbean

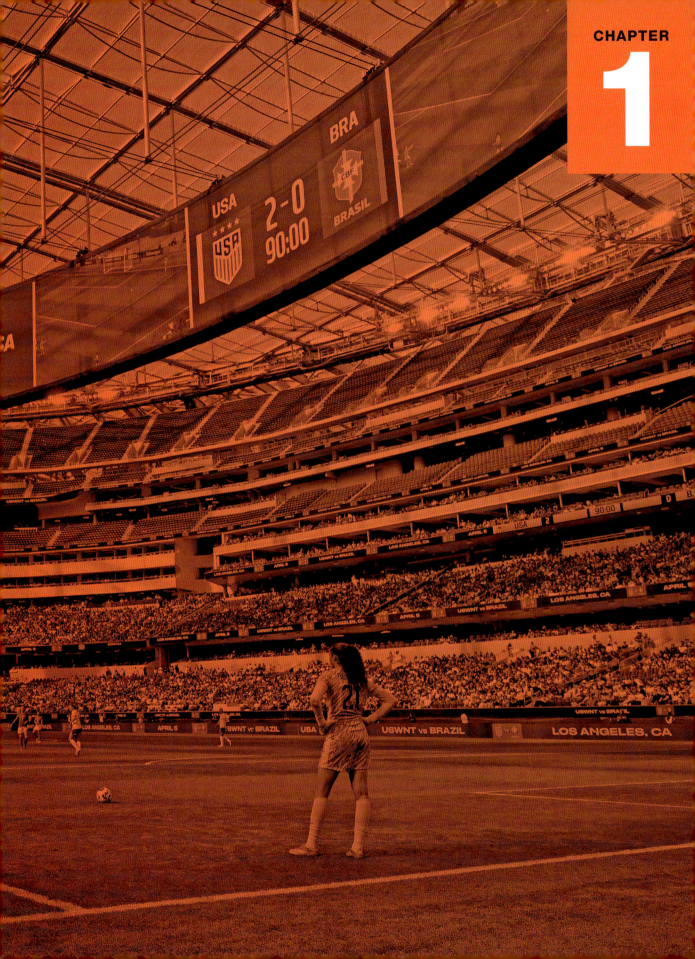

CHAPTER 1

Canada / North America

CANADA

Olympic Stadium
MONTREAL (CF MONTRÉAL)

In 2015, 61,004 fans packed "The Donut" for the CONCACAF Champions Cup final between Montréal Impact and Club América of Mexico. Home advantage wasn't enough, despite a record-breaking Canadian crowd. Two months later the Women's World Cup came to town with the United States beating Germany to book a place in the final with hat-trick hero Carli Lloyd opening the scoring.

BMO Field
TORONTO (TORONTO FC)

This stadium is a massive space complete with spectator balconies, open concourses, and a breeze from the lake. It has a capacity of 30,991 spectators, which can be expanded up to 40,000 for occasions such as the 2026 World Cup when it is due to host a historic opening game for the Canadian national team.

↑ BMO Field

↓ Olympic Stadium

York Lions Stadium
TORONTO (YORK UNITED FC)

When winters are cold and you want soccer all year-round, then enclose the pitch in a giant dome. That's the answer for the York Lions Stadium. The main stand seating is lost to the snow, but there's just enough room around the perimeter to watch a match.

ATCO Field
ALBERTA (CAVALRY FC)

ATCO Field is set within the grounds of Spruce Meadows, a prestigious show jumping venue, and you enter the ground through meadows where horses graze. The Cavalry FC fan group Foot Soldiers leads the chanting and bangs drums throughout the match, while children introduce player songs to the tune "Baby Shark."

North America / **Canada**

BC Place
VANCOUVER (VANCOUVER WHITECAPS FC)

The Cascadia Cup has been played out between three historic teams—Vancouver Whitecaps, Portland Timbers, and Seattle Sounders—across eras and leagues. Since the 1970s the clubs have vied for dominance in the Pacific Northwest. The Vancouver Whitecaps legs are played at an equally historic stadium. It was built in 1983 with an iconic inflatable roof that has since been replaced with a retractable roof supported by cables. Support spans from the Curva Collective. Tifos display pride, togetherness, and the club's fifty-year history. A large ever-present flag sums up the vibe—a power salute fist with club colors emanating like sunbeams.

King George V Park
ST. JOHN'S (NATIONAL STADIUM / MEMORIAL SEA-HAWKS)

Resting wearily on the banks of Quidi Vidi Lake, the oldest surviving soccer-specific stadium in North America is witness to Canadian soccer's greatest moment: a 2–1 defeat of Honduras and qualification for the 1986 World Cup.

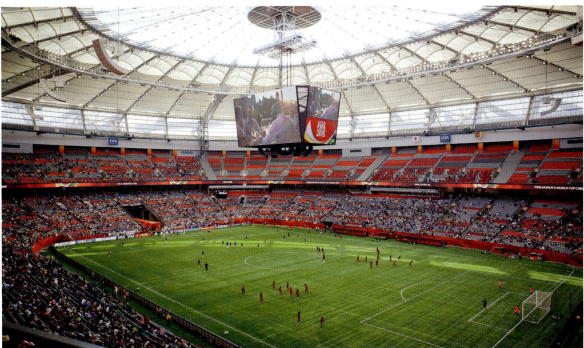

↑ BC Place

Washington/Oregon / North America

UNITED STATES

WASHINGTON

Starfire Sports
TUKWILA (TACOMA DEFIANCE / OSA SEATTLE FC / OSA XF)

Starfire Sports sits on the banks of the Green River, just south of Seattle. It is part of a complex that hosts Paris Saint-Germain soccer camps. The elegant stadium, tree-lined on one side and with a single large covered stand, is home to a number of teams including Women's Premier Soccer League OSA XF and third-tier MLS Next Pro Tacoma Defiance.

Lumen Field
SEATTLE (SEATTLE SOUNDERS FC / SEATTLE REIGN FC)

Lumen Field is like the parting of the Red Sea. Two huge wavelike stands span the length of the stadium, leaving each goal end open to the outside world. To the north you can see the downtown Seattle skyline, and to the south the majestic 14,000-foot (4,267-m) Mount Rainier.

One Spokane Stadium
SPOKANE (SPOKANE VELOCITY FC / SPOKANE ZEPHYR FC)

Home to Spokane Velocity FC and Spokane Zephyr FC of the USL, the downtown stadium is 1,900 feet (579 m) above sea level. The elevated walkway on the western side means that you can take a stroll and enjoy various views of the game, but it does result in a large concrete wall behind the goal. Low, forceful, off-target strikes can rebound back onto the pitch.

OREGON

Providence Park
PORTLAND (PORTLAND TIMBERS / PORTLAND THORNS FC)

Pelé played his last official match in the 1977 Soccer Bowl here, at the oldest soccer-specific stadium in America. The stadium has been renovated since it was first built in 1926, yet much of the original architecture remains. In recent years tifos have arrived, and superfan Timber Joey stands on top of a 100-foot-high (30-m) timber pole during games. When the team scores he descends the pole and takes a chain saw to a log, holding aloft the piece of timber in celebration.

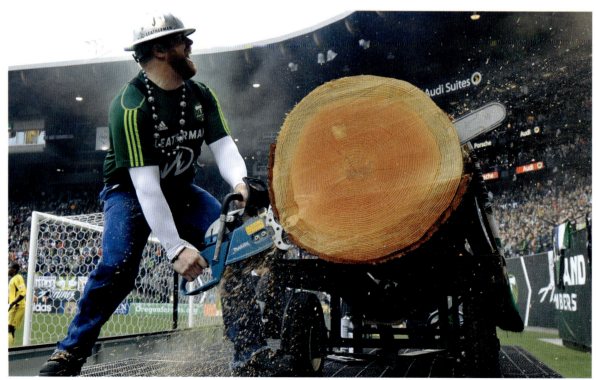

↑ Providence Park

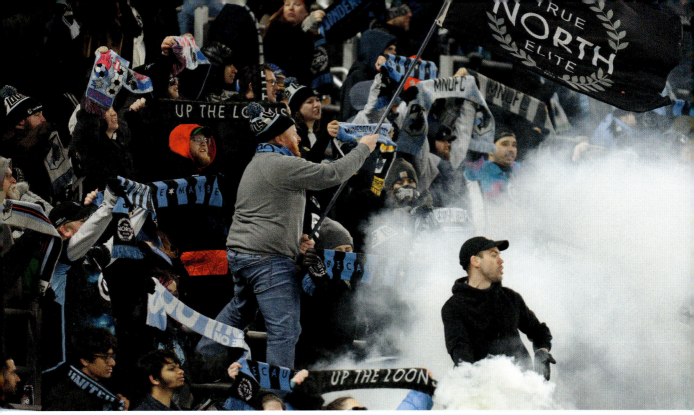

↑ Allianz Field

NEBRASKA

Morrison Stadium
OMAHA (CREIGHTON BLUEJAYS)

A fountain, cast-iron Bluejay statue, and twin redbrick towers greet you at the entrance of the Creighton Bluejays' stadium. It was built in 2003 on the campus of Creighton University, and the first championship goal was scored by US legend Clint Dempsey playing for Furman University. Despite its relatively small capacity of six thousand, the US Women's National Team has played here, drawing 1–1 with Sweden in 2010.

MINNESOTA

National Sports Center
BLAINE (MINNESOTA UNITED FC)

The National Sports Center is part of the largest soccer complex in the world. With fifty-two regulation-size soccer fields, it is in the *Guinness Book of World Records*. MLS Minnesota United FC trains here. A unique feature of the stadium is its main stand that facilitates two interconnected pitches.

Allianz Field
SAINT PAUL (MINNESOTA UNITED FC)

If you can get a ticket, then get involved in the beautiful chaos that is the safe standing terrace named the "Wonderwall" after the club's unofficial anthem. The steep single-tier stand fills with 2,920 fans. The Dark Clouds and True North Elite let off gray smoke bombs, bang drums, and sing all game long. The rest of the chaos comes from the Red Loons, named after their left-wing leanings and the Minnesota state bird and club emblem. Everything is tied together by the love for Oasis's classic anthem.

Elizabeth Lyle Robbie Stadium
SAINT PAUL (MINNESOTA GOLDEN GOPHERS)

The home of the Minnesota Golden Gophers women's team is located in Falcon Heights on the Saint Paul campus of the University of Minnesota. It has one all-encompassing stand where all the magic happens. The central clubhouse has an art deco design, with redbrick and maroon-painted walls with a sandstone trim. It fits the college colors, and gives the same vibes as Estadio Tomás Adolfo Ducó in Buenos Aires.

Missouri / North America

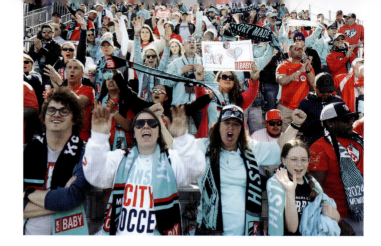

MISSOURI

CPKC Stadium
KANSAS CITY (KANSAS CITY CURRENT)

What do you do when the big local team won't let you share their stadium? For Kansas City Current of the National Women's Soccer League the answer was simple—build your own. In 2024, the result was the first professional women's sports stadium in the world. And it's a beauty—a perfect magnet stadium with an open riverside end. Only an electronic display screen stops an unhindered view of the Missouri River and cable-stayed bridge. The CPKC Plaza outside is a space for fans to gather and party before the game. Take a walk along the river heritage trail all the way to the stadium.

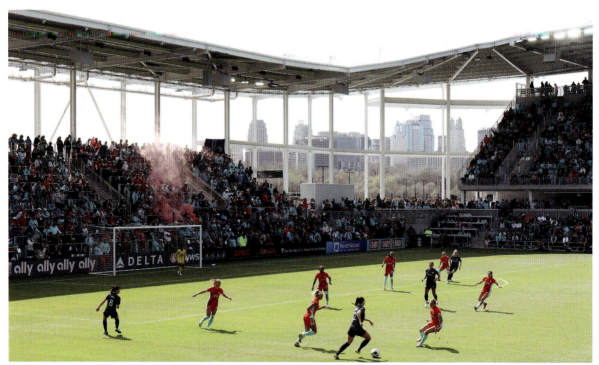

↑↗ CPKC Stadium

North America / **Missouri/Wisconsin/Illinois/Michigan**

Energizer Park
ST. LOUIS (ST. LOUIS CITY SC)

Since 2023, MLS expansion team St. Louis City SC has had a fantastic soccer-specific stadium. A sellout crowd of 22,423 watched their first-ever MLS home game, a 3–1 win against Charlotte FC. It's early days, but since City SC is one of only three teams ever to win its opening five matches in a season, Energizer Park could become something of a fortress.

Hermann Stadium
ST. LOUIS (ST. LOUIS BILLIKENS)

The stadium located on the campus of Saint Louis University is home to the first true powerhouse of collegiate soccer. The Saint Louis Billikens won a record ten national titles between the 1950s and 1970s. Their new stadium is fit to continue this success with an immaculate playing surface and two large stands, yet the last title came in 1973. Many MLS and national team players started their careers at the stadium, including Tim Ream, who played every minute of USMNT's 2022 World Cup campaign.

WISCONSIN

Breese Stevens Field
MADISON (FORWARD MADISON FC)

Forward Madison FC's motto is "playing soccer and having fun with it." At Breese Stevens Field this is taken to the next level: there are the inflatable flamingos; a rooftop bar; a pitch-side food truck; a petting zoo; and a bouncy slide by the corner flag. Throw in the funky player kits, local artist match-day posters, and pink seats, and you haven't even reached the Flock yet. This is where the fun rises further, behind the goal, with loudspeakers, flags, and plenty of songs. A stadium of beautiful mayhem.

Uihlein Soccer Park
MILWAUKEE (MSOE RAIDERS)

The Uihlein Soccer Park has indoor and outdoor soccer facilities. Spanish giants Real Madrid hold a soccer camp here for youth talent. Through the summer there is a coed adult league. The jewel is the Viets Field, where the Milwaukee School of Engineering MSOE Raiders men's and women's teams play collegiate soccer. It is an aptly well-constructed stadium with an elevated pitch, towering floodlights, and large glassfronted clubhouse.

ILLINOIS

SeatGeek Stadium
BRIDGEVIEW, CHICAGO (CHICAGO RED STARS)

The stadium on the outskirts of Chicago is home to NWSL team Chicago Red Stars and Chicago Fire FC II. Front row seats are just 3 yards (2.7 m) from the pitch, and a roof covers most of the stands, compressing the atmosphere and increasing the intensity. A redbrick facade and stone entrance archway give off a warm traditional vibe.

MICHIGAN

Keyworth Stadium
HAMTRAMCK, DETROIT (DETROIT CITY FC)

Located in a diverse, multicultural enclave of Detroit, Keyworth Stadium has a long history. It was the first to be built in Michigan as a part of the New Deal, and so it was built by the people and remains a hub of the community. Detroit City FC fans helped to refurbish the western grandstand in 2016.

↑ Energizer Park

Indiana/Kentucky/Ohio / North America

INDIANA

Bill Armstrong Stadium
BLOOMINGTON (INDIANA HOOSIERS)

The Bill Armstrong Stadium at Indiana University in Bloomington is a legacy of the burgeoning US soccer leagues of the 1970s and 1980s. The Indiana Hoosiers played their first match at the soccer-specific stadium in 1981 and are still going strong today. The large precast concrete grandstand includes a monumental press box. And there has been plenty to report: the Hoosiers are second only to Saint Louis for the most NCAA men's championships—eight in total.

Alumni Stadium
BOSTON (NOTRE DAME FIGHTING IRISH)

Home to the Notre Dame Fighting Irish, this soccer-specific arena, arguably one of the finest in the country, has witnessed some magical moments since it opened in 2009. The women's team brought home the 2010 NCAA national championship, and the men did the same three years later. For big matches the capacity can increase to more than three thousand, with additional seating on the east side's grassy berm.

↓ Bill Armstrong Stadium

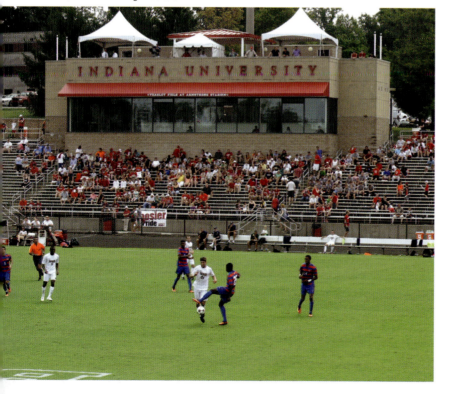

KENTUCKY

Lynn Family Stadium
LOUISVILLE (RACING LOUISVILLE FC / LOUISVILLE CITY FC)

The stadium in Butchertown is home to Louisville City FC of the USLC and Racing Louisville FC of the NWSL. The undulating copper-colored roof spans three-quarters of the stadium and has rhythmic strip floodlights. At night, they light up games in a spectacular way, and at halftime there's a mini light display, always loved by the children. The family-friendly environment continues with a playground outside the main entrance.

OHIO

TQL Stadium
CINCINNATI (FC CINCINNATI)

To see FC Cincinnati play at home, walk along Elm Street starting at the glorious nineteenth-century Gothic Cincinnati Music Hall and then take a left at West 14th Street. The TQL Stadium opens out in front of you like a giant birdcage.

Lower.com Field
COLUMBUS (COLUMBUS CREW)

MLS Columbus Crew's stadium has a fun, buzzy vibe. The crowds are high-energy with yellow-and-black fractal-checkered flags everywhere. Halftime is met with live entertainment and fireworks. Local vendors offer food and beverages from popcorn to garden salads with chickpeas, and from fish and chips to nachos. Keep your eyes open for freebies; the club often offers towels, jerseys, and drinks. The stadium has a 360–degree canopy roof peppered with underside lights, making night games a real spectacle.

PENNSYLVANIA

Subaru Park
CHESTER (PHILADELPHIA UNION)

Legendary Colombian goalkeeper Faryd Mondragón was so impressed with this stadium and fans when he played a friendly game here in 2011 that he decided to sign with the home team. His was a single glorious season, an epic run to the playoffs still talked about on the terraces today. What he saw was a bright, open, buzzing stadium in a magnificent location at the foot of the Commodore Barry Bridge, on the Delaware River waterfront.

Highmark Stadium
PITTSBURGH (PITTSBURGH RIVERHOUNDS SC)

Highmark Stadium is simply stunning. From the south stand you can take in the full panorama of tree-filled hills, skyscrapers of downtown Pittsburgh, and Fort Pitt Bridge. Between the stadium and the Monongahela River that flows beside it is a rail track and the Three Rivers Heritage Trail. You just have to remind yourself you're here to watch the game.

↓ Subaru Park

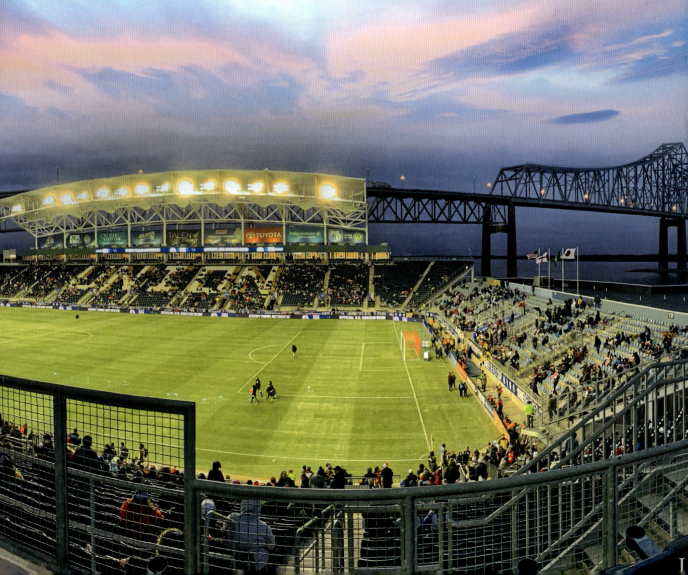

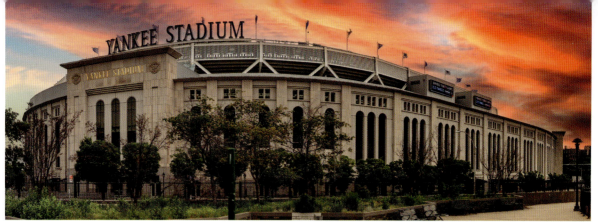
↑ Yankee Stadium

NEW YORK

Rocco B. Commisso Stadium
MANHATTAN, NEW YORK CITY (COLUMBIA LIONS)

The Harlem River flows beside this stadium, and crowd noise from the Columbia University Lions fans in the single main stand is joined by trains traveling across the Broadway Bridge, which runs behind it. The Lions have enjoyed success across three centuries; they played some of the earliest matches in the 1870s, became national collegiate champions in 1909, had a run of eight consecutive Ivy League titles from 1978 to 1985, and had Women's Ivy League success in 2006. In winter a heated, air-supported dome known as the "bubble at Baker" is erected over the pitch. A common sight in the coldest states, domes allow for small-sided, fast-paced games to continue all year round, bringing huge benefits to the development of youth soccer.

The Ground
MANHATTAN, NEW YORK CITY (MULTIPLE TEAMS)

The Ground sits in the backstreets of Chinatown, and you get an iconic view of its rooftop pitch from the Manhattan Bridge. Below it is an indoor pitch, popular for pickup games, and below that is a bar and seating area where fans can watch live matches from across the world. On an outside wall, four huge, black-and-white portraits of Diego Maradona, George Best, Sir Alex Ferguson, and Franco Baresi by New York street artist BKFoxx add to the iconography of the venue.

Pier 40 at Hudson River Park
MANHATTAN, NEW YORK CITY (MULTIPLE TEAMS)

On the Hudson River Greenway, stretching the length of Manhattan's West Side, is Pier 40, a parking garage, boat mooring point, and home to two hidden soccer fields.

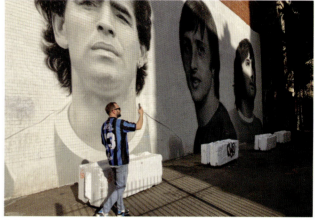
↑ The Ground

Metropolitan Oval
QUEENS, NEW YORK CITY (YOUTH ACADEMY)

Met Oval sits behind an almost hidden entrance and between rows of houses and a freight rail line, so you could be fooled into thinking you'd come to the wrong place. Yet it has been here since 1925. The once grassless, dusty ground was renovated in 2001, and is the oldest continuously used field in the country. It is home to the Met Oval Youth Center of Excellence, a feeder program to MLS and international academies. As well as watching a game, you can also enjoy views of the Manhattan skyline.

Belson Stadium
QUEENS, NEW YORK CITY (ST. JOHN'S RED STORM)

Belson Stadium is built above an underground parking garage. As well as being home to St. John's Red Storm, the stadium hosted the 2016 NASL Soccer Bowl when New York Cosmos beat Indy Eleven on penalties. This 2,168-seater soccer-specific stadium hosts matches of the historic Long Island Soccer Football League. Since 1948 the League has fed both national teams with talent. Together with its youth league (one of the largest in the US) it has cemented Long Island's reputation as a hotbed of US soccer, which is set to continue thanks to Long Island's many popular domed pitches offering year-round play.

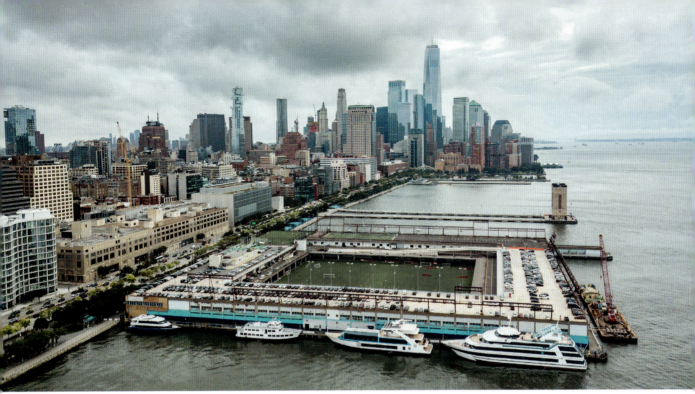

↑ Pier 40 at Hudson River Park

Pier 5
BROOKLYN, NEW YORK CITY (MULTIPLE TEAMS)

Waterside soccer under the Manhattan skyline is always special: the morning calls of shorebirds, the afternoon sun on the bay, the sunset, and then the light show of the skyscrapers.

Gaelic Park
THE BRONX, NEW YORK CITY (MANHATTAN SC / MANHATTAN COLLEGE JASPERS)

Gaelic Park sits beside railroad tracks in the Bronx and freight trains sometimes rest high above the stadium like a haunting extension of the north stand. From 1926 it was used for Gaelic games by Irish immigrants. The Irish vibe is very much intact with Irish flags flying and an emerald-green vintage scoreboard.

Yankee Stadium
THE BRONX, NEW YORK CITY (NEW YORK CITY FC)

Banging bass drums, smoke bombs, and the chanting of "Come on New York, Ooooohhh Ooooohhh" are part of a procession under the River Avenue bridge to the stadium. The noise doesn't stop until the final whistle, turning Yankee Stadium from a baseball Mecca to a soccer ground.

SU Soccer Stadium
SYRACUSE (SYRACUSE ORANGE)

The home of Syracuse Orange men's and women's teams is the same age as Major League Soccer, born in 1996. There's a special atmosphere at night games under the floodlights.

Rochester Community Sports Complex
ROCHESTER (FLOWER CITY UNION)

The "downtown soccer stadium" in Rochester was built on a filled-in section of the old Erie Canal route. With a strong tradition of hosting women's soccer, they are home to Flower City 1872, named in honor of women's suffrage campaigner and Rochester resident Susan B. Anthony voting in an 1872 federal election.

Elmore Field
ONEONTA (HARTWICK HAWKS)

Elmore Field is home to the Hartwick Hawks' men's and women's teams. Its tree-lined perimeter and sparse seating hide its importance to the growth of soccer in the United States. In fact, the US Soccer Hall of Fame was located in Oneonta for many years. It was here that Hal Greig started a soccer program in 1956, three years before the sport was even sanctioned by the NCAA. The teams became a national powerhouse before slipping into relative obscurity.

Vermont/Massachusetts/Connecticut/New Jersey / North America

VERMONT

Virtue Field
BURLINGTON (VERMONT GREEN FC)

Virtue Field, home to Vermont Green FC and the University of Vermont's NCAA-winning men's team, sits on land used by generations of Indigenous people as a site for meeting and exchange. Vermont Green FC openly recognizes their role as guests on the land and the Western Abenaki as the caretakers. "Go Green!" is chanted from the terraces and feeds into the fabric of the club. Fans pick up, separate, and discard their trash. All waste from the portable restrooms is turned into fertilizer. Green Mountain Transit buses to the stadium are free.

Applejack Stadium
MANCHESTER (BLACK ROCK FC / VT FUSION)

Applejack Stadium still has the original 1887 wooden grandstand from the site's former use as horse racing track. The stand houses five hundred, with 134 in stadium seats and the rest on wooden benches. Watch an NCAA game here against the spectacular backdrop of the Green Mountains.

MASSACHUSETTS

Lusitano Stadium
LUDLOW (WESTERN MASS PIONEERS)

Established by Portuguese immigrants in 1918, the Lusitano is one of the oldest soccer-dedicated stadiums in America. A statue of Portugal and Benfica legend Eusébio stands outside the ground. It is now home to USL League Two team Western Mass Pioneers.

Jordan Field
BOSTON (HARVARD CRIMSON)

In addition to being the home of the Harvard Crimson men's and women's teams, Jordan Field has hosted New England Revolution. The field sits in imperious surroundings between the Charles River and Harvard Stadium.

CONNECTICUT

Morrone Stadium
MANSFIELD (CONNECTICUT HUSKIES)

When Morrone Stadium opened in 1969, it was named Connecticut Soccer Stadium. This was before Pelé came to Cosmos, before Mia Hamm, before Diana Ross missed an open goal, and before the MLS. The stadium was a true trailblazer. Joe Morrone started the UConn soccer program the same year, staying until 1996, and winning the men's NCAA championship in 1981. Metal bleachers line the field and the south goal. Behind the north goal it is standing room only. This is where the Goal Patrol drive the Connecticut Huskies forward with chants, drums, and a sea of white.

Trinity Health Stadium
HARTFORD (HARTFORD ATHLETIC)

Hot dog and beer deals and a variety of food trucks every game night make Trinity Health Stadium, somewhat ironically, a gourmet delight. Soccer has been played here since 1935, and since 2018 the field has been home to USL Championship team Hartford Athletic.

NEW JERSEY

Roberts Stadium
PRINCETON (PRINCETON TIGERS)

The home of Princeton Tigers men's and women's teams is named after former goalkeeper Thomas S. Roberts. The USMNT held a weeklong training camp at the stadium in preparation for the 2010 World Cup, a testament to the quality of the facilities and playing surface. The first-ever soccer match on US soil was played nearby under London FA rules with Rutgers beating Princeton 6–4 on November 6, 1869.

Yurcak Field
PISCATAWAY (RUTGERS SCARLET KNIGHTS)

Yurcak Field has a beautiful playing surface of Kentucky bluegrass. The surface promotes slick passing and gliding attacking runs. The Rutgers Scarlet Knights are the team to benefit, and they try to emulate Barcelona.

MetLife Stadium
EAST RUTHERFORD (MULTIPLE TEAMS)

When the teams take to the field for the 2026 World Cup final, they will not enter the MetLife, but the New York/New Jersey Stadium. The pitch will change to natural grass and the stadium's transformation into a soccer arena will be complete. Although it has hosted many great international matches and club sides over the years this will be a day to rival the great Jets, Giants, and Super Bowl moments. Pelé graced the field of the MetLife's predecessor, Giants Stadium and before that the Cosmos' first home, Downing Stadium on Randall's Island, where he debuted for the NASL's major new franchise. The Cosmos have written a significant page in the history of US soccer and its stadiums have played their part.

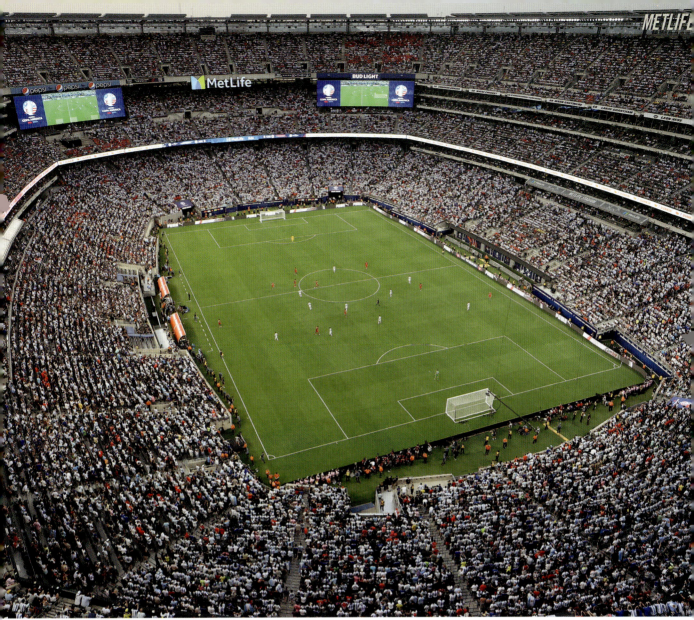

↑ MetLife Stadium

Red Bull Arena
HARRISON (NEW YORK RED BULLS / NY GOTHAM FC)

With its position on the banks of the Passaic River, the Red Bull Arena is a perfectly formed midsize stadium. The stands are close to the pitch and the corners are curved for perfect sight lines. The upper tiers are made from galvanized metal so fans can create noise by stomping their feet. The lower tiers are concrete. Big crowds descend on the arena for both the MLS New York Red Bulls and NWSL Gotham FC. The arena has the first permanent sensory room for those with autism, with fidget toys, dimmed lighting, and visual aids. It was once the office of the general manager who had an autistic daughter.

WASHINGTON, DC

Audi Field
WASHINGTON, DC (DC UNITED / WASHINGTON SPIRIT / DC POWER FC)

There are many options for experiencing the Audi Field. You can relax with a beer leaning over the balcony at the rooftop bar. Or you can feel the noise in the safe standing north stand with La Barra Brava, Screaming Eagles, and District Ultras. There's a family-friendly vibe in the east and west stands, which have a canopy roof. The stadium is home to MLS DC United and Washington Spirit of the NWSL so there are plenty of opportunities to take in a game. The walk to the stadium is a pleasure, with its location on the peninsula of Buzzard Point, where the Potomac and Anacostia Rivers meet.

Maryland/West Virginia/Virginia/North Carolina / North America

MARYLAND

Maryland SoccerPlex
BOYDS (MARYLAND BOBCATS FC)

This horseshoe-shaped stadium is landscaped with an elevated tree-lined walkway. The stands and pitch taper down into a shallow crater creating a natural intensity on match day. Behind the north-side goal is a scoreboard and star-spangled banner, to the west an impressive field house.

WEST VIRGINIA

Hoops Family Field
HUNTINGTON (MARSHALL THUNDERING HERD)

The Hoops Family Field is known as The Vet. The historic basketball Veterans Memorial Fieldhouse was demolished to make way for this new soccer-specific venue for Marshall University's men's and women's teams. The hoops and vet names pay homage, and the original 1950 memorial panel remains, built into the new entrance.

VIRGINIA

Segra Field
LEESBURG (LOUDOUN UNITED FC)

Segra Field is surrounded by forest and parking. So it's good views and tailgate parties for fans of Loudoun United FC of the USLC. The stadium is also used by DC United as a training facility, team office, and youth academy.

City Stadium
RICHMOND (RICHMOND KICKERS)

Located along the James River, the City Stadium is home to the historic Richmond Kickers. Together with Charleston Battery, the Kickers are the oldest continuously run soccer club in America, playing in USL League One. The stadium sits in a shallow crater in a semibowl shape with a steep isolated main stand. The capacity is 22,000 but the aging stand is used only for sponsorship hoardings for Kickers games, with the capacity reduced to 6,000.

Martin Family Stadium (Albert-Daly Field)
WILLIAMSBURG (WILLIAM & MARY TRIBE)

The grandstand is very steep with the press box at its peak towering above the pitch. The stadium's redbrick ticket kiosk, grandstand entrance, and team changing rooms make it a quintessential varsity venue. The field is dedicated to two highly respected soccer coaches for the William & Mary Tribe. Al Albert was twenty-two when he started in 1971 and was there for thirty-two years, leaving a year before the stadium opened in 2004.

NORTH CAROLINA

WRAL Soccer Park
RALEIGH (CASL TEAMS)

This soccer park consists of twenty-five individually sponsored soccer pitches, ten parking lots, a clubhouse, and a soccer stadium. It is a part of the youth development program of USL Championship team the North Carolina FC. The stadium is the centerpiece of the complex. The 3,200-seater arena is also home to Del Sol FC of the United Premier Soccer League.

Macpherson Stadium
GREENSBORO (NORTH CAROLINA FUSION U23)

Browns Summit, with its woodland and rolling farmland, plays host to USL League Two soccer. Macpherson Stadium is part of the twenty-soccer-field Bryan Park. This wonderful lakeside complex is rural soccer heaven.

UNCG Soccer Stadium
GREENSBORO (UNIVERSITY OF NORTH CAROLINA AT GREENSBORO)

A huge floodlight extends from the main stand above the press box. It's one of six that spans the pitch and makes night games special. The Spartans men's and women's teams of the University of North Carolina at Greensboro are well supported. For championship games, the capacity can swell to 10,583.

American Legion Memorial Stadium
CHARLOTTE (CHARLOTTE INDEPENDENCE / CAROLINA ASCENT FC)

President Franklin Roosevelt traveled to Charlotte in 1936 to dedicate the stadium, named as a memorial to local soldiers lost in World War I. Fast-forward to today, and the stadium has been completely reconstructed but with a difference. Elements of the original ground were removed, preserved off-site, and added back in. The new stadium is complete with the original ticket booths, wooden benches, and stacked stone wall around the field. And at the entrance is a World War I memorial.

Dorrance Field
CHAPEL HILL (NORTH CAROLINA TAR HEELS)

Named after Anson Dorrance, the trailblazing coach of the Tar Heels, the University of North Carolina's women's team, this stadium is home to one of the great dynasties of US sports. The new stadium sits on the site of Fetzer Field, built in 1935 and graced by legendary players such as Mia Hamm. Dorrance paved the way for America's burgeoning love affair with women's soccer, becoming head coach of the Tar Heels aged twenty-four in 1979, and leading the team to twenty-one NCAA titles before retiring more than forty years later. Enjoying the North Carolina sunsets and surrounded by sky-blue stands, the newly built field maintains its historic legacy.

WakeMed Soccer Park
CARY (NORTH CAROLINA COURAGE / NORTH CAROLINA FC)

This stadium is home to the NC Courage women's pro team, has been used by the women's national team for numerous internationals, and by the USMNT for a training camp. A distinctive feature is the seemingly floating second tier of the eastern stand. It sits behind the lower tier but is elevated and steep. It looms over like a frozen fairground ride about to flip the fans upside down.

Bank of America Stadium
CHARLOTTE (CHARLOTTE FC)

Charlotte FC set an MLS match attendance record in their first game here, when 74,479 fans saw them lose 1–0 to LA Galaxy. Matches are now reduced to thirty-eight thousand, so you'll need to get tickets early. Charlotte FC shares the stadium with NFL team Carolina Panthers. Come match day, only the lower tiers are used, and on television it looks like a packed smaller stadium. The reality is a gulf of empty seats rising into the heavens, which is an experience in itself.

↑ Fetzer Field

↓↑ Dorrance Field (Anson Dorrance above)

South Carolina / North America

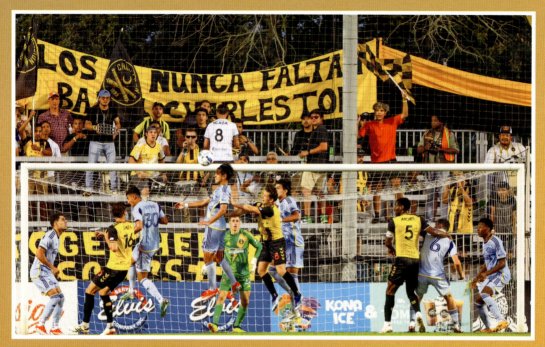

↑↓ Patriots Point Soccer Complex

SOUTH CAROLINA

Historic Riggs Field
CLEMSON (CLEMSON TIGERS)

A pedestrian bridge alongside Highway 93 leads directly into the north stand of Clemson University's stadium. Campus buildings sit snuggly behind the south stand. You can expect orange and purple smoke bombs and a huge tiger-print banner. The crowd sometimes overflows behind the east end, offering verbal volleying to visiting keepers. Collegiate sport has been played here since 1915, making it the fifth-oldest such facility in America, and soccer since 1980.

City Stadium
GREER (CITY OF GREER YOUTH TEAM)

This Gothic-looking stadium is a real piece of history untouched by time. It once hosted professional soccer, and big crowds flocked to its arched gateway.

North America / **South Carolina**

Paladin Stadium
GREENVILLE (GREENVILLE TRIUMPH SC)

Built in 1981, this family-friendly stadium has a selection of kid zones and a number of check-in points for smooth sailing to enter the venue. The capacity of sixteen thousand makes a big enough crowd to be fun without being overwhelming for young fans.

Eugene E. Stone III Stadium
COLUMBIA (SOUTH CAROLINA GAMECOCKS / FURMAN PALADINS)

Eugene E. Stone III Stadium at the University of South Carolina is known as the Graveyard. The House of Peace cemetery rests beside it. The steep grandstand, paid for by the late eponymous alumnus, has seats with armrests and a nice clubhouse. There's free parking opposite the stadium so nothing not to like here, plus drums and cheers of "Go Gamecocks!"

Patriots Point Soccer Complex
MOUNT PLEASANT (CHARLESTON BATTERY)

Ralph Lundy Field at Patriots Point Soccer Complex in South Carolina is home to the oldest continuously active professional team in the country. Charleston Battery has been going since 1993. The team of the Holy City has built up quite a following in that time, and the club's prematch tailgate parties are epic. Join the Regiment, Barra Charleston, and Queen Anne's Revenge in turning the parking lot black and yellow with smoke, Latin American *batucada* beats, beers, and barbecues.

Florida / North America

FLORIDA

Paradise Coast Sports Complex
NAPLES (FC NAPLES)

Paradise Coast Sports Complex is a dream venue for aspiring soccer players and hosts the annual Weston Cup and Showcase, one of the world's largest youth tournaments, attended by over 1,200 youth teams from across Florida and multiple states. Stretching across four Florida neighborhoods, Weston, Davie, Coral Springs, and Naples, it offers great hope for grassroots soccer. Its main stadium rests in Naples and is home to FC Naples of USL League 1.

Inter&Co Stadium
ORLANDO (ORLANDO CITY SC / ORLANDO PRIDE)

The Orlando soccer-specific stadium is like a classic British ground. It even has a sports bar called the British Pavilion. Four covered rectangular stands are filled in three corners with open seating. The fourth corner, which stops it from being a perfect octagonal shape, is dominated by a gigantic screen showing replays and match info to the crowd. It already has an iconic feel to it. The stands have serious Fiorentina vibes with the teams' distinctive purple and "Orlando" written large across the eastern side. As well as MLS and NWSL soccer, the downtown stadium hosts the annual Florida Cup, with winners including Flamengo, Arsenal, and Chelsea. The men's and women's national teams love playing here, both winning every single game.

ESPN Wide World of Sports Complex
BAY LAKE (YOUTH TEAMS)

The soccer fields of the ESPN Wide World of Sports Complex host mixed youth soccer camps. In 2020, it was the site of the MLS is Back Tournament following COVID-19. Twenty-six teams took part, with the champions Portland Timbers qualifying for the 2021 CONCACAF Champions League in the process.

Al Lang Stadium
ST. PETERSBURG (TAMPA BAY ROWDIES)

The home of the historic Tampa Bay Rowdies is located on the waterfront in downtown St. Petersburg. The shape of the stadium is heavily influenced by its sixty-year use as a baseball park. A large semicovered stand curves around the northwest corner, once the head of the diamond. The southeast side is completely open to Bayshore Drive and Tampa Bay. From the stand it creates a wonderful blend—the fervor of the match with the calm of the yacht basin.

Riverfront Stadium
TAMPA (TAMPA BAY SUNS FC)

The Tampa Bay Suns FC is a brand-new team playing in the new USL Super League. Without a stadium they have worked with local Blake High School to convert the school's Riverside Stadium, on the banks of the Hillsborough River, into a pro-level playing facility. Math and engineering students are involved in the construction, performing arts students will join the halftime experience, and communications students will help with broadcasting matches.

FAU Soccer Stadium
BOCA RATON (FLORIDA ATLANTIC OWLS)

The stadium in Palm Beach County is perhaps best known for its infamous home team, magicJack of the Women's Professional Soccer League. They existed for just one glorious season, but fielded future USWNT World Cup winners Abby Wambach, Hope Solo, and Christie Rampone. Current home team, the Florida Atlantic Owls, is as old as the stadium itself, both commencing in 1980.

Chase Stadium
FORT LAUDERDALE (INTER MIAMI CF)

Chase Stadium is home to Inter Miami, although it is actually located around thirty miles (48 km) north in the city of Fort Lauderdale. This ground will always be remembered for being the playground of Lionel Messi and the bastion of a US soccer revolution, where temporary stands shot up so more people could come and watch the show. With David Beckham as co-owner, the club entered the MLS for the 2020 season with great fanfare and a stadium dressed in the colors of the local flamingos. Pastel tones create stunning sunsets in this part of the world, when the rainstorm doesn't interrupt. A purple sky to match the now-famous pink jersey makes a good combination for a romantic soccer scene.

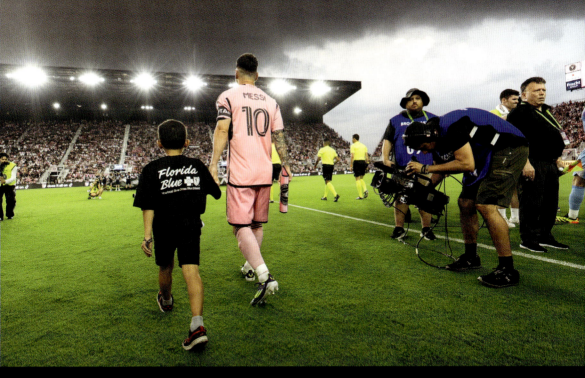

↑↗ Chase Stadium

Georgia/Tennessee / North America

GEORGIA

Tormenta Stadium
STATESBORO (SOUTH GEORGIA TORMENTA FC)

It's easy to see how this stadium, still in the early stages of development, will evolve. Plans see the capacity more than doubling in future years and the atmosphere is building. A run to the USL League One championship in 2023 saw South Georgia Tormenta FC players jumping onto the stands to celebrate with the Flight Crew supporters group. There's pregame live music, a new parking lot, and fans come pitch side for autographs and player hugs.

Fifth Third Stadium
KENNESAW (KENNESAW STATE OWLS)

Kennesaw State University and Women's Professional Soccer league team Atlanta Beat partnered to build the stadium in 2010. Beat lasted just one season with World Cup winner Carli Lloyd starring for them. Atlanta United FC has played eight matches here, winning every one. The Kennesaw State Owls are the sole home team now. The stadium has an interesting structure. The stands are formed into segments of seating, with balconied viewing boxes above them.

Mercedes-Benz Stadium
ATLANTA (ATLANTA UNITED FC)

The Mercedes-Benz Stadium opened the same year that home team Atlanta United FC was formed—2017. The Five Stripes fan base is huge, and the stadium capacity of seventy-one thousand is more than up to the task of housing them. Atlanta is the only team to average fifty thousand visitors across an entire MLS season. The circular opening in the retractable roof of the stadium is based on the ancient Pantheon dome in Rome, the world's biggest dome for a thousand years. That gives some idea of its size and wonder. The base of the opening is lined with a 360-degree LED display screen called the Halo, again one of the largest in the world.

TENNESSEE

Geodis Park
NASHVILLE (NASHVILLE SC)

Known as the Castle, due to its high walls and close proximity to Civil War–era Fort Negley, Geodis Park is the largest soccer-specific stadium in America. Its large, open, metal frame facade is topped with a 360-degree canopy roof. The farthest seats are just 150 feet (45 m) from the pitch; the result is an intense atmosphere.

Regal Stadium
KNOXVILLE (ONE KNOXVILLE SC)

Regal Stadium is located on the University of Tennessee's campus and home to Tennessee Lady Volunteers. Local professional team One Knoxville SC were temporary residents during the build of their downtown stadium. The ground has a large clubhouse with green multigabled roof. You can park for free, but may have to fight the other 2,999 fans for a space.

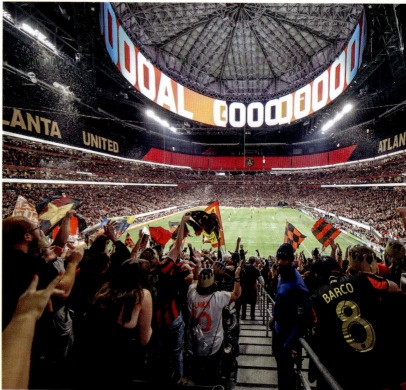

↑ Mercedes-Benz Stadium

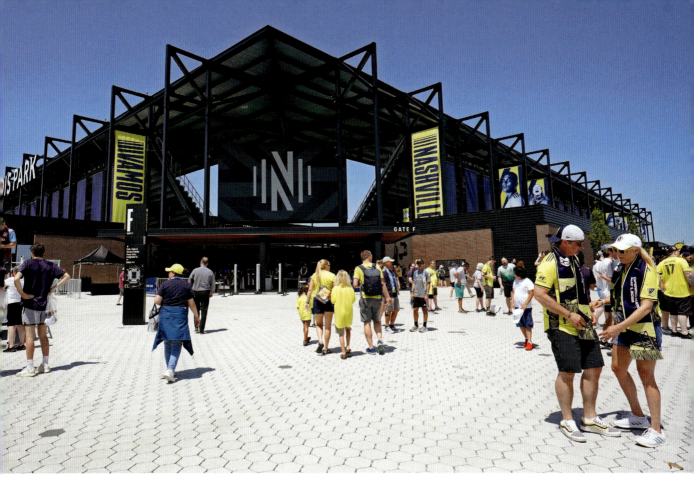
↑ Geodis Park

CHI Memorial Stadium
EAST RIDGE (CHATTANOOGA RED WOLVES SC)

For a relatively small stadium, CHI Memorial Stadium has an incredibly large jumbotron. At 2,000-square-foot (185-sq-m) it is the largest in Tennessee. Action replays look practically life-size. You can watch the Chattanooga Red Wolves SC from the stands, club lounge, skyboxes, or a two-story bar overlooking the pitch. There's DJ sets at the tailgate parties, and don't be surprised if your view of the stadium becomes completely obscured by clouds of red smoke.

ALABAMA

Orange Beach Sportsplex
ORANGE BEACH (MULTIPLE TEAMS)

Away from the sands of Orange Beach, the Orange Beach Sportsplex sits in the forested Gulf State Park. Playing second fiddle to nine baseball fields, the two soccer pitches sit quietly to the side but in beautiful surroundings.

MISSISSIPPI

Ole Miss Soccer Stadium
OXFORD (OLE MISS REBELS)

The home to the Ole Miss Rebels women's team is dominated by a redbrick gabled press box at the center of a single main stand. The rest of the ground is open to the surrounding trees on the edge of the University of Mississippi campus.

ARKANSAS

Razorback Field
FAYETTEVILLE (ARKANSAS RAZORBACKS)

Built in 1992, Razorback Field was the first collegiate soccer stadium dedicated to a women's team. Arkansas Razorbacks matches are lively and well attended. Expect plenty of calls to "Go Hogs!"

Texas / North America

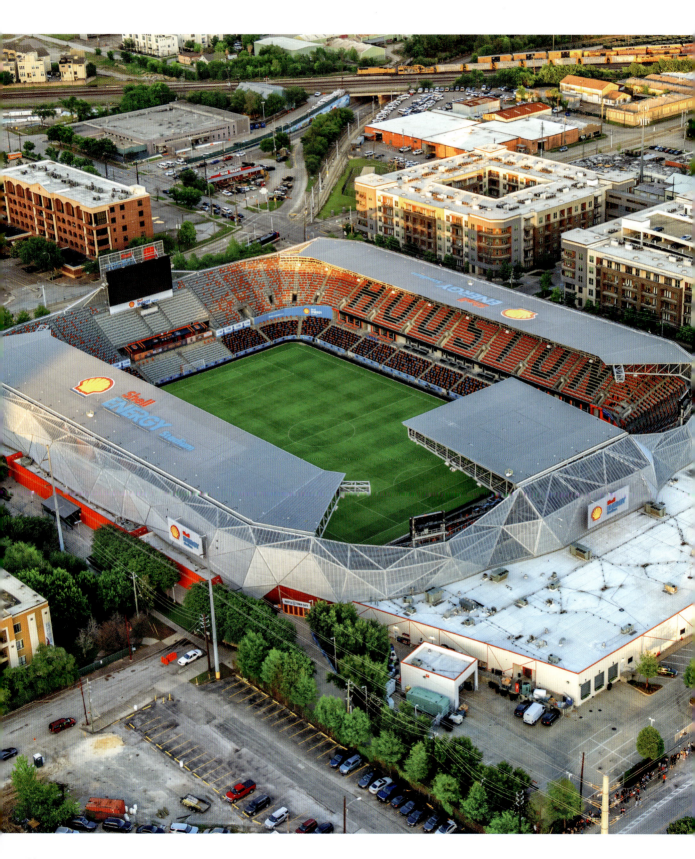

North America / **Texas**

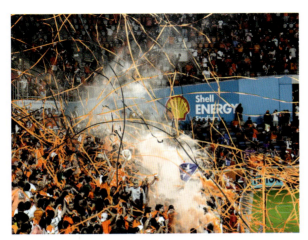

TEXAS

Shell Energy Stadium
HOUSTON (HOUSTON DYNAMO FC / HOUSTON DASH)

With a checkered metal mesh enveloping the entire stadium like a crystal bowl, the home of MLS Houston Dynamo FC and NWSL Houston Dash is unique in US soccer. It has a European feel. It sits in the heart of East Downtown Houston and is a central part of the area's redevelopment.

Texas / North America

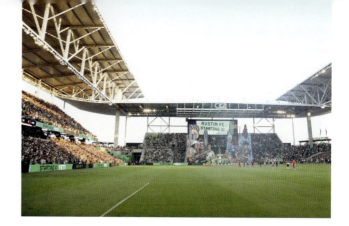

Q2 Stadium
AUSTIN (AUSTIN FC)

The stadium, built on the site of a former chemical manufacturing plant, is like a giant gazebo—open and airy but with a large canopy roof. Tifos feed into the "Keep Austin Weird" city motto. Huge banners can be seen covering much of the GA stand with a blend of Mexican and Jean-Michel Basquiat Neo-Expressionist-style artwork. There is always a flavor of eccentricity and diversity. La Murga de Austin band plays songs throughout the match, including "True Love Will Find You in the End," "Verde Submarine," and "Cinco Doce." Los Verdes and Austin Anthem lead the chants in the standing supporters section—the place to be for one of the best atmospheres in the MLS.

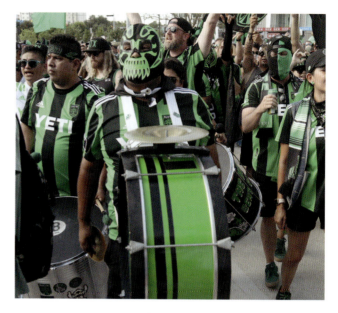

↑↗ Q2 Stadium

↑ Children's Mercy Park

Toyota Field
SAN ANTONIO (SAN ANTONIO FC)

A perfect match day for San Antonio FC fans starts with a cookout in the parking lot. Fan groups the Crocketteers and 210 Alliance organize tailgate parties with the perfect spot in the shade of Thousand Oaks Drive bridge. In the stands, fans turn out in *lucha libre* masks, while FTC de San Antonio and the Mission City Firm bring the smoke bombs. Large Lone Star flags are everywhere with "SAFC" written large, as well as rainbow pride flags. The place to be is in the Bunker, a melting pot of fans. A large banner reads "Chaos in the Bunker," and that's an apt description. A game to look out for with maximum chaos is against interstate rivals El Paso Locomotive FC. The Scorpions faithful helped their team to the USL Championship final in 2022 with more than 8,500 fans at the game.

Toyota Stadium
FRISCO, DALLAS (FC DALLAS)

The home of MLS FC Dallas in Frisco has two very distinctive features. At the north end is a large extended metal canopy structure. At the south end is the National Soccer Hall of Fame. It includes a museum and space for the Hall of Fame annual induction ceremony, all housed under its own large canopy. On match day the event space at the NSHF becomes a food and beverage hub.

KANSAS

Children's Mercy Park
KANSAS CITY (SPORTING KANSAS CITY / KANSAS CITY CURRENT)

Like the stairways in M. C. Escher's *Relativity*, the roof spirals down from a high point, across the four stands, to reach a final lower end point. The corners are angled toward the pitch so there's no need to crane your neck when watching the game. The El Capitan stand offers Mexican food like chicken taquitos and fish tacos. Or you can go for barbecue food like vegan Italian sausage, burnt ends, and pulled pork nachos. As well as being the home of Sporting KC and KC Current, the Children's Mercy Park has hosted an MLS All-Star Game, MLS Cup, and US Open Cup finals.

Colorado/Arizona/Utah/Nevada/Hawai'i / North America

COLORADO

Weidner Field
COLORADO SPRINGS (COLORADO SPRINGS SWITCHBACKS)

A spiral walkway at the northeast corner of the stadium leads you to elevated views of the field and a giant sculpture of two interlocking metal rings. The main stand is a larger form of the classic collegiate style, with a pavilion at its center. To the west is a very small stand of only a few rows; behind it, across the street, an apartment block with a view of the match. The Colorado mountains sit in the distance. At 6,035 feet (1,839 m) above sea level, the home of the USL Championship Colorado Springs Switchbacks FC is the highest stadium in US professional soccer.

Cadet Soccer Stadium
COLORADO SPRINGS (AIR FORCE TEAMS)

Cathedral Rock looks down over the Cadet Soccer Stadium at the foot of Eagles Peak in El Paso County. The stadium benefits from a lush Kentucky bluegrass pitch, making it a joy to play on. The stands are usually packed with a thousand fans cheering the Air Force Falcons men's and women's teams in the collegiate Mountain West Conference.

University of Denver Soccer Stadium
DENVER (DENVER PIONEERS)

The golden tower of the Ritchie Center looms over the stadium. It is part of a fusion of four buildings, including CIBER Field, that creates the unique backdrop of the stadium. The north side is the colonnade exterior of the adjacent lacrosse stadium. Behind the east stand are the Ritchie Center and Nagel Art Studios.

ARIZONA

Phoenix Rising Soccer Stadium
PHOENIX (PHOENIX RISING FC)

After building a new stadium at Wild Horse Pass in 2021, Phoenix Rising FC made a swift move away when the sacred land forbade any form of gambling, on apps or otherwise. The new site, right next to Sky Harbor International Airport, was built fairly hastily for the start of the 2023 season, and the club is still growing into its basic but solid surroundings.

Kino North Stadium
TUCSON (FC TUCSON)

Part of Kino Sports Complex, FC Tucson of the USL League Two beat MLS team Chivas USA 1–0 here on the stadium's opening day in 2013. Lining the edge of the stands are tifos from the Cactus Pricks and the Tucson FC chapter of the national American Outlaws. You might see George Washington, Captain America, or Rocky Balboa.

UTAH

Zions Bank Stadium
HERRIMAN (REAL MONARCHS)

When Real Salt Lake built a stadium for its MLS Next Pro team Real Monarchs, they built an almost perfect miniature version of an MLS arena. It has the incredible Utah backdrop of the Wasatch Mountain Range.

America First Field
SANDY (REAL SALT LAKE)

The home of Real Salt Lake and NWSL Utah Royals sits at the foot of the Wasatch Mountain Range. The stadium has been a fortress for Real, second in the all-time MLS home unbeaten streak of thirty-four matches. The fans enjoy roof coverage on two sides. If you can take in a night game, you'll be treated to a legendary sunset.

NEVADA

Cashman Field
LAS VEGAS (LAS VEGAS LIGHTS FC)

In the heart of downtown Las Vegas, just seconds from the world-famous strip, sits a soccer stadium that is home to the aptly named Las Vegas Lights. Sin City is famous for many reasons—and soccer definitely isn't one of them—so this little ground acts as a haven for lovers of the beautiful game trying to free themselves from the grasp of the town's casinos. Like many US soccer stadiums, the turf is also used for baseball, and so the form of the stands is completely irregular and the terraces appear out of place.

HAWAI'I

Waipi'o Peninsula Soccer Stadium
WAIPAHU (HAWAI'I RAINBOW WAHINE)

On a narrow peninsula within Māmala Bay is the home of Hawai'ian soccer. The stadium lies at the edge of nineteen further pitches. It is home to the University of Hawai'i women's team, the Rainbow Wahine, as well as the Island Championship playoffs. The two tribunes are built into curved hillside. Twin home and away changing cabins sit behind the goal at the south end.

North America / **Colorado/Arizona/Utah/Nevada/Hawaiʻi**

↓ America First Field

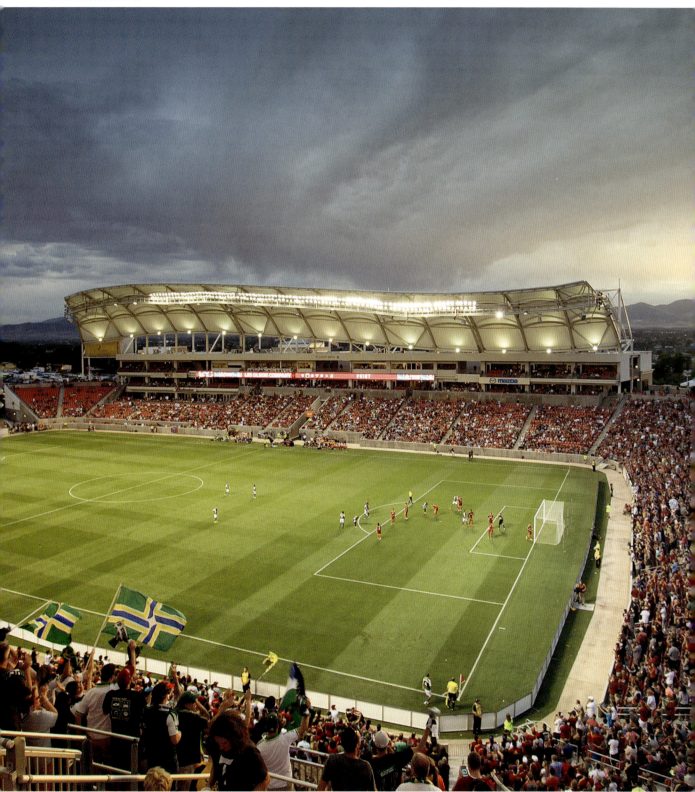

California / North America

CALIFORNIA

Snapdragon Stadium
SAN DIEGO (SAN DIEGO WAVE FC / SAN DIEGO FC)

The Sycuan Piers at the south end of the Snapdragon Stadium have to be one of the most unique viewing experiences in world soccer. Three levels of balcony bars rise above the south stand from the concourse. The top level is a pier, on which you can walk out above the seating below for an aerial view of the game, beer or cocktail in hand. The rest of the stands, largely left in the shade, are special too. Topped with inverted black floodlight towers, they unfurl like Venus flytraps.

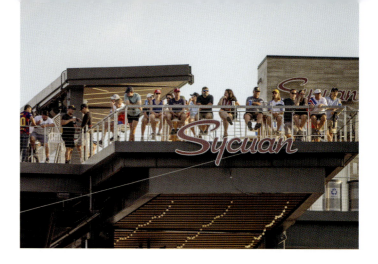

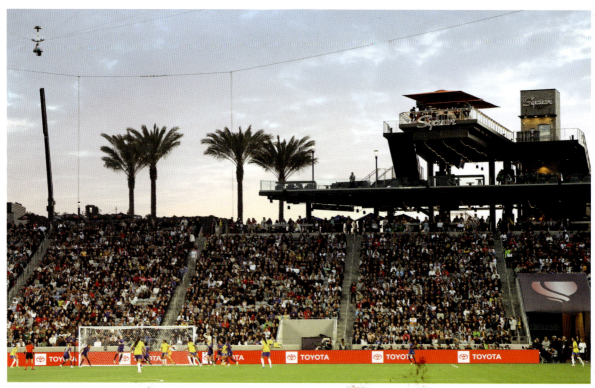

↑↗ Snapdragon Stadium

North America / **California**

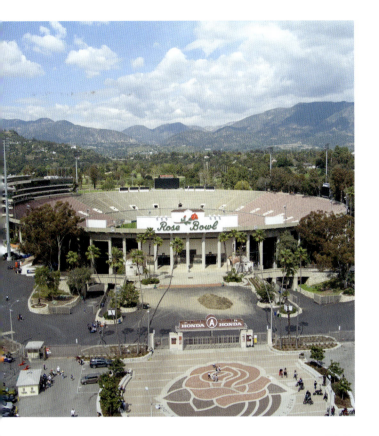

Dignity Health Sports Park
CARSON (LOS ANGELES GALAXY / LA GALAXY II)

This stadium in Carson is the home to the Los Angeles Galaxy—the most famous soccer team in the history of North America's Major League Soccer. As the stars of Europe began to migrate to stateside, this ground became the face of the American dream for the modern footballer, and Hollywood became home to many MLS Cups.

SoFi Stadium
INGLEWOOD (HOSTS OCCASIONAL MAJOR FIXTURES)

In 2020 SoFi Stadium became the most expensive ever built, at just over $6 billion. Home to NFL's LA Chargers and Rams, it also hosts major soccer events, including the Copa America, USWNT fixtures and the opening USMNT match in the 2026 World Cup. Huge windows open up to allow natural air flow and the roof is largely transparent. Looking up, you might wonder if you are inside or out. Seating eases away from the pitch into a large bowl, leaving a narrow playing surface. Think tight, combative football in a cauldron-like atmosphere.

Playa Vista Sports Park
LOS ANGELES (PICKUP)

The Playa Vista just off Lincoln Boulevard on Bluff Creek Drive is a beautiful soccer retreat set against rows of trees and elegant apartment blocks. There is a turf field and a grassy verge for watching or taking a breath from the game. There are multiple pickup leagues, and the pitch can be used 11x11 or, across the width, 7x7.

Rose Bowl
PASADENA (UCLA)

The Rose Bowl and its surrounding area is so beautiful that it doesn't even feel real. The 1994 World Cup was one of the most iconic of all time, and this stadium was home to some of its most famous moments—good and bad. In the final, Brazil triumphed, but cult figure Roberto Baggio ballooned his penalty and dropped to his knees in agony. That's soccer, but even his despair looked better in the California hills.

↑ Rose Bowl

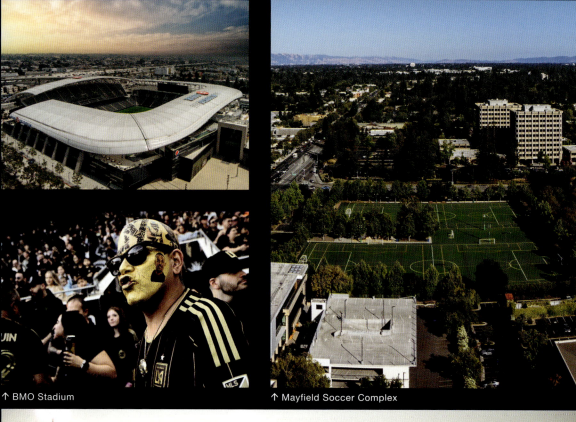

↑ BMO Stadium

↑ Mayfield Soccer Complex

↑ Harder Stadium

North America / **California**

Santa Monica Airport Soccer Field
SANTA MONICA (PICKUP)

You could literally rock up for a game in a Cessna 172, land it on the adjacent airport runway, park it, put on your soccer cleats, and away you go. The Santa Monica Adult Soccer League arranges men's, women's, and coed teams—11x11 and 7x7, but only for locals, spring, summer, and fall. If you're flying in from farther afield then just head down in the daytime and see what's happening.

Santa Monica Civic Center Multipurpose Sports Field
SANTA MONICA (PICKUP)

Close to the beach, pier, and ocean, this soccer pitch is a wonderful place for a game. The artificial turf plays well, palm trees line the pitch, and there's a permanent art structure based on an idyllic childhood house. Within its roof are the words "we sit in the cool evening breeze, whispered from the nearby sea waves." It could easily add, "watching the beautiful game."

BMO Stadium
LOS ANGELES (LOS ANGELES FC / ANGEL CITY FC)

El Tráfico derby between Los Angeles FC and LA Galaxy is the new big rivalry in the City of Angels. The BMO Stadium helps to create a cauldron of intensity, with the front row just 12 feet (3.6 m) from the pitch, and the furthest only 135 feet (41 m) away. Before the game there is a party atmosphere outside, with food, drinks, and games of teqball. During the match, if you can't get a ticket in the supporters section behind the goal, you can at least stroll the open concourse that circles the stadium and take in the atmosphere close-up.

Wallis Annenberg Stadium
LOS ANGELES (UCLA BRUINS)

You get all the fanfare of a major league stadium here—drums, chanting, hot dogs, soda—but with the Romanesque surroundings of the UCLA campus. Bruins have played on the field since 1967, although a large renovation in 2018 created the layout we see today, with modern stands and press box.

Mayfield Soccer Complex
PALO ALTO (PICKUP)

Stanford University and the city of Palo Alto combined to create a community soccer hub at an intersection of two major roads that manages to give the vibe of being in a rural spot. There is parking all around, with trees among the parking spaces and pitch side. There are two interconnecting fields with changing facilities between them.

Cubberley Community Center Turf Field
PALO ALTO (PICKUP)

This turf field is adjacent to baseball fields, but with an athletic track and trees between them, the danger of wayward baseballs is limited. While the single concrete terrace is the wrong side of a home run, it does give that soccer stadium feel.

Cagan Stadium
PALO ALTO (STANFORD CARDINALS)

Stanford University's campus was once the Palo Alto Stock Farm, a breeding and training facility for trotting horses. And so Maloney Field at Cagan Stadium is affectionately known as the Farm. Home to the hugely successful NCAA Cardinals, many future USWNT players have graced the field, including Chelsea's Naomi Girma, the first million-dollar women's soccer player.

UC Riverside Soccer Stadium
RIVERSIDE (UC RIVERSIDE HIGHLANDERS / CLUB XOLOS USA U-23)

Soccer has been played on the field at the University of California since the 1950s. Today, the UC Riverside Highlanders men's and women's teams both play in these beautiful surroundings with views of Box Springs and Shadow Mountains. Club Xolos USA U-23, affiliated with the Mexican giants Tijuana, also play here in the semiprofessional NPSL.

Stevens Stadium
SANTA CLARA (SANTA CLARA UNIVERSITY)

The stadium at Santa Clara University has hosted soccer since it opened in 1962, and Santa Clara's men's and women's teams have impressive home win records. It has also hosted the MLS, with the San Jose Earthquakes calling it home from 2008 to 2014. The sandstone entrance wall has Latin American–style archways and a terra-cotta-tiled roof. It has a large old-school-style electronic scoreboard showing match information and highlights. It's a stadium with a nice blend of old and new.

Harder Stadium
SANTA BARBARA (UC SANTA BARBARA GAUCHOS)

This stadium on the Pacific Coast is located on one of the most idyllic college campuses in the United States. UCSB is famous for soccer and has reigned across the nation. This school is lacking in the traditional American sports, but this only aided the town's love for soccer. A sign at the arena reads "This is Soccer Heaven."

41

California / North America

Vista Hermosa Sports Park
SAN CLEMENTE (PICKUP)

At Vista Hermosa you can play pickup soccer with hill views. There are powerful floodlights if you want to play a night game under the illuminated skyline.

Cardinale Stadium
SEASIDE (MONTEREY BAY FC)

The Cardinale Stadium is picture-perfect in the center of the Monterey Peninsula. The north and south stands are lined with Monterey cypress trees. The turf pitch is a wonderfully lush green. Soft floodlights cast a warm hue over games at night and the sun shines during the day.

Championship Soccer Stadium
IRVINE (ORANGE COUNTY SC)

You can sip champagne on a balcony with table service, or you can get in among the core supporters here. California United Strikers FC is the new team at the Championship Soccer Stadium, joining Orange County SC. Both teams play in the professional leagues just below the MLS. Watch them with cocktails or banging drums; the choice is yours.

↓ Vista Hermosa Sports Park

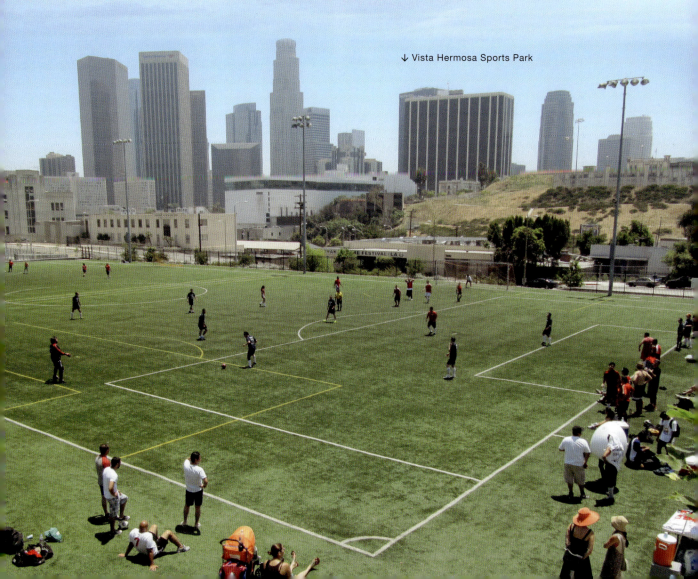

North America / **California**

Kezar Stadium
SAN FRANCISCO (SAN FRANCISCO CITY FC)

The historic Kezar Stadium, located in the southeastern corner of Golden Gate Park, was built in 1925 and was once home to the San Francisco 49ers and Oakland Raiders. Since then, the beautiful game has arrived in the form of San Francisco City FC of the USL League Two. The stadium was used for many scenes in the 1971 film *Dirty Harry*. Scorpio, the sniper killer tracked down by Clint Eastwood's character, worked as the groundskeeper and lived under the grandstand.

Boxer Stadium
SAN FRANCISCO (EL FAROLITO SC)

The historic Boxer Stadium in Balboa Park has hosted the century-old San Francisco Soccer League since 1953. It is also home to El Farolito SC, who play in the Golden Gate Conference, the fourth tier of the US pyramid. The stadium's wooden benches, concrete stands, and clubhouse take you back to a time when soccer in the United States was still building on the successes of the 1950 World Cup.

Heart Health Park
SACRAMENTO (SACRAMENTO REPUBLIC FC)

The Tower Bridge Battalion brings the noise and color to Sacramento Republic FC matches with tailgate parties in the huge parking lots, and flags, drums, and chants in the stands. It's one of the fiercest supports in the USL. The first game at the Heart Health Park drew twenty thousand fans, double the league record. The stadium has a South American vibe with open stands backed with palm trees.

PayPal Park
SAN JOSE (SAN JOSE EARTHQUAKES)

As San Jose Clash, the home team played out the first-ever MLS game in 1996, beating DC United 1–0. Having returned to their more loved and illustrious name of San Jose Earthquakes, they moved to the newly built PayPal Park in 2015. Matches against LA Galaxy are the fiercest, known as the California Clásico. Win or lose, the San Jose flags don't stop waving, and goals are met with three streaks of steam fired off behind the goal.

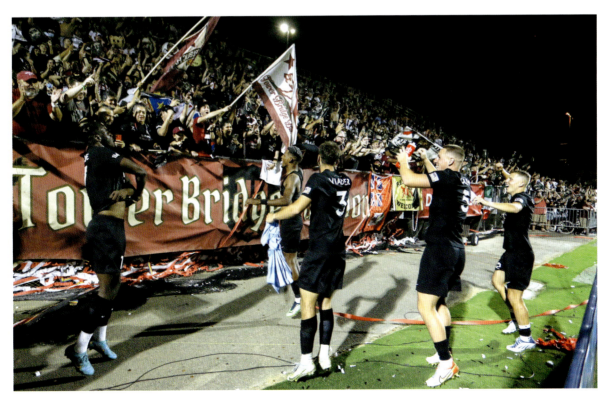

↑ Heart Health Park

Mexico / North America

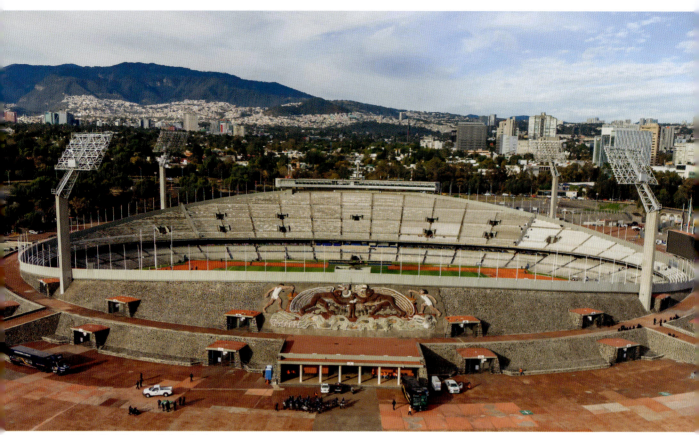

↑ Estadio Olímpico Universitario

MEXICO

Estadio Alfonso Lastras
SAN LUIS POTOSÍ (ATLÉTICO SAN LUIS)

The Estadio Alfonso Lastras is part owned by Spain's Atletico de Madrid. Home team Atlético de San Luis is made up of local talent and academy players arriving from Los Colchoneros. The playing surface is a lush natural grass, helping to promote a flowing passing game. The stadium sits on a platform, and an intriguing, colorful bridge feeds into it from the parking lot.

Estadio Ciudad de los Deportes
CIUDAD DE LOS DEPORTES, MEXICO CITY (CRUZ AZUL / TAZÓN MÉXICO / ATLANTE)

The historic home of Cruz Azul finds itself in a stay of execution, with structural improvements ongoing. Its team moved to the Estadio Azteca for four seasons, but has now returned. The distinctive stamp of Azul, a large blue cross in a red-and-white square like one on an ambulance, is everywhere at the Estadio Ciudad de los Deportes. Las Celestes have also returned; the Azul cheerleaders are the only ones in Mexico, and you can see them perform before every match.

Estadio Olímpico Universitario
MEXICO CITY (CLUB UNIVERSIDAD NACIONAL)

The second-largest arena in Mexico has a capacity of seventy-two thousand. Much of the volume comes from the enormous west stand, whose concrete benches seem to just keep going beyond what appears realistic. The east terrace is similar. Little has changed since it was built in 1952 and so watching Pumas UNAM play here is like stepping back in time. The main entrance is adorned with Mexican and Olympic iconography in a mural by Diego Rivera. The Olympic cauldron sits on a plinth above it. At the time of its build, Frank Lloyd Wright, architect of the Guggenheim in New York, called the stadium "the most important building in modern America." UNAM fits in with the iconic nature of the surroundings. Their jerseys are based on the blue and gold of the University of Notre Dame in the United States and have a huge golden puma head on the front.

North America / **Mexico**

Teoca volcano soccer pitch
MEXICO CITY (MULTIPLE TEAMS)

Fancy a pickup game at 8,858 feet (2,700 m) above sea level on the forested slopes of a volcano crater? The Teoca volcano soccer pitch, just outside Mexico City, is home to a small amateur league that meets on weekends. A single road will get you there, or you can take the 11-mile (18-km) hiking trail. If you arrive early enough, you can see the mountain mist that covers the pitch slowly fade away as the sun rises.

Estadio Azteca
MEXICO CITY (CLUB AMÉRICA)

One of the most iconic stadiums in the world, "the Steel Giant" gave the Mexican wave to the world in 1986. It conjures up images of Maradona's telepathic pass for Burruchaga, the luscious, overly green grass, the giant spider shadow across the pitch, fans wearing giant sombreros, and El Pibe de Oro kissing the trophy and then being held aloft on a sea of bodies. These iconic images were only mirroring what had gone before: Pelé scoring the one hundreth World Cup goal in the final against Italy in 1970; the Seleção's interweaving passes, gliding across the pitch to score one of the great team goals; Jairzinho running onto Pelé's nonchalant pass; and O Rei riding on a sea of bodies in celebration.

Estadio Jalisco
GUADALAJARA (ATLAS FC)

This stadium is one of the few to host matches in two World Cups—1970 and 1986. On both occasions it became the base for the Brazilian team, and there is still a bond between the people and the Seleção. It brings with it the flavor of Guadalajara life: aromas from street vendors cooking *torta ahogada* (pork sandwiches) and birria, and Atlas fans milling about in red and black with the hum of chatter and building chants. La Fiel—the Faithful—have waited decades for success, and the die-hard La Barra 51 tell you everything you need to know. The last league title was in 1951, nine years before the stadium was built.

Estadio Akron
ZAPOPAN, GUADALAJARA (CD GUADALAJARA)

The first goal at the Estadio Akron was scored by Javier Hernández, playing for home team Guadalajara against Manchester United. The match was both to inaugurate the stadium and to symbolically confirm the transfer of the Mexican star to the English club. Chicharito played for the Red Devils in the second half as a farewell gesture. Las Chivas—the Goats—won 3–2, boding well for future glory here.

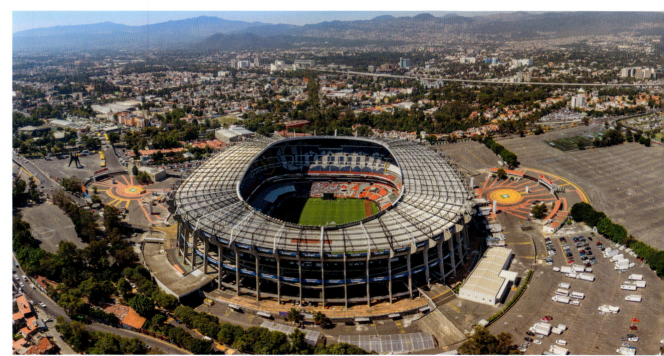
↑ Estadio Azteca

Mexico / North America

Estadio León
LEÓN (CLUB LEÓN FC)

The Estadio León is known as Nou Camp due to its similar tapering curvature to Barcelona's home. The stadium is a sore venue for England fans. The reigning World Champions were 2–0 up against West Germany in their 1970 quarterfinal at the stadium, only to substitute their star player Bobby Charlton to rest him for the semifinal, and lose 3–2. Where the Three Lions faltered, León has thrived, and a yellow lion's head adorns the goal end.

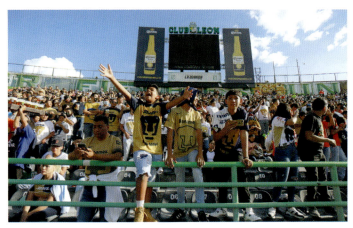

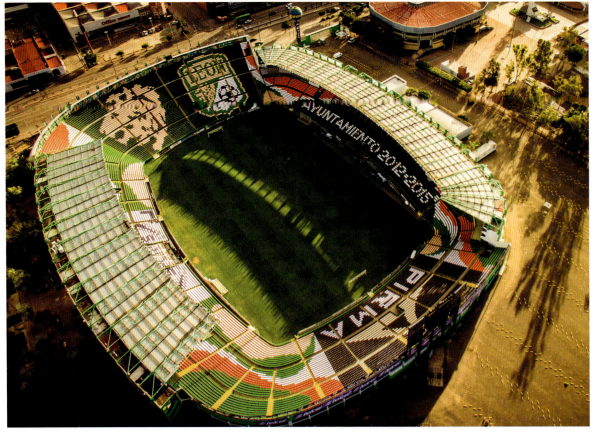

↑↗ Estadio León

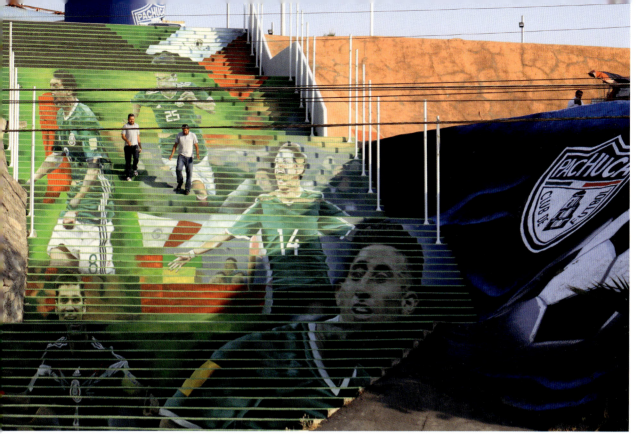
↑ Estadio Hidalgo

Estadio Victoria
AGUASCALIENTES (CLUB NECAXA)

The Estadio Victoria has a quite extraordinary feature spanning the top of the Sud Gol stand—a fountain. Tall flagpoles project from the roof and circulate around the stadium, coming to a dramatic end when the south side falls away into a shallow stand and void. The fountain fills the void and creates an amazing spectacle when lit up at night. From high in the Norte Gol stand you can see the fountain and the hustle and bustle of the streets of Aguascalientes.

Estadio Olímpico Benito Juárez
CIUDAD JUÁREZ (FC JUÁREZ)

The Olímpico Benito Juárez is one of those unique things, an octagonal stadium. It is elevated, with staircases leading into every corner, and has wonderful views of the McKelligan Canyon and Franklin Mountain.

Estadio Hidalgo
PACHUCA (CF PACHUCA)

The Estadio Hidalgo is awash with color and little elements that would fit into a gallery—from the giant football in the plaza to the stairs leading toward it painted with images of soccer players. This feeds into the culture of the city of Pachuca, where an entire hillside of houses has become a giant mural. At the Hidalgo there are orange gateways, blue cubist entrances, and seats covered in abstract artwork. All of this is topped off with a red San Siro–like roof framework.

Estadio Cuauhtémoc
PUEBLA CITY (CLUB PUEBLA)

The Estadio Cuauhtémoc is the first stadium in Mexico to embrace the ETFE technology, seen so much around the world. The membrane allows for any shape and color of facade. The Cuauhtémoc has a blue-and-white paneled pattern wrapped around the existing structure. From the inside, the membrane creates a huge wall in the areas between stands.

Mexico / North America

Estadio Corregidora
QUERÉTARO CITY (QUERÉTARO FC)

The Estadio Corregidora is known as El Coloso del Cimatario (the Colossus of the Summit) due to its location among the rolling hills, mountain ranges, and elevated flatlands of Querétaro. In a match with Atlas in 2022 fighting broke out in the crowd, the match was abandoned, and spectators banned from the stadium for a year. It is open now and is a perfect shallow twin-tiered arena, but it's advisable to be on your guard and stay safe.

Estadio Corona
TORREÓN (SANTOS LAGUNA)

The Estadio Corona has the ominous nickname La Casa del Dolor Ajeno (the House of Others' Pain). A more fitting one is perhaps El Templo del Desierto (the Desert Temple) because it has a palatial feel to it and the grandstand is lit up like an altar at night. The huge crown emblem of Corona, the beer brand that gives the stadium its name, sits on the entrance of the glass facade, tying in with the visual narrative.

Estadio Universitario
SAN NICOLÁS (UANL)

Estadio Universitario is known as El Volcán (the Volcano) due to its craterlike shape. It is located within a university campus in the city of San Nicolás, and its shallow open-air structure allows views of the Cerro de la Silla mountain. At the 1986 World Cup the stadium saw Mexico lose a heartbreaking penalty shoot-out to West Germany in the quarterfinal.

Estadio Caliente
TIJUANA (CLUB TIJUANA)

You enter the stadium through a giant red dog's head. The ticket office is to the right of the dog entrance, and you can often purchase tickets on the morning of the game. In the stadium you get to your seat through one of four wide entrances. From the grandstand, the east stand unfolds with an epic screen way up high at the center of vertical sponsor hoardings—the grandstand layers of balconies and VIP lounges. You can order beers and food from your seat, but for a hot dog you'll have to catch the eye of a roaming vendor. Try the *machaca*, a slow-dried marinated salt beef.

Estadio Nemesio Díez
TOLUCA (DEPORTIVO TOLUCA FC)

Set in a heavily built-up Toluca, the Estadio Nemesio Díez is all about space saving. Four steep stands are connected by four VIP towers at each corner. They also support the roof and leave more room for hardcore fan seating in every stand. A large multistory parking garage sits away from the stadium across the Felipe Villanueva Road, connected by two tubular bridges. The garage has a pitch of its own on the rooftop. The stadium is known as La Bombonera de Toluca for its condensed fervent atmosphere and chocolate-box appearance.

Estadio El Hogar
MATAMOROS (GAVILANES DE MATAMOROS FC)

For something truly unique visit La Ola (the Wave) in Matamoros. The main structure is a relatively basic rounded rectangle, but its supporting structure is visually jarring, fascinating, and wonderful in equal measure. Hundreds of huge concrete crossbeam structures span out rhythmically around the entire stadium like a carcass. The voids are used for parking, pop-up street food vendors, and small cabins. Whether a facade will be added, or if the slow random metamorphosis will continue, is yet to be seen. At the moment it is a glorious curiosity hosting Liga Premier third-tier soccer.

Estadio Universitario Alberto "Chivo" Córdoba
TOLUCA (POTROS)

A single concrete terrace accounts for almost the entire capacity of the stadium, and is covered in an epic 23,919-square-foot (20,000-sq-m) mural. The land art piece by Toluca artist Leopoldo Flores covers the entire semicircular terrace and runs on to the rocks above. It depicts a figure reaching up to the sky in a field of light beams.

Estadio de Mazatlán
MAZATLÁN (MAZATLÁN FC)

The Estadio de Mazatlán is known as El Kraken, the mythical sea monster of the Scandinavian seas. With its distinctive white undulating outer shell, and location on the Pacific Coast, you could imagine it emerging from the seas and devouring the Mazatlán pier.

North America / **Mexico**

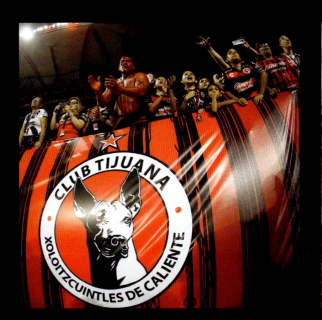
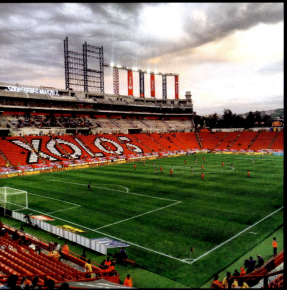
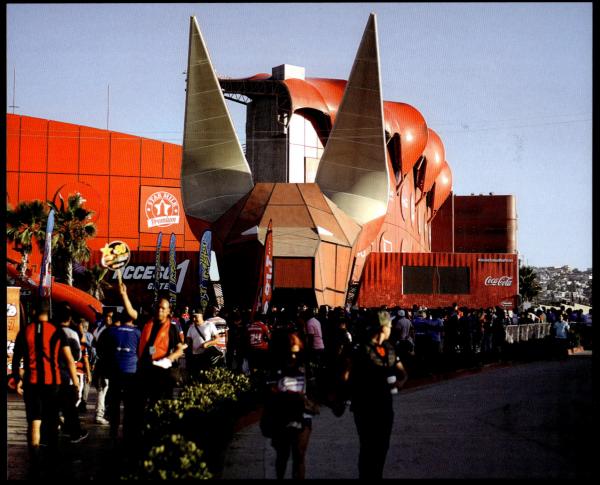

↑ Estadio Caliente

49

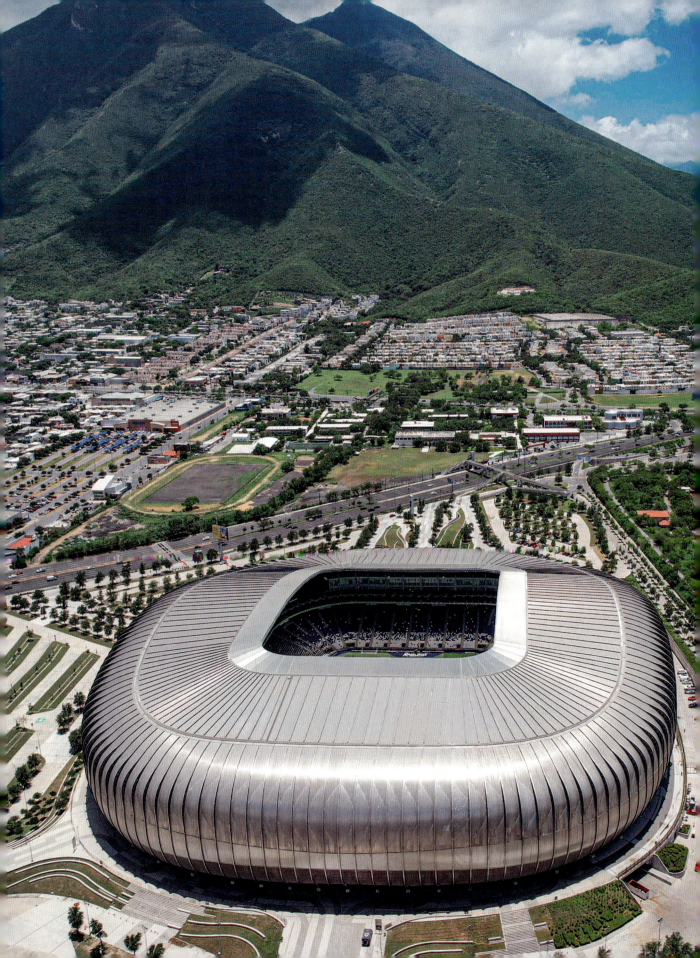

North America / **Mexico**

Estadio BBVA
GUADALUPE, MONTERREY
(CF MONTERREY)

If you can get a seat high in the northeast stands you'll have one of the most wonderful views in world soccer—the beautiful interior of El Gigante de Acero (the Steel Giant), with a pitch as close to the fans as FIFA will allow, and the epic Cerro de la Silla appearing through the roof's narrow opening.

Cuba / The Caribbean

CUBA

Estadio La Bombonera
SAN CRISTÓBAL (FC PINAR DEL RÍO)

The bus doesn't stop in San Cristóbal. You have to walk the last mile on the edge of the historic tobacco farms and under the shadow of the Sierra del Rosario mountains. In 2008, La Bombonera was ravaged by a hurricane and remains crumbling, with a dirt pitch. The stadium, though, is home to the proud club of FC Pinar del Río, and you can take a seat in the wooden and concrete stands, drink some rum, and listen to the banging *pinareños* drums.

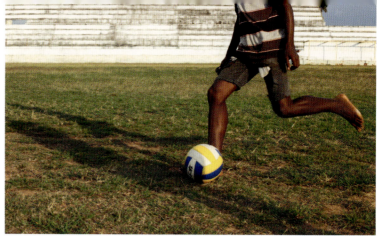

↑↓ Estadio La Bombonera

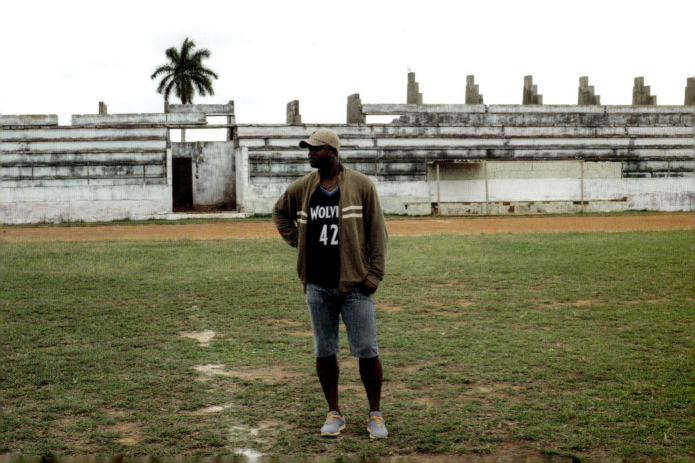

The Caribbean / **Cuba/Saint Barthélemy**

↑ Estadio Pedro Marrero

Estadio Pedro Marrero
HAVANA (NATIONAL TEAM)

The stadium commemorates Pedro Marrero who was killed in 1953 during the Cuban Revolution in an attack on the Moncada Barracks. One of the stadium's highlights is the huge digital scoreboard standing behind one of the goals. Its greatest game was perhaps "the doors are open" match between Cuba and the New York Cosmos in 2015, with Pelé and Maradona in attendance.

Estadio Luis Pérez Lozano
CIENFUEGOS (FC CIENFUEGOS)

FC Cienfuegos translates wonderfully as FC Hundred Fires. Their home, the Estadio Luis Pérez Lozano, is located at Cienfuegos Bay in the city known as the Pearl of the South. A walkway with a solitary palm tree leads you to a largely wooden main stand with a hot tin roof. You can see through to the crowd sitting in anticipation of the match, their bicycles lined up along a fence. It's a charming scene. Behind the northern goal are two small uncovered concrete terraces. The bayside goal backs onto houses and their yards.

SAINT BARTHÉLEMY

Stade de Saint-Jean
SAINT BARTHÉLEMY (NATIONAL TEAM)

Having bought a holiday home on the island of Saint Barthélemy, former Chelsea FC owner Roman Abramovich, who bankrolled the London club to English and European glory, paid for the Stade de Saint-Jean to be fully renovated. The stadium, located beside an air landing strip and the turquoise waters of the Bay of Saint-Jean, now hosts one of the smallest national teams in world soccer.

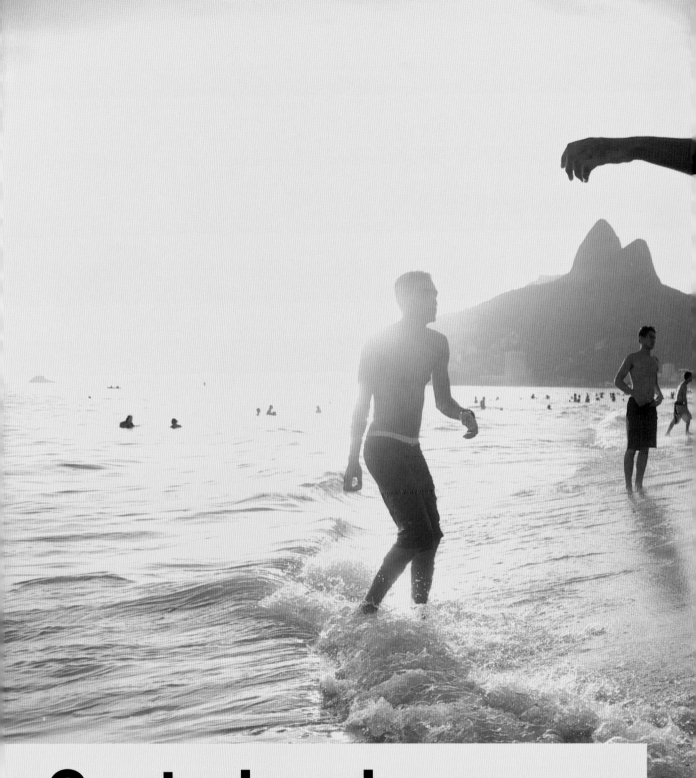

Central and South America

CHAPTER 2

Central America / **Guatemala/Nicaragua/Costa Rica/Panama**

GUATEMALA

Estadio Municipal Sampedrano
SAN MARCOS (DEPORTIVO SAN PEDRO)

If you're arriving by car it's a dream, if you're on foot be alert: A wooden wall encircles the stadium and cars park right up beside it all the way around. Most of the crowd packs into one covered main stand with bucket seats. When a mist descends from the mountains, it can be an otherworldly scene.

Estadio Dr. Óscar Monterroso Izaguirre
RETALHULEU (DEPORTIVO REU)

The stadium is lined with tall palm trees, but overall is somewhat dilapidated, giving an interesting visual play of rawness and beauty.

Estadio Mario Camposeco
QUETZALTENANGO (XELAJÚ MC)

On match day, join the crowds as they congregate on the stadium's concrete steps—you may even be able to sit on one of the plastic seats. The arena itself is a patchwork. While the main stand's concrete skeleton is visible, the framework of the stadium is composed of various elements pieced together over time, from hodgepodge stands to sponsorship hoardings. This melting pot is a hive of activity as fans watch their highly decorated team, Xelajú MC, perform.

← Estadio Nacional de Costa Rica

Estadio Julián Tesucún
SAN JOSÉ (HEREDIA JAGUARES DE PETEN)

The Estadio Julián Tesucún (also known as the Estadio Municpal el Coloso del Lago) rests in a beautiful location beside Lake Colossus, but this setting is juxtaposed with the stadium's brutalist concrete tiered seating.

Estadio Bella Vista
SAN PEDRO LA LAGUNA
(SAN PEDRO LA LAGUNA)

True to its name—and if you can take your eyes off the game—the Bella Vista has wonderful views of Lake Atitlán and distant volcanoes. A cloud-shaped roof fuses seamlessly with the surroundings.

NICARAGUA

Estadio Carlos Fonseca Amador
MATAGALPA (MATAGALPA FC)

Watch a match here and you have the unusual sensation of spectating from within half a stadium. Only two stands—connected in an L-shape—have been built. The rest of the ground is open to stunning views of the Matagalpa countryside.

Estadio Independencia
ESTELÍ (REAL ESTELI FÚTBOL CLUB)

One of the biggest stadiums in Nicaragua plays host to one of its most successful teams: Real Estelí. The Estadio Independencia has some wonderful features, such as the tavern-style bars and restaurants on the south side. A large Real crest is painted on the walkway to the pitch; it's almost identical to AS Monaco with its golden crown and red-and-white striped shield.

Estadio Nacional de Fútbol
MANAGUA (MULTIPLE TEAMS)

The majority of the crowd at Nicaragua's national stadium is part seated, part standing on a gigantic terrace built into a hillside in the capital city. The extremely distinctive stand has the name of the country painted in huge white letters on a blue background.

COSTA RICA

Estadio Nacional de Costa Rica
SAN JOSÉ (NATIONAL TEAM)

If you were to put a pin in a world map to mark the center of the American supercontinent, you'd put it through the center circle of the Estadio Nacional de Costa Rica. It sits in the heart of San José, in the center of the country. Its roof is the star, spanning over the sides of the stadium in two arches with distinctive triangular edging like a crown.

PANAMA

Estadio Olímpico Rommel Fernández Gutiérrez
PANAMA CITY (NATIONAL TEAM / TAURO FC)

The stadium commemorates the Panamanian striker who died tragically young at the age of twenty-seven. A recent renovation means the tired but characterful facade—that from a distance looked like William Shakespeare's Globe Theatre with rows of darkened windows, white walls, and terra-cotta corrugated metal roof—has been covered with a white membrane.

Colombia / South America

COLOMBIA

Estadio Américo Montanini
BUCARAMANGA (ATLÉTICO BUCARAMANGA)

Wedged between the city to the south and the valleys and mountains to the north and east, the main stand of this twenty-five-thousand-capacity stadium sticks out thanks to its vibrant loop of green, yellow, and red seats. Opened in 1941, between 2006 and 2016 it was home to the first synthetic pitch in Colombian professional football.

Estadio Centenario de Armenia
ARMENIA (DEPORTES QUINDÍO SA)

This arena is nestled in the heart of the rich, green coffee heartland. The zone is so vast, beautiful, and synonymous with the nation, that the Colombian national team is nicknamed Los Cafeteros (the Coffee Makers). The ground is home to Deportes Quindío SA. There's a theme here: Quindío is the name of the region and one of Colombia's biggest coffee companies. While this is not a football hotbed, this stadium features gardens between the stands and the pitch. The arena has floodlights that hang over the spectators like palm trees and illuminate the immaculate pitch below.

Estadio Atanasio Girardot
MEDELLÍN (ATLÉTICO NACIONAL / INDEPENDIENTE MEDELLÍN)

The Atanasio Girardot comes alive for El Clásico Paisa, fought between the two teams—Medellín and Nacional—that share the stadium. On match day you'll walk past the undulating form of the Sports Complex and into a stadium that is like a work of constructivist art—metal and geometric sculpture reflecting the surrounding urban space. Based on the work of renowned Colombian abstract sculptor Édgar Negret, even the yellow cross-bracing framework has a raw beauty. During El Clásico, Negret's red, yellow, and blue palette, which features throughout the stadium, becomes awash with the white and green of Nacional and the red of Medellín.

Estadio Deportivo Cali
PALMIRA (DEPORTIVO CALI)

Every seat in the house is the same powerful green as Deportivo Cali's crest and home strip. And the club is known as La Amenaza Verde (the Green Threat) with good reason. As a first-time spectator, you might think the stadium would not look out of place in New York or California, even though it lies deep in the heart of Colombia. The structure looks like a concert arena rather than a football stadium, or something you might see in the NBA or NFL. Deportivo Cali has been crowned Colombia's national champions ten times.

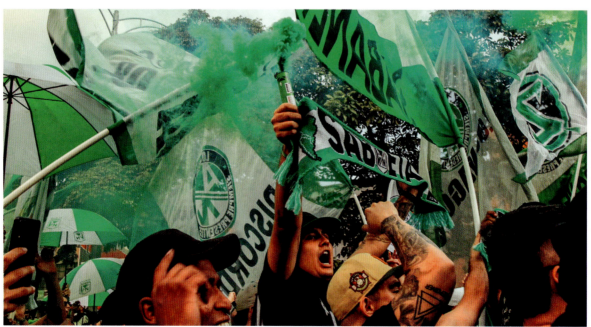

↑ Estadio Atanasio Girardot

South America / **Colombia**

↑↗ Estadio Olímpico Pascual Guerrero

Estadio Olímpico Pascual Guerrero
CALI (AMÉRICA DE CALI / ATLÉTICO / BOCA JUNIORS)

If you've ever wondered what it would be like to visit an aquarium that's also a football ground, then this thirty-seven-thousand-seater Olympic-style stadium may satisfy your curiosity: The track around the grass as well as the stadium seats are electric blue, while the circular roof is white. It is home to three football clubs: the famous América de Cali, as well as Atlético FC, and Boca Juniors de Cali. In 1930 Emilio Manrique, the president of the local Valle del Cauca Soccer League, told poet and former politician Pascual Guerrero about his idea of building a soccer stadium for the city. Today the stadium is named after the man who made it a reality.

Estadio Metropolitano Roberto Meléndez
BARRANQUILLA (NATIONAL TEAM)

The seats in this stadium, also known as El Metro, replicate the home kit of its prime occupant Junior FC—the club from Barranquilla the likes of Carlos Valderrama and Luis Díaz once called home. The top tier resembles the red and white stripes of the shirt, and the lower tier the blue of the shorts. This is also the regular home of the Colombian national team. When the *selección* is in action, the stands become a sea of yellow as visitors face a carnival atmosphere and a type of heat on the Caribbean coast they have never endured before.

Estadio Sierra Nevada
SANTA MARTA (UNIÓN MAGDALENA)

The Estadio Sierra Nevada is one of few modern grounds in this part of the world. While it is small and lacks eye-catching features, it has a striking backdrop: the Sierra Nevada mountain range that gives the stadium its name and covers almost 1,544 square mile (4,000 sq km). For the Indigenous people who inhabit the region, the area is a sacred site that maintains its harmony with the physical and spiritual universe. Top-division Colombian outfit Unión Magdalena won one national league title back in 1968. They have possibly the best nickname in football—El Ciclón Bananero or the Banana Cyclone.

Colombia / South America

Estadio Nemesio Camacho El Campín
BOGOTÁ (MILLONARIOS FC / INDEPENDIENTE SANTA FE)

El Campín is home to both major clubs from the Colombian capital of Bogotá: fierce rivals Santa Fe and Millonarios. Though this isn't the usual home of the Colombian national team, it hosted the biggest match in Colombian football history—the 2001 Copa América final. Colombia lifted the Copa América in El Campín for the only time in their history on July 29, 2001, in front of over fifty thousand spectators. Ivan Cordoba, who would go on to win a Champions League and Club World Cup with Inter Milan, scored the only goal in a 1–0 victory over Mexico.

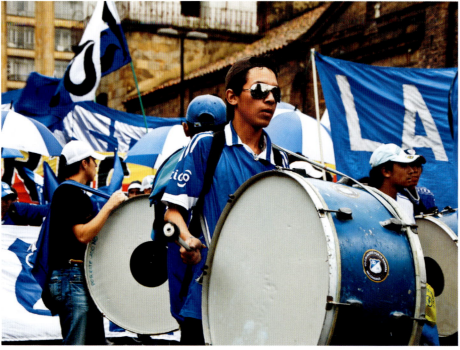

South America / **Colombia**

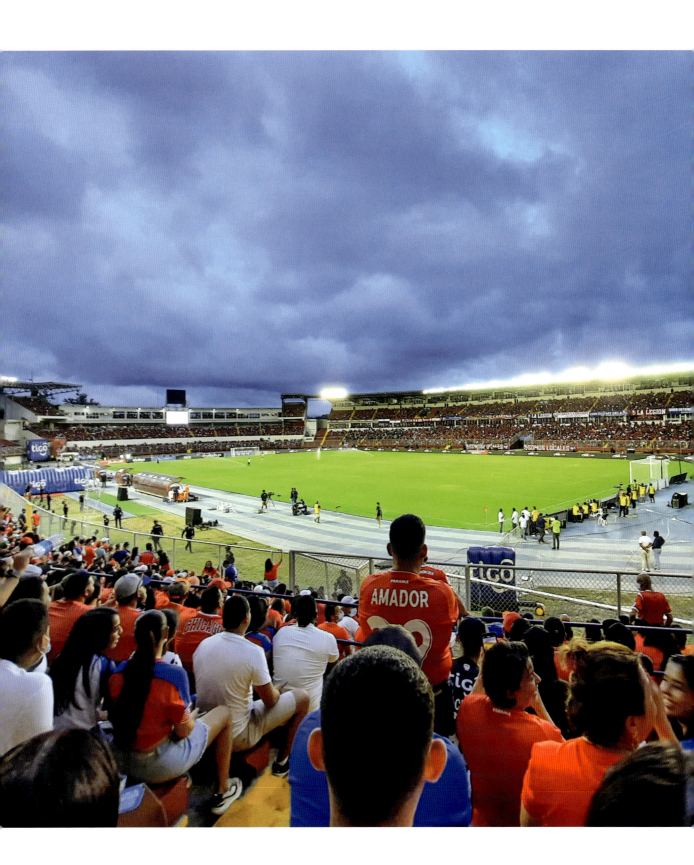

Venezuela / South America

↑ Centro Total de Entretenimiento Cachamay

VENEZUELA

Estadio Polideportivo de Pueblo Nuevo
SAN CRISTÓBAL (DEPORTIVO TÁCHIRA FC)

This stadium is a swirling wave of colorful concrete, set on the edge of San Cristóbal. It acts as a gatekeeper for the lush, green hills of La Z that roll for miles in the stunning General Juan Pablo Peñaloza National Park behind it. Big-name visitors such as Kaká, Diego Simeone, and Diego Forlán have all put Venezuela to the sword at the home of Deportivo Táchira.

Centro Total de Entretenimiento Cachamay
PUERTO ORDAZ (MINEROS DE GUAYANA / MINERVÉN DE BOLÍVAR / NATIONAL TEAM)

The Cachamay hugs the Caroni River in northeast Venezuela. In 2007 it hosted a Copa América semifinal that saw the legendary Lionel Messi make his mark on the scoresheet. The home ground of Mineros de Guayana was previously known as the Estadio Gino Scaringella; only one stand was built initially, and the stadium named in honor of Gino, a referee who helped promote football in the surrounding area, but who died while officiating a game.

Estadio Metropolitano de Cabudare
CABUDARE (ACD LARA)

As the only top-tier stadium in Venezuela without a running track, and with its red seating, the Estadio Metropolitano de Cabudare is affectionately known as the Venezuelan Old Trafford. Where this comparison with the famed English ground falls down is its north side, where there is a gaping hole. The Theater of Dreams remains incomplete, leaving it with a perfect U shape.

South America / **Venezuela/Suriname**

Estadio Olímpico Metropolitano de Mérida
MÉRIDA (ESTUDIANTES DE MÉRIDA FC)

The Mukumbari Cable Car takes you up into the Venezuelan Andes, where the Estadio Olímpico Metropolitano de Mérida forms part of an incredible panorama. Then you can descend and walk to the ground through the historic town of Mérida and along the Albarregas River at the foot of the Pico Bolívar.

Cocodrilos Sports Park
CARACAS (CARACAS FC FEMENINO)

When there's no more room for a stadium, why not build one within a rock face? That is exactly what Caracas FC did when creating a playing field for their reserves and women's teams. They simply chiseled it out of the rocks. The stadium has become a fortress for Caracas FC Femenino with multiple Superliga Femenina titles.

SURINAME

Clarence Seedorf Stadium
OOST (SV BROTHERS)

In this old Dutch colony is a stadium named after a player from the Netherlands: Clarence Seedorf. He is the only player to have won the European Cup with three teams, and was born twenty minutes away from this pitch in the country's capital. A poster outside the single stand reads "dream, believe, create, succeed." Just like Seedorf did.

↓ Cocodrilos Sports Park

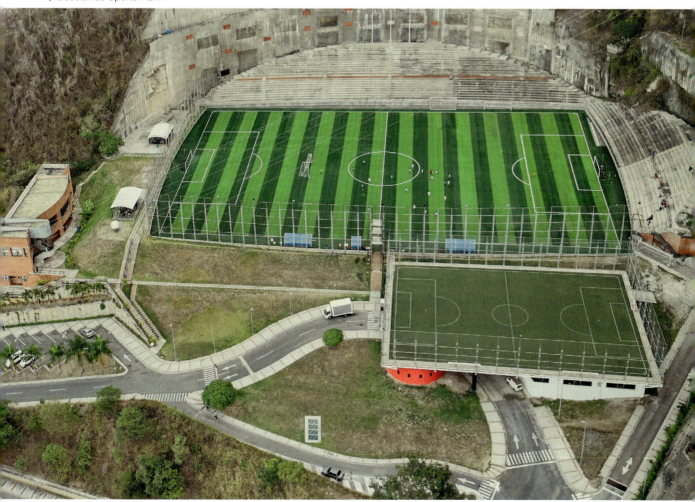

BRAZIL

Estádio Novelli Júnior
ITU (ITUANO FC)

The Novelli Júnior is owned by the municipality and is home to Ituano Futebol Clube. "Say no to violence. Peace in football" reads a sign above the stands here, as the ground regularly welcomes some of the big hitters from the state of São Paulo, where sometimes things can get out of hand on the terraces. The ultra's banner behind the goal says "Camisa 12"—the fans here are the twelfth man, even if they do say so themselves.

Estádio José Maria de Campos Maia
MIRASSOL (MIRASSOL FC)

José Maria de Campos Maia was a famous entrepreneur in Mirassol, who became the city's mayor and donated the ground on which this stadium was built as a gift to the people. The romance of this ground is its age. This is apparent when you see faded advertising boards on the exterior and the seatless stands where seat numbers are etched into the concrete like chalk on an old-school blackboard.

Estádio Doutor Jorge Ismael de Biasi
NOVO HORIZONTE (GRÊMIO NOVORIZONTINO)

This small stadium sits at an angle, but its terraces caress the landscape in a wonderful way. The entry to one concourse is above the field level and the other is below. The concrete slabs that make up the stands are emblazoned with the badge of local side Novorizontino and its symbol—a tiger. A grand statue of the big cat can be found in the area around the stadium too, which offers fun for the whole family.

Estádio Passo D'Areia
PORTO ALEGRO (SÃO JOSÉ)

This aging but honest stadium, built in 1940, rests at the confluence of five rivers. Seating is basic bucket seats on concrete tiers. The fans of São José are happy to choose passion over comfort. Match days are buzzing, and the stadium is compact, ramping up the energy.

Estádio Estadual Jornalista Edgar Augusto Proença
BELÉM (PAYSANDU SC / CLUBE DO REMO / SC BELÉM)

Also known as the Mangueirão, this stadium lights up the night sky like a futuristic spaceship. Neon green light busts from its seams as the playing surface sparkles under floodlights. This venue can hold over fifty thousand spectators, and it even hosted five Brazil international matches between 1990 and 2023. While the ground opened in 1978, it wasn't until 2002 that there were stands on every side of the playing field.

Estádio Germano Krüger
PONTA GROSSA (OPERÁRIO FERROVIÁRIO)

Known as Paraná's Black and White, or even Ghost of the Town, Operário Ferroviário is a unique club that plays at a stadium that, from some angles, could easily be mistaken for a mechanic's garage. Its humble exterior is a little misleading, though, as this ground can hold over ten thousand spectators and they can be incredibly loud, even if they are dispersed over a single skinny tier that surrounds the pitch. The best view is from the windows of a high-rise building outside the stadium that hovers over the halfway line.

Estádio Carlos Zamith
MANAUS (AMAZONAS FC)

This old ground in the Brazilian Amazon is naked and brutal in its appearance. There are no stands behind either goal, or a seat on either sideline terrace, just raw concrete fit for raw football. The dugouts are tucked underneath the stands, which are raised above pitch level and every comment from the stand can be heard by the players on the pitch below. Owned by the state of Amazonas, the ground is home to five local football clubs and is named after a local sports journalist.

Arena da Amazônia
MANAUS (EC IRANDUBA FEMINO)

Visiting a stadium within the Amazonian rainforest is easier than you might think. Avenue Constantino Nery, which leads directly from the airport, runs alongside the stadium. The Arena da Amazônia replaced the aging Vivaldão stadium in time for the 2014 World Cup. You can now watch a wide range of football here, from the women's premier league, local fourth tier, and occasionally the Brazil national team.

South America / **Brazil**

Estádio Janguito Malucelli
CURITIBA (J. MALUCELLI FUTEBOL)

Known as the Ecoestádio, the Estádio Janguito Malucelli is located on the outskirts of Curitiba in southern Brazil. With 560 square feet (52 sq m) of green space per resident, the city is known as one of the greenest in the world. The Ecoestádio follows this ethos. The pitch sits at the bottom of a sloping embankment, creating a natural stand for spectators. The seats were initially covered in grass for comfort, but plastic seating was brought in to accommodate Série B football when Atlético Paranaense played at the venue for one season. All the wood used in construction was sourced from reforested areas and the metal used for fittings was recycled from disused railway sleepers. The players enter the pitch via a wooden-framed, bush-lined balustrade, with dugouts made from raw logs. The stadium is entirely at one with its environment.

Colosso da Lagoa
ERECHIM (YPIRANGA FC)

Fresh from his exploits at the 1970 World Cup, Pelé and his Santos side played an exhibition match at the opening of the brand-new Colosso da Lagoa. It was a busy time for O Rei, helping to open several stadiums including the Estádio Rei Pelé in Maceió. He scored the first-ever goal at the Colosso in a 2–0 win against Grêmio. The ground has remained unchanged since that day and stands as a piece of history in Rio Grande do Sul, close to the Lagoa Vermelha (Red Lagoon) that gives it its name.

Estádio do Café
LONDRINA (LONDRINA EC)

You can't really attend a match at the Estádio do Café without starting the day with a Londrina coffee, chocolaty and sweet and best enjoyed as an espresso, either in the city or at the stadium itself. In the southern state of Paraná, *Londrina* translates as "Little London." Its stadium is poetically in the shape of a *C*, an incomplete bowl shape built on a natural pedestal with the crimson soil pitch sitting within the crater.

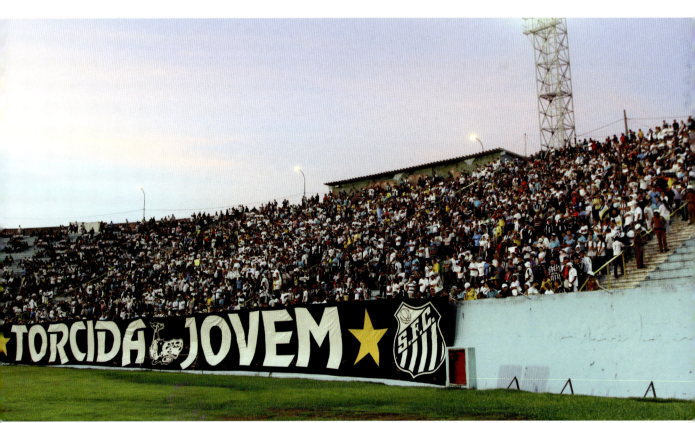

↑ Estádio do Café

Brazil / South America

Arena da Baixada
CURITIBA (CLUB ATHLETICO PARANAENSE)

The rainy season in Paraná begins when the Brazilian football season ends in December. Should the seasons collide, the Baixada is the place to be. In 2015, it was the first stadium in South America to have a retractable roof. It was also the first in Brazil to sell naming rights ten years earlier. It was known as the Kyocera Arena. The irony of being named after a Japanese electronics manufacturer is that it looks like a giant photocopier.

Estádio Couto Pereira
CURITIBA (CORITIBA FC)

Within the stadium, a series of huge photographs showing the stadium over the years is interspersed with trophy cabinets. The floor is Coritiba-green granite. You can take the trophy walkway to the food courts and out to stands where all but the VIP seats are concrete banks, and all are numbered. You can have your very own slice of concrete with a ticket bought at the entrance. Look out for the Império Alviverde fan club in the Amâncio Moro grandstand, and their tier-to-tier cascading flags.

Arena Condá
CHAPECÓ (ASSOCIAÇÃO CHAPECOENSE DE FUTEBOL)

The Arena Condá has witnessed some great victories since it opened in 1976. Yet its greatest moment was perhaps the final game of the COVID-ravaged 2020–21 season in an empty stadium. It was no ordinary victory. In 2016 the airplane taking the team Chapecoense to play the Copa Sudamericana final crashed, killing all but one of the Chapecoense players. The decimated club was relegated two seasons later, having clung on with a makeshift team of loanees, new signings, and youth team players. On that night a year later, only the empty seats and walls of the Condá could witness the extraordinary return from adversity of its team when it was promoted back to Série A.

Estádio Fonte Luminosa
ARARAQUARA (ASSOCIAÇÃO FERROVIÁRIA DE ESPORTES)

The city of Araraquara is known as "the abode of the sun," and you can witness some wondrous sunsets above the stadium. Home team Ferroviária was set up by railroad workers in 1950, but in recent years it's the women's team, created in 2001, that has eclipsed the original Locomotives. Ferroviária Feminino won their first state title within a year. A series of regional titles was followed by the Copa do Brasil in 2014 and the Copa Libertadores Femenina a year later.

Estádio Presidente Vargas
FORTALEZA (MULTIPLE TEAMS)

The stadium hosts the three hottest derbies in the Ceará region on the Atlantic Coast. The three teams involved all play at the stadium, and it creates that strange dynamic of watching your home taken over by another family when you find yourself as the "away" team. You can look at the fixture list and pick your battle: King Clássico, Ceará v. Fortaleza; Peace Clássico, Ceará v. Ferroviário; Color Clássico, Ferroviário v. Fortaleza. Whoever is playing, the seat colors remain a neutral yellow and blue.

Arena Castelão
FORTALEZA (FORTALEZA EC)

The Arena Castelão holds just under fifty-eight thousand spectators and is the fourth-largest stadium in Brazil. *Castelão* means "castle," and the name of the city and football club Fortaleza translates to "fortress." The titles go back to colonization, when the Dutch and Portuguese built forts in an attempt to control the city. The sparkling silver and white arena was renovated ahead of the 2014 World Cup, where it hosted six games, including Brazil's historic quarterfinal victory over Colombia. That fateful day Neymar Júnior picked up an injury that ended his tournament. And we all know the outcome of the semifinal.

Estádio dos Aflitos
RECIFE (CLUBE NÁUTICO CAPIBARIBE)

When you're a club that hails from the "Venice of Brazil," it makes sense to have a name with a nautical theme, which is exactly what Náutico has. And their name is painted proudly in large white letters on red seats across the east stand. On the west side, there are two large open-air swimming pools.

South America / **Brazil**

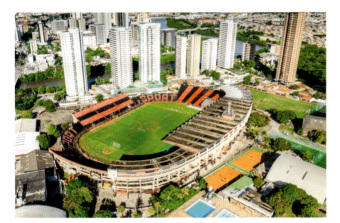

Estádio Adelmar da Costa Carvalho
RECIFE (SPORT CLUB DO RECIFE)

The Ilha is located in the heart of a sprawling urban seaport. Recife is affectionately known as the Venice of Brazil thanks to its waterways, countless bridges, and historical buildings. The only thing stopping the Ilha from being the perfect riverside spot beside the Capibaribe River is a line of tall office and residential towers. The stadium fits in with this visual poetry. Its four steep stands are bridged by curved shallow terraces. Its seating is largely concrete, and the only roof is holding onto former glories. Painted red and black, in a cubist style, and largely unchanged since being built on the site of a ranch, it is a raw historic beauty.

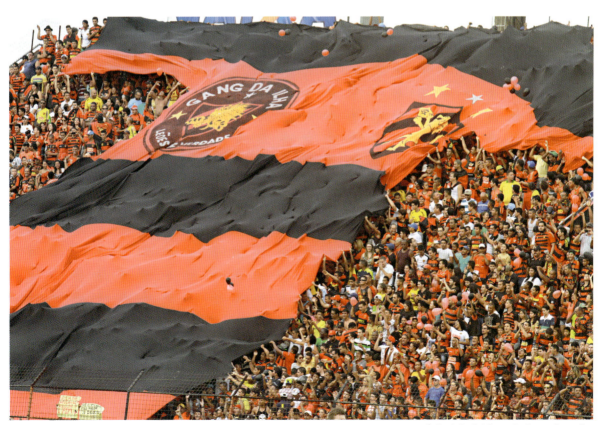

↑ Estádio Adelmar da Costa Carvalho

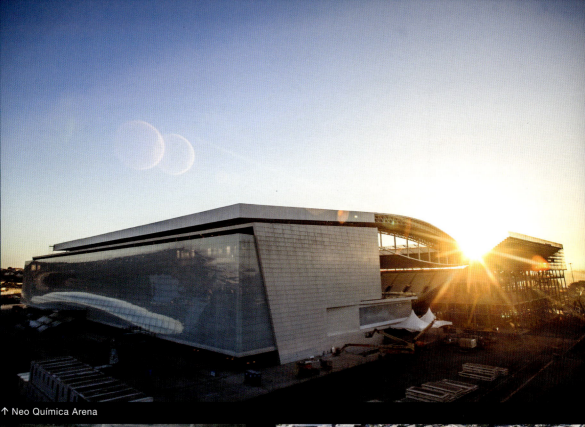

↑ Neo Química Arena

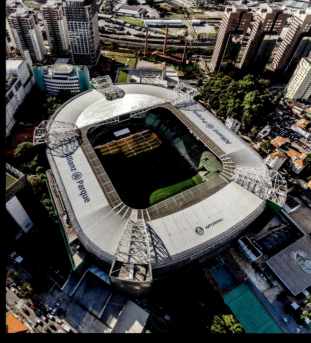

South America / **Brazil**

Arena das Dunas
NATAL (AMÉRICA FUTEBOL CLUBE RN)

The Arena das Dunas replaced the Machadão, which was demolished in 2011. The stadium sits on top of a large platform, and the undulating roof is formed of segments shaped like the protective layers of an armadillo.

Frasqueirão
NATAL (ABC FUTEBOL CLUBE)

The Estádio Maria Lamas Farache is known as the Frasqueirão. It was originally a derogatory name given to the fans of ABC by local rivals—Frasqueira is thought to be the mythical place that slave ships carrying sugarcane sailed to or a vanity case used for cosmetics. Either way, the ABC fans owned it and lovingly passed it on to their stadium. ABC isn't an abbreviation, it's the team's full name, and they have more nicknames than Maradona, including Team of Warriors, Ten-Time Champion, Champion of the Crowds, and Greatest Champion of the World.

Allianz Parque
SÃO PAULO (SOCIEDADE ESPORTIVA PALMEIRAS)

On an artificial pitch set beneath a mammoth structure, Palmeiras has dominated Brazilian and continental football. Their stadium is a stunning modern structure that has become an eye-catching part of the São Paulo skyline. Allianz Parque screams modern football domination by name and nature. São Paulo, the most populated city in South America, is football mad, and Palmeiras is the club with most national titles in history.

Neo Química Arena
SÃO PAULO (SPORT CLUB CORINTHIANS PAULISTA)

The Neo Química Arena is the supermodern home of Brazilian giants Corinthians, one of the "big three" in São Paulo. This aesthetically pleasing ground has all the trappings of a modern masterpiece. It is bright, open, sleek, and comes complete with state-of-the-art big screens and VIP boxes. Asymmetrical from above, this arena's base is built into the earth so that from ground level you can go up to the top tier and down to the lower. Behind both goals are open spaces for extra temporary seating—used for the 2014 World Cup—which increases capacity from forty-seven thousand to almost sixty-nine thousand.

Estádio Urbano Caldeira
SÃO PAULO (SANTOS FC)

This is perhaps one of the most iconic stadiums in the history of football. The Urbano Caldeira was the home of Pelé, the man they still call "the King" in Brazil, and the only man ever to win three World Cup titles. Pelé and Santos turned this seaside town into a globally recognized football team. In recent years, Neymar Júnior brought more glory. Santos's stadium resembles an English ground: it is squeezed into the city streets at the heart of the community. The stands are close enough to pitch side that fans feel like they can reach out and touch their heroes.

Estádio do Morumbi
SÃO PAULO (SÃO PAULO FC)

Years ago this stadium was like a mirage in the desert, a stunning structure in the middle of empty fields. Now São Paulo has extended into the area and the ground has a city feel. It is also home to São Paulo FC, one of Brazil's most famous football clubs. In 1977 the ground saw a breathtaking record attendance of 146,082, for a match between Corinthians and Ponte Preta. The size and spectacle of the stadium hit you on match days, when fans of the three-time Copa Libertadores champions blast their chants toward the pitch.

Estádio Moisés Lucarelli
CAMPINAS (ASSOCIAÇÃO ATLÉTICA PONTE PRETA)

The Ponte Preta fans have every right to proudly call their home Estádio Majestoso (Majestic Stadium) since they helped build it, both financially and with their bare hands. The Majestoso sits within the heart of Campinas. This community feel persists inside the stadium, where fans congregate on the flat plain behind the goal, or sit tightly on the concrete terrace steps. Automobiles park between the crowd and pitch as if stopping at a Campinas market. The obligatory fencing surrounding the pitch breaks the spell.

Estádio Brinco de Ouro
CAMPINAS (GUARANI FC)

Guarani FC built Brinco de Ouro within 546 yards (500 m) of their rival Ponte Preta, making them the closest neighbors in Brazilian football. When the Campineiro derby comes to the Golden Earring, the shallow concrete bowl and colossal grandstand bring an immense fervor to the usually peaceful neighborhood.

Brazil / South America

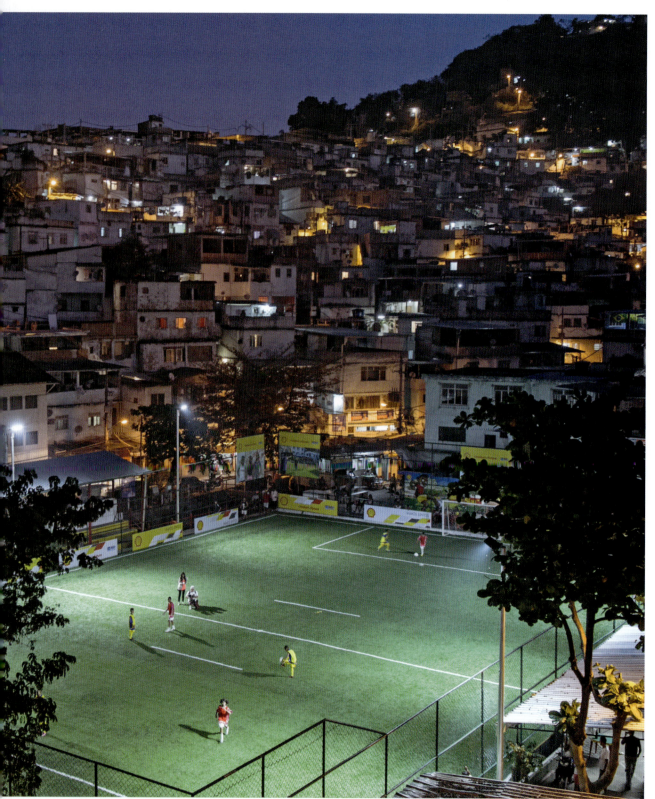

↑ Estádio Morro da Mineira

South America / **Brazil**

↑ Maracanã

Estádio Morro da Mineira
RIO DE JANEIRO (MULTIPLE TEAMS)

As the sun goes down in the heart of the Morro da Mineira favela, floodlights illuminate a kinetic pitch. The impulses created by the players' movements generate the energy that fuels the floodlights. Kinetic panels made from recycled tires, compressed by the players' footwork, transmit energy to quartz crystals and copper coils. During the day, more energy is harnessed from solar panels housed above a samba school overlooking the stadium. A decade after Pelé opened the stadium, this technology is yet to make a deeper imprint on the footballing world.

São Januário
RIO DE JANEIRO (CR VASCO DA GAMA)

This stadium is a wonderful blend of passion and design. One giant horseshoe-shaped stand covers three sides of the stadium; the terraces are steep and drenched in the black, white, and red of the home side Vasco da Gama. Behind the opposite goal is a large scoreboard, one you might see at a college football stadium in the United States. Another telling detail is that the horseshoe stand has different types of roofing. One part has no roof, yet behind the goal the stand is partially sheltered, while on the opposite sideline the stand is completely covered.

Maracanã
RIO DE JANEIRO (MULTIPLE TEAMS)

This global symbol of the beautiful game is nestled between the sparkling sea and green hills of Rio, with Christ the Redeemer watching over like a guardian angel. Few stadiums elicit the history or romance that the Maracanã can. It is a symbol of success and hope. In 1950, 173,850 fans watched Brazil's shocking World Cup defeat to Uruguay. Brazil exacted revenge by beating Uruguay in the 1989 Copa América here, and defeated Spain in the 2013 Confederations Cup. In 2014, Argentina was overpowered by Germany in the World Cup. Since then Brazil and Argentina have won Copa América trophies on the hallowed turf.

Brazil / South America

Tavares Bastos Favela pitch
RIO DE JANEIRO (MULTIPLE TEAMS)

Tavares Bastos is a favela in the Catete neighborhood of Rio de Janeiro. Built on a mountainside, it is a bustling, colorful hive of grassroots Brazilian football—or perhaps street football would be a better description. In the heart of the favela is a football pitch where the community play futsal, the samba vibe street football that has honed so much talent, feeding the Brazil national team with many exceptionally skilful and creative players. The stacked-up housing of the favela bears down on every side. Large murals of famous players such as Messi and Neymar run along the walls, combining with the vibrant turquoise, yellow, red, blue, and green walls of the houses.

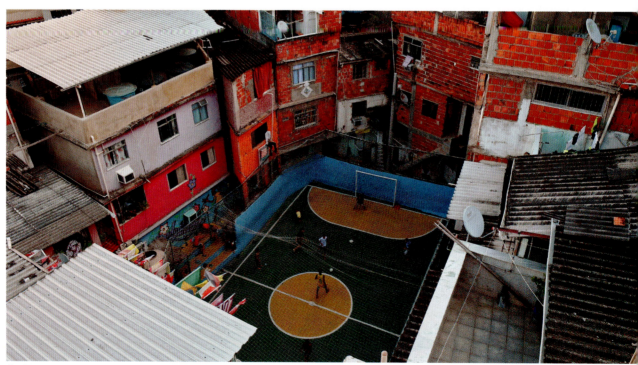

↑↗ Tavares Bastos Favela pitch

South America / **Brazil**

Estádio Olímpico Nilton Santos
RIO DE JANEIRO (BOTAFOGO DE FUTEBOL E REGATAS)

The home of Botafogo is a stunning piece of architecture stamped with the famous black star of the football club. Situated in the heart of Rio de Janeiro, the multipurpose arena is lauded for its incredible atmosphere and has seen Botafogo title charges. Flags and flares color the sky when *Fogo*—meaning "fire"—is in action.The ground opened for the 2007 Pan American Games, and later hosted the 2016 Olympic Games.

Estádio Ronaldo Luis Nazário de Lima
RIO DE JANEIRO (SÃO CRISTÓVÃO DE FUTEBOL E REGATAS)

As you race north on the main route out of Rio, a glimpse of magic pops into view. A small but breathtaking football stadium bears the name of a familiar figure, Brazilian number nine, Ronaldo Nazário. Tucked between the Rua Figueira de Melo motorway and homes and businesses, this footballing oasis in the middle of urban Rio is where young Ronaldo honed his skills as a youth footballer, paving the way for a glorious career, with two World Cups and breathtaking moments of skill and power. Young Brazilians now try to follow in his footsteps.

Estádio da Gávea
RIO DE JANEIRO (CR FLAMENGO)

The Estádio da Gávea is part of the original Clube de Regatas do Flamengo site, equipped with multisports facilities. It's been a long while since the Flamengo first team played here every week, but the four-thousand-seater hasn't lost its charm. A giant main stand is emblazoned with a Flamengo badge so bold it can be seen by tourists visiting the Christ the Redeemer statue a few miles away, making it one of the most visible pitches in this football-crazy city.

Estádio de Laranjeiras
RIO DE JANEIRO (FLUMINENSE FC)

Laranjeiras means "orange trees" and is the name given to the stadium and the neighborhood where it is found. The ground, owned by top club Fluminense, is steeped in history. It hosted the first Brazilian national team match, a 2–0 victory in a friendly against Exeter City in 1914. They returned a century later to take on Fluminense's under-23 team in a commemoration match, bringing almost two hundred fans from England. A record attendance for the ground was set in June 1925, when over twenty-five thousand watched Fluminense defeat Flamengo in one of Brazil's biggest derbies.

Estádio Proletário Guilherme da Silveira Filho
RIO DE JANEIRO (BANGU AC)

Nicknamed Estádio Moça Bonita (the Stadium of the Pretty Girls), Bangu's ground sits among the green hills of Rio de Janeiro's suburbs—and is absolutely everything that an old stadium should be. Its concrete stands are proudly painted in the club colors of red and white. There are no frills or boxes, barely even benches or a bar. This is a proper old-school hole-in-the-wall-type hospitality, from the tickets to the beers. Though the color on the stands has faded, support for the team is still strong. "Bangu" is written in red across the exterior. You can even find the "pretty girls" in graffiti on the exterior walls.

Estádio Kléber Andrade
CARIACICA (RIO BRANCO AC)

An abstract geometric design based on the work of twentieth-century artist Piet Mondrian embraces the seating on the east and west stands. The stadium structure is a perfect ring with full roof covering. To the north and south, however, are roof perforations that let in air and spots of light over the pitch. The overall aesthetic is a geometric master class.

Estádio Orlando Scarpelli
FLORIANÓPOLIS (FIGUEIRENSE FC)

The Orlando Scarpelli stadium is simple but beautiful. The green stands and pitch stand out against the blue skies like a radiant sea, and the front row is at ground level, inches from the touchline. Behind one goal is a stand that is taller than the one opposite, but this gap provides a perfect view of the city skyline beyond. It is no less than Brazilian football heaven.

Brazil / South America

Estádio da Ressacada
FLORIANÓPOLIS (AVAÍ FC)

This bright blue stadium acts as a beacon of football in a part of Brazil that is better known for summer beach holidays than the beautiful game. The ground, though small and humble, has also hosted the occasional Brazilian national team game. Avaí lost its opening game here, 6–1 to Vasco da Gama.

Estádio Atílio Marotti
PETRÓPOLIS (SERRANO FC)

The perfect pitch surrounded by two big blue stands on either side, with hanging trees behind the goal, make this ground the ideal advertisement for Brazil. The setting, just two hours outside Rio, is lush and part of the jungle that is the country's giant interior. The white exterior walls have faded to gray over the years, and the home of Serrano FC may not draw the biggest crowds, but the club still has a number of die-hard supporters. "We are the voice of Serrano" reads a banner.

Itaipava Arena Fonte Nova
SALVADOR (EC BAHIA)

The small peninsula of Salvador separates the Atlantic Ocean from the Bay of All Saints, and its tropical coastline changes color from rich turquoise to crystal blue, just like the stadium seating in the Itaipava Arena Fonte Nova. The ground looms over Dique do Tororó lake: its three tall tiers hug three sides of the pitch. A welcome breeze drifts toward the terraces thanks to the lack of a south stand behind the goal; it also allows the noise of the home fans to boom into the night sky.

Estádio Manoel Barradas
SALVADOR (EC VITÓRIA)

The stadium is built into a hillside, as if Mother Earth formed herself around the terrace. Three sides form a large stand that fits the hillside like a glove, with fans entering from above, and shops and bars overlooking the pitch. The stand is adorned with two large lion motifs. On the opposite side there is nothing—just changing rooms and benches that look as if they could be from many divisions below. Esporte Clube Vitória, one of the city's two top clubs, has boisterous support that sends noise down to the pitch like a wave. The stadium is also home to Vitória Feminino in the women's premier league.

Estádio Nabi Abi Chedid
BRAGANÇA PAULISTA (RED BULL BRAGANTINO)

The Red Bull football freight train has made its way to Brazil and backed a meteoric rise to the top for once lowly Bragantino. The Braga boys have gone from the low leagues to title challengers thanks to the Austrian company's investment. Their home was built in a lightning-quick thirty-two days in 1949 on the back of a popular movement by the then club president, for whom the stadium is named. For this reason it is extremely simplistic, and many of the old bleacher-style stands remain. This club is set on a path for continental domination, but half of their terraces look like those of a high school. It's both an homage to the past and proof of how fast Bragantino has jumped into the future.

Estádio Alfredo Jaconi
CAXIAS DO SUL (EC JUVENTUDE)

Esporte Clube Juventude plays in green and white, and every inch of Estádio Alfredo Jaconi has been dipped in the club's colors. The ground backs onto the Mato Sartori nature reserve and its trees rise up the hill behind the north stand and continue into the distance, like an extension of the green stand below. It's as if the local terrain is also a Juventude supporter. Homes on the east side of the stadium are so close to the stadium they shake when the home team scores.

→ Itaipava Arena Fonte Nova

South America / **Brazil**

South America / **Brazil**

Almeidão
JOÃO PESSOA (BOTAFOGO FC)

When the government of Paraíba state set money aside to build a new stadium in Campina Grande, there was upset in the state capital of João Pessoa. The decision was made to build two identical stadiums using the same pool of money. The result was two half-built stadiums. Inspiration for both designs came from the Estádio Mineirão in Belo Horizonte, a brutalist masterpiece built ten years earlier and housing over sixty-six thousand fans. The structure on the west side of the Almeidão has the same concrete reinforcements as the Mineirão, but where a stand should be there is wasteland. With dwindling funds, the north and south stands remained unbuilt, and the east side incomplete. The capacity of the stadium is half that of its inspiration. The beauty of the west side, however, gives a tantalizing glimpse of what could be.

Arena Pantanal
CUIABÁ (CAIABA ESPORTE CLUBE)

The design of the Arena Pantanal in the isolated Brazilian city of Cuiabá is a rare combination—a hybrid of four traditional single terraces with empty corners, and a circular exterior that encloses the whole stadium. The stadium was built for the 2014 World Cup and despite catching fire in the run-up to the tournament, it hosted four group-stage matches.

Estádio Rei Pelé
MACEIÓ (CLUBE DE REGATAS BRASIL / CENTRO SPORTIVO ALAGOANO)

Estádio Rei Pelé (King Pelé) was appropriately opened just after Brazil had won its third World Cup, with the eponymous star the hero. The shape of the stadium is unusual, like a serif capital *D*. Again, this is appropriate; the stadium has a museum inside named after Dida, hero of the 1958 World Cup.

Amigão
CAMPINA GRANDE (TREZE FC / CAMPINENSE CLUBE)

The twin stadium of the Almeidão has remained unfinished since it opened in 1975. It has a substantially higher capacity than its sibling, yet there remains a huge void behind each goal. The stadium is host to two lower league clubs, and there appears little appetite to complete the building or bring some creativity to the wasteland beside it.

Arena do Grêmio
PORTO ALEGRE (GRÊMIO FBPA)

At a bird's-eye view, the Arena do Grêmio looks more like a spaceship than a football stadium. A broad, circular base supports the stands, and a 360-degree concrete walkway fills with fans on match day. A rectangular roof structure appears to float high above it, while the interior is steep, compact, and modern. As the night sky descends upon Porto Alegre, the whole area dances in the blue light of Grêmio. The stadium can hold up to sixty thousand home fans—fanatics of Grêmio, who has been Copa Libertadores champions three times and was Interncontinental Cup champions in 1983.

Estádio Beira-Rio
PORTO ALEGRE (SC INTERNACIONAL)

The exterior of this stunning arena resembles the petals of a camellia flower or a bird with white feathers. The structure forms a roof that shades spectators from the southern Brazilian sun. This stadium was renovated in 2013, before hosting the likes of Argentina, France, and Germany at the 2014 World Cup. Now it is one of Brazil's most modern stadiums and is home to Sport Club Internacional. At night the white petals or feathers turn bright red in support of the home side, and the light from the stadium bounces off the Guaíba River.

← Estádio Beira-Rio

Brazil / South America

Estádio da Serrinha
GOIÂNIA (GOIÁS EC)

Surrounded by high-rise blocks and a large wooded park and lake, you could be forgiven for thinking you'd stepped into a Bella Vista version of New York City. The stadium's standout feature might just be its pitch. It's a superb lush green and considered one of the very best in the country.

Estádio Antônio Accioly
GOIÂNIA (ATLÉTICO GOIANIENSE)

On match day try the *feijão tropeiro* from a mobile food stall outside the stadium. A traditional dish of the Minas Gerais region, it translates as "cattleman's beans"—a mix of pinto beans, bacon, garlic, onion, collard greens, and eggs. You can also enjoy a *cerveja* (beer) and pink popcorn in the stands while watching the game.

Estádio Primeiro de Maio
SÃO BERNARDO DO CAMPO (SÃO BERNARDO FC)

This stadium was the venue for a series of huge trade union rallies and is named after International Workers' Day—May 1, 1980—when 150,000 workers gathered on the pitch and in the stands. By contrast, the largest footballing attendance was 15,159 in 2011, during a Campeonato Paulista match between São Bernardo and Corinthians.

Estádio Governador João Castelo
SÃO LUÍS (SAMPAIO CORRÊA FC / MOTO CLUB / MARANHÃO)

A two-tiered brutalist concrete bowl structure allows this stadium to mold into the undulating terrain on which it is built. The pitch is effectively below ground level on one side—you feel like you're watching football in a crater. With no modernization, its raw charm remains.

Mineirão
BELO HORIZONTE (CRUZEIRO EC)

From the outside, the Mineirão could be mistaken for a secret service HQ or even a villain's lair—its bold and brutal concrete frame lacks a splash of color or sign of life. But from above the beauty of this ground, built on the banks of Lake Pampulha, is clear: It is sumptuously symmetrical and the interior gleams. It was the scene of the famous July 8, 2014, upset. On this spot Germany defeated Brazil 7–1 in the 2014 World Cup semifinals, a day marked by many Brazilians as the most embarrassing in national history.

Arena Independência
BELO HORIZONTE (AMÉRICA FUTEBOL CLUBE MG)

One of the World Cup's biggest upsets was played out here in 1950, when the United States beat a much-fancied England team 1–0. The arena is a strange sight to behold, with three steep stands and a barren wasteland behind one goal mostly used as a makeshift parking lot. A large metal grandstand was deemed unsafe, demolished, and never replaced. Watching from one of the colossal stands is an intriguing experience as a view of the pitch unfolds into

Arena MRV
BELO HORIZONTE (CLUBE ATLÉTICO MINEIRO)

With its framework draped in the powerful black-and-white stripes of the home team—even the nets feature black-and-white stripes—Arena MRV stands out against its green backdrop. The stands sit right on top of the pitch, creating a raucous atmosphere when Clube Atlético Mineiro plays.

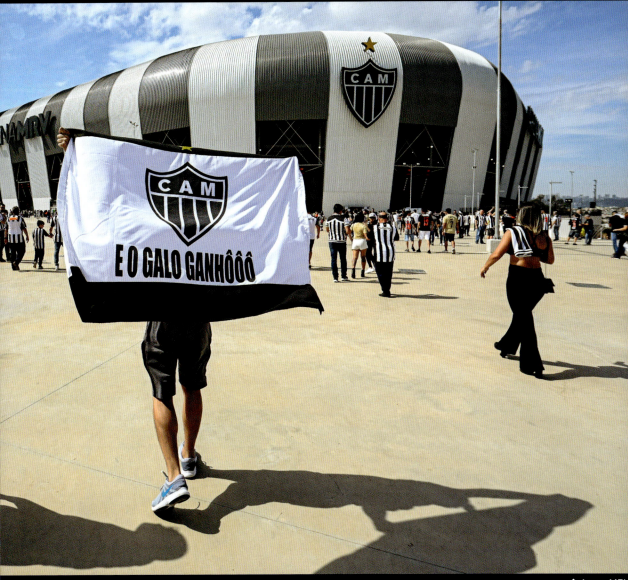

↑ Arena MRV

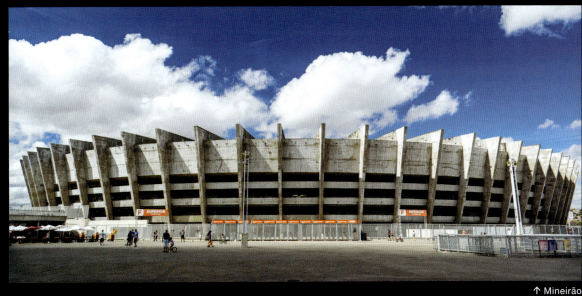

↑ Mineirão

Paraguay/Uruguay / South America

PARAGUAY

Estadio General Pablo Rojas
ASUNCIÓN (CERRO PORTEÑO)

This sprawling oval looks like a shuttle sent from outer space. With perfect curves and color, this wonderfully aligned arena is a feast for the eyes. The home of Cerro Porteño is like a smaller version of the old Camp Nou. Its tiered slopes are red and blue, its fans expect greatness, and its turf is fit to host grand finals too. A roof over just one stand, where the directors and press sit, is also a nod to the old Barcelona stadium.

Estadio Defensores del Chaco
ASUNCIÓN (NATIONAL TEAM / CLUB GUARANÍ / CLUB OLIMPIA)

Set in the west of Paraguay's capital city, the arena that hosts Paraguay's national team games is only about twelve blocks away from the Paraguay River and the country's border with Argentina. This is a proud nation tucked between giants like Brazil and Argentina, and its home is bathed in the colors of the flag, from the stadium seats to lampposts and curbstones outside the ground. If you take a walk around the arena, you will see that etched into its walls is the history of football in the country in the form of text and images. This unique setting makes for an incredible football history walking tour.

Monumental Río Parapití
PEDRO JUAN CABALLERO (CLUB DU 2 MAYO)

A winding outdoor walkway like an umbilical cord leads fans into this open-air stadium.

Estadio Antonio Aranda
CIUDAD DEL ESTE (CLUB ATLÉTICO 3 DE FEBRERO)

The busiest man in Ciudad del Este is arguably the groundskeeper of the Estadio Antonio Aranda. If he's not updating the paintwork of the benches, he's working on the pitch. When the paint, open to the elements and wear and tear, erodes, the patterned turf stands out even more in all its glory.

Estadio Feliciano Cáceres
LUQUE (SPORTIVO LUQUEÑO)

In this fine stadium, large fences protect players from the wrath of the ultras. Hedges are disguised as design features, when in reality they too are just another obstacle that separates the playing field and the most fanatic in the stands behind the goal. A yellow band on a blue backdrop runs across the stadium. Concrete transformed into one giant banner supports Club Sportivo Luqueño even before their fans have arrived.

Estadio Villa Alegre
ENCARNACIÓN (ENCARNACIÓN FC / DEPORTIVO ITAPUENSE)

The Estadio Villa Alegre hosted games for the local Liga Encarnacena de Fútbol. A team made up of players from each side then won the national interleague title and a new club was formed. Encarnación FC now plays in the Paraguayan second-tier División Intermedia. And what a stadium they play in, with a picturesque waterside location, four towering floodlights, and an elegant, compact pitch.

Estadio Tigo La Huerta
ASUNCIÓN (CLUB LIBERTAD)

Black-and-white stripes run across the seats, creating a true spectacle as the stands fill with fans.

URUGUAY

Estadio Gran Parque Central
MONTEVIDEO (CLUB NACIONAL DE FOOTBALL)

A *mirador*, or lookout post, sits behind the Tribuna Atilio García stand that fans must walk past before entering the Gran Parque Central. It is one of the few elements that remains from the original stadium that was built in 1900 and is the oldest in Uruguay. Fans have stood high up inside the ornate cast iron and terra-cotta-tiled viewing platform to watch the oldest team in Uruguay and the first World Cup match in 1930. Today, it is a blend of mid-century and ultramodern architecture.

Estadio Profesor Alberto Suppici
COLONIA DEL SACRAMENTO (PLAZA COLONIA)

The historic town of Colonia can be reached by boat from Buenos Aires. This arena, home to Plaza Colonia, is located on the water's edge, a short walk from the cobbled streets of the UNESCO-listed Barrio Histórico. The exterior wall is painted with traditional Uruguayan art. The stadium celebrates Uruguay's historic victory in the first World Cup in 1930 and is named after the coach Alberto Suppici.

Estadio Centenario
MONTEVIDEO (NATIONAL TEAM)

The Centenario was built to celebrate one hundred years of Uruguay's constitution, and to host the first World Cup in 1930. The stadium held the final of the competition, with Uruguay beating Argentina 4–2. It was also the venue for the semifinal between Uruguay and Yugoslavia. A primary school and a museum sit below the Olympic stand, while there is a police station under the Colombes stand.

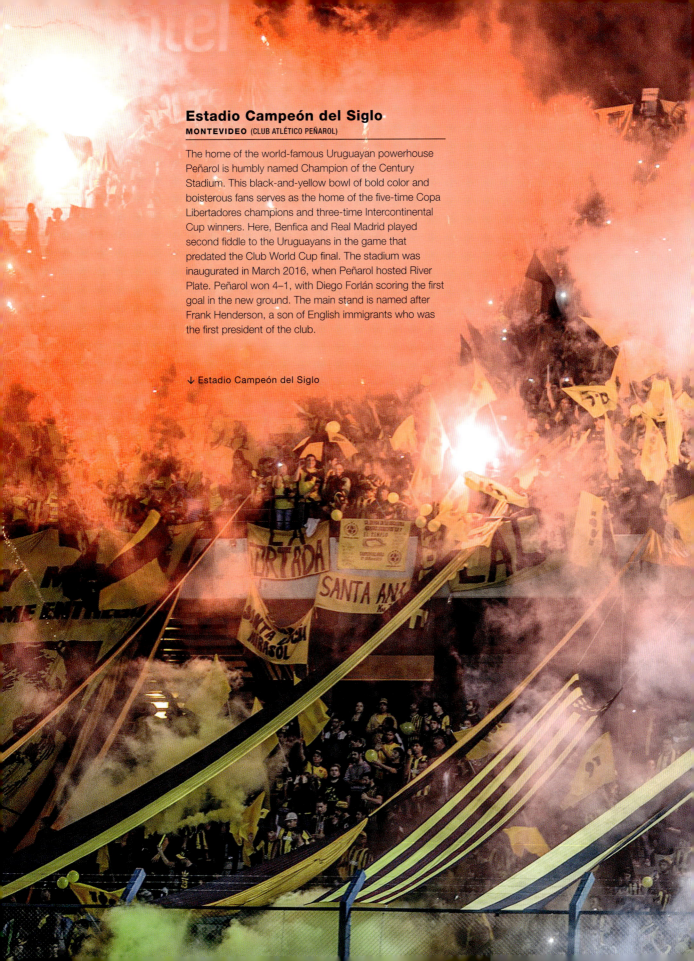

Estadio Campeón del Siglo
MONTEVIDEO (CLUB ATLÉTICO PEÑAROL)

The home of the world-famous Uruguayan powerhouse Peñarol is humbly named Champion of the Century Stadium. This black-and-yellow bowl of bold color and boisterous fans serves as the home of the five-time Copa Libertadores champions and three-time Intercontinental Cup winners. Here, Benfica and Real Madrid played second fiddle to the Uruguayans in the game that predated the Club World Cup final. The stadium was inaugurated in March 2016, when Peñarol hosted River Plate. Peñarol won 4–1, with Diego Forlán scoring the first goal in the new ground. The main stand is named after Frank Henderson, a son of English immigrants who was the first president of the club.

↓ Estadio Campeón del Siglo

ARGENTINA

Estadio Único de Villa Mercedes
VILLA MERCEDES (CLUB JORGE NEWBERY / VILLA MERCEDES)

The Estadio Único de Villa Mercedes is covered in geometric art, mirroring the landscape surrounding it, from the residential neighborhood to the rugged grassland and Quinto River. In 2022 it hosted the Trofeo de Campeones final between Boca Juniors and Racing Club de Avellaneda.

Estadio Mario Alberto Kempes
CÓRDOBA (NATIONAL TEAM / MULTIPLE TEAMS)

This stunning sphere of football is named after one of the biggest Argentinean legends of all time, and bore witness to some of the finest talent in the world in the 1978 World Cup. West Germany played here four times at that tournament, and the Netherlands twice, before they went on to lose the final to hosts Argentina. Nowadays the Kempes stadium rocks as it hosts neutral Superclásico derbies when Boca Juniors and River Plate do battle in the Argentinean national cup. It is a special ground built for big occasions.

Estadio Juan Domingo Perón
CÓRDOBA (INSTITUTO ACC)

The home of Instituto ACC spills color among the city skyline. Its terraces are dipped in the red and white stripes of the club's home jersey. Outside the stadium, the walls are lined with murals thanking past players and managers for the glories of yesteryear, and even the pavements are painted in a red-and-white checkered pattern.

Estadio Julio César Villagra
CÓRDOBA (CA BELGRANO)

Named after club legend Julio César Villagra, who tragically died by suicide while playing for the club, the stadium is known as El Gigante de Alberdi (the Giant of Their Neighborhood). It is a fusion of almost every element seen in Argentinean arenas. It has a huge, steep, single-tier stand behind one goal that curves into the western grandstand. Opposite is a large barren area where fans congregate on foot. Behind them there's a small standing terrace. The narrow eastern side has an outer wall that backs onto a road. Every stand has myriad of seating and standing areas. All this is tied together by an ocean of flags and ticker tape in the light blue of Belgrano.

Estadio Francisco Cabasés
CÓRDOBA (CA TALLERES)

The stadium known as La Boutique is a superb example of art deco design. The white facade of the main entrance has art deco orittull windows and a central embossed tower shaped like New York's Empire State Building. This shape is repeated with four blue debossed paintings across the facade. To mark their 110th anniversary, stadium owners CA Talleres commissioned a Córdoban artist to decorate the facade and a series of stunning geometric patterns were integrated into the existing decor.

Estadio 15 de Abril
SANTA FE (CA UNIÓN)

This ground is aptly named after the date on which Unión de Santa Fe football club was founded, April 15, 1907. The club came into existence around two years after their rivals Colón. When the pair do battle here in the Clásico Santafesino, the whole region comes to a standstill as the ground shakes and the stands tremble. It is one of the biggest derbies in a country that is eternally gripped by football passion.

Estadio Doctor Osvaldo Baletto
BUENOS AIRES (CA SAN TELMO)

The home of Club Atlético San Telmo is located in the barrio of Isla Maciel, a poor and run-down neighborhood near the city docks, where the club is the center of the community. If you look over your right shoulder from the main stand you can see the outline of Boca Juniors' La Bombonera stadium—and it's not uncommon to see the shirts of both teams being worn here. San Telmo's almost permanent status outside Argentina's top division does not perturb their small but loyal fan base. Here, young children hang onto the fencing that separates supporters and pitch. If the referee gets too close to the touchline on a bad day, he might have to evade a few flying objects from the terraces. To feel San Telmo you need to visit this ground, and yes, it's better to go with a local guide and proceed with caution, but the people are warm and the experience unforgettable.

→ Estadio 15 de Abril

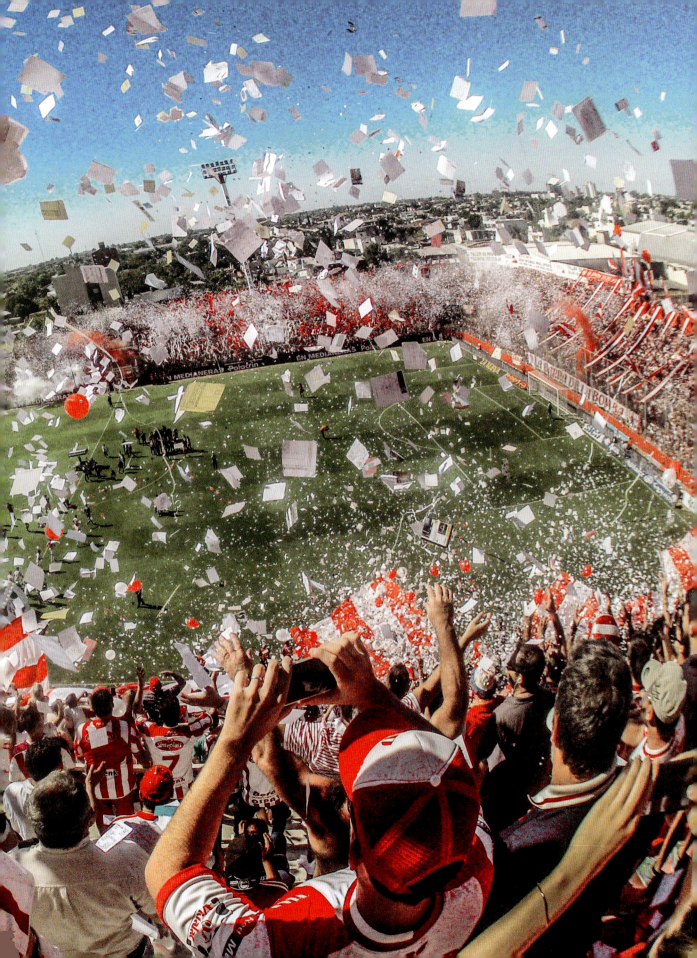

South America / **Argentina**

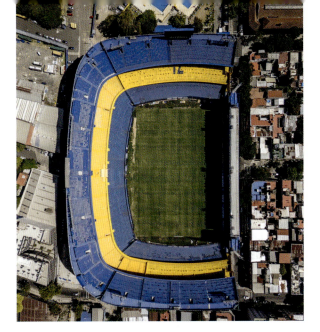

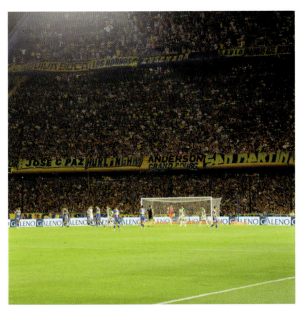

Estadio Alberto José Armando
BUENOS AIRES (CA BOCA JUNIORS)

The streets of La Boca are awash with vibrant colors, salsa dancing, and rock music. Walls of pink, green, blue, and yellow patterns lead you to a stadium clad with iron strips painted in the iconic blue and yellow—colors taken from the flag of a Swedish ship, the first to sail into La Boca harbor when the club was choosing new colors in 1906. The smell of *choripán* (chorizo, bread, and chimichurri) floats around the outskirts of the stadium. The tiers of La Bombonera (the Chocolate Box) are awash with flags and flares, and the stadium literally moves to the beat of pounding feet. Only home fans are allowed in the stands, hemmed in by soaring wire fences. Here their team is a religion, and La Bombonera their cathedral. The Palcos stand is a sliver of executive boxes, pitch one side, Doctor del Valle Iberlucea the other. Diego Maradona could be seen cheering his team from this vantage point, Cuban cigar in hand. The pitch is small, the minimum size allowed by FIFA, and the fans are intimidatingly close. The Boca ultras, La Doce, orchestrate the chants and lead the intimidation. A giant flag is taken on a ride over heads and arms in Sector L and for a time it feels like you're in the belly of a whale as it swims through the ocean of bodies, chants, flare smoke, and drums.

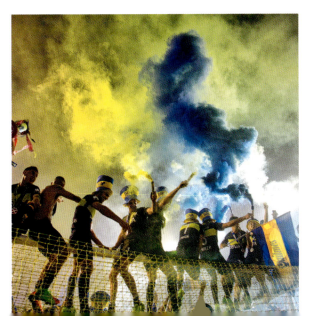

85

Argentina / South America

El Monumental
BUENOS AIRES (CA RIVER PLATE)

The biggest stadium in South America is gargantuan by name and by nature. It is a sea of red and white passion on alternate Sundays. The home of River Plate and the national team, it hosted the 1978 World Cup final and is one of football's most historic cathedrals. The walls whisper a rich history of iconic goals and momentous matches. It merges pride, passion, and sheer size with a fantastic football team and modern renovations to make it the most spectacular arena in the country. Although River Plate is known as Los Millonarios (the Millionaires), their stadium is home to many, not the few. People pilgrimage here from across Argentina, dressed in the famous *banda roja*. They come to rock and shake this showstopping ground with unwavering loyalty toward their team. Every element makes for a spine-tingling and emotional football experience.

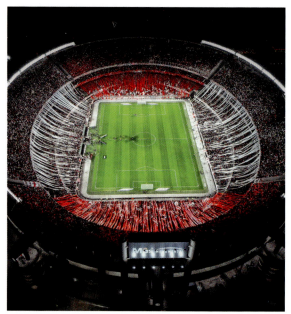

↑ El Monumental

Estadio Tomás Adolfo Ducó
BUENOS AIRES (CA HURACÁN)

Huracán's red hot-air balloon is one of the great football crests. A huge balloon, with its large "H" on the front, adorns the seats of Estadio Tomás Adolfo Ducó's "popular local" stand. It's so big that only the upper half can be seen. On the seats opposite, "HURACAN" is written in huge type. An art deco tower rises above the Miravé stand like a space shuttle. A statue of legendary boxer and Huracán fan Oscar "Ringo" Bonavena sits in one of the seats. The exterior is a marvel of art deco design, featuring geometric brickwork and white stucco beams. The stands are a sea of white and red and the concrete bowl, its seating forged into armchair-style shapes, is open to the elements. It is easy to see why the stadium is known as El Palacio (the Palace). It is named after a two-time former club president.

Estadio Claudio Chiqui Tapia
BUENOS AIRES (BARRACAS CENTRAL)

The home of Barracas is so small that there isn't space for the club's ultra group behind the goal. Instead they occupy the larger part of a small stand on the sideline, while the areas behind the goals are filled with kids who hang onto the railings and shout abuse at the opposition. While the size and stature of the stadium make it feel like a community club, in recent years Barracas has made its way to the top football league. This has given loyal locals some big days out, and some domestic superstars an uncomfortable away day.

Estadio Guillermo Laza
BUENOS AIRES (DEPORTIVO RIESTRA)

This stadium is something of a hidden gem in the multitude of Buenos Aires's football wonders. It sits in the shadow of San Lorenzo's monumental El Nuevo Gasómetro, yet it is arguably the grandstand and attached clubhouse that steal the show in Villa Soldati. The thriving Malevos of Pompeya has made it all the way to the Primera División.

Estadio Ciudad de Vicente López
BUENOS AIRES (CA PLATENSE)

The Ciudad de Vicente López stadium is home to 2023 Copa de la Liga Profesional finalists Platense. Unfortunately for the club they are located very close to River Plate and so rarely fill their 28,530 capacity. Yet, as with all Argentinean clubs, they have a core fan base who would die for the shirt. Also common with all Argentinean clubs is a love for Diego Maradona, even if he had no personal association with the club. At Platense, like the others, young boys fly flags with the face of "El Diego" and the "Islas Malvinas" (Falkland Islands) emblazoned on them.

South America / **Argentina**

Estadio Saturnino Moure
PIÑEIRO (CA VICTORIANO ARENAS)

The stadium shares a raw, authentic quality with many lower league Argentinean grounds; the fences are lined with barbed wire and the stands are a little dilapidated. In 1998, the ground saw Florencia Romano referee an official Argentinean match—the first woman to do so. Another official was at the center of a less celebratory story; when a dubious late penalty was awarded to the away team, the locals pushed the referee's car into a river.

↓ Estadio Saturnino Moure

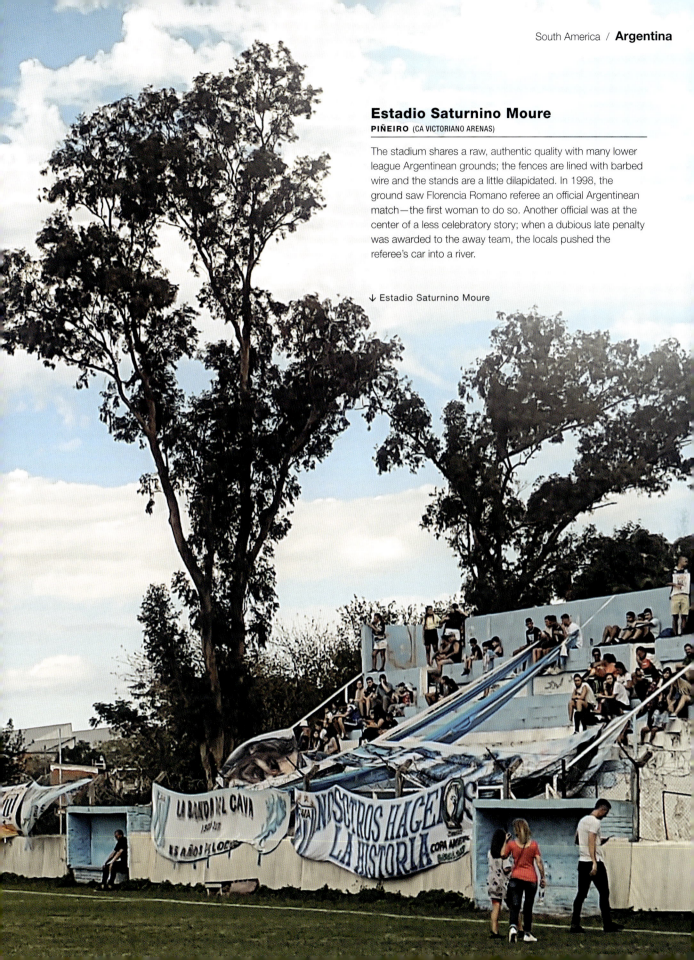

Argentina / South America

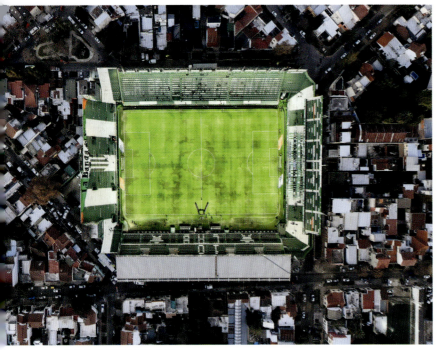

↑ Estadio Florencio Sola

Estadio Florencio Sola
BANFIELD, BUENOS AIRES (CA BANFIELD)

Recent renovations mean that this green-and-white ground has a relatively modern finish; but like many Argentinean stadiums, it is bare and raw, without frills and displaying the club colors. The fans who fill those colorful terraces make it what it is. Like its name and local area, the ground has an English feel; the stands are tight and superclose to the pitch, giving the ground an intimate and exciting ambience. Banfield, the home team, is a humble club that won an unprecedented first division title in 2009. It was set up by British workers in the small town just outside Buenos Aires back in 1896.

Estadio Liga Mercedina
MERCEDES (CLUB MERCEDES)

The stadium is somewhat ramshackle, with random elements such as a small tiered concrete stand to the side of one of the goals, and sporadically placed small wooden pavilions within the two open terraces. One stand enjoys wooden benches with metal armrests and a roof. A high metal fence separates the fans from the pitch. It is a wonderful example of grassroots football played in front of vocal fans who bring banners to pin to the fence in support of their team. It is a joyful experience away from the cauldron of the Primera División.

Estadio de Argentino de Quilmes
QUILMES, BUENOS AIRES (ATLÉTICO ARGENTINO DE QUILMES)

Quilmes is a small city south of Buenos Aires that is famous worldwide for being home to one of Argentina's most iconic exports—Quilmes beer. It is the beer of the Argentinean workingman, and the town and stadium make it feel like this is the football club of the workingman, too. The humble old ground harks back to yesteryear. A tiny picturesque stand is connected to the dugouts via a short players' tunnel, and vintage megaphones tied to the roof provide an old-school sound system for those close enough to hear it. Though the color has faded, the light blue and white paintwork blends in with the blue sky, and the Quilmes die-hards behind the goal bring the atmosphere.

Estadio Diego Armando Maradona
BUENOS AIRES (ARGENTINOS JUNIORS)

The Estadio Diego Armando Maradona is exactly what it says on the tin—not just a stadium but a shrine to the man they call "God" in Argentina. El Diego's face is everywhere, including on the stadium's exterior and the surrounding neighborhood—and his memory lives on. The club that provided his big break is now a place where fans come to mourn and celebrate on the anniversary of the legendary player's passing. A giant number "10" adorns the stand behind the goal at the home of Argentinos Juniors. The stadium also has a museum with relics from Maradona's era at the club. A visit here is a truly religious experience.

Estadio Juan Carmelo Zerillo
LA PLATA (CLUB DE GIMNASIA Y ESGRIMA LA PLATA)

This stadium, also known as El Bosque (the Forest), may sit between 60th Avenue and 118th Street, but it's not New York City. This ground is in the city of La Plata, and is named after the club president who was in charge between 1929 and 1931, when Gimnasia won their first-ever title in Argentina. This pitch sits perfectly on the map, with the sideline running from east to west. Two standing terraces hug the areas behind the goal and smaller seated areas sit facing each other on the halfway line.

South America / **Argentina**

Estadio Jorge Luis Hirschi
LA PLATA (CLUB ESTUDIANTES DE LA PLATA)

The home of Estudiantes is one of the most spectacular and modern stadiums in Argentina, but the famous four-time Copa Libertadores winners have maintained their old soul and fanfare. Outside the stadium the *choripán* street stands are as regular as anywhere else, and thousands of fans sip prematch drinks in their red-and-white shirts. On the inside, however, the stadium is so futuristic that one stand is fitted only with premium seats, boxes, and even a pitch-side restaurant. In 2005 the old stadium was demolished when wooden stands were banned in topflight Argentinean football. It once had an exquisite pavilion grandstand that burned to the ground and has been replaced by a concrete structure. The new pavilion is like La Bombonera's with a tall, slim structure topped with VIP balconies and hemmed in by Avenue 1.

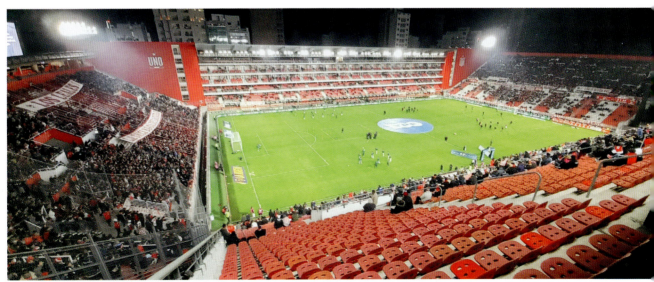

↑ Estadio Jorge Luis Hirschi

Argentina / South America

Estadio José Amalfitani
BUENOS AIRES (VÉLEZ SARSFIELD)

From 1914 to 1933 Vélez wore green and red jerseys, but then in 1933 the jersey with the iconic *V* pattern (also associated with Brescia in Italy) arrived. The stands at Vélez are emblazoned with the *V* design and it is still part of the club's home and away shirts. The stadium is famous as it can be seen just off one of the main motorways out of Buenos Aires; its floodlights have doubled as giant Coca-Cola cans in a colorful and creative marketing event that took advantage of its location.

El Nuevo Gasómetro
BUENOS AIRES (SAN LORENZO)

The Nuevo Gasómetro, officially Estadio Pedro Bidegain, is the home fortress of San Lorenzo, one of Argentina's top five football clubs. It's really not much more than a barren concrete structure, but the fervor and color of the fans who swarm there on match day transform this old structure into a bouncing carnival of red and blue. The Cyclone from the Boedo area of Buenos Aires won a famous Copa Libertadores title in 2014.

Complejo Pedro Pompilio
BUENOS AIRES (BOCA JUNIORS WOMEN'S TEAM)

If you keep walking north along the Doctor del Valle Iberlucea, away from La Bombonera, you will reach the Complejo Pedro Pompilio, home of the Boca Juniors women's team. In true La Boca style, a long blue and yellow painted wall bridges the two venues.

Estadio José Dellagiovanna
VICTORIA, BUENOS AIRES (CLUB ATLÉTICO TIGRE)

Hemmed in on every side by houses, the stands are necessarily slim, except on the west side, where there is a little breathing space and a large curved stand with the name of the team "TIGRE" written across it. The stadium has been a part of the neighborhood since 1936.

Estadio Norberto "Tito" Tomaghello
FLORENCIO VARELA, BUENOS AIRES (CLUB SOCIAL Y DEPORTIVO DEFENSA Y JUSTICIA)

This small city humbles even the big dogs when it comes to the quality of the turf; the stadium is widely regarded as having the finest playing surface in Argentina. Defensa y Justicia was formed as an amateur football team in 1935, but their current stadium wasn't built until 1978. Now they are continental football regulars and domestic challengers.

Estadio Ciudad de Lanús
LANÚS, BUENOS AIRES (CLUB ATLÉTICO LANÚS)

Considered to be in Buenos Aires by many, Lanús is actually a barrio southwest of the city. The stadium has been home to the club since 1929, with recent triumphs including league titles in 2007 and 2016 and a historic 2013 Copa Sudamericana title. This stadium has roof coverage on three sides, which is far more than most in Argentina. It is painted in the unmistakable claret of the team, and the stands are tight and within feet of the playing surface.

Estadio Eva Perón
JUNIN (SARMIENTO)

The home of Sarmiento is that of a small club, but one that is filled as ferociously as any other in Argentina by the club's passionate followers. Here, figures tattooed from head to toe wear green bucket hats and fake Sarmiento merchandise, bang their drums, and smoke cigarettes as they march to the popular stand every Sunday. They enter in their numbers and roar through the gaps in the cage behind the goal.

Estadio Presidente Perón
AVELLANEDA, BUENOS AIRES (RACING CLUB)

The corners of the pitch cut into the stands like a rectangular cookie cutter in a rolled-out oval of pastry dough. The stadium is home to Racing Club, and sits just 328 yards (300 m) from their rivals Independiente, making the Clásico de Avellaneda the closest derby in Argentinean football.

Estadio Libertadores de América
AVELLANEDA, BUENOS AIRES (CLUB ATLÉTICO INDEPENDIENTE)

Independiente believe they are the biggest club in Argentina, and with that comes a boisterous atmosphere and fiery home crowd. This ground has a standout feature too—its corner stands. Four towers behind each corner flag, each with four small tiers of extra seating, replace a corner breeze with more fanatic voices. The stadium shares a name with the most famous football trophy in South America, one that home team the Red Devils has won more than anybody else. Hence their nickname, the King of Cups.

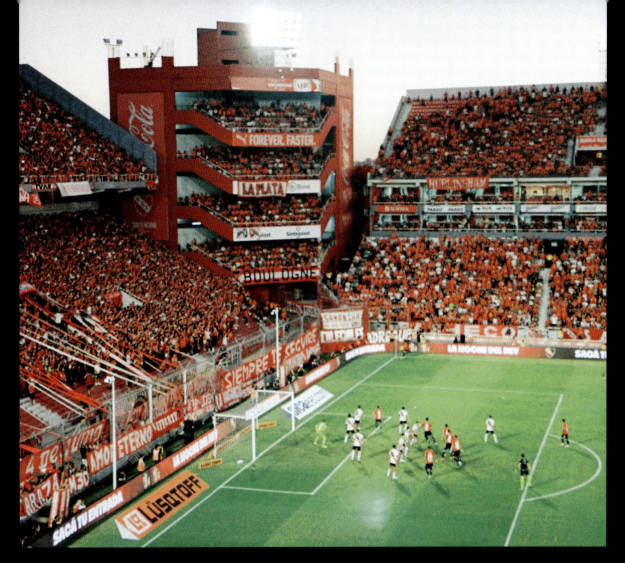

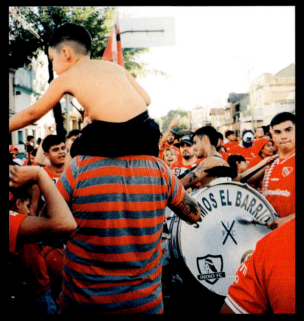

↑ Estadio Libertadores de América

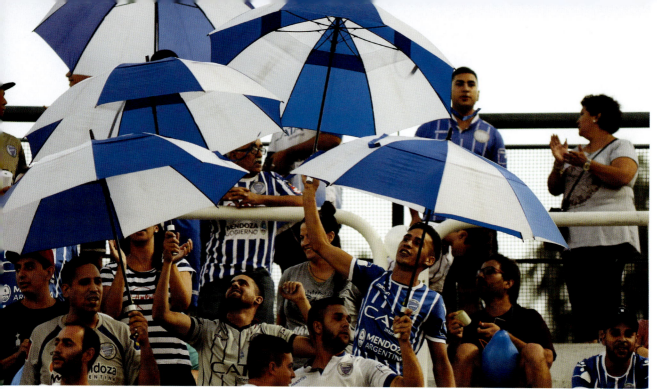

↑ Estadio Feliciano Gambarte

Estadio Alfredo Terrera
SANTIAGO DEL ESTERO (CLUB ATLÉTICO CENTRAL CÓRDOBA)

The land on which this stadium stands has an interesting history. Before its current owners Central Córdoba arrived, it was a field used for the sports classes at a local school. The city's mayor ensured it was donated to the football club as they had suffered economic issues and were searching for a permanent home. According to former club executives, when they were building the ground in 1942, bones were found underneath the playing surface and in the spot where the grandstands were to be built. It seemed that before being a playground the site served as a cemetery.

Estadio Feliciano Gambarte
GODOY CRUZ (CLUB DEPORTIVO GODOY CRUZ ANTONIO TOMBA)

Mendoza may not have the football-crazy feel that you cannot avoid in Buenos Aires or Rosario, but rest assured, the famed wine region has its own pocket of passion for the beautiful game. This comes in the form of the Estadio Feliciano Gambarte. The home of Godoy Cruz has small but extremely steep stands hanging over the pitch. The single-tier "popular" standing and singing section behind the goal is the heartbeat of the arena on match days. The ultras bring color and noise in a city of calm and tranquility, a blue army in a city associated with Malbec red.

Estadio Único Madre de Ciudades
SANTIAGO DEL ESTERO (NATIONAL TEAM)

Consideration has been given to every angle and element of the aesthetic here. From a bird's-eye view, the stadium resembles a human eye: The pitch is the pupil; the blue, patterned pitch surround is the iris; the roof the white sclera; and the walkways leading from the intermittent dark panels of the facade, the lashes. The area surrounding the pitch can be used to expand the seating area when needed, increasing the capacity to 42,000.

Estadio Anselmo Zingaretti
MAIPÚ, MENDOZA (GUTIERREZ SPORT CLUB)

As is common in Argentinean stadiums, players enter the pitch via an underground tunnel. As they emerge, the fans greet them with a sky-blue spectacle of flags, ticker tape, smoke bombs, and feverish vocal support. Drums are pounded, hand-painted banners line the stands, and toilet rolls are thrown onto the pitch. Some fans climb the high wire fence in a tribal show of passion. Everyone else is bouncing to the beat of the drum. Five thousand fans sound like twenty-five thousand. This is third division Argentinean football.

South America / **Argentina**

Estadio Monumental José Fierro
SAN MIGUEL DE TUCUMÁN (CLUB ATLÉTICO TUCUMÁN)

This compact stadium is more than a hundred years old and home to Club Atlético Tucumán. It billows with blue smoke when "the Giant of the North" is playing. From the outside, the white-and-blue paint cannot cover the naked exterior of the concrete stands. The back end of the terraces encourages you to wonder what is waiting on the other side—the fresh turf, the bright lights, and everything you anticipate before a match.

Estadio Gigante de Arroyito
ROSARIO (CLUB ATLÉTICO ROSARIO CENTRAL)

Rosario Central owns this two-tiered stadium nestled among the trees on the bank of the Paraná River. As the trees wave in the breeze outside, the Rosario fans shake the stands of the Gigante de Arroyito. Internationally overlooked in favor of their noisy neighbors Newell's Old Boys, Rosario Central has a proud history and passionate fan base. "This is Rosario Central, The Greatest Passion in the Country" reads the graffiti on the stadium entrance.

↓ Estadio Gigante de Arroyito

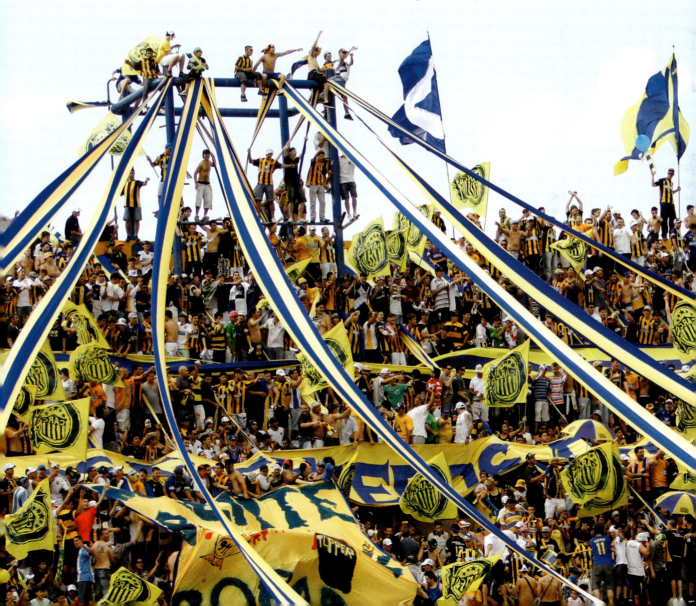

Argentina/Chile / South America

↑↗ Estadio Marcelo Bielsa

Estadio Marcelo Bielsa
ROSARIO (NEWELL'S OLD BOYS)

Named after the legendary Argentinean manager Marcelo Bielsa, Newell's Old Boys's ground also has close ties to the two gods of Argentinean football: Diego Maradona and Lionel Messi. Maradona played for Newell's, and delivered the 1986 World Cup to his homeland. Meanwhile, Messi grew up around the corner and played in the red and black of Newell's as a boy. He went on to deliver the 2022 World Cup title. The city and area around the stadium feature murals in the club colors, as well as Messi, Maradona, and other star players. The stadium is on the edge of a park with cafés, lakes, and trees, yet the doors to the arena represent the gates to hell for Newell's opponents—they are always met with a red-hot atmosphere.

Estadio de Chacarita Juniors
VILLA MAIPÚ (CLUB ATLÉTICO CHACARITA JUNIORS)

Here, the players walk onto the pitch through a tight blow-up tunnel as fireworks explode out of a sloping stand behind one of the goals. Behind the other goal is a massive version of the same stand—a huge sloping concrete block engulfed in red and black flare smoke.

CHILE

Estadio El Teniente
RANCAGUA (O'HIGGINS FÚTBOL CLUB)

Bernardo O'Higgins was the former supreme director of Chile. That's right, a man with Basque and Irish heritage helped liberate Chile from Spain, and now a topflight football team plays in his name. Their home is bathed in blue, from the sky to the seats; mountains linger on the horizon. The stadium is polished and modern. It was used to host games at the 2015 Copa América tournament.

Estadio Monumental
MACUL (COLO-COLO)

It took an incredible thirty-three years to complete the build of Colo-Colo's Estadio Monumental. An earthquake devasted the build in 1960. An initial opening in 1975 lasted for just seven games. It took funds from the sale of Hugo Rubio to Serie A's Bologna and a national television fundraiser the *Colotón* to complete it in 1989. When the stadium is full, it's an amazing sight, with the Andes Mountains as a backdrop. When empty, one of the great crests in world football is on display over the seating—a profile of the sixteenth-century Indigenous Mapuche warrior leader, Colocolo. A final unique feature is the pitch; it has a name—David Arellano—the club's founder.

South America / **Chile**

Estadio Regional de Antofagasta
ANTOFAGASTA (MULTIPLE TEAMS)

At night this stadium is stunning thanks to the combination of a translucent roof that becomes luminescent, and the flickering lights from houses cascading from the hills. The approach to the stadium is equally magical. At each end, the stadium walls are covered in a mosaic of rocks, ceramics, and seashells, created by the Deportes Antofagasta community. A footbridge takes you from one of two squares to the entrance. The seating is covered with an abstract white-and-blue pattern to mimic the desert mountains. The pitch is made from a mixture of ryegrass and Bermuda grass for traction and softness. Once inside, the crowds build and the stands become a Wurlitzer of energy. Everything about this stadium is exquisite.

Estadio Zorros del Desierto
CALAMA (CD COBRELOA / NATIONAL TEAM)

Cobreloa's stadium is known ominously as El Infierno Naranja (the Orange Hell). Match days are intense and colorful. Everything to do with the club is based on the color orange, derived from their nickname, the Desert Foxes; the seating, the club crest, and the player kits. The stadium name was put out to a fan vote to which their answer was unanimous—Estadio Zorros del Desierto, the "Desert Foxes Stadium." The front row of orange seats touches the edge of the pitch like a rising sand dune, and a wonderful tree grows in one of the corners. Only the lush green pitch interrupts the mirage of a desert scene. The original 1952 stadium was completely reconstructed in 2015, but much of its charm has remained.

Estadio San Carlos de Apoquindo
LAS CONDES (UNIVERSIDAD CATÓLICA)

Although it was built in the 1980s, the Estadio San Carlos de Apoquindo follows the classic design of Chilean stadiums from the 1920s and 1930s. The entrance has an art deco feel, the stands are supported by a series of narrow external columns, and the seating is an open-air ring of wooden benches.

↓ Estadio San Carlos de Apoquindo

Chile / South America

Estadio Sausalito
VIÑA DEL MAR (CD EVERTON)

If you have the pleasure of visiting the Estadio Sausalito, you'll find that one entrance is prettier than the other. On the north side, there's a walk by the laguna; on the south is a walk up Avenida Padre Hurtado. Here, you can peek through the walls and trees for a glimpse of the pitch before you enter the stadium and walk back down the hill to the stands. It is as if you are entering an ancient Roman amphitheater. The stadium is home to Everton, probably named after the Liverpool club; it was founded by a group of English immigrants in 1909.

Estadio Elías Figueroa Brander
VALPARAÍSO (SANTIAGO WANDERERS)

The entrance facade closely resembles the White House in Washington, DC, and its pillared supports wrap around the earring-style bowl. The home of one of Chilean football's founding teams, Santiago Wanderers, is simply extraordinary. It looks out onto Valparaíso Bay and the South Pacific Ocean. Its backdrop is the Artillería Hill. On match days, it's worth starting from here, using the funicular railway, so that you can appreciate the majesty of the stadium from afar and get drawn toward the harborside.

Estadio El Cobre
EL SALVADOR (COBRESAL)

The Estadio El Cobre is rare in that its capacity is greater than the population of the town it is in. The mining town of El Salvador has a population of seven thousand—just over half the capacity of the stadium. It sits more than 7,874 feet (2,400 m) above sea level in the foothills of the Andes, and in the middle of the Atacama Desert.

Estadio Santa Laura Universidad SEK
SANTIAGO (UNIÓN ESPAÑOLA)

The Estadio Santa Laura has a very Spanish feel. Everything is red and yellow, and the team plays in the colors of the Spanish national team. The outer wall brings you to a castle-style gateway. The stadium entrance is a sprawl of geometric shapes and three wooden "ribbons." The concourse is the raw underbelly of the stands, and you step out into a classic Chilean open-air arena with a mountain backdrop. When the match begins, ticker tape is fired into the air. Absolutely everywhere.

Estadio Nacional Julio Martínez Prádanos
SANTIAGO (NATIONAL TEAM / MULTIPLE TEAMS)

In 2006 a match here was played with a 11-yard-high (10-m) magnolia tree planted on the center spot. It was the culmination of a weeklong exhibition by artist Sebastián Errazuriz to mark a dark chapter in the history of the Chilean national stadium—the place where political prisoners were tortured during the dictatorship of Augusto Pinochet (1973–90). The match, played in front of a crowd of fifteen thousand, was a richly cathartic moment. Forty-four years earlier, the stadium had hosted the "Battle of Santiago" between Chile and Italy, the most violent game in World Cup history.

Estadio Rubén Marcos Peralta
OSORNO (PROVINCIAL OSORNO)

The Estadio Rubén Marcos Peralta is unique in that much of the stadium is made of wood.

Estadio Regional de Chinquihue
PUERTO MONTT (DEPORTES PUERTO MONTT)

A wavelike undulating roof extends to ground level on one side of the Estadio Regional de Chinquihue to offer spectators views of the Petrohué River. The roof design gives the effect of shimmering water, which is continued with a wave and riverside design across the seats within the stands

Estadio de Hanga Roa
HANGA ROA, EASTER ISLAND (CF RAPA NUI)

Known as the smallest "national stadium" in the world, the home ground of CF Rapa Nui in the capital of this small Chilean province hosts the Easter Island football team.

Estadio Municipal Joaquín Muñoz García
SANTA CRUZ (DEPORTES SANTA CRUZ)

The home of Deportes Santa Cruz is named after one of its founders, Joaquín Muñoz García, who also donated the land on which the stadium is built.

Estadio Carlos Dittborn
ARICA (SAN MARCOS DE ARICA / DEPORTIVO UNIVERSIDAD DE TARAPACÁ)

When Colombian player Marcos Coll scored against Russian legend Lev Yashin during a World Cup match here in 1962, it was a unique moment: It is the only World Cup goal to date to be scored direct from a corner.

↑↓ Estadio Sausalito

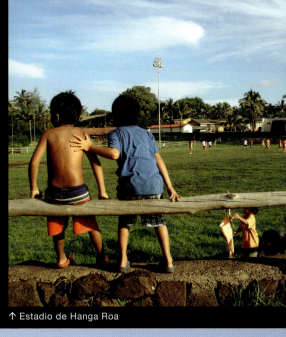
↑ Estadio de Hanga Roa

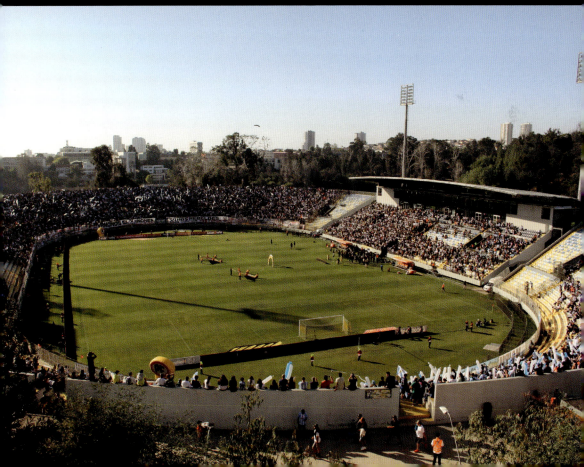

Bolivia / South America

BOLIVIA

Estadio Hernando Siles
LA PAZ (NATIONAL TEAM / MULTIPLE TEAMS)

La Paz is surrounded by mountains and the stadium echoes this; its large, colorful, bowl-style structure is surrounded by housing blocks. Fans take cable cars around the city and to the stadium. At an altitude of 11,932 feet (3,637 m) it is the highest national stadium in the world. The Brazilian team required oxygen after a World Cup qualifier against Bolivia here, with Neymar describing playing there as "inhuman." The stadium is owned by the city of La Paz, which rents it to any club wanting to use it for matches; as a result many teams call it home.

Estadio de Villa Ingenio
EL ALTO (CLUB DEPORTIVO ALWAYS READY / CLUB DEPORTIVO FATIC)

Located in El Alto in the Altiplano highlands, this is the second-highest stadium in the world. At 13,392 feet (4,082 m) above sea level, players often need breathing apparatus after matches. It is home to the wonderfully named Always Ready.

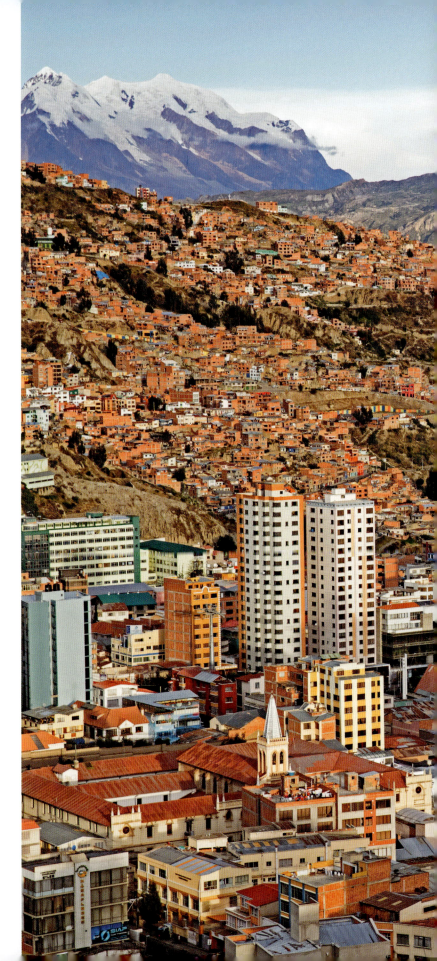

→ Estadio Hernando Siles

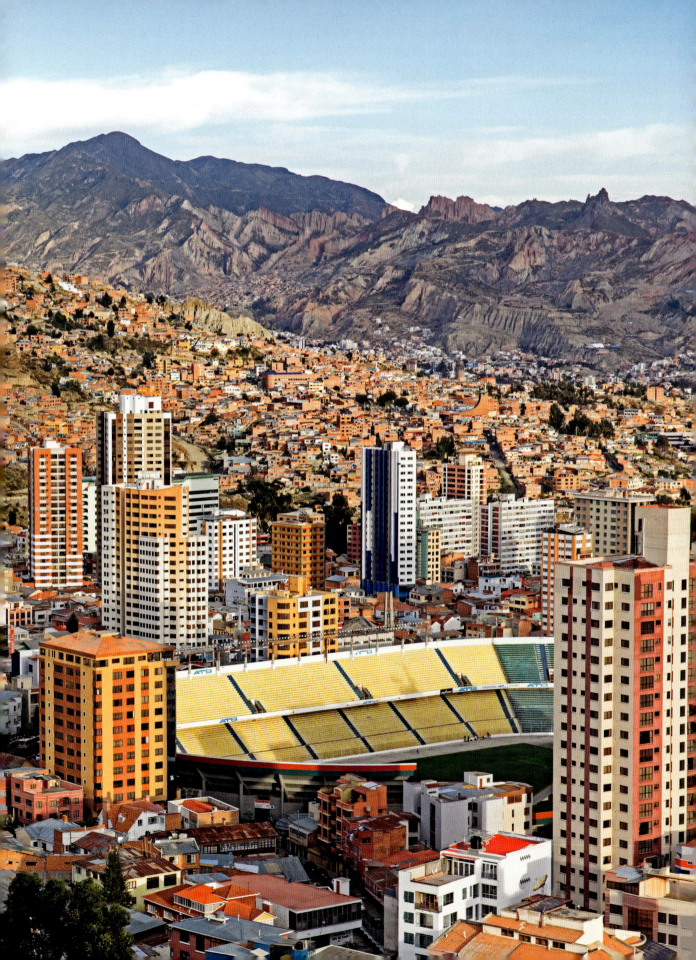

Peru / South America

↓ Estadio Monumental

PERU

Estadio Alejandro Villanueva
LIMA (CLUB ALIANZA LIMA)

Aging images of the club legend that gives the stadium its name, Alejandro Villanueva, are painted on walls leading to a side entrance. Smoke bombs in alternate blue and white stripes span three tribunes. A large tifo displays the club's founding year, 1901. The pride for Club Alianza Lima, *El Equipo del Pueblo* (the People's Team), is everywhere. And so too for the neighborhood in which the stadium lies and takes its colloquial name—Matute.

Estadio Monumental
LIMA (CLUB UNIVERSITARIO DE DEPORTES)

This monolith seems to have been forged from the surrounding environment—the dusty ground, the urban expanse to the west, and the low mountains to the east. Even the team's jerseys have an off-white dusty hue. Like so many Peruvian stadiums, it has an unapologetic ruggedness. The pitch and lower tiers sit within a bowl housing almost sixty thousand fans. At ground level, and towering over the stands, are boxes hosting over twenty thousand. It has the second-highest capacity in South America, behind El Mounumental.

Estadio Unión Tarma
TARMA (ADT TARMA)

The Estadio Unión Tarma sits at the foot of a sprawling mountainside town and appears to flow out of the surrounding buildings.

→ Aguas Calientes Football Pitch

South America / **Peru**

Aguas Calientes Football Pitch
MACHU PICCHU (CLUB TIJUANA FC)

Football in the foothills of Machu Picchu, beside the Urubamba River (the sacred river) and under the spotlight of the local community.

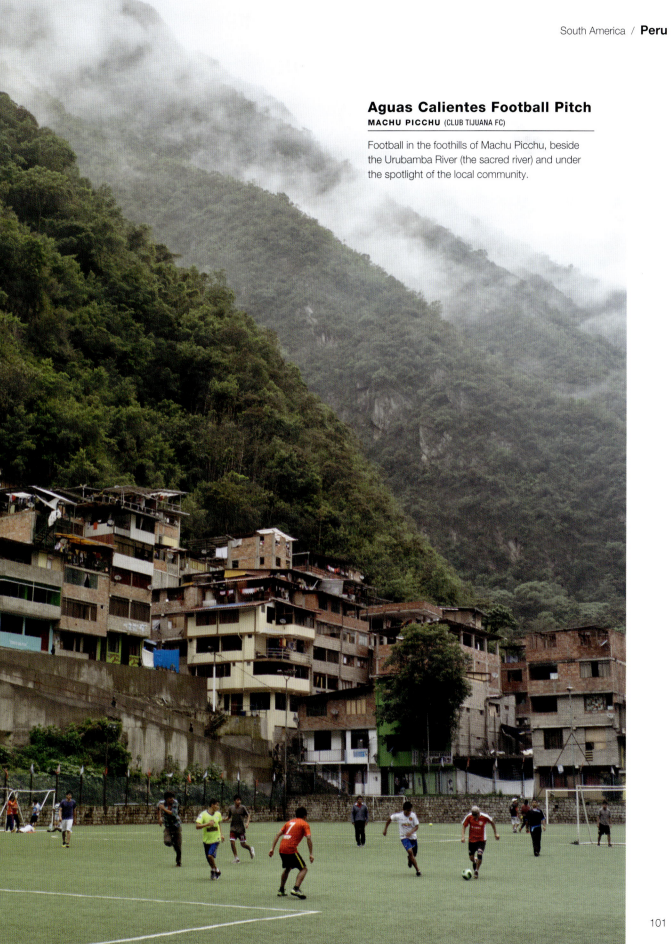

Peru / South America

Estadio Nacional del Perú
LIMA (NATIONAL TEAM)

The Estadio Nacional del Perú seems to have been carved out of the streets of the Santa Beatriz district in which it sits—like tectonic plates colliding to create a huge monolith. And then rising through the center on the north side is a red steel tower, like a knife cutting into a wedding cake. Despite an expressway running along the east side, there is a calmness in the streets around the stadium, the neighborhood leaving the giant to sleep in its downtime from match day. Even street vendors selling scarves and counterfeit shirts on the expressway bridge keep a respectful distance from this seventy-year-old national monument.

Estadio Municipal de Amantaní
AMANTANI ISLAND, LAKE TITICACA (MULTIPLE TEAMS)

Among the Inca roads and farming terraces on Amantani Island, just off the coast of Capachica on Lake Titicaca, you'll find a wonderful old stadium. Running along the top of its single stone-benched terrace is a series of arched windows with a sun icon at their center. You can take a football for a kickabout on the sandy pitch then watch the sunset from the terrace, over the desert terrain, across the lake, and out to the snowcapped mountains.

Estadio Melgar
AREQUIPA (MULTIPLE TEAMS)

A pale blue tower adorned with the Arequipa coat of arms in the center of the grandstand is just enough to bring your focus back to the stadium and the football, away from the jaw-dropping backdrop of the Misti volcano and the valley of the Chili River.

Estadio de la UNSA
AREQUIPA (ALFONSO UGARTE DE PUNO)

The Estadio Monumental Virgen de Chapi was built by the historic University of San Agustín in a field where the eponymous saint had been coronated by Pope John Paul II years earlier. With the help of a fundraising lottery organized by the university, they constructed the second-largest stadium in Peru. Large palm trees line the walkway to this huge brutalist bowl, and a large wooden cross stands against a palm tree at the entrance.

Estadio Enrique Torres Bolen
PUNO (ALFONSO UGARTE)

Sitting beside Lake Titicaca, this stadium is unique in that it is built entirely of stones. And at an altitude of 12,595 feet (3,839 m), it is the fourth-highest stadium in the world.

South America / **Peru**

Estadio Garcilaso
CUZCO (CIENCIANO / GARCILASO / CUSCO FC)

Rarely is a football ground used as a canvas for works of art, but the seating arrangement in Estadio Garcilaso makes your jaw drop as soon as you set your eyes on its interior—and every stand displays a different design. The most spectacular one beats Joseph's technicolor dreamcoat for vibrancy and shimmers like glitter in the sun. It resembles the famous patterns of Peru's Rainbow Mountain.

Estadio 25 de Noviembre
MOQUEGUA (SPORT HUANCAYO / SPORT AGUILA)

The nearby Plaza de Armas of Moquegua was designed by Gustave Eiffel, and in a poetic parallel, the grandstand roof support is a curved intertwined steel arch reminiscent of the Parisian tower.

Estadio Daniel Alcides Carrión
CERRO DE PASCO (UNION MINAS)

At 14,370 feet (4,380 m) above sea level, players require oxygen masks after a match here. Located at the top of the Andes mountains, this is the highest stadium in the world. In 2007 the home team, Unión Minas, was forced to stop playing when FIFA introduced a ban on stadiums over 8,202 feet (2,500 m) above sea level. This was lifted when a forty-seven-year-old Maradona played a match for Argentina at Estadio Hernando Siles, the Bolivian national stadium and the highest national stadium in the world, to prove football could be played safely at such a height. The ban was lifted, and the Unión Minas players breathed a heavily oxygen-reduced sigh of relief, then resumed their fixtures.

Estadio Max Agustín
IQUITOS (COMERCIANTES FC)

The Estadio Max Agustín cannot be reached by road. It sits in Iquitos, the largest city in the Peruvian Amazon, east of the Andes, and can only be reached by air or river.

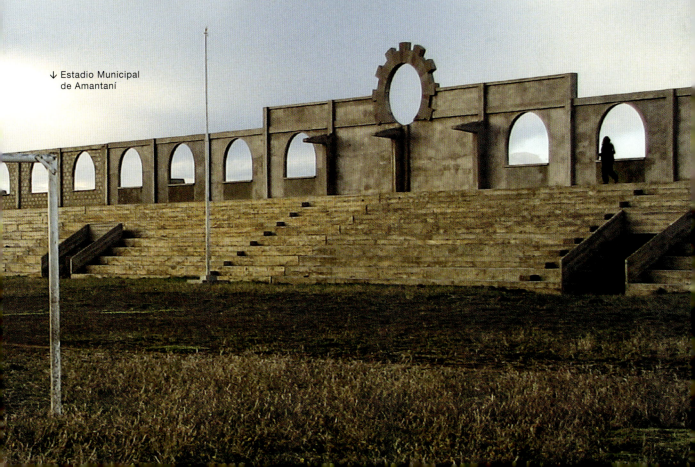

↓ Estadio Municipal de Amantaní

Ecuador / South America

ECUADOR

Estadio Rodrigo Paz Delgado
QUITO (LDU QUITO / NATIONAL TEAM)

The stadium known as the White House has previously been home to the Ecuador national team and is permanently home to one of the nation's top clubs, LDU Quito. This ground was only built in 1997, but at an altitude of 8,970 feet (2,734 m) it is an unwelcoming environment for visiting teams, where oxygen is hard to come by. The ground has its corners filled in with buildings and boxes to trap an electric atmosphere and use up every possible inch of space.

Estadio Olímpico de Atahualpa
QUITO (CLUB DEPORTIVO EL NACIONAL)

The Estadio Olímpico de Atahualpa sits in a valley on the eastern slopes of the Pichincha volcano in the Andes, and at an altitude of 9,127 feet (2,782 m) is a nightmare for visiting national teams. Ecuador has an enviable record. Kaká, Ronaldinho, and Messi have all lost here.

Estadio Jorge Andrade
AZOGUES (DEPORTIVO AZOGUES / GUALACEO SC)

The main stand is perhaps the ultimate Kop. It is steep, single-tier, shaped like the Spion Kop in South Africa (the hill from which every Kop derives its name, brought from the Boer War all the way back to Arsenal's old Manor Ground in 1904 . . . but that's another story), and what's more it's built into a hillside. It tapers away from the rest of the stadium and is painted with the outstretched wings of an Andean condor in red, white, and green. This pattern is repeated behind the home goal, where the stand is shaped like a wedge of lemon.

South America / **Ecuador**

Estadio Monumental Banco Pichincha
GUAYAQUIL (BARCELONA SC / NATIONAL TEAM)

When Estadio Monumental Banco Pichincha opened in 1987, Pelé described it as the most beautiful in the world. Whether or not he was swept away by the furor of the occasion, with Barcelona SC taking on FC Barcelona, it is certainly breathtaking. The stands behind both goals are separated from the rest of the stadium, like two slices of cake waiting to be eaten. The top tier of both stands sits outside the stadium, and on match days the huge number of fans in each stand appears to be overflowing from the confines of the stadium.

Estadio Bellavista
AMBATO (CLUB DEPORTIVO MACARÁ / MUSHUC RUNA / TÉCNICO UNIVERSITARIO)

At first sight, the name of stadium—Beautiful View—looks a little misleading. Its beauty lies in its ruggedness and the way in which it is fused with the concrete urban sprawl around it. Fans sit on long, curved, concrete tiers while four large floodlights shine down from the corners of the pitch, with two dozen smaller floodlights above the one stand that offers plastic seating. In the far distance is the *bella vista*—a view of the Andes.

Estadio George Capwell
GUAYAQUIL (CLUB SPORT EMELEC)

An incredibly high main stand with vertical tiered seating gives a unique fan perspective. Not for anyone suffering from vertigo.

← Estadio Monumental Banco Pichincha

105

Europe

CHAPTER 3

Iceland / Europe

ICELAND

Hásteinsvöllur
HEIMAEY (ÍÞRÓTTABANDALAG VESTMANNAEYJA)

The best seats at Hásteinsvöllur are in the covered grandstand looking over to the open north stand under a steep right-angular rock face. Built on the volcanic island of Heimaey in the Vestmannaeyjar archipelago, this must be one of the world's most beautiful football locations.

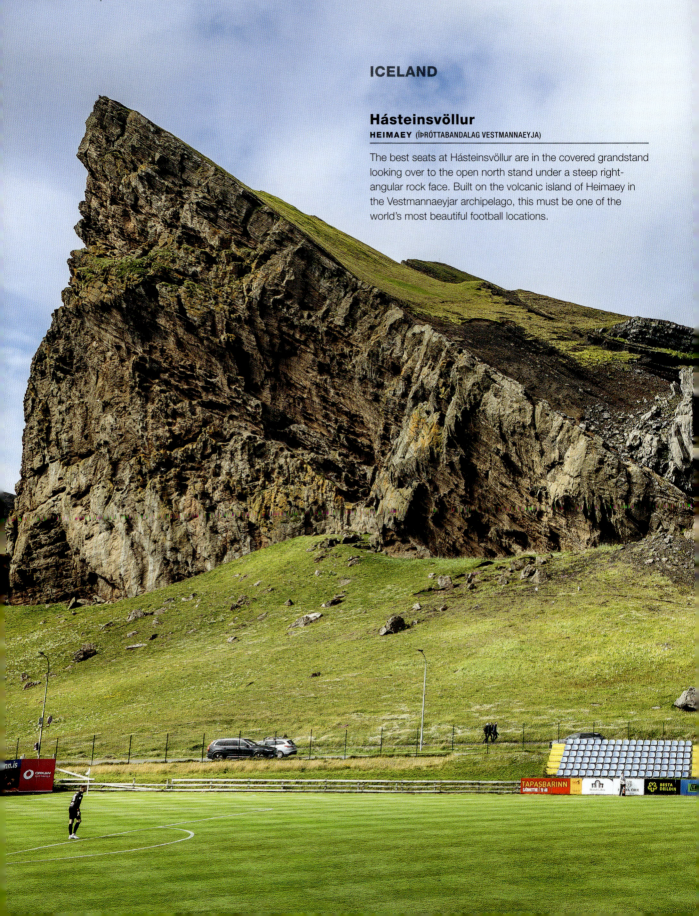

Europe / **Iceland**

Akranesvöllur
AKRANES (ÍA AKRANES)

Akranesvöllur is the oldest stadium in Iceland and, because of the relative unchanging nature of the environment and the ground, you can watch a match and imagine stepping back in time to 1935 when it was built. The most authentic experience comes sitting on the grass terrace sloping up from the pitch. Here you can look out to Langisandur beach, Old Akranes Lighthouse, and the North Atlantic Ocean while enjoying the game.

Olafsvikurvöllur
ÓLAFSVÍK (VIKINGUR OLAFSVIK FC)

Ólafsvík's main stand and clubhouse are built into a grass verge leading down from a large rock face. Beside them is a small, white modernist church created entirely of triangles, with its bell tower next to it. With its harborside location and unusual surroundings, this feels like a dreamscape.

↓ Hásteinsvöllur

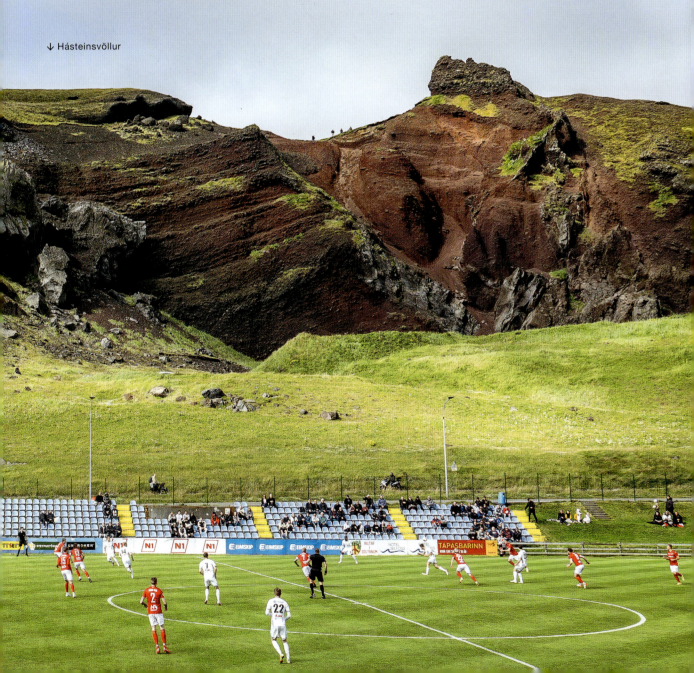

Norway / Europe

NORWAY

Intility Arena
OSLO (VÅLERENGA FOTBALL)

Fans enjoy safe standing terraces behind each goal at Vålerenga Fotball's stadium. Seats are locked into a metal framework that keeps spectators a safe distance from one another and avoids the risk of crowd surges when celebrating a goal. As a result, crowd noise is heightened. When the temperature dips near the end of the season, this freedom of movement helps to relieve cold fingers and toes. The seats are unlocked for European games. An intriguing addition to the stadium is Valle Hovin High School—a secondary school integrated into the west stand.

Vallhall Arena
OSLO (VÅLERENGA FOTBALL)

This indoor arena with an artificial pitch was built so that Vålerenga Fotball could continue to play during the harsh months of snow cover.

Lerkendal Stadion
TRONDHEIM (ROSENBORG BK)

Four main stands—all with three tiers—almost complete Rosenborg BK's 21,423-capacity stadium. A unique addition in 2014 was the Scandic Lerkendal hotel beside the west and south stands, which has a bar on the twentieth floor overlooking the pitch. There is further luxury on the central tiers with VIP boxes, and, for the players, one of the few grass playing surfaces in Norway.

↓ Intility Arena

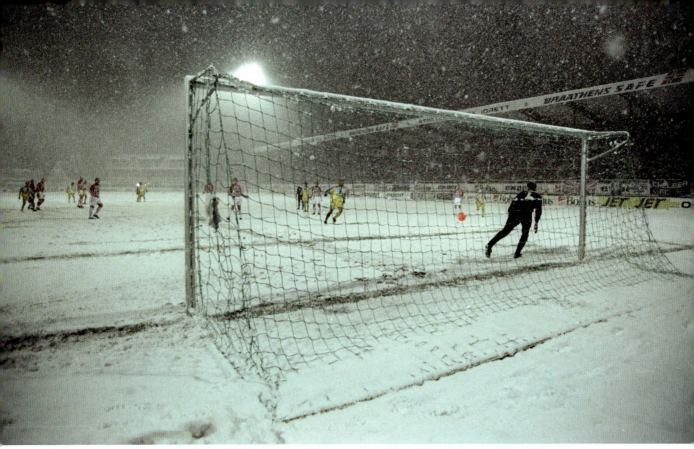

↑ Romssa Arena

Skagerak Arena
SKIEN (ODDS BALLKLUBB)

Founded in 1894, Odds Ballklubb is the oldest club in Norway. They have played at Skagerak Arena (formerly Odd Stadion) for over one hundred years. The stadium was rotated 90 degrees to increase the pitch size. Now the only remaining element of the original stadium is the old main stand, which sits behind one of the goals. Fans have witnessed some great moments at the stadium. Odds Ballklubb has won the Norwegian Cup a joint-record twelve times. They watch a rich brand of football in the Eliteserien, with their team playing on an undersoil-heated artificial turf.

Fosshaugane Campus
SOGNDALSFJØRA (SOGNDAL FOTBALL)

In 2006 Fosshaugane was demolished and completely rebuilt as part of a unique project—the new stadium is connected to and architecturally integrated with a university and school. Now known as Fosshaugane Campus, it is perhaps the only one of its kind in the world. The stadium sits within the small town of Sogndalsfjøra and the entire population could sit within its stands. Fans enjoy a spectacular backdrop of the Sognefjord. Prior to its transformation, the ground witnessed an extraordinary cup run. In 1976 third-tier Sogndal Fotball made it all the way to the Norwegian Cup final, losing 2–1.

Romssa Arena
TROMSØ (TROMSØ IL)

The Romssa Arena (previously Alfheim Stadion) is the most northerly topflight stadium in the world. This is football within the Arctic Circle and the pitch is often covered in snow, making an orange ball a must-have.

Viking Stadion
STAVANGER (VIKING FK)

First built as an all-seater stadium, Viking FK's west stand has now been converted into a safe standing area. This return to a bygone era of watching a match on your feet encourages a more vocal crowd—a standing fan will always sing louder than one sitting in comfort.

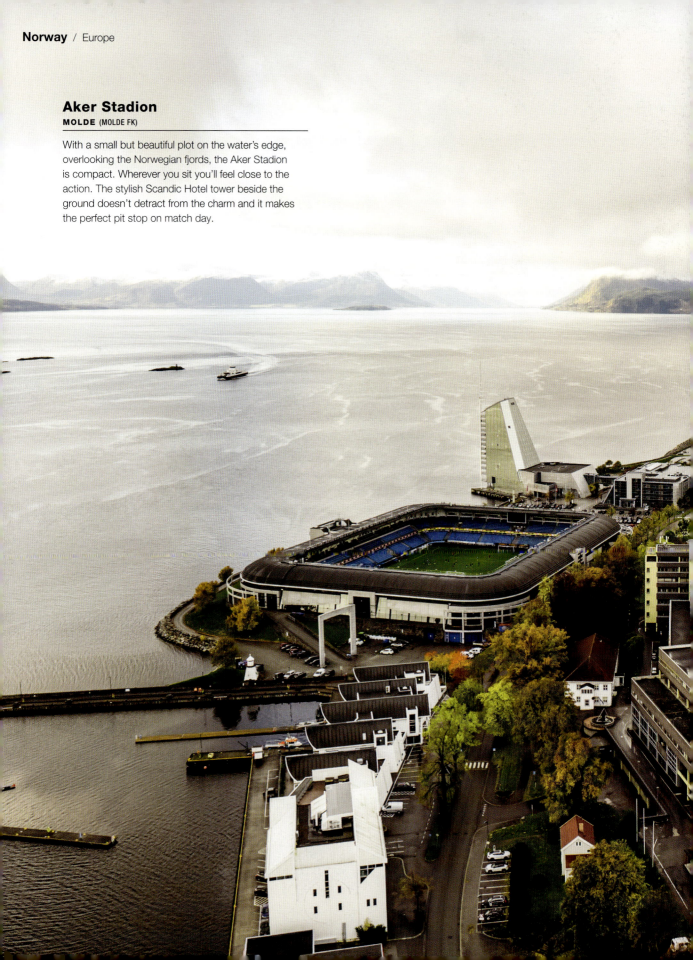

Norway / Europe

Aker Stadion
MOLDE (MOLDE FK)

With a small but beautiful plot on the water's edge, overlooking the Norwegian fjords, the Aker Stadion is compact. Wherever you sit you'll feel close to the action. The stylish Scandic Hotel tower beside the ground doesn't detract from the charm and it makes the perfect pit stop on match day.

Europe / **Norway**

Norway / Europe

↑ Aspmyra Stadion

Aspmyra Stadion
BODØ (FK BODØ / GLIMT / GRAND BODØ)

It is a tradition for fans to arrive at Aspmyra Stadion holding giant toothbrushes. Bodø/Glimt even has its own range of standard-sized brushes sold nationwide. The story goes that, during a match at the Aspmyra in 1975, Arnulf Bendixen, a rather vocal member of the Yellow Horde, became frustrated with the lack of crowd noise. He demanded that someone give him a baton, or something similar, so that he could conduct proceedings and increase the volume. He was handed a toothbrush. A toothbrush salesman happened to be sitting nearby and the following week he brought a number of giant promotional display toothbrushes to the game. The craze has never stopped.

Henningsvær Stadion
HENNINGSVÆR (HENNINGSVÆR IL)

Henningsvær sits on the rocks of Hellandsøya Island off the Norwegian coast and within the Arctic Circle. The ground was built on leveled-out bedrock, surrounded by fish drying racks. It takes an adventure to reach the ground. Traveling through tunnels, across bridges, using infrequent buses, rental cars, then hiking over rocks, through a tiny village of 428 people, past an old caviar factory that's now an art gallery, to within touching distance of the Arctic Sea. Whatever it takes, get there. There is no seating, the smell of the cod stockfish processing plant fills the air, and the crisp Arctic breeze keeps your hands in your pockets. But it's regarded by many as the most beautiful stadium in the world and is a must for lovers of unique footballing experiences.

→ Henningsvær Stadion

Denmark / Europe

DENMARK

Tasiilaq Field
TASIILAQ, GREENLAND (ATA 1960)

With a backdrop of colorful fishermen's cottages, the Qimmeertaajaliip Qaqqartivaa mountains, and Greenland's calm blue waters, there are few more tranquil and scenic places to enjoy the beautiful game.

Qeqertarsuaq Football Pitch
QEQERTARSUAQ, GREENLAND (G-44 QEQERTARSUARMI TIMERSOQATIGIIFFIK)

Imagine watching a game of football only to see a humpback whale appear in the distance beyond the icebergs. This is a reality for fans of G-44 Qeqertarsuarmi timersoqatigiiffik in the Greenlandic Football Championship.

Aalborg Portland Park
AALBORG (AALBORG BOLDSPILKLUB)

Houses with big, long gardens back onto the Aalborg Portland Park. The garden end is the smallest stand in the arena, and just about tall enough to avoid Aalborg Boldspilklub players knocking on doors asking for their ball back. It would have been a long night for residents when the original wooden stadium burned to the ground in 1960. Its modern replacement is a noisy but attractive neighbor.

↓ Qeqertarsuaq Football Pitch

Europe / **Denmark**

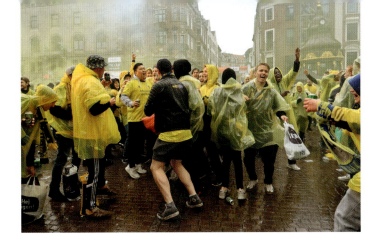
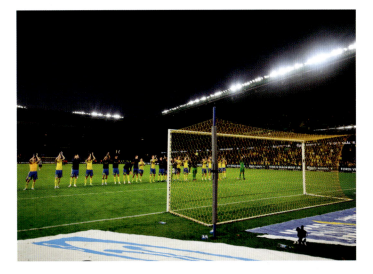

←↙ Brøndby Stadion (Vilfort Park)

Brøndby Stadion
BRØNDBY (BRØNDBY IF)

Known as the Hell in the North, Brøndby Stadion, also known as Vilfort Park, is best experienced during a night game under 1,500 floodlights. For the biggest game in Danish football, take in the Copenhagen derby between home team Brøndby IF and FC Copenhagen. It's seen as the suburbs versus the city. Giant tifos greet the home team. A banner reads "Our heart beats only for Brøndby IF." The show of affection comes alive as the tifosi lift and drop yellow-and-blue banners, forming stripes, in unison to the rhythm of a heartbeat.

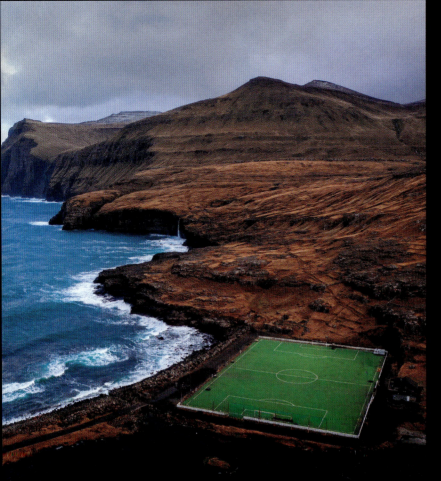
↑ Eiði Stadium

↙ Parken

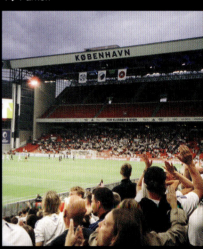

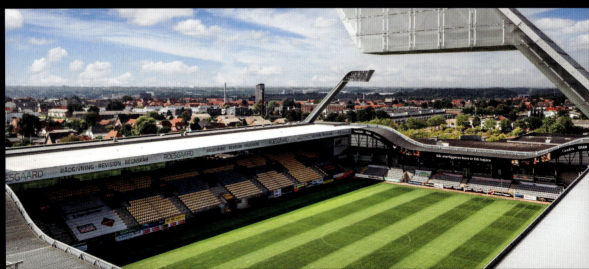
↑ Horsens Idrætspark

Europe / **Denmark/Faroe Islands**

Parken
COPENHAGEN (FC COPENHAGEN / NATIONAL TEAM)

While many stadiums are proud to have anything more than a mobile hot dog cart, imagine having one of the world's best restaurants on-site. Geranium, holder of three Michelin stars, is on the eighth floor at Parken. And so, you can watch FC Copenhagen—Denmark's best team—in the afternoon, and eat the country's best food in the evening.

Frederiksberg I P Opvisning
FREDERIKSBERG (KJØBENHAVNS BOLDKLUB)

Kjøbenhavns Boldklub once played at Parken, the largest stadium in Denmark, and was the country's most successful team, winning fifteen league titles before 1980. Founded in 1876, it is the oldest club in Denmark. In 1991 its professional team merged with Boldklubben 1903 to form FC Copenhagen, now the dominant team in Danish football. Kjøbenhavns Boldklub continued, but now plays in the fifth tier and at a stadium consisting of one stand seating thirty, a clubhouse, and a running track around the pitch.

Horsens Idrætspark
HORSENS (AC HORSENS)

The entire east stand of Horsens' stadium can be retracted, or even removed, to make space for concerts. This makes for an intriguing configuration. The roof of this standing terrace, which is mirrored in the opposite stand, is an undulating brushed metal, like a sheet of dough being turned out of a pasta machine.

Roskilde Idrætspark
ROSKILDE (FOOTBALL CLUB ROSKILDE)

The stadium known as the Eagle's Nest has an area with picnic tables next to the grandstand, a standing terrace, and occasional oil drums in the barren areas—for leaning on or for winter fires. The walkway to the Nest passes two further pitches and a graffiti-covered exterior wall. Postmatch, it's a short walk to the magnificent Roskilde Fjord. It's a raw experience of lower league football.

FAROE ISLANDS

Svangaskarð
TOFTIR, FAROE ISLANDS (TOFTA ÍTRÓTTARFELAG, B68 / NATIONAL TEAM)

Built into a hillside above Toftir, the town's stadium holds six times the local population. Yet fans often pack the steep stands that flow into the rocks, some traveling across the Tangafjørður Sound through the undersea tunnel. The Scottish Tartan Army set up camp on the rocks when they visited, with flags lofted high. And you won't get any closer to the action of an international match than here. You can reach out and touch the goal net. And you can stay here, at the stadium's own hostel.

Tórsvøllur
TÓRSHAVN, FAROE ISLANDS (NATIONAL TEAM)

The national stadium is located within the Gundadalur sports district and is one of three connecting football pitches. The small, compact stadium sits proudly above the rest of the complex with three all-seater stands and a flat, glass-paneled roof. There is a grass-roofed hotel nearby that is worth a stay if not for the potential irony that you'll be watching a match played on artificial turf.

Eiði Stadium
EIÐI, EYSTUROY, FAROE ISLANDS (NATIONAL TEAM)

Located in the middle of the Norwegian Sea on the rocky island of Eysturoy with a population of seven hundred is a rugged, beautiful football field. Fans once embraced the cold winds and crashing waves to watch EB/Streymur play. But then the elements became too much and the team relocated. The stadium is now used as a campsite.

Við Djúpumýrar
KLAKSVÍK, FAROE ISLANDS (KÍ KLAKSVÍK)

The nature of the rugged landscape in Klaksvík creates layers around the stadium: on the south side a road and houses sit above the ground; two covered stands and a clubhouse look over the pitch; the ground is surrounded by hills; and then the layers fall away down to the harbor. In the distance is the monolithic Klakkur Mountain.

Inni í Vika
ARGIR, FAROE ISLANDS (ARGJA BÓLTFELAG)

Wrap up warm as there is little to break the path of the freezing breeze coming across the Havnardalur valley and Sandá River. You can huddle in the single covered stand backing onto a rocky hillside, brave the elements, or even view the pitch from the hillside with vistas over Argir and Tórshavn. Kickoff times are only confirmed three or four days before a match so it's worth checking before you travel.

Sweden / Europe

SWEDEN

Ullevi
GOTHENBURG (IFK GÖTEBORG)

Built for the 1958 World Cup, the Ullevi is now home to IFK Göteborg of the Allsvenskan, and the largest football tournament in the world. The Gothia Cup is a youth competition with over two thousand teams and eighty nations taking part. After five thousand matches played at the Heden fields, the final comes to the Ullevi. Many stars started here—Zlatan Ibrahimović, Andrea Pirlo, Xabi Alonso, and Zé Roberto, to name just a few.

Strandvallen
HÄLLEVIK (MJÄLLBY AIF)

A thick field of trees separates Strandvallen and the crystal-blue waters of Hanö Bay. This picture-perfect location is complemented by a perfect Nordic-style stadium. The exterior is an extension of the buildings surrounding it within Hällevik, the local village. Its terra-cotta frontage and slate-gray roofs hug the pitch.

Strawberry Arena
SOLNA (NATIONAL TEAM / AIK FOTBOLL)

Zlatan Ibrahimović provided a magical moment in the very first game at the Strawberry Arena with an audacious 30-yard (27-m) bicycle kick in a 4–2 win against England. It was the final goal of the game, but Ibrahimović also scored the first at the stadium.

Stockholm Olympic Stadium
STOCKHOLM (DJURGÅRDENS IF [WOMEN] / FC STOCKHOLM INTERNAZIONALE)

From its formation in 2010 until 2018, FC Stockholm Internazionale went on an incredible run of promotions. Together with four in the first four years, they went from Division 7 to Division 2. They outgrew the tree-lined pitch where they won their promotions and moved to the Stockholm Olympic Stadium. They replaced Djurgårdens IF, who had moved into the new Tele2 Arena. The Djurgårdens IF women's team remained and with Internazionale are forging new pages in the history books of this stadium built in 1912.

3Arena
STOCKHOLM (DJURGÅRDENS IF / HAMMARBY IF)

A tifo rigged up to the retractable roof lifts a fierce-looking King Kong holding a dead mouse as he mounts the tower of Stockholm City Hall. As the second half starts, the players on the pitch can no longer be seen as smoke covers the pitch. This is the Tvillingderbyt, Scandinavia's most heated rivalry. Home team Djurgårdens IF and neighbors AIK were both formed in 1891 and are equally successful. The wonderfully named Tvillingderbyt translates as the "Twin Derby."

Tunavallen
ESKILSTUNA (AFC ESKILSTUNA / ESKILSTUNA CITY FK / IFK ESKILSTUNA/ESKILSTUNA UNITED DFF)

As soon as you see it, you can spot the four obvious reasons why Tunavallen is unforgettable—there is a high-rise apartment block in each corner. The capacity is officially 7,800, but it could be argued the apartment blocks (and their residents) are a part of the stadium. Residents of the top floors have a bird's-eye view of the pitch and views across historic Eskilstuna and its river.

Eleda Stadion
MALMÖ (MALMÖ FF)

When Malmö FF decided to build a new stadium in the space occupied by their parking lot, fourth-tier IFK Malmö moved into the empty stadium. Malmö FF's new home is improved, but one of Sweden's biggest clubs now has a smaller capacity stadium than the less successful team next door. The Malmö teams are now the closest footballing neighbors in the world, taking over from Dundee and Dundee United, at just 185 yards (170 m) apart.

Malmö Stadion
MALMÖ (IFK MALMÖ)

IFK Malmö was once great rivals of Malmö FF, the team whose old stadium they moved into in 2009. Formed in 1899 and one of Sweden's oldest clubs, they share a page in the World Cup archives with their new stadium. At the 1958 World Cup, Germany and Argentina played a group match at the Malmö Stadion. There was a clash of shirts. Argentina had no alternative kit and Germany refused to change strip. And so, Argentina borrowed the yellow shirts of the local team that finished runners-up in the league two years later. The team was IFK Malmö.

Europe / **Sweden**

Borås Arena
BORÅS (IF ELFSBORG)

The Borås Arena is unique for two very different reasons. The ground was built using funding from its own investment company—a shrewd move. The stadium it replaced still sits next door and, what's more, they are connected. They share a roof. The south stand of the old stadium is fused with the north stand of the new. To top it off, both stadiums have wonderful views of the surrounding hills. Crowds are a vibrant sea of yellow when Elfsborg are playing.

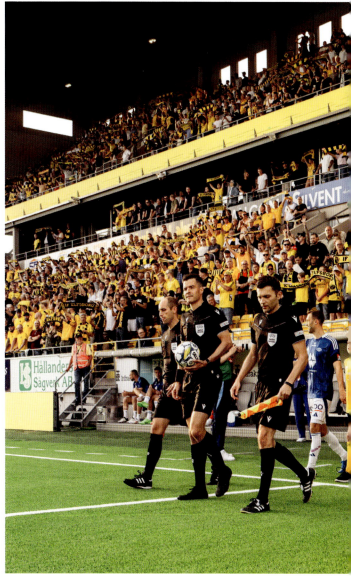

↖↑ Borås Arena

Estonia / Europe

ESTONIA

Pärnu Rannastaadion
PÄRNU (PÄRNU JK VAPRUS / PÄRNU JALGPALLIKLUBI)

Pärnu Rannastaadion has its own beach, hotel, spa, gym, athletics track, and a football pitch that hosts topflight Estonian football. The old stadium was demolished, rebuilt, and reopened in 2016. The new main stand is where all the magic happens. Players, supporters, and tourists all use the same building without ever crossing paths. This marvel of functional architecture is constructed from white concrete and pale timber. The stand's roof is a wooden cantilever with clean, angled lines. Match days are a relatively peaceful, harmonious experience, with the breeze from Pärnu Bay adding to the sense of calm.

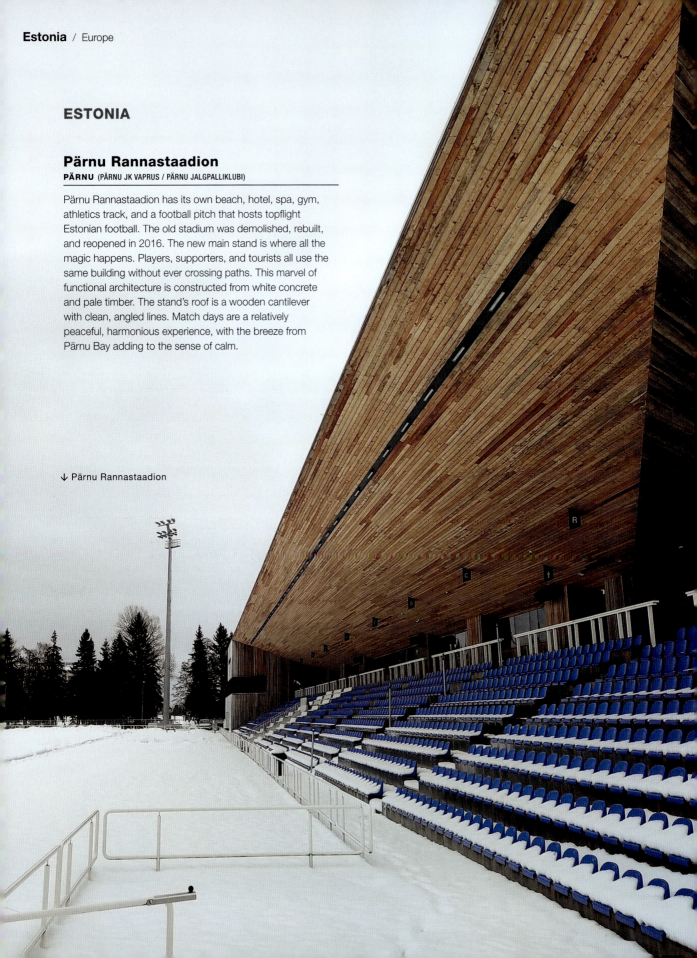

↓ Pärnu Rannastaadion

Europe / **Lithuania/Poland**

LITHUANIA

Darius and Girėnas Stadium
KAUNAS (NATIONAL TEAM / FK KAUNO ŽALGIRIS)

The stadium is named after the Lithuanian pilots Steponas Darius and Stasys Girėnas, who died during a nonstop flight from New York to Lithuania in 1933. It was reconstructed in 2022, increasing its capacity to enable it to host international matches.

POLAND

Stadion im. Czesława Kobusa
BYDGOSZCZ (CHEMIK BYDGOSZCZ)

A match here is an experience of, incredibly, fifth division Polish football. The attention of a group of armed police is focused on a penned-in group of ultras, here to watch their team Chemik Bydgoszcz. The stadium holds fifteen thousand, but you'll find yourself with plenty of space to enjoy the match, with the flares, banners, and noise coming from the pen.

Polsat Plus Arena Gdańsk
GDAŃSK (LECHIA GDAŃSK)

Rainbow colors can often be seen shining from the roof of Polsat Plus Arena Gdańsk and into the night sky, promoting Lechia Gdańsk's commitment to diversity. The stadium's roof is made up of a collection of small, clear panels. Lights shining upward from the stands illuminate the roof in myriad colors that can change to celebrate a specific event or anniversary.

Stadion im. mjr. Mieczysława Słabego
PRZEMYŚL (CZUWAJ PRZEMYŚL)

It would be hard to find a more alluring place to watch the beautiful game. Stadion Czuwaj is located on the banks of the San River close to the Old Town of Przemyśl, itself designated a national monument. The stadium is blessed with an original 1932 pavilion clubhouse where you can watch Czuwaj Przemyśl from the balcony. It is built from wood in the traditional Zakopane style of the Carpathian Mountains, based on Swiss and Austro-Hungarian-style chalets.

Stadion Wojska Polskiego
WARSZAWA (LEGIA WARSZAWA)

The Legia tifosi are creative. One of their best displays has to be their Legioland tifo. The giant banner showed three Lego figures, one in a Legia jersey, one masked, and one holding aloft a red flare; in the background there's a sea of red flares. A large section of the stadium's 1930 facade remains following the complete reconstruction of the stadium in 2011. The original ground was owned by the Polish army and it's still named for them.

Tarczyński Arena Wrocław
WROCŁAW (ŚLĄSK WROCŁAW)

As you step inside this stadium, built for the 2012 European Championship, you are met with the unusual sight of single-tiered curved stands. The entire setup is monumental. Stadion Wrocław sits on top of a large podium under which fans enter. When illuminated at night, it stands out like a paper lampshade.

Stadion Jagiellonii Białystok
BIAŁYSTOK (JAGIELLONIA BIAŁYSTOK)

A large, single-tier stand behind the home goal is a perfect canvas for the tifosi. A mean-looking Mexican cactus wearing a sombrero, holding a megaphone, surrounded by a sea of yellow and red with a banner inscribed "Los Ultras Hermanos" was a celebration of the Mexican wave performed by the Jagiellonia ultras in the 1980s. When the team swept to their first Ekstraklasa title in 2023–24, the light show outside the arena was phenomenal.

Zagłębiowski Park Sportowy
SOSNOWIEC (ZAGŁĘBIE SOSNOWIEC SSA)

A wondrous wooden facade—a series of thin, vertical larch wood slats—encircles the exterior, mimicking Sosnowiec's historic pine forests. Like the stadium of Chengdu Rongcheng in China, the arena looks like a gaiwan tea set from a Sichuan tea ceremony; it sits like a cup, saucer, and lid on an undulating platform alongside two smaller sporting arenas. When the snow arrives, this spell is broken, and the stadium displays its raw beauty.

Poland / Europe

↓ Kazimierz Górski National Stadium

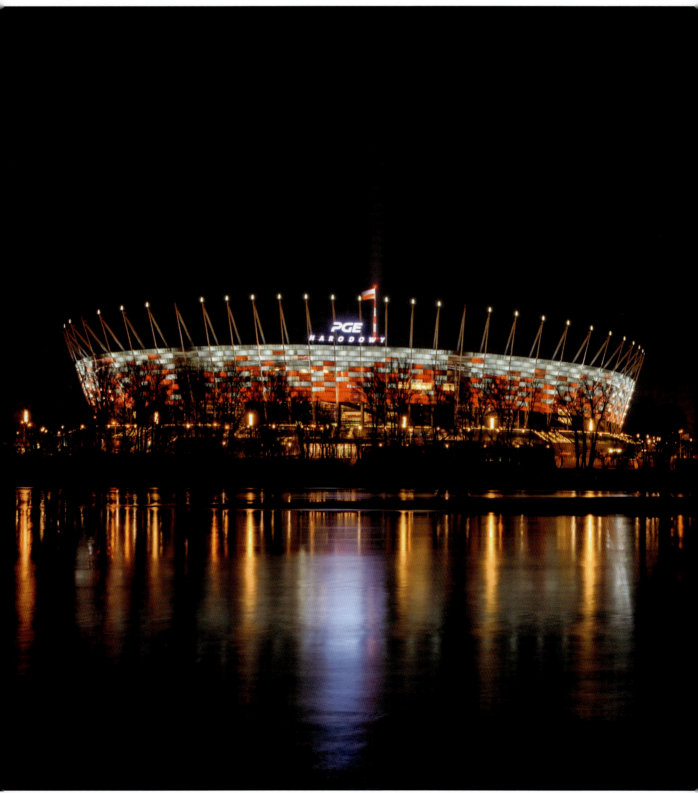

Europe / **Poland**

Kazimierz Górski National Stadium
WARSAW (NATIONAL TEAM)

The illuminated facade of the Kazimierz Górski lights up the banks of the Vistula River at night. Structural roof supports extend into the sky and span the stadium. At the center of the retractable roof, inspired by the home of Eintracht Frankfurt, is a large flagpole flying the Polish colors. The largest stadium in the country is a proud host of the national team. Fittingly, record scorer Robert Lewandowski scored the first international goal at the venue during Euro 2012 when it was a host stadium.

Stadion RKS Marymont
WARSAW (MARYMONT WARSZAWA)

The concrete terraces of this example of postwar modernist architecture have been taken over by lichen. Graffiti covers every inch of the corridors within the grandstand and its surrounding walls. It looked inevitable that it would be demolished, but then the grandstand was awarded protected status. It is now undergoing renovation and being returned to its former glory.

Stadion im. Ernesta Pohla
ZABRZE (GÓRNIK ZABRZE)

When it opened in 1934, the stadium was named after the leader of the Nazi Party. Its dark past was confined to history when the old stadium was demolished in 2011 and a new one built, honoring the team's greatest player, Ernest Pohl. Fans had to wait more than a decade for the stadium, built with only three stands in a C-shape, to be completed.

Poland / Europe

Zimowit Rzeszow Stadion
RZESZOW (ZIMOWIT RZESZOW)

The pitch used by the Stal Rzeszów and Resovia teams has two small stands (a former bus stop and a former bandstand). The viewing figures for a match could be anything from twenty to a thousand, depending on who is looking out of their window in the two apartment blocks that overlook it.

Opole Stadium
OPOLE (ODRA OPOLE)

This venue moved from a picturesque stadium surrounded by trees and a redbrick water tower to a newly constructed stadium with photovoltaic roofs, heat pumps, and other elements designed to run it using green energy.

Stadion Poznań
POZNAŃ (KKS LECH POZNAŃ)

This stadium is a white dome that turns blue at night, an ode to home side Lech Poznań. A clear landmark on the city's skyline, this is where the famous Poznań celebration was born. It has been adopted by the likes of Manchester City and more. This tribal dance sees fans turn their backs to the pitch and bounce up and down arm in arm. It is a victory ritual, reserved for the final minutes of joyous occasions.

Stadion Wielofunkcyjny OSIR w Łowiczu
ŁOWICZU (MUKS PELIKAN ŁOWICZ)

This ground offers something unusual—a mural of an idyllic rural scene with three children picking flowers and playing with butterflies is

SOSiR Stadium
SŁUBICE (POLONIA SŁUBICE)

When building started at the outbreak of World War I, the stadium was located in Germany and the workers were Russian prisoners of war. It took thirteen years to complete and remains one of Poland's oldest stadiums. Following extensive renovations in 2013, the imperious main stand remains. You can cheer on Polonia Słubice from within its stone archways.

Stadion Promienia Opalenica
OPALENICA (KS PROMIEŃ OPALENICA)

The large thatched-roofed Hotel Remes sits behind the single main west stand. It makes for an incredible spectacle when viewed from the east. The stadium was the training venue of the Portuguese team at Euro 2012. People often ask to stay in the hotel room that Cristiano Ronaldo stayed in.

Stadion Orzel Kozy
GMINA KOZY (ORZEL KOZY)

Concrete seating is carved from the rocky bank at the side of the pitch at Orzel Kozy. Plastic seating sits at the top of a tapering bank of grass, while a small bridge leads to a traditional terra-cotta-roofed clubhouse.

Spodek Arena
KATOWICE (SPODEK SUPER CUP)

There have been some notable flying-saucer-style stadiums in recent years: Zenit's Krestovsky Stadium in Russia and the Toyota Stadium in Japan are two. The original and still the best is Spodek Arena in Katowice.

Stadion Cracovii im. Józefa Piłsudskiego
KRAKÓW (KS CRACOVIA / PUSZCZA NIEPOŁOMICE)

The first "Holy War" derby between Cracovia and Wisła Kraków was played at Błonia Park in 1908, and tensions have been ramping up ever since. Błonia Park now sits between the clubs' stadiums in one of the closest and fiercest rivalries in world football. Cracovia's stadium was completely rebuilt in 2010 and has an intriguing facade. While being sympathetic to the socialist-style brutalist buildings that surround it in the heart of Kraków, it is elevated by its ceramic envelope and steel roof beams supported by steel columns left visible from the exterior.

Stadion Miejski im. Henryka Reymana
KRAKÓW (LKS POGON LEBORK)

One half of the "Holy War" between Cracovia and Wisła Kraków once had Acropolis-style structures behind both goals, but has since been rebuilt, with the construction's underbelly appearing completely visible. Rarely has there been such a contrast between demolished and reimagined as at Wisła Kraków's Stadion Miejski ground. When the neighbors meet, the stadium becomes a sea of flags that are used as cover to enable fans to let off flares. A barrage of banging drums never stops. The stands appear on fire as masked ultras, stripped to their underwear and trying to avoid detection and lifetime bans, reemerge in the safety of the swaths of smoke.

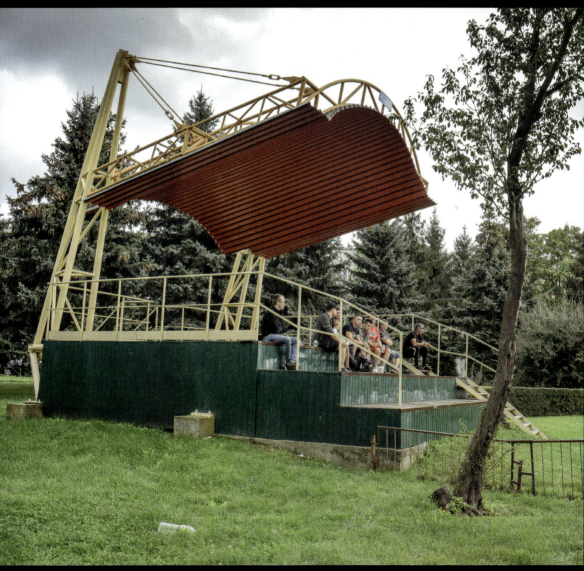

↑ Zimowit Rzeszow Stadion

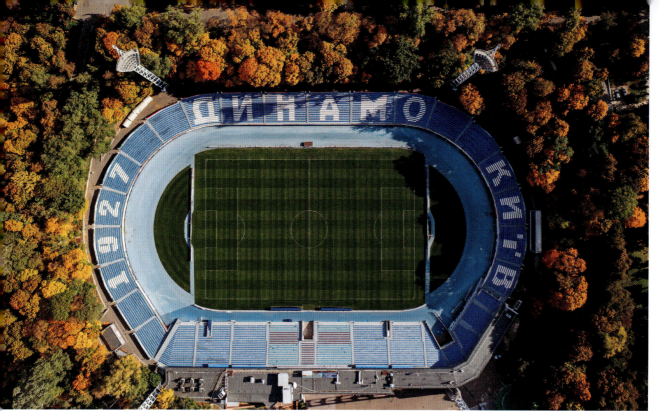

↑ Valeriy Lobanovskyi Dynamo Stadium

BELARUS

Borisov Arena
BARYSAW (FC BATE BORISOV)

The home of Belarusian Premier League team FO BATE Borisov is shaped like a curled snake and known as the Anaconda. Its metal facade and large, irregular, rounded windows mimic the serpent's skin.

UKRAINE

Olimpiyskiy National Sports Complex
KYIV (NATIONAL TEAM / FC DYNAMO KYIV / FC SHAKHTAR DONETSK)

Extensive reconstruction projects through the years give this stadium a paradoxical question: Like the Ship of Theseus, which had all its parts replaced over time, is it the same stadium? The stands were once enveloped in thick privy hedges, with an Acropolis-style entrance. They are now covered with a cylindrical roof membrane with 640 skylights, raised like pretensioned wheel spokes to cope with the heavy Ukrainian snow.

Valeriy Lobanovskyi Dynamo Stadium
KYIV (FC DYNAMO KYIV / FC OLIMPIK DONETSK)

The Valeriy Lobanovskyi Dynamo Stadium, built in 1933, rests among the trees beside the Dnipro River, with only its floodlight towers visible until you reach its walls. It is the spiritual home of Dynamo Kyiv and still its official home, away from the bigger NSC Olimpiyskiy. The Ukraine national team also uses the stadium, a safe haven when a smaller capacity is beneficial.

GEORGIA

Boris Paitchadze Dinamo Arena
TBILISI (FC DINAMO TBILISI)

The Dinamo Arena can be an intimidating yet captivating place to visit. The huge stadium is rarely full, so you can find a spot where you can simply soak up the atmosphere. A small section of the north stand behind the goal is controlled by the Elita ultras: Do not try to enter Sector 17; no other supporters or visitors are allowed in.

Europe / **Georgia/Russia**

Adjarabet Arena
BATUMI (FC DINAMO BATUMI)

The Adjarabet Arena is encased in an architectural membrane, the molded contours of which take their inspiration from the Georgian national dance, the *Khorumi*. The dance performed by Georgian warriors starts with a tight, orderly, rhythmic march that leads to a concertina effect as each warrior pulls away in sequence. The roof and facade reference this movement perfectly. At night the membrane allows the stadium to light up in varying colors, and the design really shows what it can do.

Kvarlis Tsentraluri Stadioni
KVARELI (KVARELI DURUJI FC)

In one of the most unusual stadiums in the world, Kvareli Duruji FC plays within the courtyard of a seventeenth-century fortress. In 1755, the fortress was involved in repelling an attack by twenty thousand Avars at the Battle of Kvareli. Now it hosts fifth-tier Georgian football and repels attacking fullbacks. Spectators can view the pitch from the fortress's wooden balconies, ladders propped against the walls, a smattering of plastic chairs, or a makeshift stand for no more than five or six. For the rest it is standing room only around the edge of the pitch, where the turf meets the fortress walls.

RUSSIA

Rostov Arena
ROSTOV-ON-DON (FC ROSTOV)

When nighttime comes, the Rostov Arena comes alive. Fans are treated to spectacular light displays. The membrane roof and perforated metal facade allow light to seep through the entire exterior. The undulating roof mirrors the flow of the Don River, which runs beside the stadium.

Nizhny Novgorod Stadium
NIZHNY NOVGOROD (FC PARI NIZHNY NOVGOROD)

For centuries the Nizhny Novgorod Kremlin fortress stood alone on the banks of the Volga and Oka Rivers, creating a golden hue when it was lit up at night. Not many stadiums could compete with its magnificence, but the home of FC Pari NN certainly does. Built for the 2018 World Cup, it has a distinctive surround of thin vertical white supports encasing a blue and white diamond-paneled central structure. The roof is a mosaic of pale blue, mid-blue, and white. At night it shines a bright azure that complements, but doesn't quite overpower, the fortress.

↓ Nizhny Novgorod Stadium

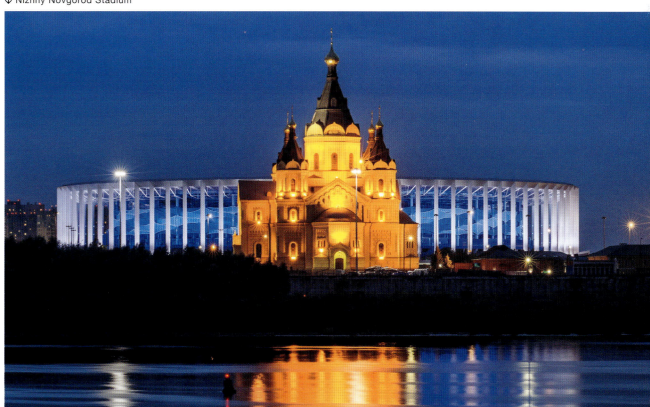

Russia / Europe

Krasnodar Stadium
KRASNODAR (FC KRASNODAR)

The Krasnodar looks like an ancient amphitheater. It sits on a plinth, with the surrounding architectural landscape falling away beneath it. It's a dream for drone shots. Viewed from above, the whole venue really pops with the spirals and vertical lines of the surrounding gardens continuing far beyond the stadium.

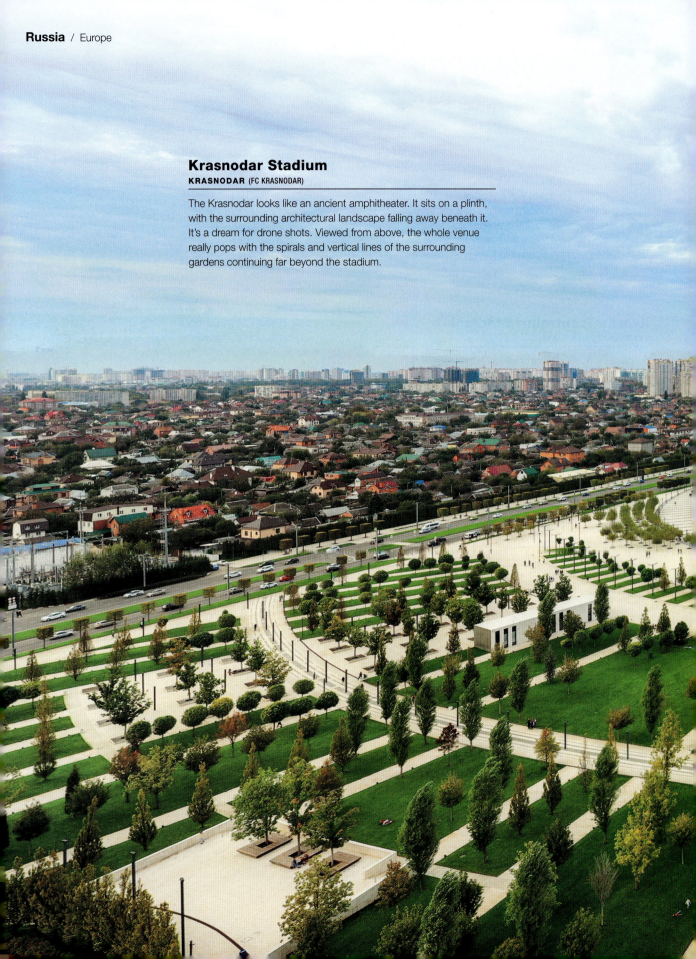

Europe / **Russia**

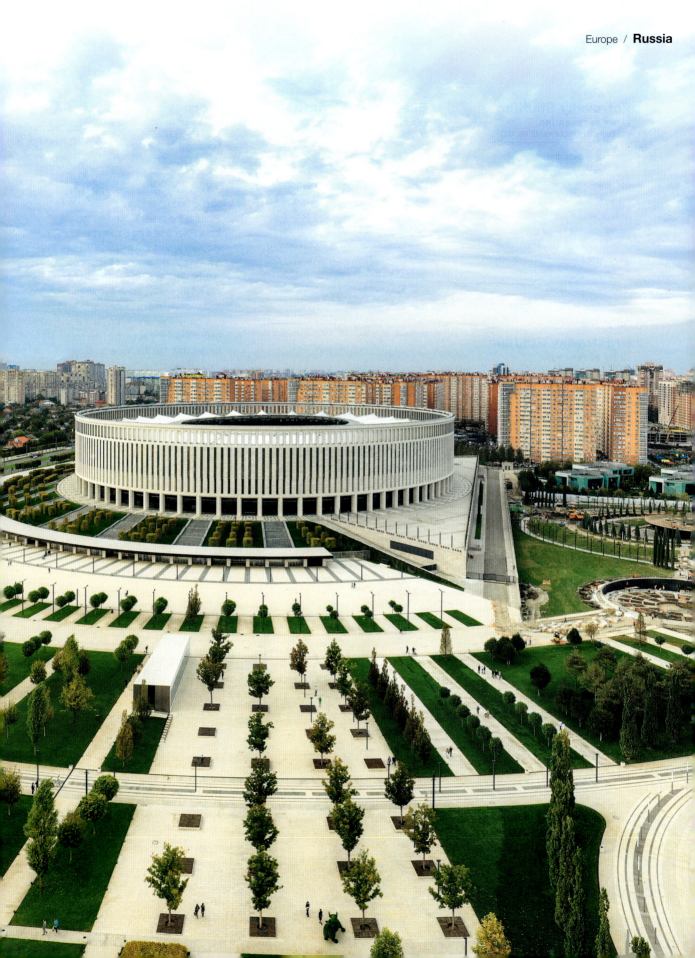

Russia/Moldova / Europe

Petrovsky Stadium
SAINT PETERSBURG
(FC LENINGRADETS LENINGRAD OBLAST)

Russia's oldest stadium, built in 1925, is completely surrounded by water. It sits alone on its own patch of land linked to Petrovsky Island by a thin strip of land. From any viewpoint it is an amazing sight. And that's before even taking in the stadium itself, which is a perfect embodiment of a Russian arena, with its rhythmic pillars encasing an inner open bowl.

Krestovsky Stadium
SAINT PETERSBURG
(FC ZENIT)

When it was announced that a stadium would be built in Saint Petersburg for the 2018 World Cup, it was decided the site of Zenit's historic stadium, which had been demolished ten years earlier, would be used. The design was put out to tender and Kisho Kurokawa's the Spaceship was chosen. It doesn't disappoint. The design is a larger version of Kurokawa's Toyota Stadium but with a retractable roof. Both look like giant flying saucers.

Volgograd Arena
VOLGOGRAD (FC ROTOR VOLGOGRAD)

The Motherland Calls statue, once the tallest freestanding sculpture in the world, looks down on the Volgograd Arena, while the Volga River flows beside it. FC Rotor Volgograd's old home was demolished to make way for this brand-new arena for the 2018 World Cup, which has an impressive exterior of overlapping metal rods, resembling a bird's nest or a ball of rubber bands.

Ekaterinburg Arena
YEKATERINBURG
(FC URAL YEKATERINBURG)

The Ekaterinburg Arena is home to FC Ural Yekaterinburg, the oldest club in Russian football (founded in 1930), and is layered in history. When renovations were required to host World Cup matches in 2018, the original neoclassical facade (a monument to Joseph Stalin) was preserved, and a large colander-like structure added on top. Still unable to accommodate the required thirty-five thousand fans, two huge temporary stands were added— outside the stadium, with spectators looking in through a huge void.

Meshchersky Park
MOSCOW (MULTIPLE TEAMS)

Known as the Forest Pitch, Meshchersky Park is surrounded by thousands of evergreen trees and yet is just twenty minutes from the center of Moscow.

Luzhniki Stadium
MOSCOW (FC TORPEDO MOSCOW)

One of the largest stadiums in Europe, the Luzhniki is an imposing sight. It sits on the flood meadows of the Moskva River giving the stadium its name— *luzhniki* means "meadow" in Russian. The coliseum-like Stalinist-style arena, with its lavish domed roof, hosted the final of the 2018 World Cup.

Mordovia Arena
SARANSK (FC MORDOVIA SARANSK)

Following its use during the 2018 World Cup, three successive FC Mordovia Saransk teams played at the stadium before dissolving. As fans pulled up in shared taxis, walked through the streets, or navigated the Isnar River that runs beside the stadium to watch a match, they saw a huge symbol of their Mordovian culture. The towering 164-foot-high (50-m) monolith sits on a platform and is covered in a mosaic facade of orange, yellow, and white panels to depict the rising sun. The fans no longer visit, but the hope continues they will return.

MOLDOVA

Sheriff Arena
TIRASPOL (FC SHERIFF TIRASPOL)

The style of this stadium is a hard one to pin down. It looks like a cross between a large built-up hotel complex and a birthday cake with candles. The white candles support a blue cantilevered roof. A tower at the entrance gate is topped with a large gold sheriff badge, leaving no doubt about the stadium name and Tiraspol team, FC Sheriff.

→ Meshchersky Park

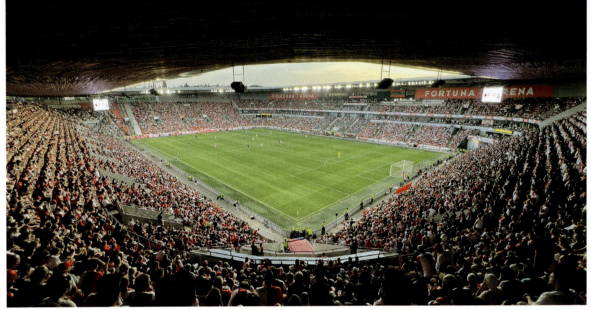
↑ Fortuna Arena

CZECHIA

Na Stínadlech
TEPLICE (FK TEPLICE)

To improve sight lines, and as an alternative to curved stands, the main stands of FK Teplice's stadium have a natural break in their middle, with each half angled toward the pitch. There is little of the north stand, giving the overall look of a crooked horseshoe. Ironically the best views are from the south stand, where you can watch a match, FK Teplice beer in hand, with a clear sight of the Bohemian Central Highlands.

Stadion u Nisy
LIBEREC (FC SLOVAN LIBEREC)

Located in the historic town of Liberec, this stadium is named after the Nisa River, which flows behind the north stand. The main pitch and neighboring training pitches blend in with their tree-filled surroundings, making this a beautiful setting to watch football. But when a new grandstand was added following Slovan's promotion to the top flight in 1993, it had to be embedded into the rock face that runs along the south side of the ground.

Andrův Stadion
OLOMOUC (SK SIGMA OLOMOUC)

Andrův Stadion's north stand has a distinctive, steep, arched structure. The stand opposite has a similar arc, but with large integrated VIP facilities towering above. When the stadium first opened in 1940, it had one large stand and open terraces housing twenty thousand spectators. During World War II it was used to house German ammunition, which the occupying force blew up at the end of hostilities, damaging the stadium. If you're planning to see Czechia play, check the venue—Andrův Stadion hosts their matches when a smaller crowd is expected, making a trip to Prague unnecessary.

epet ARENA
PRAGUE (AC SPARTA PRAGUE)

The home of Sparta Prague ranks high on the size-to-noise scale. Despite a modest capacity of just under twenty thousand spectators, it becomes a blinding cauldron of noise, not least during the fierce derby against rivals Slavia. The walls on the side of this stadium, also known as Letná Stadium, welcome visitors with murals of hooded figures in Sparta colors.

Ďolíček Stadium
PRAGUE (BOHEMIANS PRAGUE 1905)

Imagine opening your front door and seeing a football stadium in front of you. And not just the outer wall, but faces in the crowd in the opposite stand watching a football match. This is the case for residents of Sportovni Road. The stadium is so close that the east side has only a handful of seats and the south can't be built on at all. From any distance, a traditional baroque apartment block looks like the fourth stand.

Fortuna Arena
PRAGUE (SK SLAVIA PRAGUE)

North stand sectors 106–110 are dedicated to the Slavia ultras. Here there is little need for seats as smoke bombs are let off and flares fired toward the pitch. The wooden ceiling to the oval roof looks in danger of being set alight. Meanwhile charcuterie and champagne are served in a VIP skybox as a Slavia Prague historic highlights reel plays on a 50-inch (127-cm) plasma screen on the wall. The Fortuna hosted the 2023 Europa Conference League final.

Europe / **Slovakia**

↓ TJ Tatran Čierny Balog Stadium

SLOVAKIA

TJ Tatran Čierny Balog Stadium
ČIERNY BALOG (TJ TATRAN CIERNY BALOG)

For a unique football experience, nothing beats a match at TJ Tatran Čierny Balog Stadium. The Čierny Hron Railway cuts right through the ground and from time to time a twentieth-century steam locomotive passes between the main stand and the pitch. Then, the action takes a back seat as fans applaud the passing train.

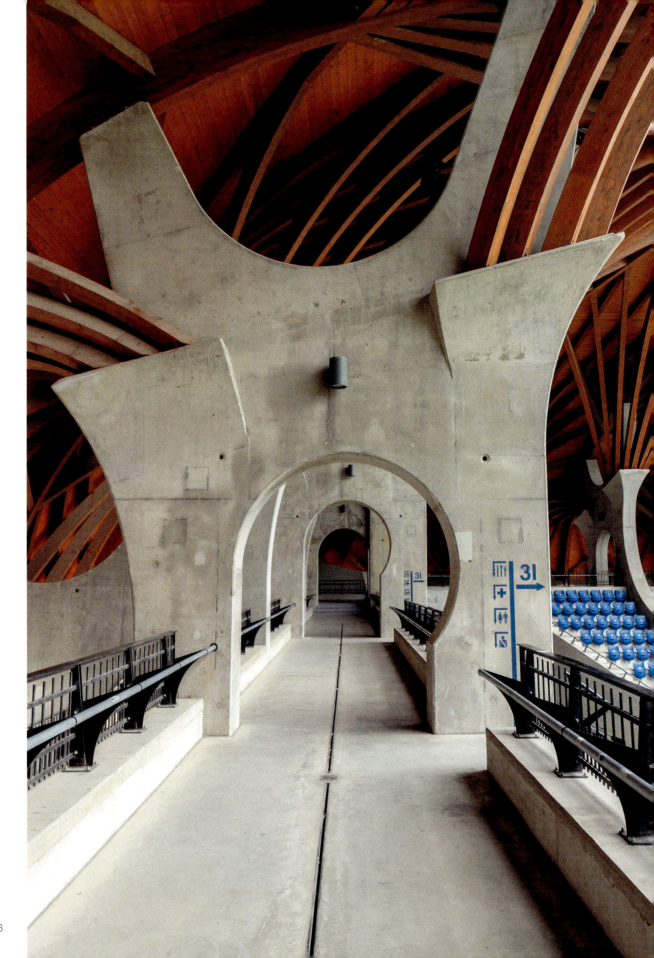

Europe / **Hungary**

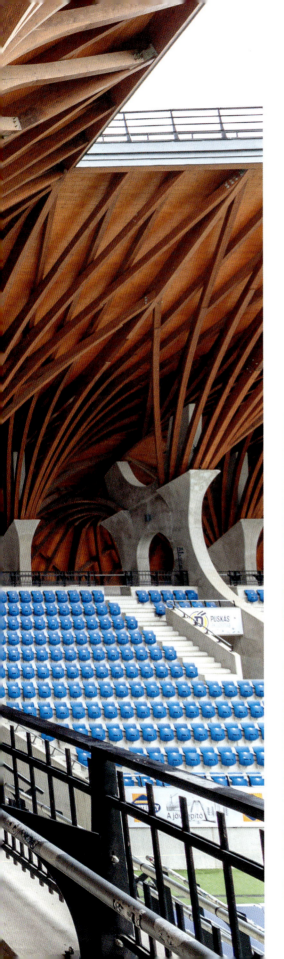

HUNGARY

Pancho Aréna
FELCSÚT (PUSKÁS AKADÉMIA FC)

When fans say they are going to church on a footballing Sunday, visitors to the Pancho Aréna mean it almost literally. Like many churches, the interior has a cantilevered, carved-wood roof supported by columns. This structure curves 43 feet (13 m) above the Puskás Akadémia FC fans, holding up a medieval-style roof that undulates like a thatched roof yet is made from slate tiles. The design is a protest against the Communist brutalist architecture that came before. The stadium uses the nickname given to Hungary's greatest ever player, Ferenc Puskás, by Real Madrid fans.

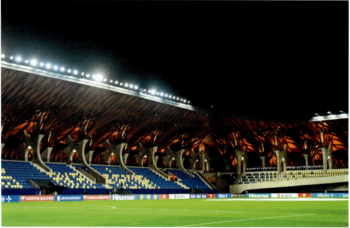

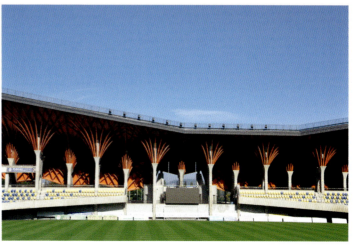

Hungary/Romania / Europe

Puskás Aréna
BUDAPEST (NATIONAL TEAM)

The arena named after Hungary's greatest player, Ferenc Puskás of the Magnificent Magyars era, is a go-to choice for major finals. It has modern facilities, transport links, a great atmosphere with the stands close to the pitch, and a bowl-shaped roof. It hosted games for Euro 2020 and the 2023 Europa League final, and will host the 2026 Champions League final.

Bozsik Aréna
BUDAPEST (BUDAPEST HONVÉD FC)

A golden lion leaping from its plinth greets you on the walkway to the stadium. It's only a matter of time before its foot gets rubbed away to bare metal, so get there fast to see it in its full unadulterated glory. The same sculptor, Gabor Miklós Szöke, created the Falcon outside the Mercedes-Benz Stadium, where Atlanta Falcons play.

ROMANIA

Cacica Salt Mine
CACICA (MUTIPLE TEAMS)

It's almost impossible to watch a game at the Cacica pitch—it's part of an underground village built for salt miners. The recreational facilities include a football pitch built 164 feet (50 m) belowground in a large, carved-out rectangular cave. The stadium has no room for fans as the pitch is flush with the walls. But if you have the chance to visit, the cave is a constant temperature of 53°F (12°C) and the air has a fresh, healthy, mineral quality to it. Together with the echoes reverberating from the salt-encrusted walls and ceiling, this is an incredible place for a game of football.

↓ Puskás Aréna

Europe / **Romania/Slovenia**

Sepsi Arena
SFÂNTU GHEORGHE (SEPSI OSK SFÂNTU GHEORGHE)

Sepsi OSK Sfântu Gheorghe's stadium has a unique facade and roof structure—the roof is in the style of traditional slate-tiled houses while the entrance resembles a Buddhist temple.

Arena Națională
BUCHAREST (FCSB)

With a stunning exterior like a birthday cake, Romania's national stadium has a retractable roof. And there's no excuse for missing the score or replays—a central pod that hangs above the center of the pitch informs fans of everything they need to know.

SLOVENIA

Stadion Pod Obzidjem
PIRAN (NK PORTOROZ PIRAN)

This stadium, perched on the edge of a rock face, has only a line of trees to prevent a wayward ball from finding its way into the Adriatic Sea below. The ground sits below one of Piran's ancient fortress walls, which once protected the town. Stadion Pod Obzidjem translates as "the stadium below the wall."

↓ Stadion Pod Obzidjem

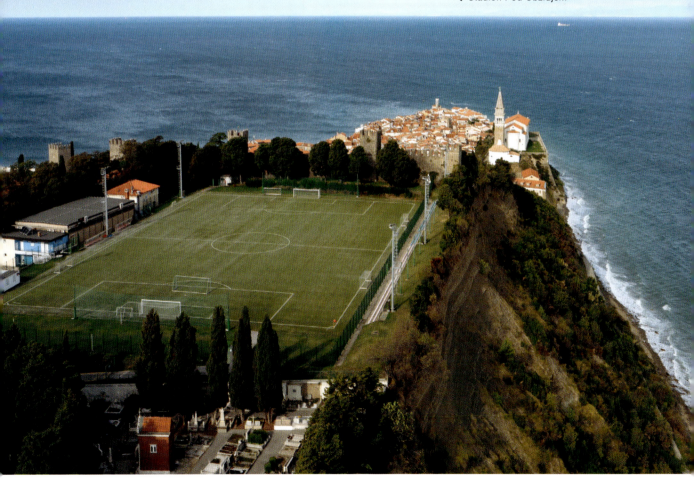

↑↗ Marakana

BOSNIA AND HERZEGOVINA

Stadion Grbavica
SARAJEVO (FK ŽELJEZNIČAR SARAJEVO / NATIONAL TEAM)

Half the stadium used by FK Željezničar Sarajevo and the Bosnia and Herzegovina team has modern seating with a roof covering, and the other half is underdeveloped, allowing large fir trees to grow there.

Koševo Stadium
SARAJEVO (FK SARAJEVO)

The stadium was built into a rock face and sits within a shallow bowl surrounded by hillside on one side and housing on the other. It was the site of the Opening Ceremony of the 1984 Winter Olympics, and the cauldron still sits on a plinth behind the east stand. Although known by many as the Olympic Stadium, fans of FK Sarajevo know it as Stadion Asim Ferhatović - Hase after their greatest player.

Stadion Rođeni
MOSTAR (FK VELEŽ MOSTAR / ŽF / NK EMINA MOSTAR)

It would be hard to find a more idyllic location than this—a stadium built on the edge of farmland, beside the Neretva River, and with a backdrop of the green Vodice mountain range. The Red Army Mostar brings the fire in the form of red flares, and a fire engine parks close by during matches.

Europe / **Serbia**

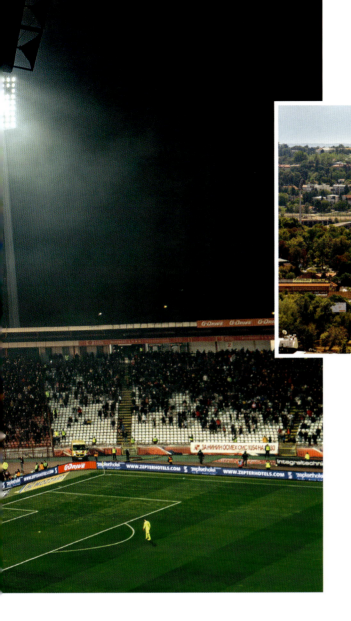

Marakana
BELGRADE (FK CRVENA ZVEZDA)

The Marakana—Rajko Mitić Stadium, previously known as Stadion Crvene Zvezde—is a cauldron of red heat. An open bowl of intense and hostile noise, support here wins games as visitors cower under the gaze of the most successful football club in Serbian history. The Red Star is an icon known and feared by many during years of triumph, and even had a visit to the summit of European football with a penalty shoot-out win against Marseille to lift the 1991 European Cup.

Stadion Partizan
BELGRADE (FK PARTIZAN)

When Partizan Belgrade won the Serbian cup and Super Liga double in 2017, the tifosi created an incredible choreographed display of pyrotechnics in a "Ring of Fire" around the entire stadium. This exemplified a long-standing tradition of ferocious support at "The Temple of Football" over fifty years in the making. The Grobari—the Gravediggers or the Undertakers—are legendary. To see them in the Grobari Jug, their south stand, is both awe-inspiring and terrifying in equal measure.

Stadion Dubočica
LESKOVAC (GFK DUBOČICA)

GFK Dubočica fans are remarkably close to the pitch here, and in some places the seating area touches it. The golden lattice-style exterior wall encloses the entire stadium, while fans are protected from the elements by a bright, white roof.

SERBIA

Stadion Voždovac
BELGRADE (FK IMT)

Known as Stadion Shopping Center, it is exactly that—a stadium on top of a shopping mall in old town Belgrade. Tickets can be purchased from the mall's information desk. Access is via stairs leading from the underground parking garage. Despite twenty large floodlights and relatively high metal fencing in the voids at the corner of the stands, a ball kicked beyond row Z could certainly find its way into someone's shopping cart on their way to the garage.

Bulgaria/Greece / Europe

BULGARIA

Vasil Levski National Stadium
SOFIA (PFC CSKA SOFIA / NATIONAL TEAM)

The stadium is located within Borisova Gradina Park, and a stroll past the pines and spruces, decorative wooden houses, and Waterlily Lake on the way to a match acts as the quiet before the storm. Especially if you're attending Sofia's version of the Eternal derby—CSKA versus Levski. Expect tifos, ticker tape, firecrackers, and smoke bombs. It's a far cry from Waterlily Lake.

Georgi Asparuhov Stadium
SOFIA (PFC LEVSKI SOFIA)

To say the home of Levski Sofia is a fortress would be an understatement. The team holds the European record for the longest unbeaten run at home: from October 1966 to February 1985. That's eighteen years, four months, and twenty-two days, or 203 consecutive matches. The stadium is named after Georgi Asparuhov, who was there at the start of that miracle run and who features with other club heroes above the main entrance.

GREECE

Theodoros Kolokotronis Stadium
TRIPOLI (ASTERAS TRIPOLIS FC)

Asteras Tripolis players clearing the ball into row Z at the Theodoros Kolokotronis Stadium could conceivably clear the shallow stands and score a goal in one of the connecting pitches.

Diagoras Stadium
RHODES (PAE GS DIAGORAS 1905 / AS RODOS)

Built in 1932, the stadium is based on an ancient Hellenic U-shaped arena and named after the ancient boxer Diagoras of Rhodes. The original Italian architect named the stadium the Arena del Sole (Sun Arena), and light floods the pitch. A narrow art deco gateway with barrel-shaped posts and an ornate Rolex clock overhead takes you into the stadium. Sit in the sandstone grandstand backed with Grecian archways. It's an incredible sight.

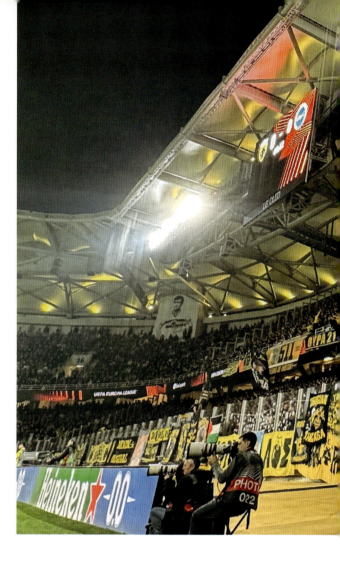

Toumba Stadium
THESSALONIKI (PAOK FC)

A classic South American earring-bowl stadium sits beside the Thermaic Gulf in the Aegean Sea. Black-and-white stripes cover the ground from the exterior to the curved stands. On the southside, a chunk has been bitten out of the stadium where the neighboring buildings of the Mikras Asias eat into the stands.

AEL FC Arena
LARISSA (SAE LARISSA FC)

Walking toward the entrance you may get the feeling you are walking into a school or an office building, but inside is a tidy, compact stadium. The roofs of the four rectangular stands are loaded with solar panels, and the stadium gets a lot of sun. A cooling breeze flows across the expansive farmland to the east and through the voids between stands.

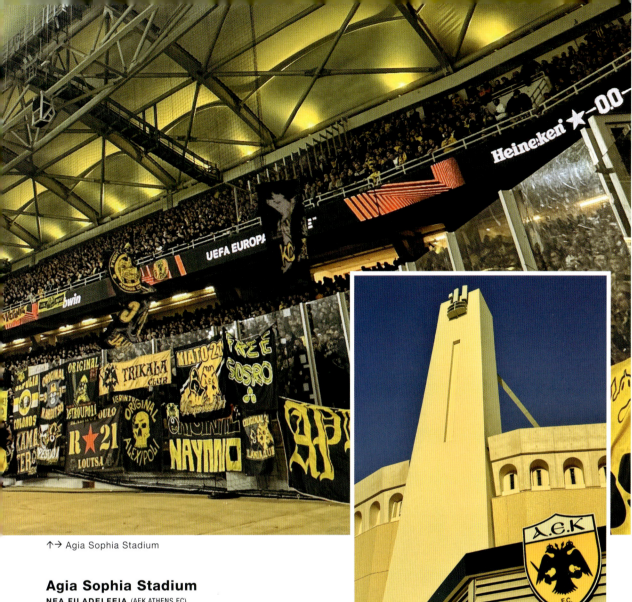

↑→ Agia Sophia Stadium

Agia Sophia Stadium
NEA FILADELFEIA (AEK ATHENS FC)

AEK Athens—a club established by Greek immigrants from Turkey—used the Byzantine Hagia Sophia mosque in Istanbul as the inspiration for the name and the design of their stadium. Each section of the arena is named after historical cities of Anatolia, with the exception of Gate 21. This is reserved for the AEK ultras, Original 21. It was at Gate 21 of AEK's former home on the same site that the group was formed. They were the first to raise the skull and crossbones flag taken on by so many ultra groups. With Olympique de Marseille and Livorno of Italy, they are part of the left-wing Triangle of Brotherhood; they also have a friendship with FC Partizan Minsk and St. Pauli. If ever the stars align and you can witness a fixture with any of these clubs, then it will be a once-in-a-lifetime experience. When AEK met Marseille in a European tie, a monumental tifo was displayed behind the goal in Gate 21, showing an Original 21 and OM ultra arm in arm, their backs to the pitch.

Georgios Karaiskakis Stadium
PIRAEUS (OLYMPIACOS FC)

The stadium is visually impressive with fourteen exterior red-metal towers supporting the concrete structure. The Olympiacos fans create a major spectacle with flares and huge intimidating tifos. When British team West Ham visited for a European game, they were greeted with the message "Tonight you dine in hell." The original Georgios Karaiskakis Stadium was built as a velodrome for the first modern Olympic Games in 1896. It evolved into a football ground and hosted the newly formed Olympiacos in the 1920s. Having fallen into disrepair, the stadium was rebuilt for the 2004 Olympic Games, and Olympiacos moved back in.

↑ ↓ Grigoris Lambrakis Stadium

Grigoris Lambrakis Stadium
KALLITHEA, ATHENS (KALLITHEA FC)

This stadium, built on the site of an old quarry, is extremely photogenic thanks to its rock-face backdrop. It became known as El Paso because of its rugged resemblance to the town where the famous duel scene in Clint Eastwood's *For a Few Dollars More* took place. Its women's team is the Victoria Park Vixens, whose shirts match the iconic heuchera foliage growing across the rockface.

Europe / **Greece/Albania/Montenegro**

Nea Smyrni Stadium
NEA SMYRNI (PANIONIOS GSS)

The Nea Smyrni sits in the center of a densely populated community, which craves a large-capacity stadium. It is home to Panionios GSS, the oldest club in Greece, founded in 1890. The original stadium was rebuilt to accommodate European football when Panionios reached the heights of the Cup Winners' Cup in 1998, which reduced its capacity to an 11,700 all-seater. The team has since slipped to the third tier of Greek football. Despite a new roof to one of the stands, the stadium is looking a little tired again.

Theodoros Vardinogiannis Stadium
HERAKLION, CRETE (ASTERAS TRIPOLIS FC)

OFI Crete's stadium sits on the site of an ancient Armenian cemetery. When construction began shortly after World War II, during which Crete was occupied by the Nazis, two large German guns had to be removed from where the pitch now lies.

Sochora Stadium
RETHYMNO, CRETE (NEOS ASTERAS RETHYMNO FC / STAR WOMEN)

The Sochora Stadium is set on a small peninsula in Rethymno on the northern coast of Crete, looking out to the Mediterranean Sea. From the pitch you can see the hilltop Fortezza, a sixteenth-century citadel, to the right the old town and Venetian Harbor lined with tavernas. The star-shaped Fortezza gives the men's team its crest and the women's team its name—Star Women.

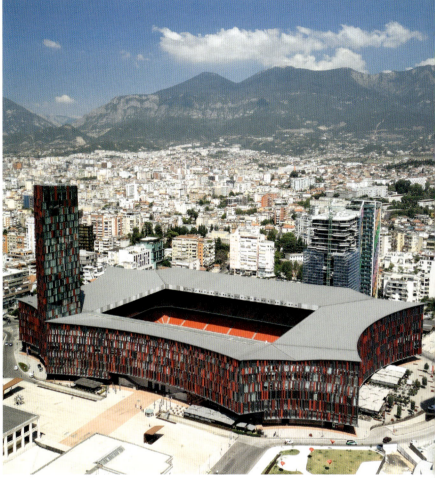

↑ Air Albania Stadium

ALBANIA

Air Albania Stadium
TIRANA (KF TIRANA / NATIONAL TEAM)

The Arena Kombëtare is a unique, six-sided stadium in Italia Square. An Italianate entranceway leads you to the stadium, which is covered with thousands of window shutters that appear like fluid mosaic tiles. These extend to a matching tower hotel attached to the arena at the northwest corner.

MONTENEGRO

Podgorica City Stadium
PODGORICA (NATIONAL TEAM / FK BUDUĆNOST PODGORICA)

This is national team football at its rawest. Seats are broken or missing; there's high gauze netting behind both goals to avoid missiles being thrown onto the pitch; and games are often sparsely attended. Yet to watch the Varvari (Barbarians) stand in an isolated congregation behind the home goal, ultraclose to the pitch, is a true spectacle.

North Macedonia/Croatia / Europe

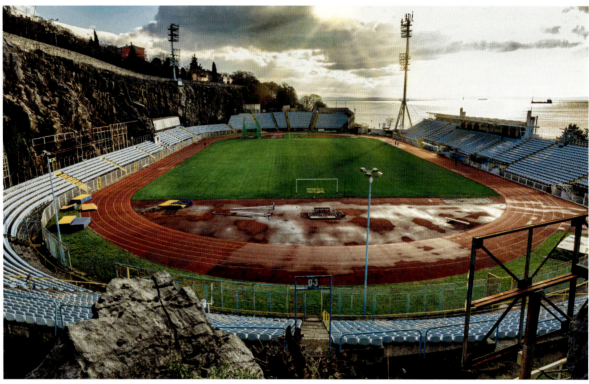

↑ Stadion Kantrida

NORTH MACEDONIA

Petar Miloševski Stadium
BITOLA (FK PELISTER)

The home of North Macedonia premier league team FK Pelister in the Pelagonia valley is surrounded by mountains. The stadium is slowly developing over time, but its two modern stands are still competing with nature. A line of tall fir trees surrounds the western goal end.

Sports Center Pandev
STURMICA (FC AP BRERA)

Sports Center Pandev accommodates everything in one huge venue on one side of the pitch. It houses a hotel, club offices, a seated stand, and three showstopping viewing pods.

CROATIA

Stadion Hvar
HVAR (NK HVAR)

Fancy taking a yacht to a football match? You can moor your boat, step onto the bay at Križna Luka, and into the Stadion Hvar.

Stadion Rujevica
RIJEKA (HNK RIJEKA)

Stadion Rujevica is built into a hillside. The slope tapers away into two further pitches and then into the town of Rijeka and the Adriatic coast. It is the exceptional training facility of top-tier HNK Rijeka men's and women's teams and was once their home.

Stadion Kantrida
RIJEKA (ŽNK RIJEKA)

The Kantrida sits below a steep rock face in what was once a quarry. Together with the hills of the Učka Nature Park in the distance, and trees that surround the rock face, it has been one of the most spectacular stadiums in the world for over a century. The rawness of the site contrasts with the beauty of the Adriatic shoreline on its south side. ŽNK Rijeka's equally impressive training pitch lies next to the stadium within yards of the water.

Europe / **Croatia**

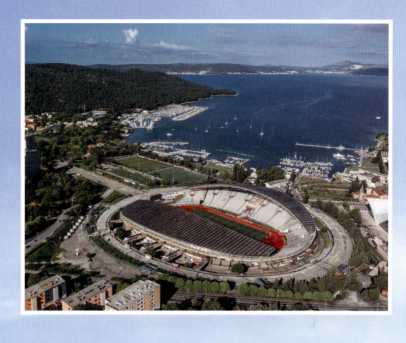

Stadion Poljud
SPLIT (HNK HAJDUK SPLIT)

The backdrop of this captivating saddle-style stadium in Split's historical bay includes Telegrin Peak and its hilltop crucifix.

↓↑ Stadion Poljud

Stadion Maksimir
ZAGREB (GNK DINAMO)

Stadion Maksimir was the venue for the infamous "kick that started a war." In 1990, during a heated match between Dinamo Zagreb of Croatia and Red Star Belgrade of Serbia, tensions spilled into the crowd, sparking a riot. In the middle of the chaos, Dinamo player Zvonimir Boban kicked a police officer in the head, arguing he was protecting Dinamo fans. It was a flash point that brought tensions between Yugoslavia and the nationalist population of Croatia to a breaking point, and civil war ensued.

Croatia / Europe

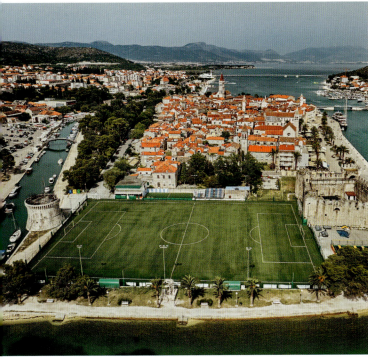

↑ Igralište Batarija

Stadion Gradski vrt
OSIJEK (ZRINSKI OSJEČKO 1664)

With grandiose plans, construction began for the stadium known as the Jail in 1949. Only the large west stand was constructed and, over time, the ground morphed into the octagonal version we see today. Concrete pillars projecting from the back of the large main stand are still waiting to be fitted with a roof. If you sit at the top, you can see over the neighborhood of Novi Grad while watching the game.

Stadion Gospin dolac
IMOTSKI (NK IMOTSKI)

The Gospin dolac sits within a karst, a natural crater within a valley of rocks. The main stand and small terrace follow the contours of the crater's edge. The rest of the pitch is surrounded by a steep rock face. High above the main stand is the ninth-century Topana Fortress and Our Lady of Angels church from which the stadium derives its name. Fans trekking the 141 feet (43 m) up to watch their team can also take in the Blue Lake, which is formed within a huge sinkhole.

↑ Stadion Gospin dolac

Igralište Batarija
TROGIR (HNK TROGIR)

Fans of HNK Trogir have a strong case to argue that their team plays at the most picturesque stadium in the world. The Batarija is located within a small island city, a UNESCO World Heritage Site, on the Adriatic coast. The west side of the pitch is lined with palm trees, and there are yachts moored in the bay beyond. Behind one goal is the fifteenth-century Kamerlengo Fortress. Behind the other is the fifteenth-century St. Mark's Tower. The small, uncovered all-seater stand on the east side, the only terrace in the stadium, means some fans can enjoy a comfortable front-row seat.

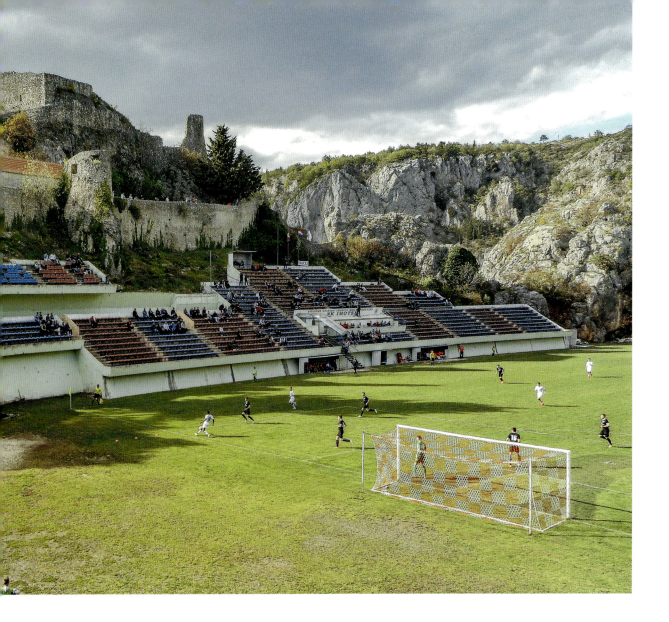

MALTA

Kerċem Ajax Stadium
KERĊEM, GOZO (MULTIPLE TEAMS)

Kerċem Ajax Stadium is busy—it hosts every match of the island's second division, which makes it easy to take in a game or two if you're visiting. But check the fixtures list beforehand—as the stands are uncovered, the season doesn't extend through the heat of the summer months.

Luxol Stadium
PEMBROKE (ST. LUCIA FC / ST. ANDREWS FC / NATIONAL AMATEUR LEAGUE)

The Luxol plays host to a lot of football, with two professional teams and the Maltese National Amateur League calling it home. It is part of a complex where you can book to play a game yourself.

Grawnd Nazzjonali
TA' QALI (NATIONAL TEAM / MALTESE PREMIER LEAGUE)

There was a time when Manchester United played a European Cup game in Malta on a sand pitch, and another when England played with fans standing on rooftops. Fast-forward fifty years and the national stadium is an all-seater ground, with a grandstand, VIP stand, and a hybrid grass pitch.

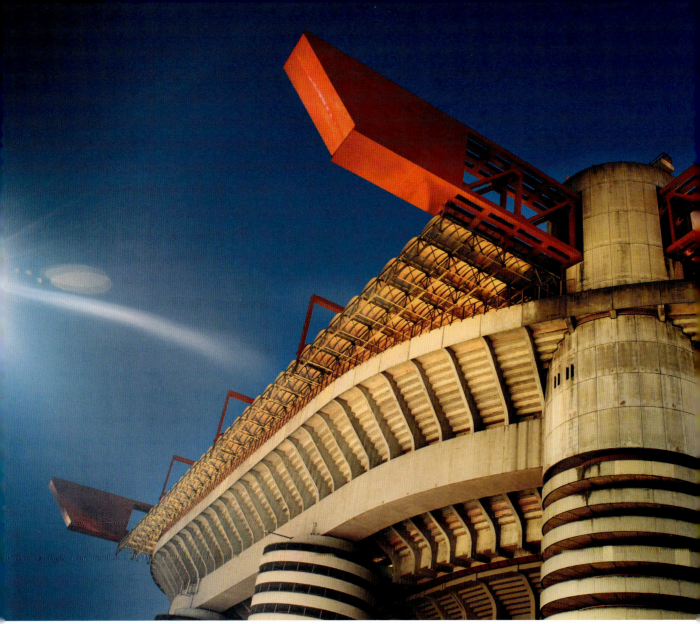
↑ San Siro

ITALY

Stadio Armando Picchi
LIVORNO (US LIVORNO 1915)

For some quality Serie D, fourth-tier action, it doesn't get much better than the Stadio Armando Picchi and US Livorno. Before entering the ground, stop to take in the original 1935 art deco facade, one of the finest examples of the period anywhere.

San Siro
MILAN (AC MILAN / INTER MILAN)

The San Siro may be the most iconic football stadium on the planet. A city that is home to one of the world's biggest football derbies (between Inter Milan and AC Milan) has also hosted the World Cup and various European Cup finals. History has always been made between these four walls, the iconic floating roof, the Curva Nord and Curva Sud, and those unmistakable swirling towers.

Stadio Vittorio de Sica
MONTEPERTUSO (ASD SAN VITO POSITANO 1956)

A Roman wall with filled arches runs along the coastal side of this miraculous stadium high above the Amalfi Coast in a small hamlet under Montepertuso. It is home to San Vito Positano, who compete in the sixth tier, the Promozione Campania. Positano is the ancient Greek word for relaxation, and that's exactly the football vibe up here.

Europe / **Italy**

Arena Civica
MILAN (BRERA CALCIO)

Napoleon oversaw the construction of Italy's oldest stadium, built in 1807, and even attended its opening ceremony. To many Nerazzurri it is Inter Milan's spiritual home. It was their fortress in the early years of success from 1930 to 1947, and the venue for the Azzurri's first international match against France in 2010, a 6–1 demolition. It isn't until you step inside that you see the full wonder of this neoclassical masterpiece, which now hosts lower league football and the Brera Calcio. The Pulvinare, or royal lodge, with its impressive columns, rises above the terraces. It fuses with the Palazzina Appiani entrance hall, which you can see from the Viale Comizi di Lione that runs around the arena. An athletics track leaves you disjointed from the action on the pitch, but it's all part of the original setup. Until recently amateur, Brera Calcio is now part of a network of three teams playing top-flight football in North Macedonia, Mongolia, and Mozambique.

Centro Sportivo Agostino Cascella
MILAN (AS VELASCA / US TRIESTINA 1946)

AS Velasca is a long-form art project; a Gesamtkunstwerk (a total work of art). Dubbed by FIFA as the "most artistic club in the world," every match day ticket, and each season's jersey, is unique and designed by a different artist. Built into the dugout is Thomas Wattebled's *The Artist's Bench*, a seat that can be used for creative endeavors on match days. The corner flags are a bespoke design—clear plastic with a large red cross denoting its purpose. The club mascot, the Velasca Tower, made from one hundred pizza boxes, parades around the edge of the pitch while fans bang on drums. The stadium started as a dirt field with a wooden grandstand. When its now-owner, Roberto Cascella, was five years old, the grandstand was swept away in a storm. His father vowed to regenerate the ground and, in 1989, the new stadium was born bearing his name.

Gewiss Stadium
BERGAMO (ATALANTA BC)

This stadium is an epic blend of old and new. The home of Atalanta has gone through massive redevelopments in recent years, but the original facade of the grandstand, the Tribuna Giulio Cesare, built in 1927, remains. The Curva Nord is known for its intense atmosphere with flares, fireworks, and a huge black-and-blue striped flag, but the glorious old stand with its Italianate entrance looking onto the fans of La Dea (the Goddess) is arguably the place to be.

Stadio Teofilo Patini
CASTEL DI SANGRO (ACD CASTEL DI SANGRO CEP 1953)

The Miracle of Castel di Sangro by Joe McGinniss chronicles the rise of village team ACD Castel di Sangro Cep 1953 through the lower leagues and all the way to Serie B, where they survived for a single glorious season. Their success meant that upgrades were needed to their stadium to accommodate more fans. One stand became four and the capacity increased to 7,220 (the village has 5,500 residents). And that is how it looks today, hosting fifth-tier football.

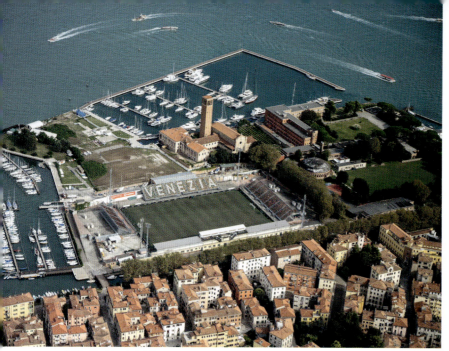

↑ Stadio Pier Luigi Penzo

Stadio del Conero
ANCONA (US ANCONA)

US Ancona plays third-tier football in an epic, near-empty stadium with a capacity of 23,967. The previous Ancona team was dissolved after bankruptcy, and the new team had to start again in Serie C. The stadium sits in a concrete bowl at an angle, sloping up on one side and down on the other. Short walkways leading into the bowl surround the ground. You won't struggle to get a seat and the experience is quite unusual.

Stadio Rigamonti-Ceppi
LECCO (CALCIO LECCO 1912)

The Stadio Rigamonti-Ceppi is as picturesque as they come. Alpine air and mountain views overwhelm the senses as the football goes on in the background. Caught between the ski slopes of the Italian north, and the metropolis of Milan, this stadium is like an oasis in the desert. Without a doubt, the apartment building on the corner that looks like a ski lodge has the best view of the pitch.

Stadio Nereo Rocco
TRIESTE (US TRIESTINA CALCIO 1918)

The Stadio Nereo Rocco is something of a hidden gem. With Triestina in Serie C, it's a mighty stadium for third-tier football. The magnificent Tribuna Colaussi and Tribuna Pisanti are like altars with art nouveau centerpieces. The Curva Furlan is where the tifosi bring their passion. With both teams in the lower echelons, there is a chance to visit the Derby Triveneto, Triestina vs Vicenza—a spectacle that could grace Serie A, in the greatest stadium never to experience the top division.

Stadio Brianteo
MONZA (AC MONZA)

The Stadio Brianteo is one of those venues that has one incredible standout feature—its main stand is like a brutalist version of London's Tower Bridge. It's so much bigger than the rest of the stadium, which tapers away at the sides. The stand contains skyboxes and VIP areas as well as steep seating. Yet all the atmosphere comes from the far smaller Curva Sud. Where the main stand seems cut off and isolated, the south side feels like it's part of the action—open and pitch side.

Stadio Olimpico
ROME (AS ROMA / SS LAZIO)

The arena is lined by stunning statues and tall trees and fits in with the style of its city—one of the most romantic and regal on Earth, but with a passionate heart. This is one of those cathedrals of football that doesn't need much of an introduction. It was the home of the 1990 World Cup and, since then, has seen many iconic moments and fiery derbies between Roma and Lazio.

Stadio Via del Mare
LECCE (US LECCE)

The stadium of the "street leading to the sea" would fit right into the heart of Bogotá or Caracas. The terra-cotta roof of the grandstand is the only element of the red, yellow, and blue earring-shaped bowl that suggests Italy. It's a wondrous sight. Start match day at the San Cataldo lighthouse and drive along the long, straight Via del Mare to the stadium.

Stadio Pier Luigi Penzo
VENICE (VENEZIA FC)

The best way to reach the Stadio Penzo is by boat, either by vaporetto or, even better, by yacht—just moor your vessel in the Venetian lagoon beside the stadium. You can walk from Piazza San Marco in thirty minutes, following the Riva degli Schiavoni seafront, passing through the Biennale to reach Isola di Sant'Elena. The views from the stands are inevitably stunning, and the team turns out in some of the finest jersey designs in Italian football.

Europe / **Italy**

Campo Gerini
ROME (PROCALCIO ITALIA)

Under the shadow of the ancient Felice Aqueduct in the Parco degli Acquedotti sits a clay football pitch, home to Lazio regional league football. A handful of spectators watch from small makeshift wooden stands. Abandoned buildings rest among the ancient ruins, and a train track runs along one side.

Campo Pio XI
ROME (VATICAN CITY NATIONAL TEAMS)

The first documented football match at the Vatican was played in 1521, and today even Vatican City has a national football team. It has played two international matches at the Campo Pio XI, under one of the great backdrops in world football—the dome of St. Peter's Basilica. Both matches were against the Monaco principality national team (not the French club AS Monaco), with a win and a loss. The team's greatest victory at the Campo Pio XI was against Swiss amateur side SV Vollmond, resulting in a 5–1 win for the papal side. The team's motto is to "lose well rather than win badly." They have won six out of twenty-seven matches, with eleven losses, but only one at their new home, which has become something of a fortress since they moved there in 2006.

Allianz Stadium
TURIN (JUVENTUS)

Like a baby born to wealth, this stadium has grown up with nothing but titles and success, and its sleek design means that every seat offers a spectacular view. It is one of the few ubermodern football grounds in Italy, and arrived with the twenty-first-century wave of Juventus dominance. It was christened by the waltz of the legendary Andrea Pirlo.

Stadio Olimpico Grande Torino
TURIN (TORINO FC)

The Stadio Olimpico cannot escape history. Now the home of Torino, it was once the stadium where their most fearsome rivals, Juventus, played too. Way beyond that, it was built by and named after 1930s Italian dictator Benito Mussolini and his regime. Under his rule, Italy hosted the World Cup as part of one of the original sportswashing events. This beautiful basin has seen many things in over a century of tournaments and titles.

Stadio Luigi Ferraris
GENOA (GENOA CFC / UC SAMPDORIA)

This is the city in which Calcio was born, the spiritual heart of Italian football. That passion feeds into the fabric of the stadium, and Italy's oldest club, Genoa CFC, has played here since 1911. The Derby della Lanterna between Il Grifone and Sampdoria—the two Genoese clubs that share the Stadio Luigi Ferraris—is a beautiful sight. The steep stands are boxed deep within the terra-cotta walls creating a special sound. The structural towers, spanning out like a suspension bridge above, are a unique feature. The tifosi in the Gradinata Nord create displays of griffins and fortresses. The signature of the Ultras Tito Cucchiaroni in the Sud is flags and flares.

↓Stadio Luigi Ferraris

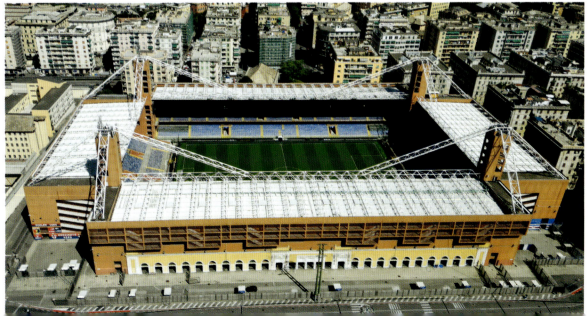

153

Italy / Europe

Stadio Diego Armando Maradona
NAPLES (SSC NAPOLI)

Once the fans in the B stand begin to chant "When we will be in Curva B, we will explode as a bomb," the noise does not stop. Napoli fans are said to feel isolated from the rest of Italy, a sentiment Maradona (whose name was given to the stadium following his death) echoed during his time with *I Ciucciarelli* (the Little Donkeys). This passion for their team and community as an "us against them" sentiment erupts on match day in Curva B with flags, flares, and song, and feeds the entire the stadium. No wonder it's known as the cauldron of hatred.

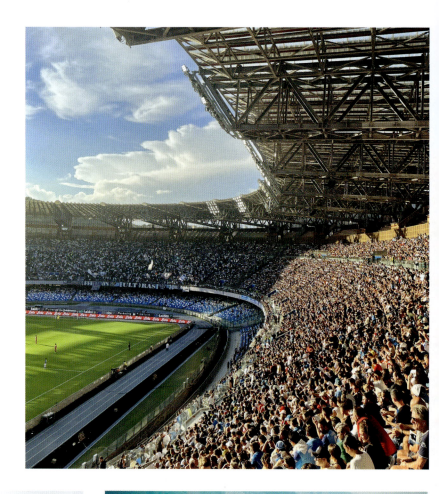

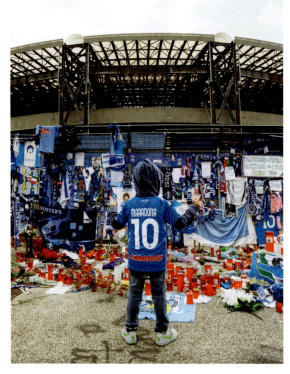

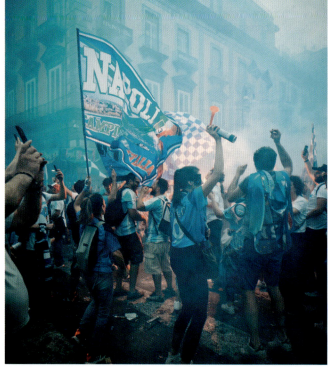

Europe / **Italy**

155

Italy / Europe

Trampolino Olimpico
CORTINA D'AMPEZZO (SG CORTINA)

Set high in the Dolomites, the Trampolino Olimpico ski jumping hill has been dormant since 1990. It was used for the 1956 Winter Olympics and is now a sporting monument. The area at the base was once used as a football pitch when the snow cleared. This incredible setup is reminiscent of the Alpensia Ski Jumping Centre, which hosts the South Korean national team. Here it is used by locals and visitors alike.

Stadio Ennio Tardini
PARMA (PARMA CALCIO 1913)

The home of Parma Calcio has it all, from high-school-style yellow bleachers to a museum with European trophies, and an iconic archway guarding the main stadium entrance. In the 1990s the likes of Thuram, Buffon, and many more World Cup winners rose to fame in this very spot.

Stadio Giovanni Mari
LEGNANO (AC LEGNANO)

Don't expect to get close to the action if you visit Stadio Giovanni Mari to watch AC Legnano—a large horse racing track encircles the pitch. Once a year, on the last Sunday in May, it is used for the Palio di Legnano, a horse race commemorating a twelfth-century battle in the city.

Stadio Antonio Riciniello
GAETA (GAETA CALCIO 1931)

An abandoned factory with a tall chimney sits on the north side of the Stadio Antonio Riciniello. The entrance, beside Serapo beach, is to the south. It consists of three red metal gates, each with portrait wall art beside it. From the stands are views across the Tyrrhenian Sea and Monte Orlando.

↓ Trampolino Olimpico

Europe / **Italy**

Campo di Calcio San Costanzo
CAPRI (RACING CAPRI FC)

The Campo di Calcio San Costanzo, home to Racing Capri FC, sits between Monte Solaro and the Tyrrhenian Sea. With views over the Spiaggia Marina Grande and a top-class playing surface, it's a stunning venue to watch lower league football in the competitive fifth-tier Eccellenza Campania.

Stadio Druso
BOLZANO (FC SÜDTIROL)

We often associate Italy with natural beauty, and the Stadio Druso is the perfect example. Despite the home side not being Serie A competitors, the playing surface is like a carpet fit for the finest footballers and the grandest games. The trees and hills behind the stadium come to life in the spring months, their green color contrasting with the blue of the sky, dwarfing the main stand below, and adding some magic to the match-day feel.

Stadio Libero Liberati
TERNI (TERNANA CALCIO)

What is it about the blue skies and large green trees hanging over Italian football stadiums that look as if they were put there by God himself? This is not the Garden of Eden, this is the Stadio Libero Liberati. The passionate fans of home club Ternana add their own green and red color to the mix here and they have a knack for a fabulous prematch display. From its exterior balconies to the mountain view, this ground has got a bit of everything.

Mapei Stadium (Città del Tricolore)
REGGIO EMILIA (US SASSUOLO CALCIO)

The Mapei Stadium has steep tiers and stairs leading into the stadium trapped in the green, white, and red tricolor of Italy. It holds over twenty thousand spectators, and since 1995 has been home to the Reggiana, Carpi, and Sassuolo football clubs. The latter rose to fame recently with the likes of Manuel Locatelli and Domenico Berardi in the side, and a famous trip to Europa League football in the 2016–17 season.

Stadio Renzo Barbera
PALERMO, SICILY (PALERMO FC)

All roads lead to . . . the Stadio Renzo Barbera, apparently. This emblem of Palermo is the pride of Sicily. The Palermo players look pretty in pink and their stadium is aesthetically pleasing too. On one side of the ground large rocks loom over the open stands, and on the other the city's interchanges are lined with pink flags and thousands of motorbikes parked by fans on match days.

Stadio "Valerio Bacigalupo" di Taormina
TAORMINA, SICILY (ACR MESSINA)

Imagine a cable car traveling directly above your head when taking a last-minute penalty for the three points. That's the reality for Città di Taormina. The stadium sits in the hills of southern Sicily. Visitors park beachside and take the aerial tramway up to the game.

Stadio Alberto Braglia
MODENA (MODENA FC 2018)

The city of Modena is famous for opera, balsamic vinegar, and being the original home of Enzo Ferrari. But now you can add the Stadio Alberto Braglia to the list of tourist attractions. A futuristic roof makes the home of Modena football look like a spaceship stranded in the forest of Emilia-Romagna.

Stadio Giovanni Zini
CREMONA (US CREMONESE)

As well as having one of the coolest names in football, the Giovanni Zini has one of the most underrated atmospheres too. Despite historically being a yo-yo club, the Gray and Reds have some of the most loyal fans in the country. Cremonese's stadium may be small but has a big atmosphere thanks to its steep stands that are close to the action, and the colorful and loud ultras behind the goal.

Stadio Nicola Ceravolo
CATANZARO (US CATANZARO 1929)

Catanzaro poses a red-and-yellow wall of emotions at the Stadio Nicola Ceravolo. Met by graffiti outside the ground, etched into the city walls by the ultras, this ground is a vital part of this town. Its main stand looms over the spectators, its ticket booth has a roof pattern that creates hexagonal shadows in the sun, and its tunnel statue is the club eagle, standing boldly as a warning to visiting players.

Italy / Europe

Stadio comunale San Vito "Gigi Marulla"
COSENZA (COSENZA CALCIO)

The delightful southern town of Cosenza is home to the old-school and very Colosseum-like Stadio comunale San Vito "Gigi Marulla." There is plenty of space between the stands and the pitch, and the stands themselves are anything but steep. You can imagine chariots racing around this arena back in the day, as the shape looks more suitable for old Roman games than modern-day football, but that's what makes it unique.

Stadio Giuseppe Sinigaglia
COMO (COMO 1907)

Few stadiums are quite so sublimely located as this one. Lake Como is known for famous faces on vacation, not football. Yet this ground fits into the background so well; not the most stunning arena on its own—every stand is different and irregular—but from a bird's-eye view you can see a green pitch, swimming pools, yachts, and one of Europe's most beautiful lakes.

Stadio Pier Cesare Tombolato
CITTADELLA (AS CITTADELLA)

You do not want to be an away fan at a Cittadella game. Not only do you feel like you are a million miles from the pitch, with advertising boards and a running track between you and the action, there's also a giant fence in front of the stand for good measure. The rest of the ground is anything but unsavory. It boasts a crisp pitch and has a community feel, hosting just over seven thousand fans.

Stadio Arechi
SALERNO (US SALERNITANA 1919)

From the outside, the Stadio Arechi's single stands are brutalist and bold, almost an eyesore among what otherwise would be a crystal clear sky. Yet on the inside, the warm red of Salernitana is romantically wrapped into some of the finest fan displays in the country. The Curva Sud is filled with style.

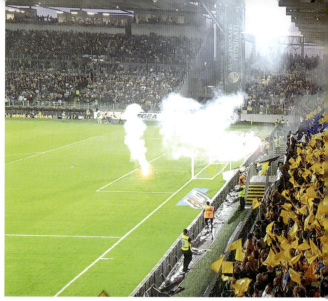
↑ Stadio Benito Stirpe

↑ Stadio Giuseppe Sinigaglia

Europe / **Italy**

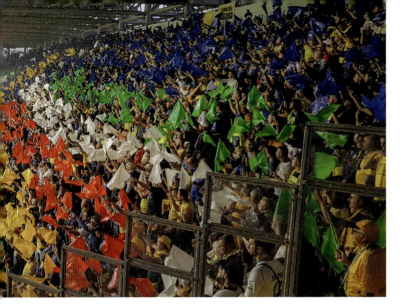

Stadio Benito Stirpe
FROSINONE (FROSINONE CALCIO)

When Frosinone Calcio of Lazio took over the lease on the Stadio Benito Stirpe in 2015, they completed a build started in 1974, abandoned in the 1980s, and left derelict for over forty years. They did a great job. It's a magnet-style stadium with three tribunes feeding into a separate majestic main stand. Four modern corner floodlights are attached to the outer framework that envelops the stadium. The project coincided with Frosinone's immediate promotion to Serie A.

Stadio Mario Rigamonti
BRESCIA (BRESCIA CALCIO)

The stadium's Curva Nord is something special, and the white *V* shape against a bright blue background is an iconic football symbol known the world over. It can be found emblazoned on these terraces, and has been immortalized upon the city walls too. Despite dropping divisions, Brescia Calcio is a big club, and the Stadio Mario Rigamonti is one of Italy's most famous.

Stadio Friuli
UDINE (UDINESE CALCIO)

Stadio Friuli is one of the lesser-spotted modern football stadiums of Italy. It is home to Udinese Calcio and perhaps its most spectacular feature is the dazzling display of colors shown on its twenty-five-thousand-plus empty seats. Of course, this ground is more alive with spectators bouncing inside it, but on a non-match-day its silver exterior glimmers in the sun, and its Technicolor backside supports are some of the most beautiful and creative in the very specific category of football stadium seating.

Italy / Europe

Stadio Alberto Picco
LA SPEZIA (SPEZIA CALCIO)

One look at Spezia Calcio's arena and you cannot help but let out a gasp of satisfaction. Oh yes, she is an absolute beauty. The Curva Ferrovia is the perfect place to watch football from and it is postcard perfect too. The pitch sits beautifully beneath, and behind the stand the hills rise up at a similar angle, acting as an extension of the stadium.

Stadio San Nicola
BARI (SSC BARI)

The Stadio San Nicola holds a grandeur that most cannot replicate, both physically and through the history that it represents. Designed like a flower, the top stand splits into sections like dahlia petals. On the hallowed turf, Italy defeated England to be crowned third-place finishers at the iconic 1990 World Cup. The stadium sits between gardens where symmetrical stairways lead directly to the upper tier of the dome.

Stadio Sant'Elia
CAGLIARI, SARDINIA (CAGLIARI CALCIO)

The Stadio Sant'Elia is relatively inconspicuous from the outside. Its beige tones and inoffensive frame blend into the concrete wasteland that surrounds it. And why would a football stadium in Sardinia be so imposing anyway? For life is good here, the sun shines and the beach is free. Well, fear not, visitors, because once you work out how to get inside, this ground has as great a reputation as any. On match days the blue and red of Cagliari swing in your face and swoop into the sky.

Stadio Carlo Castellani
EMPOLI (EMPOLI FC)

For want of a better phrase, the Stadio Carlo Castellani is a mad mix of stands and structures. It is far from being the prettiest stadium in the land of sun and spaghetti, but the town of Empoli has enough beauty to make up for its arena's harsh exterior. The ground is as functional as it needs to be, and is made up of permanent and temporary stands, and those behind the goal don't even sit parallel to each other.

Stadio Marcantonio Bentegodi
VERONA (HELLAS VERONA FC)

Once a cutting-edge example of modernist design, this stadium has remained largely unchanged since it opened in 1963. Birds and planes will see the main addition of a full roof covering of solar panels. A myriad of winding exterior staircases take you inside. There is a wonderful sense of the past on entering the oval arena. On match day the athletic track houses layers of sponsorship hoardings like picket fences. There's always the chance of seeing a player hurdling them in a run toward the crowd to celebrate a goal—something you don't see very often anymore.

Piazza Santa Croce
FLORENCE (SANTA CROCE, AZZURRI / SANTA MARIA NOVELLA, ROSSI / SANTO SPIRITO, BIANCHI / SAN GIOVANNI, VERDI)

During the month of June in Florence, dirt is thrown onto the Piazza Santa Croce in front of its church to re-create a sixteenth-century pitch and the birth of Italian football. Four teams, dressed in traditional clothing and representing the four local neighborhoods, play a knockout competition to the original rules, *Calcio Storico*, twenty-seven-a-side. *Calcio* translates as "kick," and it's not just the ball that's kicked. In today's football every player would be sent off. It is brutal. You can get tickets for the Tribune C, or the two Curva for local supporters. Tribune A is reserved for the Corteo Storico della Repubblica Fiorentina, a local historical society.

Stadio Artemio Franchi
FLORENCE (ACF FIORENTINA)

Deep in the Tuscan wine region, you'll find the Artemio Franchi Stadium, home to Fiorentina, nicknamed La Viola. Like a fine Italian grape, the team's shirts are an unmistakable purple. The venue's distinctive feature is the Tower of Marathon. The stadium's capacity was increased—and its running track removed—ahead of the 1990 World Cup, making a visit here a more intimate experience.

↑ Piazza Santa Croce

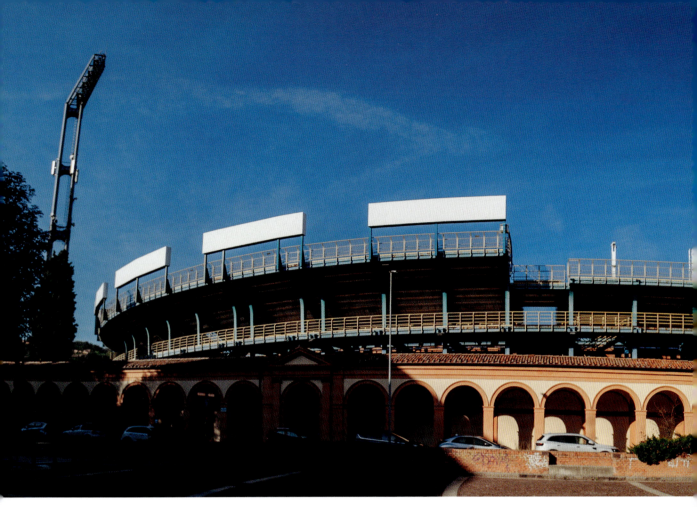

Stadio Renato Dall'Ara
BOLOGNA (BOLOGNA FC 1909)

The Stadio Renato Dall'Ara is quite frankly cheating when it comes to design and splendor. It seems to offer two buildings for the price of one. The centerpiece of Bologna's stadium is the fabulous archway, which once held a statue of dictator Benito Mussolini, hauled down during the city's liberation in 1943.

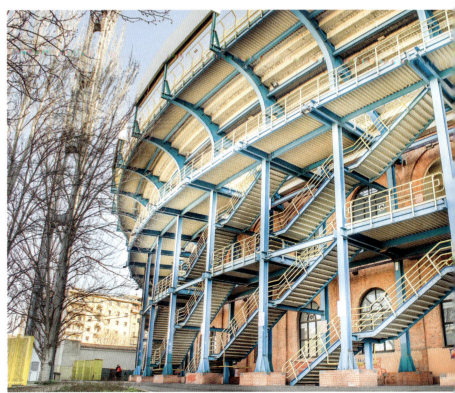

Europe / **Italy**

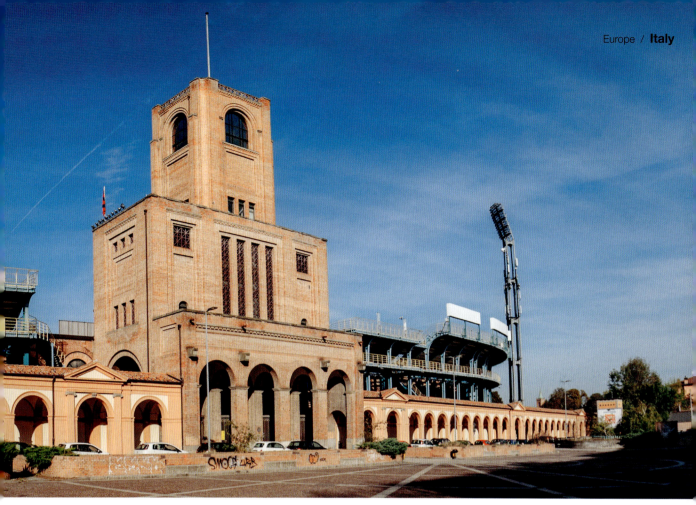

Austria/Switzerland / Europe

AUSTRIA

Wörthersee Stadion
KLAGENFURT (SK AUSTRIA KLAGENFURT)

In 2019 the pitch at SK Austria Klagenfurt's Wörthersee Stadion was the site for an art installation of 299 trees. The project, called *For Forest*, highlighted humanity's impact on the environment. The trees were relocated to a neighboring forest after the exhibition had finished.

FavAC-Platz
VIENNA (FAVORITNER ATHLETIK CLUB)

The main stand is fused into the lower floors of an apartment block. From one viewpoint it is a small, seated stand with roof covering. From another it is one of the largest stands in Europe. It can be an intimidating ground to play on, with over three hundred windows overlooking the pitch.

Hohe Warte Stadium
VIENNA (FIRST VIENNA FC)

The stadium of First Vienna FC—the oldest team in Austria—is extraordinary. It sits at the foot of the huge Hohe Warte hill. The stadium was once a single stand, supported by tiered wooden platforms, that housed eighty-five thousand fans. To the other side was another small single stand, which is now the sole survivor of what was once considered the greatest stadium in Europe, where fans flocked to witness the Austrian *wunderteam* of the 1930s. Argentinean legend Mario Kempes played for the club for the 1986–87 season. Attendances, though, inevitably dwindled after those glory days, and in 2005 the Austrian authorities deemed the stand unfit and banned its use. The capacity dwarfed to 5,500 and it is now a small, beautifully green stadium. When the sun sets over the Hohe Warte, it is truly in history's shadow.

SWITZERLAND

St. Jakob-Park
BASEL (FC BASEL)

St. Jakob-Park has a capacity of under forty thousand, but at the best of times it can feel like seventy thousand. The reality is that this ground, small and sweet, has more to it than meets the eye. When it is full of home supporters it can turn into a blazing arena of smoke and noise. The Swiss giants have famous ultras who are creative with their displays and unyielding in their vociferous support for their team. This ground has an intentionally uneven roof, and the front is painted in the red and blue stripes of FC Basel in a comic-book style. The design provides a lighter moment to go with the thunder of the home fans.

Stadion Wankdorf
BERN (BSC YOUNG BOYS)

The BSC Young Boys ultras put on some incredible shows of creativity from the Ostkurve Bern. With every tifosi in black, a thin withered hand rises toward the roof as if from a coal pit, like a team rising from the ashes of defeat. The Young Boys players sometimes will sit postmatch in front of the stand, tired and weary, awaiting the climax of a chant, and then rise up and bounce arm in arm in unison with the Wankdorf faithful.

Swissporarena
LUCERNE (FC LUZERN)

FC Luzern's golden stadium matches the buildings that surround it. The stadium's roof has been fitted with extensive solar panels.

↓ Wörthersee Stadion

Stade de la Tuilière
LAUSANNE (FC LAUSANNE SPORT)

A small airport runway is located next to the stadium, so expect to see light aircraft landing and taking off during a match. The venue is part of a wider complex, with two rows of full-size pitches—nine in total—leading from the north side. The Stade de la Tuilière itself is a beauty; the four corners are cut away and the base "folds" upward to create triangular open entranceways.

↑ Stade de la Tuilière

↓ Stade Louis II

Ottmar Hitzfeld Arena
GSPON (FC GSPON)

The stadium of a thousand lost footballs. This is the claim of FC Gspon's greatest ever player, Timo Konietzka, who scored the first-ever Bundesliga goal. To reach the Ottmar Hitzfeld Arena, you have to take a cable car. At 6,561 feet (2,000 m) above sea level, it is Europe's highest stadium. Here you can sit on the upper slope or in the club lodge balcony, take in the mountain air and exceptional views into the valley, and watch Swiss Mountain Village Championship football. One more bonus—tickets are free.

MONACO

Stade Louis II
MONACO (AS MONACO FC)

Simply one of the most gorgeous stadiums in the world. Standout features are nine connected arches on the south side and a roof that would look more at home on a Venetian town house. Plus there's the breathtaking location overlooking the yachts in the Port de Cap d'Ail, with the backdrop of Mont Agel.

AS Monaco Performance Centre
LA TURBIE (AS MONACO FC)

When one world-class venue isn't enough. Actually in France rather than Monaco, AS Monaco's training center in the Alpes-Côte d'Azur is simply breathtaking.

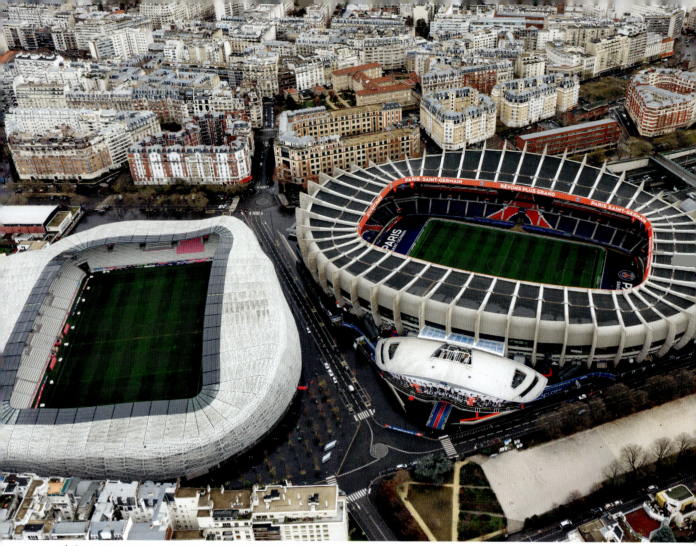

↑ Stade Jean-Bouin (left) and Parc des Princes (right)

FRANCE

Parc des Princes
PARIS (PARIS SAINT-GERMAIN FC)

Driving along the Périphérique ring road directly underneath the east side of this avant-garde spectacle is an incredible sight. The view of the huge concrete shards that intersect the arena as you pass through is as unique as any in French football. The raw beauty outside contrasts with the elegance of the football on the pitch. The atmosphere has a mix of both, with one of the most vociferous crowds in France. In a one-piece tifo, an image of a muscular flame-haired manga character wearing a PSG badge is lifted from the floor to the roof. Above are the words repeated on the roof's edge spanning the Parc, *Ici c'est Paris*—"Here, this is Paris," a statement of pride and representation chanted by the fans.

Stade Jean-Bouin
PARIS (FC VERSAILLES)

Separated from the Parc des Princes by the width of a road, the home of FC Versailles stands in complete contrast to its avant-garde, concrete neighbor. The Stade Jean-Bouin is covered in an art nouveau metal mesh. Inside you can enjoy a prematch game of pétanque.

Stade Émile Anthoine
PARIS (MULTIPLE TEAMS)

Do backdrops get much better? Football at dusk under the Eiffel Tower and Renaissance revival apartments at the Stade Émile Anthoine.

Europe / **France**

Stade Sébastien-Charléty
PARIS (PARIS FC)

Despite the modern emergence of Paris Saint-Germain as the largest club in the French capital, the biggest rivalry in the city—between Paris FC and Red Star FC—is based on political affiliations, right wing against left. The Stade Sébastien-Charléty brings a South American flavor to the derby. With its classic earring-shaped dome, it could be mistaken for an Argentinean cauldron.

Stade Bauer
SAINT-OUEN-SUR-SEINE, PARIS (RED STAR FC)

With the step-by-step demolition and rebuilding of their stadium, Red Star FC has continued to play at the site. One thing that never changes is what has arguably become one of Stade Bauer's most iconic elements—and it's not even a part of the stadium. The large right-angled triangular apartment building behind the south stand is now synonymous with the historic ground's aesthetic. Jules Rimet, who founded both the World Cup and Red Star, is revered here.

Stade Paul-Lignon
RODEZ (RODEZ AF)

An evening stroll along Avenue Victor Hugo from Rodez Cathedral to the Stade Paul-Lignon is a real treat. Both buildings and walkway light the way. Inside the stadium you can watch a match from the stands or from an enclosed balcony running the entire length of the west side. Check the fixture list for night games.

Stade Geoffroy-Guichard
SAINT-ÉTIENNE (AS SAINT-ÉTIENNE)

A perfect way to visit AS Saint-Étienne is to stay at its own hotel, Le Chaudron Vert (the Green Cauldron), the local fans' name for their cherished stadium. You can enjoy a meal in the restaurant, which is as green as you would expect and full of club history and memorabilia. If you can tie this in with the Rhône-Alpes derby against bitter rivals Olympique Lyonnais, then you're in for a treat.

↓ Stade Jean-Bouin

France / Europe

Stade du Hainaut
VALENCIENNES (VALENCIENNES FC)

From a distance the stadium looks like it's hovering. As you get closer you can see the slim, red, V-shaped supports that don't look substantial enough to hold up the huge metal body. Closer still and you can see the concourse, crowd, and pitch, and you're still not inside. But once you're inside the ground, everything opens out into a mass of red.

Stade Francis-Le Blé
BREST (STADE BRESTOIS 29)

Every country seems to have one of those stadiums that tests the mettle of the league's top stars. A phrase has entered the football culture in England. When a skillful player is lauded, the question is asked, "Yes, but can he do it on a cold, wet night in Stoke?" In France that stadium is on the coast of Brittany. The region reaches out into the Atlantic Ocean, bringing with it torrential storms and cold snaps. The stadium is open to the winds coming through the unprotected corners between the stands. Neymar, Mbappé, and Messi have all had to prove themselves here.

Stade Océane
LE HAVRE (LE HAVRE AC)

Everything about this stadium is designed to evoke its ocean-side location on the western tip of France. Light coming into the concourses is turned blue by the translucent blue facade. The inner framework surrounding you is curved like the barrel of a wave. The seats are blue and the western roof flows over the stand; even the railings are curved to maintain the motion of the stadium, which is a fitting tribute to the Sky-and-Navy, France's oldest club.

Roazhon Park
RENNES (STADE RENNAIS FC)

This stadium in the heart of the city stands as a statement of its identity. The very name of the ground—Roazhon—means "Rennes" in the Breton language. They have their own flag, seen everywhere on match day, and their own anthem "L'hymne Breton," which is sung before kickoff. To join the crowd is to be part of a national team, and the pride and passion will give you goosebumps.

Stade Auguste Delaune
REIMS (STADE DE REIMS)

A statue of club legend Raymond Kopa stands proudly outside this stadium in the Champagne region. The once-great French champions have fallen on harder times in recent years, but you can still toast the team while watching from the champagne lounge.

Stade de la Beaujoire
NANTES (FC NANTES)

Taking in one of the Canaries' matches offers a chance to sample some real history. Starting at the Place de la Bourse, you can have drink in the Maximo Club, once the Grand Café des Allies, where the club was formed in 1943. A tram takes you to the stadium, which remains largely unchanged since its construction for Euro 1984, where Michel Platini led Les Bleus to victory.

Stade Michel-Moretti
AJACCIO, CORSICA (AC AJACCIO)

The view from the north stand takes advantage of a very small south side with incredible views out to the Mediterranean Sea.

Stade du Moustoir
LORIENT (FC LORIENT)

To get the full Lorient experience, you must begin with *merlu et frites* (hake and chips) with a glass of pinot blanc for lunch in a harborside restaurant. Walk up Avenue de la Marne to the stadium and you should hear the Merlus ultras. You can take a quieter seat and look over to the Kop Sud and, with any luck a hake-inspired tifo, or get fully involved. But make sure you wear orange. Everything in and around this wonderfully traditional stadium is orange.

Stade du Fort Carré
ANTIBES (FC ANTIBES)

Set on the Côte d'Azur, looking over the Mediterranean Sea, this magical piece of football history remains completely unchanged since its heyday in the 1930s. And it's still in use. Amateur league team FC Antibes plays at a stadium originally built for the 1938 World Cup. The stone tribunes and statue of the Fallen Soldier remain, resting below the sixteenth century star-shaped fort from which the stadium takes its name.

Stade Di Giovanni
MARSEILLE (US MARSEILLE ENDOUME CATALANS FC)

A football ground from the gods. From the city's highest point, US Marseille Endoume Catalans plays its matches overlooked by an apartment building and the Notre-Dame de la Garde Basilica. And from there they look down upon the old port of Marseille.

→ Stade Di Giovanni

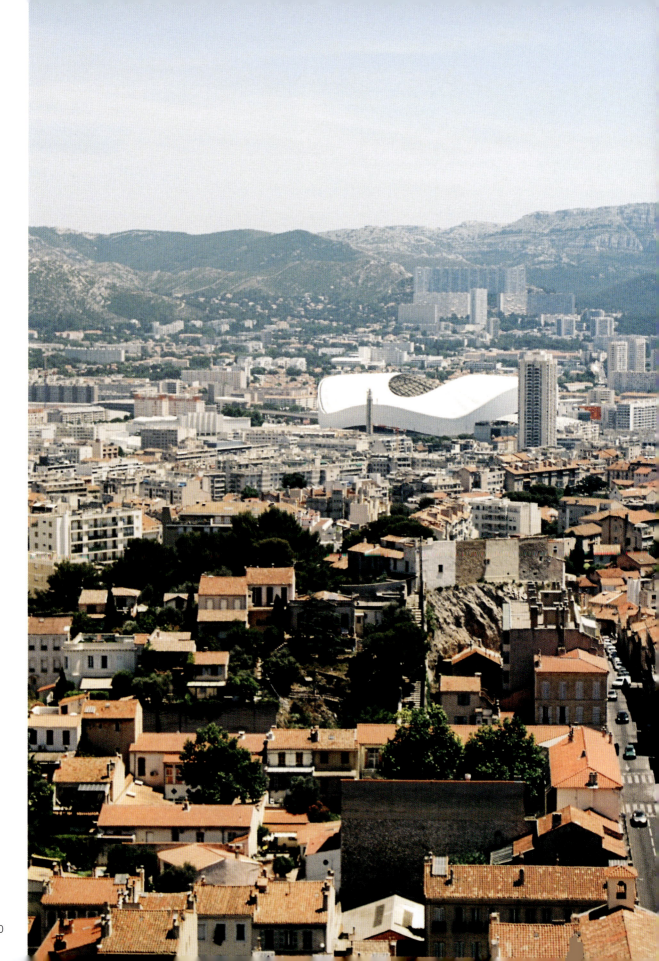

Europe / **France**

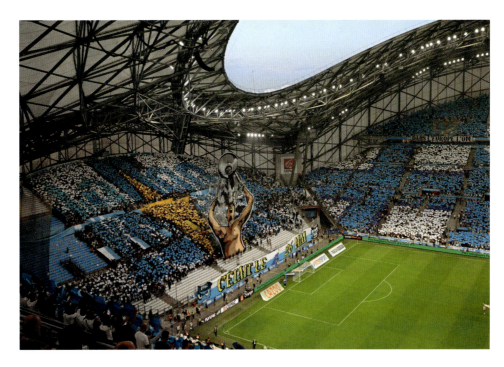

Stade Vélodrome
MARSEILLE (OLYMPIQUE DE MARSEILLE)

It would be easy to simply take a seat and spend ninety minutes sitting open-mouthed in awe of the Stade Vélodrome's giant roof structure. Just remember to take the occasional glimpse at the match. The curvature of the roof and ultrasteep stands create a visual sea of bodies and a noise that swirls and draws your attention around the ground and, ultimately, toward the pitch. It's simply mesmerizing. In a stroke of tifosi genius, smoke bombs are released through a small opening in a tifo of the legendary reggae singer Bob Marley, exactly at the tip of the reefer he is smoking. As the smoke rises the ironic sophistication of the usually crude, throwaway smoke bomb is admired. This is classic Marseillais fan culture.

France / Europe

Allianz Riviera
NICE (OGC NICE)

Away from the sea and champagne of the Côte d'Azur, and on the banks of the appropriately named Var River, is the Allianz Riviera. Something the VAR system couldn't dispute is the beauty of the silver light that floods the concourse and tribunes of the arena through the transparent cladding.

Stade de la Licorne
AMIENS (AMIENS SC)

Four white-framed transparent windbreakers cover the stands like a giant rib cage. The roof structure fuses beautifully with the white seating and, when the sun begins to set, a wonderful orange light covers the stadium. To add to this visual poetry, the name of the arena translates to "Unicorn Stadium."

Stade Raymond Kopa
ANGERS (ANGERS SCO)

In the 1950s, Raymond Kopa spent just two years playing in Angers, but his statue stands outside the Stade Auguste Delaune in Reims (and he is still talked about at Real Madrid). Those two magical years were enough for this stadium to be named after him. He died in the city and his funeral took place at Angers Cathedral. The stadium has changed completely, but his spirit lives on.

Stade des Alpes
GRENOBLE (GRENOBLE FOOT 38)

Windbreakers bring much needed protection from the winds at the Stade des Alpes. As they are transparent, they also allow for a breathtaking view of the mountains. A walk to the stadium along the Isère River is equally awe-inspiring.

Stade de Roudourou
GUINGAMP (EN AVANT GUINGAMP)

Be prepared if you're visiting the small town of Guingamp by train—it's a half-hour walk through the streets and across the Trieux River to reach the stadium. The town has a population of seven thousand, while the stadium has a capacity of nineteen thousand. This is perhaps the biggest disparity in world football. For many years En Avant Guingamp was an amateur club, then a number of promotions saw them climb the French pyramid, drawing in new support within the Côtes-d'Armor region, and in 1990 a new home was built.

Stade Gérard Houllier
LYON (OLYMPIQUE LYONNAIS WOMEN'S TEAM)

Set within Olympique Lyonnais's training ground, and with the inspiring outline of the club's main stadium as a backdrop, the Stade Gérard Houllier is home to the trailblazing Olympique Lyonnais women's team. They have conquered Europe time after time and are one of the most inspiring women's sports teams on the planet. The ground is named after the famous former Liverpool FC coach.

Groupama Stadium
LYON (OLYMPIQUE LYONNAIS)

From above, the Groupama Stadium stands out on the map of Lyon like a bright white diamond. During the 2016 European Championship, for which the stadium was built, the French national team triumphed in a game here. Now the Olympique Lyonnais ultras bring a new type of atmosphere to the ground, one where family fun is replaced by flares. The blue, white, and red are the same, but the atmosphere is even more deafening.

Matmut Atlantique
BORDEAUX (FC GIRONDINS DE BORDEAUX)

The design of the Matmut Atlantique is a perfect representation of the Landes pine forests surrounding it. Where many stadiums represent the curves and undulations of their mountainous or waterside locations, few if any pull off the vertical lines of nature. Hundreds of thin, white, randomly positioned pillars support the roof. Inside, the corridors look like a Greek temple—everything from the roof to the seats is white. On match day you can experience the incredible acoustics, and listen to the back-and-forth chants between the north and south stands.

Decathlon Arena – Stade Pierre-Mauroy
LILLE (LOSC LILLE)

One of the biggest cities in France, Lille shows signs of its past as a rapidly growing industrial town and trading center. Today, one of its most impressive modern features is the Stade Pierre Mauroy. This arena is built to be loud and has seen Lille triumph to a famous French league title.

Stade Bollaert-Delelis
LENS (RC LENS)

The Stade Bollaert-Delelis is a modern take on an old English ground, where four separate single stands sit tight to the touchline. The red-and-yellow Lens team has now reached the European Cup with the power and strength of this stadium behind them.

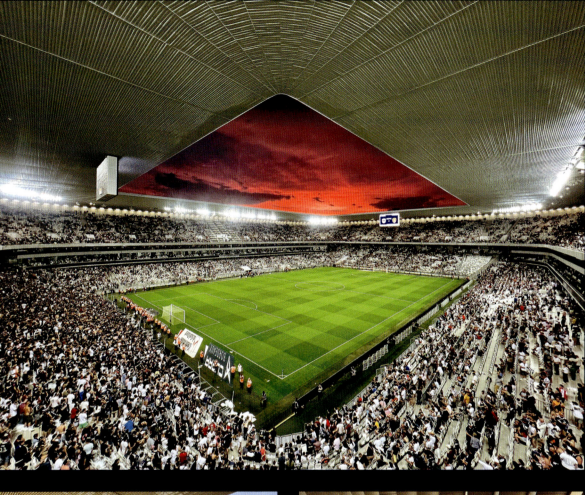
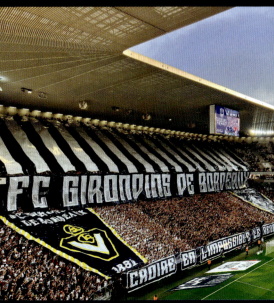

↑↗ Matmut Atlantique

Andorra/Spain / Europe

ANDORRA

Estadi Nacional d'Andorra
ANDORRA LA VELLA (FC ANDORRA / NATIONAL TEAM)

This stadium in the heart of the capital sits within the Pyrenees mountains, and the Valira River flows behind the south stand. The north stand is cut in half, flanked by buildings from outside the stadium spilling into it. Apartment buildings loom over the concrete wall on the east side. The main stand has a flat, laminated-glass roof ending with a wonderful central gable. Four modern floodlights in each corner tie it all together. As well as watching the national team here, you can enjoy Spanish league football at the ground with FC Andorra.

Estadi Comunal d'Andorra la Vella
ANDORRA LA VELLA (NATIONAL TEAM / MULTIPLE TEAMS)

A little restaurant beside the stadium, simply called L'Estadi on Avenue Salou, serves Basque dishes and cold beer, and is a perfect way to start match day at the Estadi Comunal d'Andorra la Vella. The busy stadium hosts almost every team in Andorra's two leagues, so you'll never be short of a game to watch.

SPAIN

Estadio Municipal de Riazor
A CORUÑA (RC DEPORTIVO DE LA CORUÑA)

Deportivo de La Coruña's ground sits just 109 yards (100 m) from the white sand of the town's main beach, the Playa de Riazor. The club has languished in the lower leagues of Spanish football since winning La Liga in 2000, yet their stadium is up there with the best.

Estadi Johan Cruyff
BARCELONA (FC BARCELONA ATLÈTIC)

The arena that hosts Barcelona's women's and youth football teams presents magical modern architecture on the surface, and yet old footballing aristocracy lingers in the air. Johan Cruyff is a figure of the past, but he brought FC Barcelona into the future. His name is emblazoned upon this perfectly formed blue rectangle as his philosophy continues to dictate the direction that this club takes.

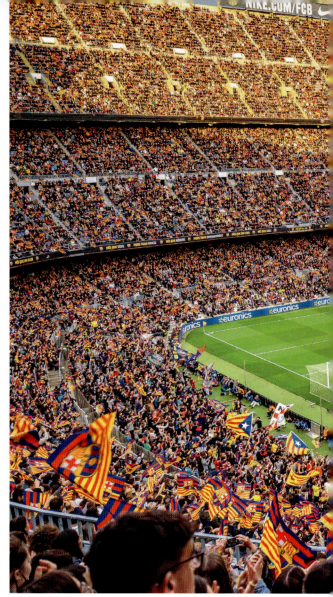

↑ Camp Nou

Camp Municipal de Futbol de la Satalia
BARCELONA (UNIÓ ESPORTIVA POBLE SEC / ATLÈTIC LA PALMA / CE APA POBLE SEC)

The Camp Municipal de Futbol de la Satalia is located in the hills of Montjuïc overlooking Barcelona. You can take a cable car all the way to the top for a view of the stadium, and, in the distance, the Sagrada Família. At night, when both are illuminated, it's a spectacular sight. Visit the castle and then take the cable car into the Circuit de Montjuïc to the stadium, and watch EU Poble Sec or Atlètic La Palma play in the Catalonia league. There is a drinks service from the clubhouse bar to the stands. And the sunsets from up here are phenomenal.

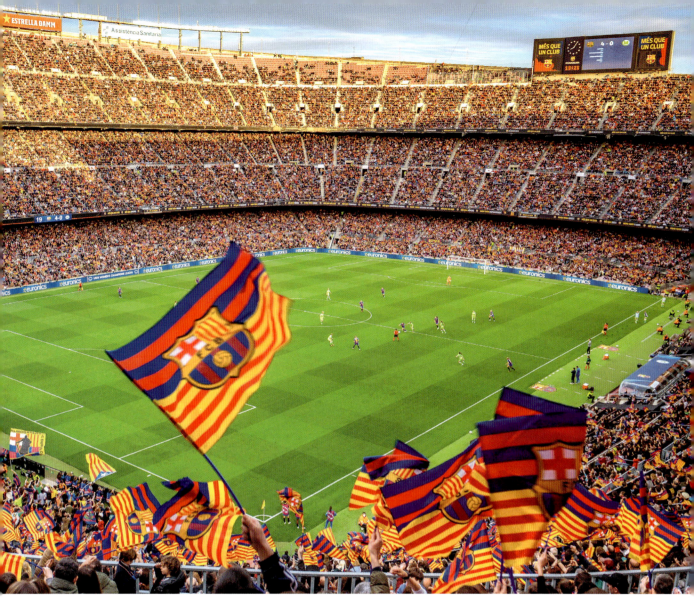

Estadi Olímpic Lluís Companys
BARCELONA (FC BARCELONA / CATALONIA NATIONAL TEAM)

The Estadi Olímpic Lluís Companys is set among the old Olympic Village on the hill of Montjuïc. It is a majestic sports space fit for the Greek greats who inaugurated the Olympic Games. Archways and pillars are the order of the day; the stadium is set in perfect symmetry. The area adopted by football has a nostalgic air to it, named after a man who was president of the region but executed by Franco's forces in the 1940s.

Camp Nou
BARCELONA (FC BARCELONA)

When Barcelona left their old home, the Camp de Les Corts in 1957, there was a sense of leaving the "old field" for pastures new. And so they named their future home "new field"—Camp Nou. Some of the greatest players across generations have called it home including Kubala, Cruyff, Maradona, and Messi. It has hosted major finals including two Champions Leagues, the 1992 Olympics, and, in 1982, five World Cup matches. Yet it is El Classico against Real Madrid where the atmosphere reaches its climax. The famous amphitheatre of dreams is now being transformed, the historic exterior carefully maintained while evolving into a modern giant. The South American style earring with partial covering is now a magnificent symmetrical bowl with retractable roof. The capacity of 105,000 makes it the largest in Europe and third largest in the world. A 215-square-yard (180-square-meter) area for commemorative plaques and ashes of deceased blaugrana fans sits behind large murals highlighting the club's most evocative moments.

Spain / Europe

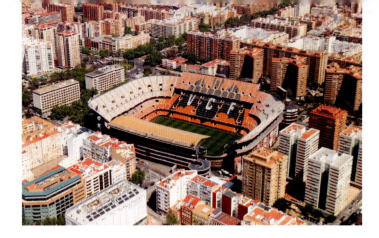

Estadio Mestalla
VALENCIA (VALENCIA CF)

This stadium comes out of nowhere, tall but hidden within the city streets and apartment buildings. The club has adopted orange as one of its key colors, an homage to the Valencia oranges that grow throughout the region. This shade of orange provides the backdrop in the stadium, but the key figure here, of course, is the big black bat. The main symbol of the city spans three steep stands of this glorious old ground, and is proudly etched into the Valencia crest.

↓→ Estadio Mestalla

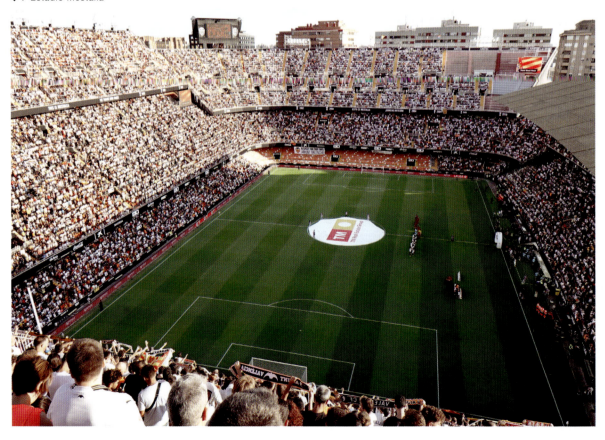

Europe / **Spain**

Estadi Ciutat de Valencia
VALENCIA (LEVANTE UD)

Often overshadowed by the neighboring Mestalla Stadium, the City of Valencia Stadium and its club, Levante, have a distinct charm of their own. On match days people of all ages head to watch Valencia's "family club." Parents and children, draped in red and blue, walk hand in hand from the neighboring districts of Els Orriols and Benimaclet, sandwiches packed and ready for the bright lights of the stadium. Until recently this was a typical Spanish bowl-style stadium, but a new roof and a couple of big screens have changed this. The playing surface is pristine, and there isn't a bad seat in the house.

Estadio Municipal de Chapín
JEREZ DE LA FRONTERA (XEREZ CD)

You can watch a Xerez CD match from the balcony of a hotel room from within their stadium. In 2002 a section at the end of the west stand was removed and replaced by a hotel, spa, and gym that extend outside the ground. A collection of trees inside the stadium represents the demarcation.

Estadio José Rico Pérez
ALICANTE (HÉRCULES CF)

The upper seats of the huge two-tiered south stand set are at a vertiginous height, all the better to enjoy the view of the Hércules CF's formations on the immaculate pitch below. A young Maradona scored two goals against Hungary here during the 1982 World Cup.

Estadio Nuevo Colombino
HUELVA (RECREATIVO DE HUELVA)

Be prepared for the heat of the Andalusian sun. Other than a large covered main stand on the Odiel River side, Recreativo de Huelva's stands are open to the elements. This is Spain's oldest club and the year of their foundation—1899—is inscribed across the seating behind both goals.

Estadio El Molinón
GIJÓN (REAL SPORTING DE GIJÓN)

Built on the site of an old watermill, El Molinón (the Big Mill) is Spain's oldest football stadium. An infamous match was played here during the 1982 World Cup. With Germany leading Austria 1–0, and Algeria losing its match, both teams realized they would go through to the group stages whatever the score. And so they strolled around the pitch, allowing passes to go unchallenged. Any Gijón fans witnessing this in their home ground must have felt like throwing the ball in the Piles River, which flows beside the stadium.

Estadio de la Cerámica
VILLARREAL (VILLARREAL CF)

You will find this yellow submarine gleaming in the Spanish sun. The small town of Villarreal, famous for its ceramics exports, has a stunning stadium fit for any big city. The old El Madrigal stadium is now very much the new La Cerámica. Recent renovation has seen the ground covered in a bold, unmistakable, giant yellow case.

↓ Estadio de la Cerámica

177

Spain / Europe

Estadio Benito Villamarín
SEVILLE (REAL BETIS BALOMPIÉ)

This ground is famous for many reasons. Betis fans are some of the best in Spain, the green and white they adopted from Celtic makes for an iconic kit, and the Benito Villamarín dwarfs the arena of their crosstown rivals Sevilla. However, nothing is as magical as when plush toys rain down from the stand, an event organized once a year. The toys are gifted by the home fans to disadvantaged children at Christmas.

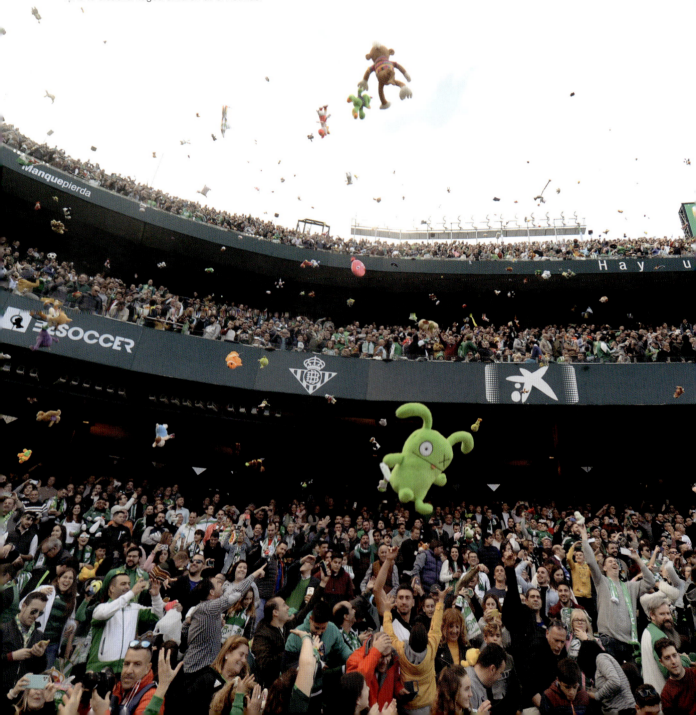

Europe / **Spain**

Estadio Ramón Sánchez-Pizjuán
SEVILLE (SEVILLA FC)

The stands at the Ramón Sánchez-Pizjuán are so steep that Sevilla fans are known to tumble into the rows below after a goal celebration. The excellent weather here means the stadium wasn't built with a roof, and if anything, one might provide some shade from the hostile Andalusian heat. This isn't the biggest stadium in the world, but it is the home to famous European nights.

UD Almería Stadium
ALMERÍA (UD ALMERÍA)

The players' tunnel has the words "Sons of the Desert" next to the Almería crest on the wall and "*esta batalla sera un inferno*" on the other, repeated in English in huge letters on the floor—"THIS BATTLE WILL BE HELL." This rallying cry, and warning to the opposition, flows through the stadium. Every inch of the exterior and interior is a bright "hell" red.

Reale Arena
SAN SEBASTIÁN (REAL SOCIEDAD DE FÚTBOL)

This modern arena in the Basque country has big blue stands that hug the roof like a wave. Above the Anoeta, as its is known, the treetops come into view, and a breeze drifts in from the northern coast a few miles away.

Estadio Municipal Butarque
LEGANÉS, MADRID (CD LEGANÉS)

The home of Leganés is a perfect earring stadium. The "ring" runs uncharacteristically tight to the pitch, meaning the corner seating curves around the corner flags. There's little room for a run-up when whipping the ball into the box. A blue mural of celebratory fans runs the length of the entrance that forms the "jewel" of the earring. The Butarque River runs close by and gives the stadium its name.

Estadio Municipal de Santo Domingo
ALCORCÓN, MADRID (AD ALCORCÓN)

Real Madrid were the first visitors to the Santo Domingo for a friendly to celebrate its opening in 1999. Little did Los Blancos know that ten years later, at the same stadium, their third-tier opponents AD Alcorcón would defeat them 4–0 in the Copa del Rey. Real, fielding a world-class team including Raúl, Marcelo, Benzema, and Kaká would not have enjoyed the fifteen-minute coach ride home.

← Estadio Benito Villamarín

Spain / Europe

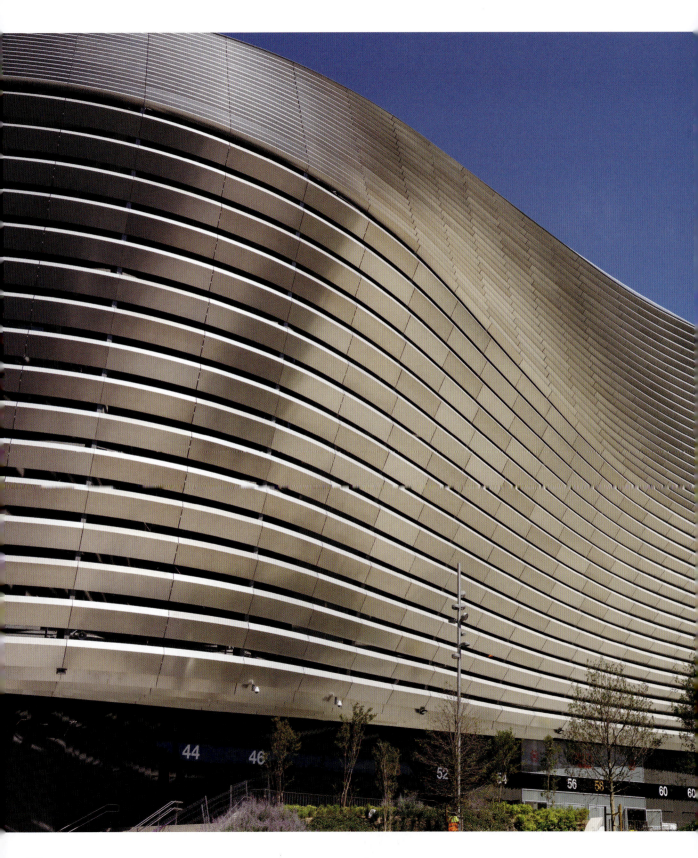

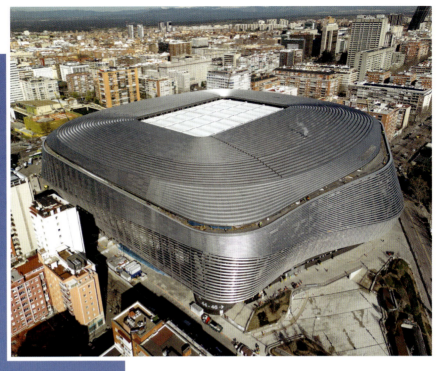

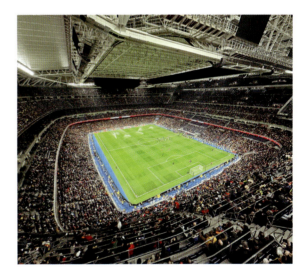

Estadio Santiago Bernabéu
MADRID (REAL MADRID CF / REAL MADRID CF FEMENINO)

Perhaps the greatest stadium of all, the Bernabéu has been remodeled to resemble a spaceship from afar. But inside, this is very much a football cathedral, one where players come out of the tunnel and have to lean back in order to see the top of the stands. Now fitted with a giant 360-degree screen, this arena lives up to the reputation of being home to Real Madrid, the most successful club in European football history.

Spain / Europe

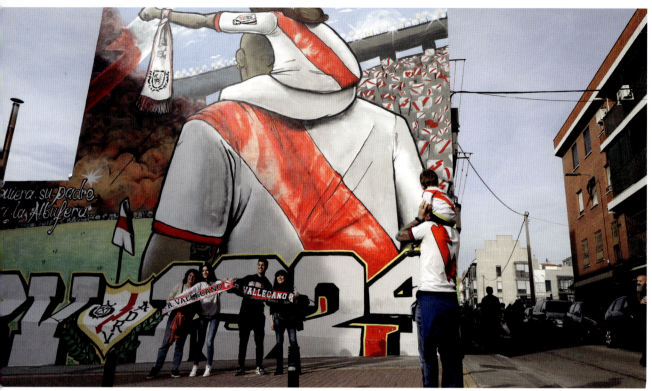

↑ Estadio de Vallecas

Estadio Alfredo Di Stéfano
MADRID (REAL MADRID CF FEMENINO / REAL MADRID CASTILLA)

As you walk through the main gate, a monument to club legend Alfredo Di Stéfano greets you. The stadium is within a natural bowl, and access to the west stand is via two bridges where you'll see four huge Champions League trophy replicas on plinths. The name of Alfredo Di Stéfano is written large across the west and east entrances, above a series of sepia images of the great Real Madrid team of the 1950s. Inside, the stadium is compact, with a lush, slick playing surface. Home to Real Madrid Femenino and the reserves, Castilla, you can join six thousand Merengues and watch the famous Los Blancos.

Estadio de Vallecas
MADRID (RAYO VALLECANO)

Life in Madrid's Vallecas neighborhood revolves around its beloved football club Rayo Vallecano, and the red lightning bolt synonymous with the team is visible on every wall and pavement of the area. Stunning graffiti and weekend fanfares show that Rayo is a community and social movement as well as a football team.

Riyadh Air Metropolitano
MADRID (CLUB ATLÉTICO DE MADRID)

One of the most modern stadiums in Europe is also home to one of the most booming atmospheres. At this ground on the outskirts of Madrid, every seat, stall, and blade of grass is perfectly placed. Yet on match days, the home fans fill the grand emptiness with a burning passion. From the arrival of the team bus to the moment the Atlético de Madrid players leave the field, a match here is up there with the best.

Estadio de La Romareda
ZARAGOZA (REAL ZARAGOZA)

This stadium, set on the university side of town, has a harsh, brick-built exterior that might make you think of an old school—they are the sort of walls that you could kick a ball against during recess. Yet it has hosted events such as the World Cup. Its towering floodlights stretch into the sky, while the stadium itself is built into the ground. An iconic corner of Zaragoza.

→ Riyadh Air Metropolitano

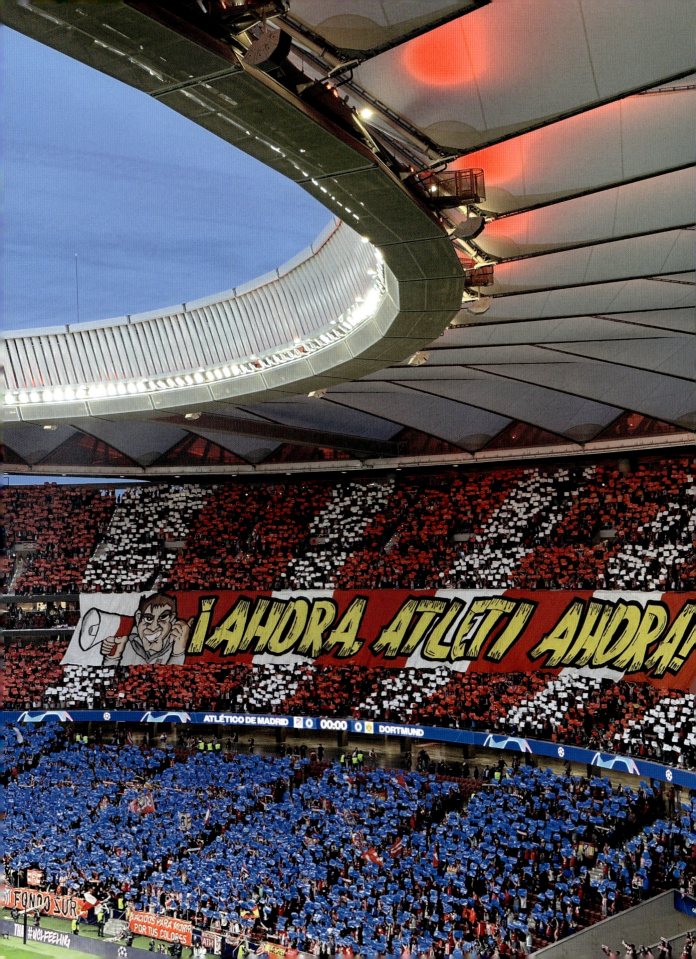

Spain / Europe

↓ Ipurua Municipal Stadium

Ipurua Municipal Stadium
EIBAR (SD EIBAR)

The Ipurua Municipal Stadium is nestled in the valleys of the Basque country and like Eibar, its resident team, it is humble and unassuming but with plenty of recent improvements. It is small enough to not look out of place at amateur level, but continues to write its own history as its team flies high. Locals in neighboring high-rise apartment buildings have the best view of the pitch; those inside the ground can almost breathe on the players, and the ground is surrounded by lush, green hills. The rise of Eibar from the Spanish lower division to La Liga saw the ground undergo necessary renovations in 2016 and 2019 so that it was fit to host visitors such as Lionel Messi.

Estadio José Zorrilla
VALLADOLID (REAL VALLADOLID CF)

The José Zorrilla Stadium is a purple bowl set in a city that is situated in the terrain they call "empty Spain." In the area between Madrid and the coast, people are scarce, but here a population of under three hundred thousand has a football ground fit for 10 percent of the whole city. The budget definitely went to the brightly colored seats, because the facade of the stadium isn't pretty. In September 2018 Ronaldo Nazário became the owner of Real Valladolid CF.

Estadio El Sardinero
SANTANDER (REAL RACING CLUB)

El Sardinero almost feels like an English ground. Unlike many stadiums in Spain, the roof covers every seated part and, although small, the stands almost touch the pitch. The players and fans interact with ease here. It has even been the home of some *Game of Thrones*–themed tifos by the Racing Club de Santander fans.

Estádio Carlos Belmonte
ALBACETE (ALBACETE BALOMPIÉ)

From certain angles, Albacete Balompié's stadium looks like a small replica of Madrid's new Estadio Santiago Bernabéu, where a silver shell covers the exterior. From other angles, the architecture is less attractive, and the silver looks rather flat, its appearance more like a automotive mechanic's garage. The stadium has a redbrick base and a small tower too, and its rusty gates bring Real Madrid fans back down to earth when they come to town.

Estadio Santa María de Lezama
LEZAMA (ATHLETIC CLUB)

The Estadio Santa María de Lezama is famous for its perfect pitch, state-of-the-art facilities, and unique sideline architecture. You might mistake this structure for a highway bridge or perhaps even the Wembley arch, but it is neither. It is striking in appearance and supports the roof of the stand below, which guards one of four tight terraces.

Estadio Nuevo Mirandilla
CÁDIZ (CÁDIZ CF)

Old town in the morning, football in the afternoon, beachside restaurant in the evening. And don't forget to stop at the Mercado Central for some paella, and buy some sunflower seeds for the match. If the weather is hot, you'll want a seat in the stadium's only covered stand or lap up the breeze off the Bay of Cádiz.

Estadio Coliseum
GETAFE (GETAFE CF)

The stadium was originally named the Coliseum Alfonso Pérez, after the city of Getafe's most successful player, although he never played for Getafe CF. His name was removed when he made negative comments about women's football in an interview. The name Coliseum sounds way cooler anyway. And the stadium celebrated the women's game when it hosted the Champions League final in 2010.

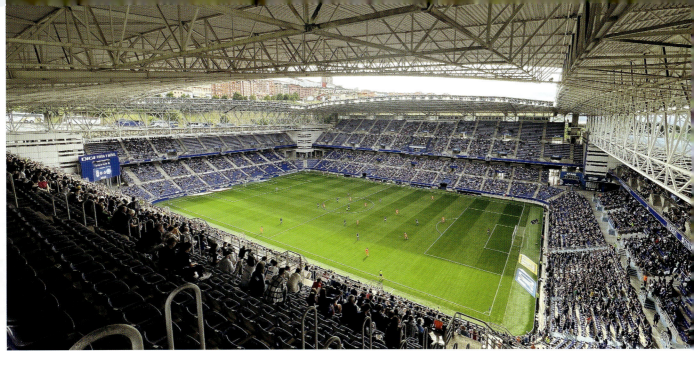

Estadio Carlos Tartiere
OVIEDO (REAL OVIEDO)

This ground has it all. It may look like a concrete beast from the outside, but on closer inspection, even the framework is easy on the eyes. Hollow rings cut out of the concrete act like windows that stretch across the concourse, while Oviedo's blue shirts fly past in the distance. Despite having four traditional separate stands, the corners of the ground are filled in to trap the incredible atmosphere, keeping the noise in and the wind out. The stadium is the focal point of the community, so much so that the locals, alongside some big-name former players, saved their beloved Real Oviedo from sinking into financial oblivion in 2012.

Spain / Europe

San Mamés
BILBAO (ATHLETIC CLUB BILBAO)

The San Mamés is one of the diamonds of Bilbao, a city where the people are as wonderful as its landmarks. The new San Mamés lights up the night sky in red and white, while the noise in this new arena is deafening. A long avenue of bars and restaurants connects the city center and the stadium and sings with life and color on match days.

Estadio Municipal de El Plantío
BURGOS (BURGOS CF)

The Estadio Municipal de El Plantío is home to Burgos CF. This small club from a little town in the north of Spain punches above its weight at this cute and quaint arena. Remodeled and repainted to appear gleaming white in 2018, this was once an old tin shed of a ground, constructed in 1963 for little over ten thousand spectators.

Estadio Municipal Cartagonova
CARTAGENA (FC CARTAGENA)

This stadium—an open concrete structure with no roof to protect spectators from the burning Murcia sun—stands alone on the edge of town. The surrounding area is full of palm trees and red soil; it's too far south for green grass. A river runs along one side of the ground and there's a park with grand statues on the other; apartment buildings provide the backdrop on the northeast side.

Estadio Abanca Balaídos
VIGO (RC CELTA DE VIGO)

Waves of steel on the exterior of the Estadio Abanca Balaídos mimic the nearby Atlantic Ocean. As you walk toward the ground you might think it's moving. A series of renovations spanning a decade saw the historic stadium, built in 1928, evolve into the modern football-specific venue you see today. The North Tribuna was even moved 3 yards (3 m) closer to the pitch.

Estadio Gran Canaria
LAS PALMAS, CANARY ISLANDS (UD LAS PALMAS)

The top row of seats backs directly onto the streets surrounding the stadium. You could literally stand up, turn around, and walk straight into the local Spar for a bag of sunflower seeds and a can of Dorada. The pitch sits well below ground level, but the stands are extremely shallow. It's a fantastic atmosphere close to the sea; just don't sit behind anyone wearing a large hat.

Estadio Virgen de las Nieves
SANTA CRUZ DE LA PALMA, CANARY ISLANDS (SD TENISCA)

The poetically named Our Lady of the Snows Stadium is built into the hillside, and sits on an artificial plateau overlooking the Atlantic Ocean. A mountain road passes above pitch level along the west side. The south section falls away into a training pitch, and the east into the valley. A tiki-taka style of play, stroking the ball along the surface, is preferred to avoid seeing a wayward aerial ball rolling down into the village of Las Toscas below.

Estadio Nuevo Silvestre Carrillo
SANTA CRUZ DE LA PALMA, CANARY ISLANDS (CD MENSAJERO)

When a group of friends who played football together in the hills of Santa Cruz de la Palma decided to form a youth team in 1922, little did they know that the club, CD Mensajero, would have their own extraordinary stadium built into the rocks near their homes in Barranco de los Dolores (the ravine of sorrows). Or that their club would make it all the way to Segunda B, the third tier of Spanish football.

Estadio Heliodoro Rodríguez López
SANTA CRUZ DE TENERIFE, CANARY ISLANDS (CD TENERIFE)

A red archway forms the street entrance to the Estadio Heliodoro Rodríguez López. The ground was constructed in 1925, and since then it has hosted Spanish national team matches. Built among the city, hills, and sea, this symmetrical arena is the perfect spot to visit during a summer vacation.

Estadi Mallorca Son Moix
PALMA, MALLORCA, BALEARIC ISLANDS (RCD MALLORCA)

The Mallorca Son Moix is one of those visually ingriguing stadiums, often seen in South America, where construction is deliberately left half complete. It was built as a sunken bowl with two steep opposing double-tiered stands, one with a roof, and the ends are yet to be connected.

↑ San Mamés

Gibraltar/Portugal / Europe

GIBRALTAR

Europa Point Stadium
GIBRALTAR (NATIONAL TEAM)

Europa Point is notorious for being the spot where unloaded cars that had carried contraband across the Spanish border would be pushed into the sea to avoid detection. Now, it is home to the Gibraltar national football team. Their previous home, the Victoria Stadium, was known for its breathtaking location. Europa Point Stadium is better still. The other side of the Rock of Gibraltar, next to the lighthouse and serene white mosque, looking out to the Strait of Gibraltar and the Alboran Sea, is a little cove of perfection. The stadium allows you to take it all in, with stands on just two sides and facing the rock.

PORTUGAL

Estádio Nacional
OEIRAS (CASA PIA AC)

The stadium looks like a building in the process of being overcome by nature, but the iconic concrete bowl stands its ground among the trees. The south side opens out into a walkway and then to a stadium flanked by the trees that flow into it. You can even watch the Portuguese Cup final sitting beside an oak tree if you sit in sectors 43 or 44. The stadium is a must-visit for Glasgow Celtic fans since their team won the 1967 European Cup final here against fancied Internazionale, and gained them the name the Lisbon Lions.

Estádio do Marítimo
FUNCHAL (CS MARÍTIMO)

The Estádio do Marítimo is built into a hillside, placing the roof of the west stand at street level. On the east side the land tapers away, allowing for a three-story parking garage under the east stand. This leads to a promenade on level four, and a viewing deck that looks out over a panorama of the city, Madeira Mountains, and Funchal Bay.

↓ Europa Point Stadium

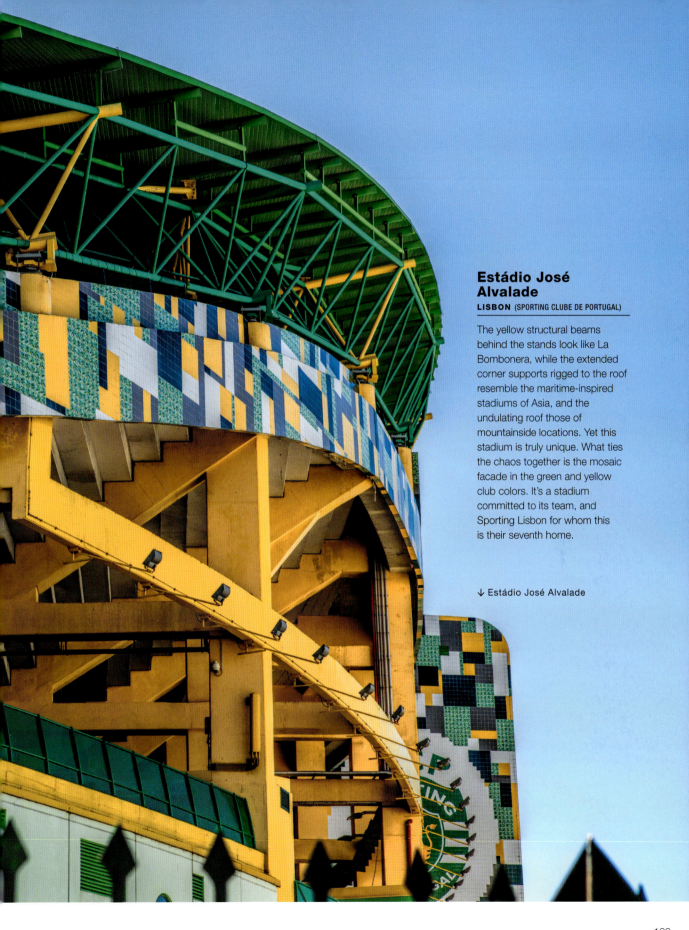

Estádio José Alvalade
LISBON (SPORTING CLUBE DE PORTUGAL)

The yellow structural beams behind the stands look like La Bombonera, while the extended corner supports rigged to the roof resemble the maritime-inspired stadiums of Asia, and the undulating roof those of mountainside locations. Yet this stadium is truly unique. What ties the chaos together is the mosaic facade in the green and yellow club colors. It's a stadium committed to its team, and Sporting Lisbon for whom this is their seventh home.

↓ Estádio José Alvalade

Portugal / Europe

Estádio do Sport Lisboa e Benfica
LISBON (SL BENFICA)

The design of this stadium is twinned with Arsenal's Emirates Stadium in London; big red waves form a ground fit for the finest style of play and the bright lights of the Champions League. Outside the arena known as da Luz, a statue of team hero Eusébio stands proud, a reminder that once upon a time, Benfica was the biggest side on the Continent, and set the standard globally.

Estádio de São Miguel
PONTA DELGADA, THE AZORES (CD SANTA CLARA)

This small earring-shaped stadium set in green surroundings on São Miguel Island hasn't changed dramatically since it was built in 1930. Remarkably for such a small stadium far away from the mainland, it has hosted the Portuguese national team, when Luís Figo starred in a 2–0 win against Egypt.

Estádio D. Afonso Henriques
GUIMARÃES (VITÓRIA SC)

If there were a manual explaining the perfect magnet-style stadium, it would show you the Estádio D. Afonso Henriques. The main structure is a three-sided covered curve that picks up a metallic, rectangular grandstand. It is compact, the sight lines are fantastic, and it fuses with its surroundings.

Estádio Algarve
ALMANCIL (LOULETANO DC)

The unusual architecture of Estádio Algarve is based on Portugal's seafaring traditions. The roof mimics two sails, supported by four tall metal "masts" held up by rigging that extends far outside the stadium's walls. The design of the stands, including those behind the goals, which also sit outside the main structure of the building, mimics waves. Unusually, this large, modern stadium is home to fourth-tier Louletano DC. But it also hosts the Portuguese national team. Cristiano Ronaldo scored his 110th goal (against the Republic of Ireland) here in 2021, becoming the all-time leading men's international goal scorer.

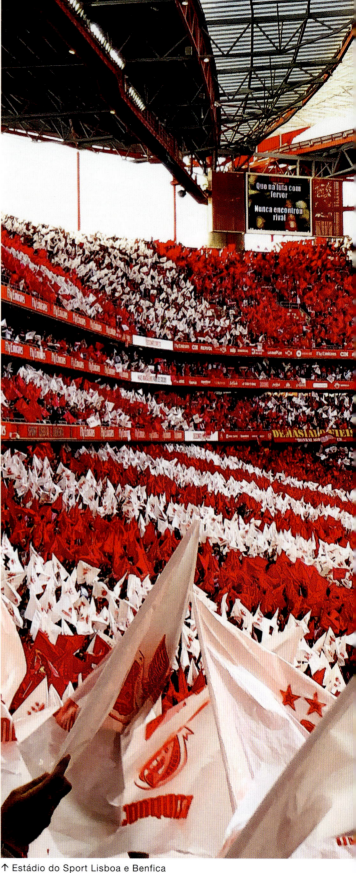

↑ Estádio do Sport Lisboa e Benfica

Europe / **Portugal**

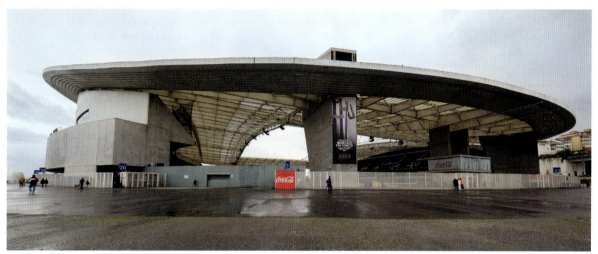
↑ Estádio do Dragão

Estádio Municipal de Arouca
AROUCA (FC AROUCA)

The stadium was built in 2006 for AC Arouca when they played in the minor district leagues. It was renovated and expanded when they made it all the way to the Primeira Liga.

Estádio José Gomes
AMADORA (CF ESTRELA DA AMADORA)

An unusual feature spans above the seats of Estádio José Gomes's south stand—the huge concrete exterior wall of a bingo hall. The rest of the stadium juxtaposes this oddity with colorful seating and an immaculate pitch, accompanied by two equally impressive training pitches and two large floodlights behind the east stand.

Estádio do Dragão
PORTO (FC PORTO)

If you follow the locals from the city center to the Estádio do Dragão (Dragon Stadium) you can stop for a Sagres (beer) and a *francesinha* (meat sandwich) along the way, or maybe even a *bifana* (pork sandwich) outside the ground. This city supports its team in constant battles with its two famous rivals from Lisbon, and the Dragon often rears its head on the European stage.

Estádio do Bessa
PORTO (BOAVISTA FC)

Boavista FC was founded by workers at a textile factory and are known as the Chequered Ones due to the factory's signature cloth. This feeds through to the look of the snug, compact stadium with three-quarters of the extremely steep seating covered in black-and-white checks. On match days, Panteras Negras create a visual spectacle with flares and tifos, although the stands rarely fill up unless the big three of Porto, Benfica, or Sporting are visiting. When they do, it gets intense.

Estádio Municipal de Braga
BRAGA (SC BRAGA)

Built into an old quarry, this is no ordinary football ground; it is renowned for having one of its stands traded in for a cliff. Bare and brutal, it is a lasting image of a wonderful Euro 2004 tournament and is unlike any other stadium in the world.

Estádio Municipal Eng. Manuel Branco Teixeira
CHAVES (GD CHAVES)

Built in 1949, the Manuel Branco Teixeira has a long history and witnessed the first game of Portugal's greatest ever goalscorer. Cristiano Ronaldo made his debut for the national team here in a match against Kazakhstan in 2003, winning 1–0.

Belgium / Europe

BELGIUM

Edelhart de Lille Stadion
MALDEGEM (FC SOBEMEI)

Players taking a corner kick on one side of this stadium have to take a very short run-up or they will collide with a dilapidated railroad car. The ground sits on land that was earmarked for a theme park that never materialized. Sometime before 1970, Maldegem resident and the man behind the plan, Edelhart de Lille, started to collect railroad cars, engines, and more to fulfill his dream. But when it didn't happen, the collection was left to deteriorate, creating a train graveyard. Then, in 1973, FC Sobemei was evicted from their stadium. De Lille suggested that his train graveyard would make a perfect football venue, with plenty of space for a pitch and some stands, but stated that the trains had to stay. The result is a football ground where rusty engines can puncture the ball and wayward shots can lead to searches inside train carriages.

Jan Breydelstadion
BRUGGE (CLUB BRUGGE KV / CERCLE BRUGGE KSV)

Flemish pride boils over into this modern stadium—which is home to both Club Brugge and Cercle Brugge—thanks to its vociferous fan base. The attendance of Club Brugge matches dwarfs that of Cercle Brugge events. The stadium is named after a member of the fourteenth-century Flemish militia who led a massacre against French rule in the city.

Stade Maurice Dufrasne
LIÈGE (ROYAL STANDARD DE LIÈGE)

Enjoy a *frites mayonnaise*—a cone of French fries with a large dollop of mayonnaise on top like a soft-serve ice cream—while watching one of Belgium's most successful clubs in a stadium shaped like a giant red horseshoe magnet. What's not to like? Well, there is another side. Standard Liège matches against other elite clubs can become heated. The Liege Ultras Inferno 96 see themselves as representing the industrial workers against the more "bourgeois" clubs. Matches against RSC Anderlecht are known as the Classico.

King Baudouin Stadium
BRUSSELS (NATIONAL TEAM)

The crumbling Heysel Stadium was completely rebuilt in 1995, ten years after the disaster of the European Cup final between Liverpool and Juventus, when thirty-nine Juve fans were killed. The horseshoe-shaped replacement stadium was given a new name and a fresh start.

AFAS Achter de Kazerne Stadium
MECHELEN (KV MECHELEN)

An army base once stood beside the stadium and gives the ground its name; it means "behind the barracks."

Edmond Machtens Stadium
MOLENBEEK-SAINT-JEAN (RWD MOLENBEEK)

The approach to the Edmond Machtens Stadium takes you past graffiti-tagged walls and to the entrance to one of two aging grandstands where copper-colored curved support beams protrude from the building. Inside, the stands are close to the pitch, but thousands of seats are deliberately left empty for security reasons. Despite the roar from the crowd being somewhat tainted by this, the atmosphere still has an intensity that comes with fans from a phoenix club. When RWD Molenbeek's previous incarnation was declared bankrupt in 2002, some fans kept the club going, starting again in the lowest tier of Belgian football and making it back to the pro leagues.

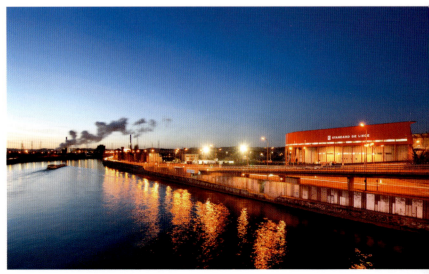

↑ Stade Maurice Dufrasne

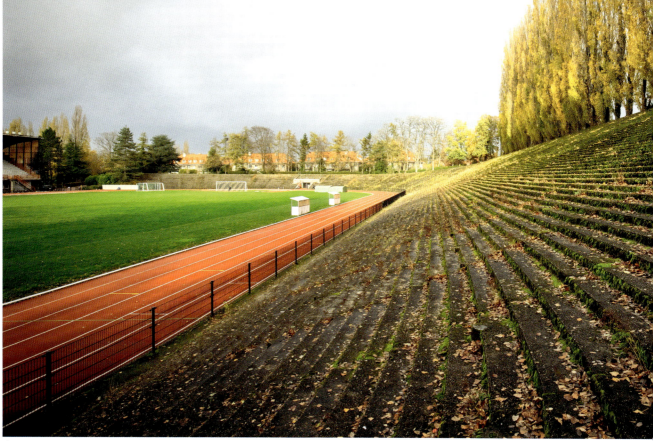
↑ Stade Trois Tilleuls

Joseph Marien Stadium
FOREST (ROYALE UNION SAINT-GILLOISE)

Union Saint-Gilloise's stadium is an enigma. The art deco entrance, designed by Oscar De Clerck, is a wonderful example of 1926 bas-relief. Behind the entrance is a pleasant covered grandstand, and to the north a small modern stand. To the south is a large tiered concrete curve with basic plastic seating, and to the east a desolate concrete terrace, both overcome by the nature that surrounds them.

Bosuilstadion
ANTWERP (ROYAL ANTWERP FC)

Fans of Royal Antwerp can be seen displaying their passion for Belgium's oldest club (founded in 1880) in the form of red smoke bombs and tifos celebrating their heritage.

Legrand Stadium
HUY (ROYALE FOOTBALL CLUB DE HUY)

With so much green space available, playing next to the Tihange nuclear power plant seems to be an inspired choice. Royal Football Club de Huy plays under the shadow of three colossal pressurized nuclear reactors beside the Meuse River.

Stade Trois Tilleuls
WATERMAEL-BOITSFORT (RC BOITSFORT)

The stands are made up of concrete tiered seating and moss and they haven't changed since the stadium was first built just after World War II. The rawness of the stands is in stark contrast to the wonderful line of fir trees that surround them.

Gemeentelijk Sportpark Molenbaan
BAARLE (KVV DOSKO BAARLE-HERTOG)

The village of Baarle is unique in that it has two football teams, each playing in a different country. KVV Dosko Baarle-Hertog plays in the Belgian league while Gloria UC plays in the Dutch league. A complex border runs through the village, with both Dutch and Belgian enclaves. The streets are marked with lines of "X" to highlight the border. Shops, bars, and restaurants that sit side by side are similarly divided. Most of the Gemeentelijk Sportpark Molenbaan is in Belgium, but the parking lot is in Holland.

Liechtenstein/Luxembourg / Europe

LIECHTENSTEIN

Rheinpark Stadion
VADUZ (NATIONAL TEAM)

The home ground of FC Vaduz and Liechtenstein's national football team, this is the only football stadium in this tiny country, which has a population of less than forty thousand. It is also one of the most beautifully located stadiums in Europe; it is surrounded by mountains and sits beside the Rhine River.

LUXEMBOURG

Stade de Luxembourg
LUXEMBOURG (NATIONAL TEAM)

From the abstract interpretation of the national flag on the seats, to the fully integrated floodlights and roof structure, this stadium is a tiny gem. It's one of the smallest national stadiums in the world, but this brings with it a minimalist quality. When its white rectangular encasing illuminates at night, it's like a pearl in sunlight.

Stade du Thillenberg
DIFFERDANGE (FC DIFFERDANGE 03)

The Stade du Thillenberg is an old rustic ground in rural southwestern Luxembourg. It is blessed with a largely wooden pavilion with an epic forest backdrop.

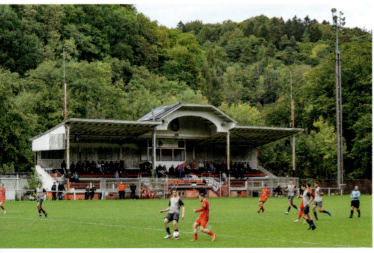

↑ Stade du Thillenberg → AFAS Stadion

THE NETHERLANDS

GelreDome
ARNHEM (SBV VITESSE)

With its glass facade and retractable roof, the GelreDome could be mistaken for a shopping center, albeit an incredibly impressive one. The stadium is home to Holland's second oldest club, Vitesse Arnhem, formed in 1892, and has hosted both the men's and women's Dutch teams as well as the group stages of Euro 2000.

Parkstad Limburg Stadion
KERKRADE (RODA JC)

The prominent strips of blacked out windows and yellow cladding across the entire exterior are based on the crest of the home club, Roda JC Kerkrade. From a distance, the segmented nature of the design looks like a cityscape. The four floodlights in the corners of the roof are equally as eye-catching. They lean over the playing area from pitched-tent style supports.

AFAS Stadion
ALKMAAR (AZ ALKMAAR)

The stadium opened to an expectant crowd with a friendly against Arsenal. AZ Alkmaar lost 3–0. They then went on to win their first competitive game 8–1. Settle down in the Victorie Tribune (as its fans call it) and expect fireworks.

Kras Stadion
VOLENDAM (FC VOLENDAM)

Kras Stadion is an extension of the community buildings around it; one stand looks like an office block, one like apartments, and one actually is a school that backs onto the stadium. There's a pleasant narrow waterside path on the south side. All of this coziness, yet there's room for eight further football pitches to the west side.

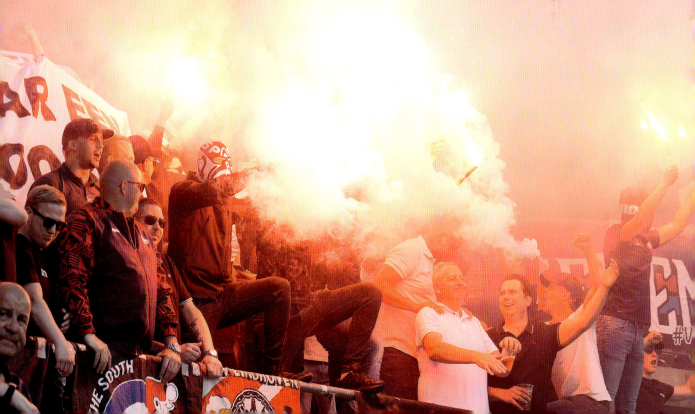

The Netherlands / Europe

Euroborg
GRONINGEN (FC GRONINGEN)

Two apartment buildings extend from a riverbank and loom over the Euroborg stadium. Their design is integrated with that of the ground, making the complex appear as one. Inside the stadium has a tight, cozy feel with perfectly spaced seating. Fans are close to the pitch and are joined by spectators viewing from the upper floors of the apartment buildings.

Johan Cruijff ArenA
AMSTERDAM (AFC AJAX)

The name of this arena says it all. Home to Ajax and the Dutch national team, this is a place where trophies have been won, legends have been born, and football has been revolutionized. This youth academy keeps churning out talents just like "king" Johan would have wanted. And when the roof closes on this stadium, you had better be ready for the noise.

Stadion Feijenoord
ROTTERDAM (FEYENOORD / NATIONAL TEAM)

Ever since its initial build in 1937, two free-hanging tiers have circled the Stadion Feijenoord, a feature it shares with few other arenas, Yankee Stadium in New York being one. The resulting oval shape with high walls and steep stands gives it its nickname De Kuip (the Tub). And within the compact tub, with seating tight to the pitch, the very foundations are said to shake when fifty-thousand-plus Het Legioen really get bouncing on match day. The team and support are so intertwined with their home that they are known as De Stadionclub (the Stadium Club).

Sparta Stadion
ROTTERDAM (SPARTA ROTTERDAM)

The Sparta Stadion's nickname Het Kasteel translates as "the Castle." It refers to the historical facade that has remained completely intact since the stadium was first built in 1916, while renovations have gone on around it. The turreted twin-towered pavilion even stood firm when the stadium orientation was rotated ninety degrees. The oldest stadium in the Netherlands is also home to the country's oldest team, Sparta Rotterdam, formed in 1888. With a capacity of just 11,026, and with the team's success, book tickets early as they tend to sell out.

↑ Sparta Stadion

GERMANY

WWK Arena
AUGSBURG (FC AUGSBURG)

Take in the Augustus Fountain, Town Hall, historic Fugger housing complex, and the old town along the Lech canals. Then stroll to the Rosenaustadion beside the Wertach River, FC Augsburg's historic former stadium where the reserve team still plays. And finally, to the edge of town and the WWK Arena—the home of Bundesliga football.

Voith-Arena
HEIDENHEIM AN DER BRENZ (1. FC HEIDENHEIM)

A stadium that sits in the center of a forest and sees the full glory of the four seasons unfolding around it. When the German season starts, solar panels soak up the last of the summer sun and the surrounds begin to turn from green to brown.

Allianz Arena
MUNICH (FC BAYERN MUNICH)

When Franz Beckenbauer passed away, Bayern Munich was able to honor the great man with a huge demonstration of respect and affection on the side of the Allianz Arena. In huge letters "DANKE FRANZ" lit up the stadium on a background of red as 2,874 luminous inflated foil panels illuminated the sky. The arena stands out like a beacon. It becomes rainbow-colored for Gay Pride weekend, a star-spangled banner on the Fourth of July, and red, yellow, and black when the national team plays. Match day is special, but a stadium tour is worth a visit if you can't secure a ticket to a game. The museum is extensive and you get access to all the key areas, including the luxurious changing rooms. Bayern is everywhere in Munich. There's a large club shop at the airport, FC Bayern World in the center just off Marienplatz, their headquarters and training facility at Säbener Straße, a Bayern restaurant, and a Bayern hotel.

↓ Allianz Arena

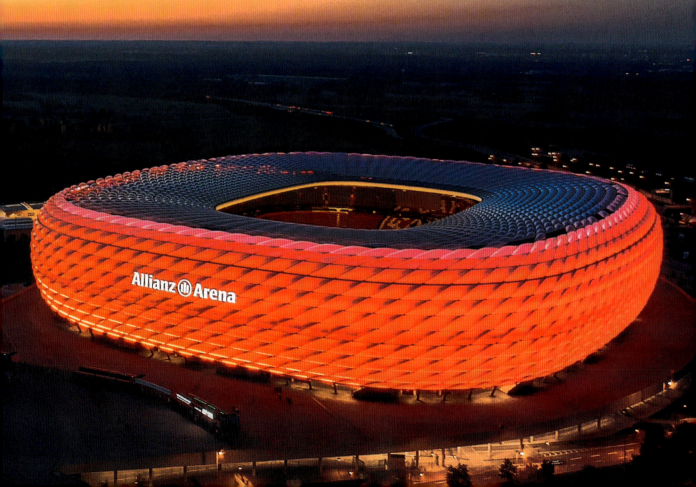

Germany / Europe

↓ Signal Iduna Park

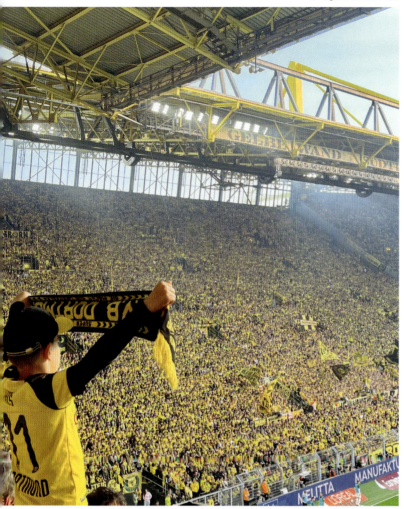

Signal Iduna Park
DORTMUND (BORUSSIA DORTMUND)

Signal Iduna Park's south stand, known as Die Gelbe Wand (the Yellow Wall), is the stuff of legend. To watch it build momentum is a magical sight. A few bodies begin to bounce, the energy flows out like a whirlpool, and soon the entire stand is jumping together. The sheer weight of the swell makes individual figures hard to make out—it has become a single unit. And the noise of twenty-five thousand harmonious standing fans will resound within you long after the match is over. Before the Borussia Dortmund players are displayed on the big screen, the opening chords of Van Halen's "Jump" come over the speakers and the Südtribüne is a mass of yellow flags. When finished, a blast of yellow poppers bursts into the air. The match is yet to begin, and your adrenaline is already pumped. Tifos can be epically choreographed, like a BVB-headband-wearing skull revealed in a slick upward flourish. They are saved largely for meetings with rivals Schalke 04 and Der Klassiker against Bayern or for big European nights.

Europe / **Germany**

Weserstadion
BREMEN (SV WERDER BREMEN)

Werder translates as "river peninsula," and that's exactly where Werder Bremen's stadium resides. The Weser River flows alongside it, giving the stadium its name while it is reflected in the exterior's glass-paneled facade. The roof was built using photovoltaic panels, meaning the structure itself is a solar-powered system. The four cylindrical towers on the southside and the floodlight towers are a legacy of the old Weserstadion, but add an extra charm to the arena.

Europa-Park Stadion
FREIBURG IM BREISGAU (SC FREIBURG)

In the heart of the Black Forest is the new home of SC Freiburg. It's never easy for fans to say goodbye to their spiritual home, and the Schwarzwald-Stadion is still used by the reserve team. Yet the German tradition for standing terraces perhaps enhances the chance of a smooth transition. One-third of the Europa-Park—the area behind both goals with one section emblazoned with a huge club crest—is standing. It just remains for the Breisgau Brazilians to bring their slick style of play.

Waldstadion
FRANKFURT AM MAIN (EINTRACHT FRANKFURT)

Waldstadion translates as "Forest Stadium" and it's no surprise the stadium was given this name, as it stands in the heart of Frankfurt City Forest. A walk to the stadium takes you from the banks of the Main River and through the trees, or you can take a tram, train, or bus. The arena looms large over the trees with a retractable roof that looks like a cloud. When the roof is closed, the din from the ultras in the Nordwestkurve is immense.

Mewa Arena
MAINZ (1. FSV MAINZ 05)

Acres of fields filled with grass and yellow flowers surround the Mewa Arena. In contrast, the concourses above the stadium's tiers of naked concrete bustle with home fans trying to get a beer in before the action kicks off. Every detail here is red, from the seats to the subtle lighting in the pressroom, the walls of this arena to the ticket booth outside.

Fritz-Walter-Stadion
KAISERSLAUTEN (1. FC KAISERSLAUTERN)

The Fritz-Walter-Stadion looks like one of the Lego Star Wars space stations you might see advertised ahead of the holiday shopping period. Like the concrete shell of a giant tortoise, it looks equal parts quirky and powerful.

PreZero Arena
SINSHEIM (TSG 1899 HOFFENHEIM)

For a club that is a mainstay in the top division, TSG Hoffenheim is unusual in that almost the entire population of the town where its stadium is located could fit into the arena. Even more unusual is that the entire population of the village where the club originates could fit behind the goal on its south terrace. The beautiful historic village has 3,200 residents. The stadium 3 miles (5 km) away holds more than thirty thousand.

↓ Mewa Arena

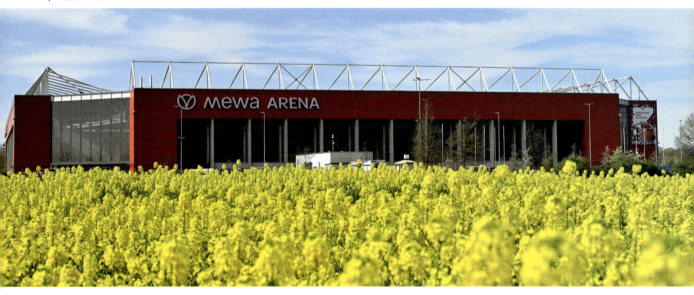

Germany / Europe

Volkswagen Arena
WOLFSBURG (VFL WOLFSBURG)

Fans of VfL Wolfsburg have been on an incredible journey, from the building of their city by the Nazis just before the outbreak of World War II in 1938, to an improbable Bundesliga title seventy years later. The city was built as a center for the production of the Volkswagen, the People's Car. Fittingly the Volkswagen Arena looks like a giant VW showroom, with its boxlike shape, glass-panneled facade, and flat roof. The Aller River flows beside it, and the club's original home still stands right across the river, preserved as a national monument.

AOK Stadion
WOLFSBURG (VFL WOLFSBURG WOMEN'S TEAM)

The AOK Stadion sits right next to the Volkswagen Arena and is home of the highly successful Wolfsburg women's team. Within the main stand you can visit a museum dedicated to both the men's and women's teams, and where children can play football. Arguably more beautiful than its larger cousin, the stadium has a tree-lined walkway that leads you to a green-fronted lakeside entrance.

Sportanlage Heiligengeistfeld
HAMBURG (SC HANSA HAMBURG)

SC Hansa Hamburg plays under the shadow of an unworldly World War II bunker, now a sprawling apartment building. And directly behind them is the stadium of St. Pauli.

Volksparkstadion
HAMBURG (HAMBURGER SV)

It's hardly surprising that Hamburger SV's stadium is almost identical to VfB Stuttgart's Neckarstadion. Or that it is a carbon copy of the Imam Reza Stadium in Iran, only bigger. They all share the same architect.

Heinz von Heiden Arena
HANOVER (HANNOVER 96)

A stadium set in magical surroundings, the Heinz von Heiden Arena is enveloped by trees and flanked by the Ihme River and Maschsee Lake.

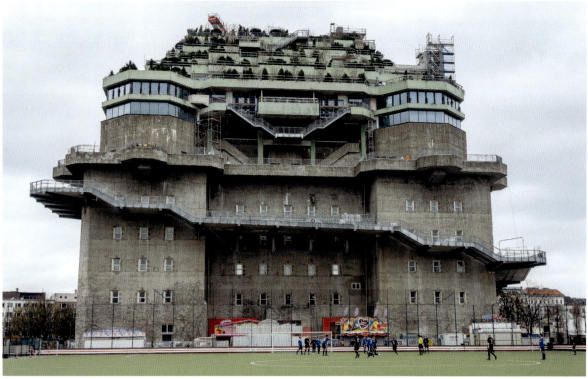

↑ Sportanlage Heiligengeistfeld → Heinz von Heiden Arena

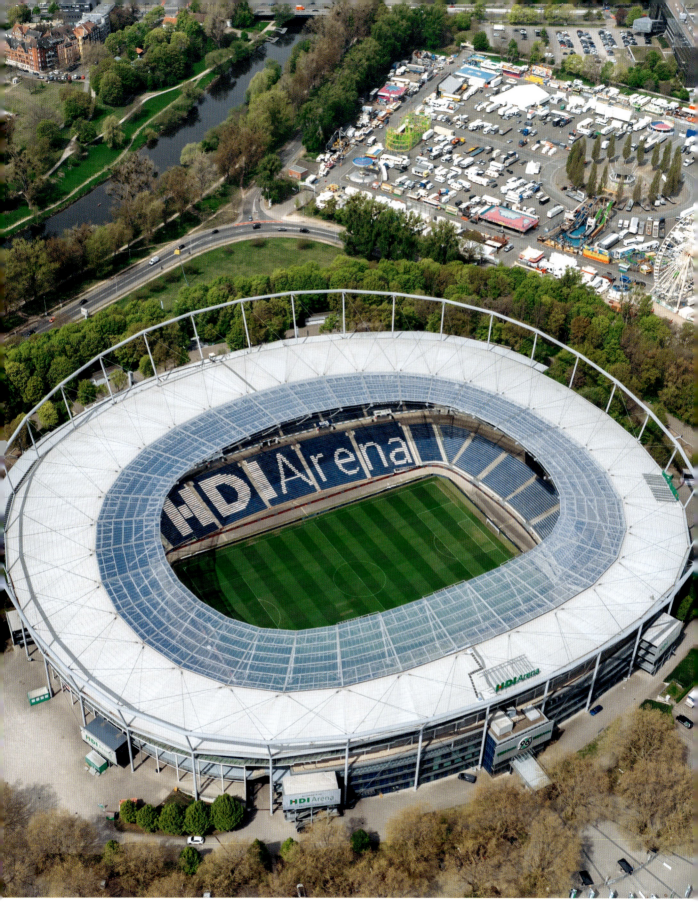

Europe / **Germany**

Milllerntor-Stadion
HAMBURG (FC ST. PAULI)

Long regarded as one of the coolest clubs in the world, FC St. Pauli is many people's second team. And judging by the celebrations in the streets of Hamburg when they returned to the Bundesliga in 2024, many people's first. The 29,546-capacity Millerntor-Stadion is almost always full, half of which is season ticket holders. If you can get a ticket, you'll experience an atmosphere like no other. Every goal is met with Blur's "Song 2" and a massive "woo-hoo" from the crowd. The skull and crossbones is everywhere in the stadium, including the corner flags. Brought to the stadium by the nomadic commune-living punk Doc Mabuse, and originating at AEK Athens who shares the same antiestablishment left-wing values and friendship, it is their icon. Steps leading to the away end read "Welcome to the Hell of St. Pauli." Visiting players walk through a tunnel to the pitch that looks like a postapocalyptic biker bar: black walls, red luminescent graffiti, and a projected skull and crossbones across the exit. The Millerntor's location in the red-light district known as *die sündige meile* (the sinful mile) only adds to the offbeat nature of this cult club.

Germany / Europe

Merkur Spiel-Arena
DÜSSELDORF (FORTUNA DÜSSELDORF)

Intriguingly this arena is a cube on the outside and an oval on the inside. A hotel projects out from the south side of the stadium, and a railroad runs under it. Locomotives stop at the stadium's own station nearby. And so, the logistics are all set for a perfect visit.

Waldstadion an der Kaiserlinde
SPIESEN-ELVERSBERG (SV ELVERSBERG)

The ground that translates as "the Forest Stadium on the Lime Tree" has a unique main stand. Spikes protrude from the framework of the roof. A wayward kick could result in a punctured ball, and it's a wonder that this has never happened. Above the seating is a long balcony with a view of the forest and the spot where the lime tree once stood; it was blown down during a storm in 2015.

Max-Morlock-Stadion
NUREMBERG (1. FC NÜRNBERG)

The Max-Morlock-Stadion is a rare thing in football—an octagonal stadium. There are some pleasant walks through woods from the town to the stadium. Close by is the Zeppelin Field, the site of the Nuremburg rallies. The plinth where Hitler delivered his speeches is still there, and the stadium can be seen through the trees. The thriving place where people come together for the common love of football and camaraderie is a beautiful contrast to this relic.

Neckarstadion
STUTTGART (VFB STUTTGART)

You could start a match day at the Neckarstadion, also known as MHPArena, with a visit to the Schlossplatz and the Neues Schloss, a wonderful baroque palace and the site of celebrations for VfB Stuttgart's phenomenal 2007 Bundesliga title. The S-Bahn will then take you to the Neckarpark station, a short walk to the stadium.

Gazi-Stadion auf der Waldau
STUTTGART (STUTTGARTER KICKERS / VFB STUTTGART II)

The oldest stadium in Germany—it was built in 1905—also has the longest standing home team at a single venue—the Stuttgarter Kickers. And you can watch a match from one of the oldest stands. The original grandstand was a wooden copy of Arsenal's Highbury. It lasted until 1976 when it was replaced by the existing grandstand. The view is also an experience; it is thick with oak trees on two sides, and there are a dozen or so further pitches on the other.

Merck-Stadion am Böllenfalltor
DARMSTADT (DARMSTADT 98)

Join the Darmstadt fans when they bang their feet in unison on the newly constructed metal north stand for a fine acoustic, saved for corners and goal kicks. Or you can take a walk along the loge balcony and take in different views of the game. The walkway behind the north stand houses the Dugena clock, the legacy of a sponsor from the 1970s. Behind the walkway, the ground is thick with trees at the edge of Darmstadt Forest.

New Tivoli
AACHEN (ALEMANNIA AACHEN)

Here is a lower-league match day like no other. First a walk through historic Aachen: Aachen Cathedral, the Shrine of Charlemagne, and the fourteenth-century Town Hall. Then to the Aachener Brauhaus for bratwurst, chips, sauerkraut, and a Hefe Weissbier. Then to the New Tivoli. Wear yellow, everything is yellow. Alemannia Aachen's ultras Yellow Connection have followed their team from the Bundesliga to eleven years in the regional leagues with unrivalled passion; over twenty thousand fans coming together for fourth-tier football.

Olympiastadion
BERLIN (HERTHA BSC)

Olympic rings hang between the towering twin monoliths at the entrance of Hertha BSC's ground. It's an intimidating sight for away fans as they enter the coliseum-like cauldron. The stands are swathed in scarves and flags, while blue and white flares fire from the Ostkurve and beyond. The blue running track, which can diminish a stadium's vibe, mirrors the underside of the roof, which spans the entire stadium with electric blue panels. This creates a vociferous, compact feel and generates even greater fervor. The west side of the stadium, behind the goal, features a large void in the roof and upper tier, completely open to the outside, where the original 1936 Olympic Games cauldron sits.

↑ → Stadion An der Alten Försterei

Stadion An der Alten Försterei
BERLIN (1. FC UNION BERLIN)

The home of Union Berlin sits in a forest. To enter the arena you must climb stairs built into the grass banks that surround it. This club has an incredible story: Its fans fundraised so that it could expand, and at times they have built this stadium with their own hands. It is a football sanctuary, hidden between the red roofs and towering trees of Germany's historical capital city.

↑ Olympiastadion

205

Germany / Europe

Sportplatz an der Götzstrasse
BERLIN (BFC GERMANIA 1888)

With its three-step standing terrace and bench, Sportplatz an der Götzstrasse is as inauspicious as BFC Germania's first home. The team was formed by seventeen-year-old Paul Jestram, his brothers, and some classmates in 1888 and they played their first matches in a field, which is now an airport. Two years later they were the first German champions. The team now plays in the tenth tier, and their place in history is commemorated on a banner at their current home.

Veltins-Arena
GELSENKIRCHEN (FC SCHALKE 04)

A gigantic video pod hangs down toward the center of the pitch from the framework of a retractable roof. It's the largest of its kind in Europe. The biggest fixture in the calendar is the fierce Ruhr valley Revierderby against Borussia Dortmund. The player tunnel is built as a dark, rock-lined mining tunnel to intimidate opponents. You'll need to book tickets for this battle well in advance, as home team Schalke 04 plays to capacity for most games.

BayArena
LEVERKUSEN (BAYER 04 LEVERKUSEN)

From the outside, the BayArena looks as bland and sanitary as one would expect of a football club and ground owned by a major pharmaceutical company. However, within the winding white staircases and floating roof, a football miracle has occurred—and the stadium has an atmosphere to match. Xabi Alonso's 2024 Bayer Leverkusen revolution turned German football upside down and set this stadium on fire. Inside, the noise is deafening and the passion is off the scale. White becomes red and black, fearsome and abundant.

Schwabenstadion
GUNDELFINGEN (FC GUNDELFINGEN)

Kick back, relax, and enjoy some lower league football on the banks of Gartnersee Lake.

Wildparkstadion
KARLSRUHE (KARLSRUHER SC)

Despite its name, this stadium looks anything but wild; its clean-cut design is symmetrical and functional. Perhaps it's Karlsruher SC's fans who bring the wild to the matches—home supporters are prone to lighting a few flares, and the noise and colorful displays they provide are always spectacular. The modern design amplifies that passion.

Holstein-Stadion
KIEL (HOLSTEIN KIEL)

A trip to Holstein-Stadion is a journey back in time. By 2019, the home of Holstein Kiel Football Club had been renovated more than twelve times and, at one stage, wasn't seen as being "fit for football" by the German football authorities. Sadly this meant the modernization of a stadium that had concrete steps that acted as terraces and formed a large circle around the playing field. Today the ground is rectangular, but the look and feel still gives a nod to yesteryear.

RheinEnergieStadion
COLOGNE (1. FC KÖLN)

The RheinEnergieStadion could be mistaken for an industrial complex, or even the cool HQ of a new tech start-up. Originally built in 1921, it was rebuilt in 2004. The transformation was so successful the stadium won an award from the International Olympic Committee. The new building has the soul and character of a traditional football ground, but is set in the twenty-first century.

Red Bull Arena
LEIPZIG (RB LEIPZIG)

The Red Bull Arena in Leipzig is a mix of old and new. The entrance came from the old East Germany while the building's shiny dome belongs to a 2004 rebuild. The stadium hugs the river and is part of a multisports complex fit for summer festivals.

Vonovia Ruhrstadion
BOCHUM (VFL BOCHUM)

The Vonovia has a unique roof structure; it is divided into sections by tapering framework elements like concrete knives cutting into butter. Four towering floodlights continue this aesthetic, cutting into the corners of the roof.

Borussia-Park
MÖNCHENGLADBACH (BORUSSIA MÖNCHENGLADBACH)

The support beams of this stadium are slim and supple. They stick out of the ground and find their way up above the height of the stadium, clinging onto the roof like spider's legs. Below the white cover are neon green lights. You can't mistake this ground—it is the home of multiple Bundelisga title-winning side Borussia Mönchengladbach. Among fields and concrete parking lots this arena sits alone and powerful on the edge of town.

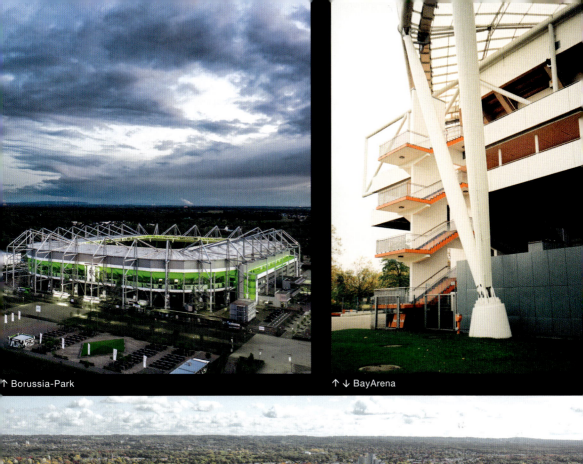

↑ Borussia-Park ↑ ↓ BayArena

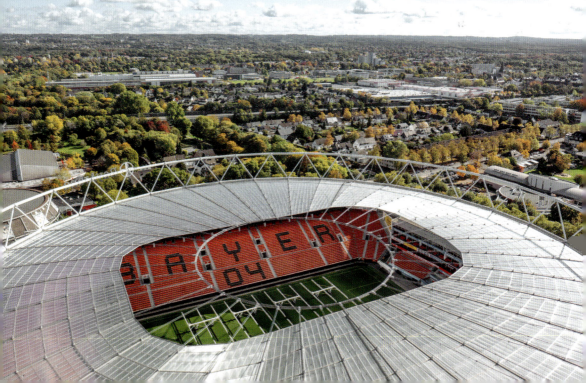

ENGLAND

Field Mill
MANSFIELD (MANSFIELD TOWN FC)

Field Mill, home of Mansfield Town, is the oldest stadium in the English football league. The ground is named after an eighteenth-century cotton mill that was once close by. The Stags have called it home since 1919, although football has been played here since the doors first opened in 1861.

The Hawthorns
WEST BROMWICH (WEST BROMWICH ALBION FC)

"The moment I walked into The Hawthorns I felt I was home," is inscribed on the statue of club legend Tony Brown outside the ground. An ornate entrance gate has a colored figurine of "the King" Jeff Astle. History is in the fabric of England's highest stadium, the first built in the twentieth century. Between the modern east stand and Birmingham Road End, the Woodman corner remains, with an effigy of the club emblem, a song thrush on a hawthorn branch.

Molineux
WOLVERHAMPTON (WOLVERHAMPTON WANDERERS FC)

Start match day at the Billy Wright pub, named after the Wolves and England legend. The stadium is just around the corner. Molineux has held onto its charm despite extensive renovations. As you approach you can see into the stadium over a low wall between the terraces.

The City Ground
NOTTINGHAM (NOTTINGHAM FOREST FC)

The stadiums of two-time European Cup winner, Nottingham Forest and the world's oldest football league club, Notts County are two of the closest neighbors in world football. The River Trent and 295 yards (270 m) divide them. County used to play even closer, next-door to Forest's City Ground on the adjacent cricket pitch. When land became available across the river, Forest helped float a stand from the cricket ground to County's Meadow Lane. A story of true neighborly love.

↓ The City Ground

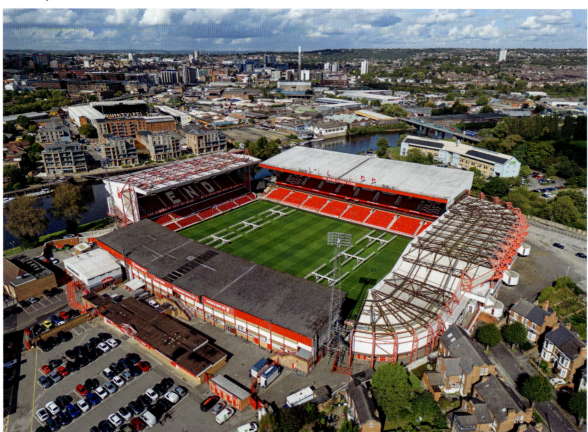

Europe / **England**

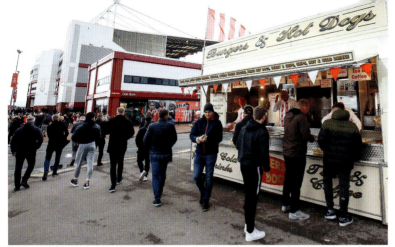
↑ Bet365 Stadium

↑ Molineux

Riverside Stadium
MIDDLESBROUGH (MIDDLESBROUGH FC)

Middlesbrough FC was an early pioneer of the modern process of stadium relocation, demolishing an iconic stadium and building a shiny new home. Ayresome Park was the club's spiritual home, but is now a housing estate. The Riverside Stadium is named correctly for its site beside the River Tees. Fans have built good memories at the ground since 1995, flirting with the Premier League and European competition, and witnessing mercurial talent like Brazil's Juninho and Italy's Ravanelli.

King Power Stadium
LEICESTER (LEICESTER CITY FC)

The site of the Foxes' miracle season, when the team with 5,000-1 odds shocked the world and took home the Premier League title in 2016. The King Power, with Thai owner Vichai Srivaddhanaprabha and family embraced by the people of Leicester, became a fortress. The team's fortunes have faded since, but that magical time with home wins against Chelsea and Liverpool will live long in the memory.

Millmoor
ROTHERHAM (MULTIPLE YOUTH TEAMS)

When Rotherham United moved to New York Stadium in 2008, it seemed their former ground would go the same way of so many others—fall into disrepair or be sold to developers. In 2016 the abandoned ground started to see signs of life, with the owners inviting children to play there. It is now thriving as a home to youth and Sunday league football.

New York Stadium
ROTHERHAM (ROTHERHAM UNITED FC)

Rotherham's New York Stadium derives its name from its location on the site of a factory that made New York City's red fire hydrants. Walking along the stadium corridors you'll find numerous New York City maps.

Earls Orchard
RICHMOND (RICHMOND TOWN FC)

Richmond Town FC plays its matches under the shadow of the epic ruins of one-thousand-year-old Richmond Castle.

Bet365 Stadium
STOKE-ON-TRENT (STOKE CITY FC)

"Yes, but can they do it on a cold windy night in Stoke?" So goes the eternal question when a great talent arrives from abroad in blistering form in the opening summer sparring of the league season. A player's real mettle is truly tested at the home of Stoke City where the weather can be nightmarish, and the team is known for toughness on the pitch.

Leigh Sports Village
LEIGH, GREATER MANCHESTER
(MANCHESTER UNITED FC WOMEN'S TEAM)

Manchester United Women's stadium, 10 miles (16 km) outside the city, is a part of Leigh Sports Village and surrounded by Pennington Flash Nature Reserve. The village includes a gym, sports hall, swimming pool, hotel, and supermarket. And you can have a prematch drink in the Whistling Wren pub.

Old Trafford
TRAFFORD, MANCHESTER (MANCHESTER UNITED FC)

Old Trafford has not become known as the Theatre of Dreams without good reason. Here legends like George Best and Bobby Charlton were born, and the likes of Sir Alex Ferguson and Roy Keane would manifest a first-ever European treble won by a British team, as well as years and years of dominance. The Stetford End eats up opponents, and the mystical framework of this ground has a hypnotizing effect on all of its visitors. Over seventy-five thousand United fans roar, and even on a bad day United can beat anybody here.

←↑ Old Trafford

↑ Etihad Stadium

Etihad Stadium
MANCHESTER (MANCHESTER CITY FC)

The Etihad Stadium popped up out of nowhere in the land that was once the kingdom of Manchester United; much like its owners did, the "noisy neighbors" of Manchester City have since dominated English football and been more than just a thorn in the side of their giant Red Devils rivals. Originally built for the Commonwealth Games in 2002, this arena is fit for all sorts of concerts and events as well as football. It is big, it is blue, and it is now part of an empire that expands across East Manchester and includes the state-of-the-art City training facilities, hotels, and learning spaces.

Academy Stadium
MANCHESTER (MANCHESTER CITY WOMEN'S TEAM / MANCHESTER CITY FC EDS)

The Academy Stadium is part of the expansive Etihad Campus. A 623-foot (190-m) bridge over Alan Turing Way links it to Etihad Stadium. Although it's an academy venue, many clubs around the world would be envious of its quality. It is home to Manchester City Women FC, which plays all but the Manchester derby with United at the ground. Only then do they need a bigger venue. What's intriguing is that it harks back to former times of English football when fans could stand in terracing behind the goal.

Broadhurst Park
MANCHESTER (FC UNITED OF MANCHESTER)

Set up by Manchester United fans incensed by the corporate takeover of their club, everything about FC United of Manchester represents the "anti-modern football" movement. It took ten years for the club to build a stadium to call home. Watching from the terraces is like entering a parallel universe. The team wears Manchester United colors but with no sponsorship (a rule in the club's constitution). And so, to a chorus of anti–Glazer chants, it's like watching Bobby Charlton, Denis Law, and George Best playing seventh-tier football. Magical.

211

↑ Prenton Park

Peninsula Stadium
SALFORD (SALFORD CITY FC)

David Beckham isn't just the owner of Inter Miami. With other members of Manchester United's Class of '92, he is a shareholder in Salford City FC, and can sometimes be seen in the crowd with Paul Scholes, Ryan Giggs, and other ex-teammates. The fans sing "Dirty Old Town," the song made popular by the Pogues and written by Ewan MacColl, who was from Salford.

Prenton Park
BIRKENHEAD (LIVERPOOL FC WOMEN'S TEAM / TRANMERE ROVERS FC)

Prenton Park isn't technically the name of Tranmere Rovers's ground. They took the name of their previous home with them to their newly built stadium in the Wirral in 1912. The ground has a less famous Kop than their Liverpudlian neighbors at Anfield. Away supporters are herded into the Cowshed. Matches against nearby Wrexham of Wales are heated derbies.

Everton Stadium
LIVERPOOL (EVERTON FC)

The stands are formed into an octagon. The roof is rhythmic, curved on the waterside and sheer at either end, where a modern take on classic Crittall windows offers a bow to the past. Everton's journey started at Stanley Park, then Anfield, before moving to the iconic Goodison Park. The old home remained a legacy of the game's traditional stadiums as new arenas sprung up elsewhere with increasing modernity. There were the old wooden seats, blue and white Tudor style rafters, and an atmosphere to rival any other. Now, beside the River Mersey, they must bring that energy and Goodison roar. Resting in the heart of Liverpool's dockland at Bramley-Moore dock it feels like a perfect ancestral home. Where so many clubs can lose something special when moving home, the Toffees have every chance to thrive.

Walton Hall Park
LIVERPOOL (EVERTON FC WOMEN'S TEAM)

Everton Women FC's stadium in Walton Hall Park is the first purpose-built venue in the Women's Super League. There is seating for five hundred, and you'll hear drums and chants. You can walk the perimeter, or stand behind the goal with what Evertonians call "Boss support." Face painting, aimed at children but open to anyone, is available. The vibe is fun, inclusive, vocal, and ultraclose to the action.

Anfield
LIVERPOOL (LIVERPOOL FC)

The experience of the Kop stand on a European night is legendary: Thirteen thousand of the most vocal fans in football singing "You'll Never Walk Alone," with scarves held high and wide above their heads, becoming Liverpool's twelfth man on the pitch. You feel the history of all those big nights within the fabric of the stadium, from the walk along a street of terraced houses and seeing the giant Liver bird crest on the redbrick stadium wall, to the old-style vertical turnstiles and the sea of red in the foyers and stands. There is a deep-seated vibe even when visiting on a non-match day and in relative silence. The tunnel that leads to the pitch and the sign reading "This is Anfield" bring an enormous sense of pride to every Liverpool player who passes through.

Villa Park (Ray Parker Stadium)
WALLASEY (ASHVILLE FC)

The Merseyrail railroad runs alongside the pitch, increasing the ground's capacity for a fleeting moment every fifteen minutes. The stadium is also unique in that an Ashville FC fan, Ray Parker, purchased the naming rights before the 2022–23 season.

Deva Stadium
CHESTER (CHESTER FC)

This is a rare club whose record attendance is less than its capacity. The stadium sits on a large concrete rectangle surrounded by green fields. Rarer still, the east stand sits within two countries—the England/Wales border runs through it. Fans sitting in the right place can have one foot in England, the league in which their team plays, and one in Wales.

↑ Anfield

↑ Villa Park

Highbury Stadium
FLEETWOOD (FLEETWOOD TOWN FC)

Just as Arsenal's old Highbury ground was being demolished in 2006, Fleetwood Town was preparing to add a new stand at their Highbury Stadium for the first time since it was built in 1939. Fast-forward almost two decades and little remains of the old ground. The infamous Scratching Shed standing terrace, set well back from the pitch by a huge patch of cinder, has gone. The team plays in the same red body/white sleeves jerseys as Arsenal—the Gunners in a gleaming, new sixty-thousand-capacity all-seater, Fleetwood in their spiritual home.

Turf Moor
BURNLEY (BURNLEY FC)

Burnley have carved their own path among the Premier League elite, and that's impressive for a place where the area's total population isn't that much greater than the stadium's capacity. On the road leading to the stadium you will find the Royal Dyche pub, named after Burnley's former manager Sean Dyche and with the face of the man himself on the pub sign, leading visitors to the door. Away fans often choose to enjoy a pint at Burnley Cricket Club on the corner of the stadium. From there they can see their first glimpse of the pitch—another stop on an epic away day in Burnley town.

Cadbury Recreation Ground
BIRMINGHAM (CADBURY ATHLETIC FC)

If you asked an AI program to create a quintessentially quaint English amateur football venue, it would generate the Cadbury Recreation Ground at the Victorian chocolate factory, which is home to Cadbury Athletic FC.

Villa Park
BIRMINGHAM (ASTON VILLA FC)

Villa Park is one of the most famous and iconic grounds in England. Home to a record fifty-five FA Cup semifinals, this ground has tales to tell on and off the field of play. The image from outside the Holte End is a vivid one; stairs lead up to the old redbrick stand, where claret-colored rails guide fans toward the turnstiles and the window frames are painted sky blue. Behind that wall the double-tiered Holte End is home to the bedrock of Aston Villa's fan base. Generations have been coming to this ground since 1897, a time when few of the world's famous football clubs had been established.

St. Andrew's
BIRMINGHAM (BIRMINGHAM CITY FC)

When your old home is hard to leave, just build around it and be sure to keep the family's favorite room, in this case the north stand built in 1954, exactly where it is. The rest of the stadium has been fully modernized, but has retained the stand containing the Paddock, and a memorial clock holding on to the past.

→ Kingsmeadow

Europe / **England**

Deepdale
PRESTON (PRESTON NORTH END FC)

Built on the land that was once Deepdale Farm, this ground has an incredible history. Construction began in the 1890s, but in 1913 it was almost burned to the ground by the suffragettes' arson campaign. The famous Kop stand was erected in the 1920s. From 1986 to 1994, Preston North End decided to play on an artificial pitch. Deepdale has been home to Bill Shankly, Tom Finney, and David Moyes.

Queen Elizabeth II Stadium
ENFIELD (ENFIELD TOWN FC)

Enfield Town FC's main pavilion is a Grade II–listed art deco café. It acts as the clubhouse, changing rooms, and main stand and spans the entire width of the pitch. There is a second seated stand opposite, and two covered terraces behind each goal. But it's the café that steals the show.

Kingsmeadow
KINGSTON UPON THAMES (CHELSEA FC WOMEN'S TEAM / CHELSEA DEVELOPMENT SQUAD)

Kingsmeadow was originally built by local nonleague club Kingstonian. In 2017 they moved to Imperial Fields, the home of Chelsea Ladies FC, who went in the other direction. In their first season at Kingsmeadow, the Blues won the league and cup double. The following year they rebranded as Chelsea FC Women. Kingsmeadow has since become a fortress. The Chelsea Women Supporters Group songbook promotes the atmosphere and encourages everyone to show their support for the team.

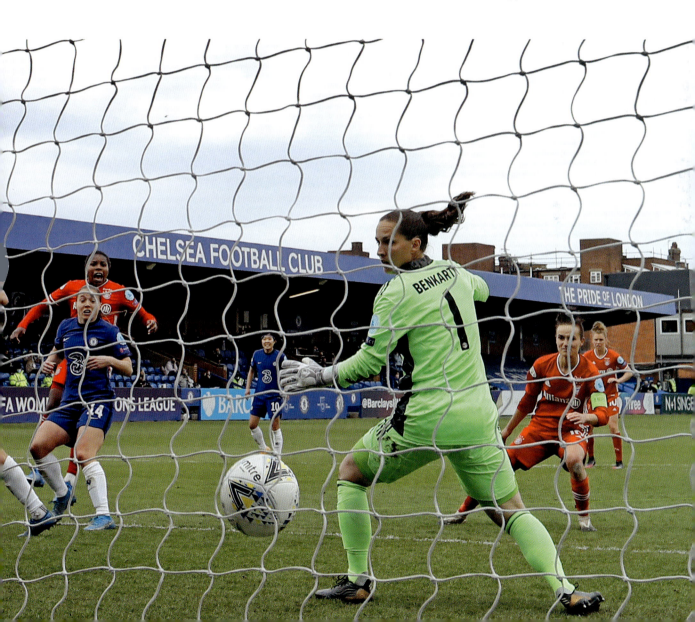

England / Europe

The Old Spotted Dog Ground
LONDON (CLAPTON COMMUNITY FC)

If you want to journey deep into the history and culture of the game, then visit the oldest stadium in London. Five hundred years ago the Old Spotted Dog hunting lodge was a favorite of Henry VIII. It remains today as the Spotted Dog pub; the stadium was built on its grounds in 1888. You can enjoy a prematch beer and pork pie at the pub before entering Clapton Community FC's picture-perfect amateur football ground. But then you see the anti-fascist banners, red smoke bombs, and a team wearing the colors of the Second Spanish Republic flag, and you realize this is no ordinary ground. It is home to a small cultural revolution. For an unforgettable match-day experience, join the Clapton Punks and the Gravy Ultras, or maybe a proud Castilian parading the colors (thousands of away shirts are sold in Spain where it has become a cult kit).

→ The Old Spotted Dog Ground

↑ Barbican Football Field

Barbican Football Field
LONDON (MULTIPLE TEAMS)

You can enjoy a pickup game under the iconic Barbican performing arts center on Silk Street in the city. It's a true spectacle of geometry, brutalism, and green elegance in England's capital.

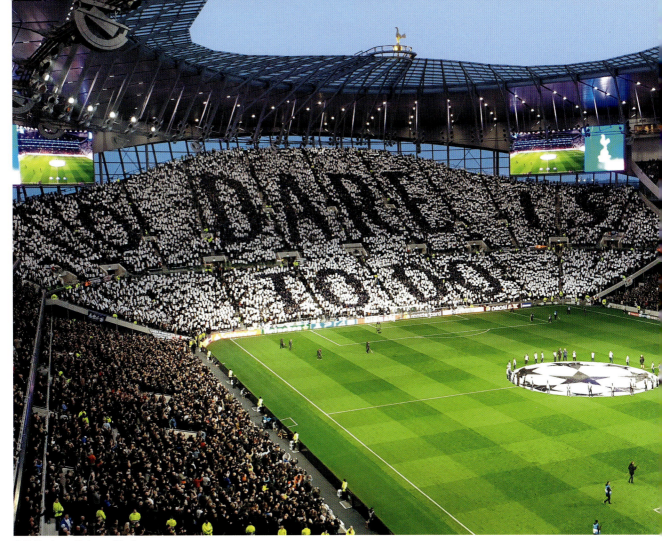

↑ Tottenham Hotspur Stadium

Stamford Bridge
LONDON (CHELSEA FC)

Remembrance is part of the fabric of Chelsea's stadium. Peter Osgood's ashes are scattered under the penalty spot at the Shed End, and his statue stands outside the West Stand. On a nearby wall is a mural depicting two Jewish footballers killed in Auschwitz, and a British prisoner of war known as the Goalkeeper of Auschwitz. Every executive box is named after a club legend.

Emirates Stadium
LONDON (ARSENAL FC)

It was always going to be difficult to follow Highbury, but Arsenal's Emirates Stadium has begun to write its own history, and on a good day it has an atmosphere up there with the best. Based on the stunning design of Benfica's Estádio da Luz, this arena was one of the first bowl-like grounds to pop up in the early twenty-first century. It set the tone for football stadiums that have been built thereafter, with all of the fancy boxes and modern conveniences necessary to earn enough income that might lead to footballing glory.

Tottenham Hotspur Stadium
LONDON (TOTTENHAM HOTSPUR FC)

Tottenham has blazed a trail with their new single stand behind the goal and the gigantic glass face on the side of the stadium. This ground is mesmerizing and light-years ahead of most others on the planet. Now a popular spot for concerts, boxing, and American football, it has the sound and vision to match the world's best entertainment, and everything is perfect down to the last urinal. The days of cramped concourses are long gone. From the longest bar in the world to the best advertising LEDs in the land, this is the quintessential twenty-first-century football arena.

↓ Selhurst Park

Selhurst Park
LONDON (CRYSTAL PALACE FC)

Selhurst Park has its rusting corners and chipped bricks, but that only adds to the romance of this old stadium that sits in suburban South London. Set on a very slight slope, the ground is built into the land at the Holmesdale Road end. From there rings out "South London's number one," the rallying cry of the Palace ultras. The site was bought for £2,750 by Crystal Palace FC way back in 1922. Palace climbed through the leagues in the 1960s, despite a 4–3 defeat at home to Real Madrid in a historic friendly in 1962. Since then they have become a permanent fixture in the Premier League, and Selhurst Park has earned a reputation as a very hard place to win.

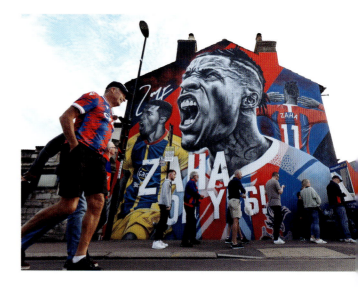

Europe / **England**

The Menace Arena
LONDON (PECKHAM TOWN FC)

The genesis of Peckham Town, and the stadium with its foreboding name, began with a thirteen-year-old boy searching in vain for a local team. Bryan Hall pinned a poster to a tree in Peckham Rye Park for a recruitment drive that would start with an under-fourteens team and evolve into a cult club with multiple promotions through the 1990s and 2000s, culminating in the eleventh tier of English football. As they developed men's and women's teams, and rose through the Sunday leagues, opposing teams began to see the once "harmless" team of under-fourteens as "a menace." And so, when Peckham Town FC established their own stadium on Dulwich Common, they embraced the name, and their new home became the Menace Arena. The ground has a tea bar, beer stand, and the smallest stand in English football—perhaps even the world—with seating for two, or three at a squeeze. From the terraces the Menace ultras sing a tribute to their founder and hero.

Champion Hill
LONDON (DULWICH HAMLET FC)

A rainbow banner at the clock end reads "In our house we are all equal." The stand opposite is affectionately known as the Toilets Opposite stand. A large concrete wall that extends from the main stand fittingly houses the temporary Brick Brewery beer tent. The crowd sits and stands almost on the touchline. Dulwich Hamlet is a club and stadium with humor, passion, and compassion. Champion HIll has the accolade of having hosted an international match between Mexico and South Korea at the 1948 London Olympic Games. Not many amateur clubs can say that.

↑ The Menace Arena

Gaughan Group Stadium
LONDON (LEYTON ORIENT FC)

When six ticketless Derby County fans made the 260-mile (418-km) round trip to Brisbane Road for a League One away match against Leyton Orient, they were disappointed. They had hoped to buy a ticket at the door or from a scalper, but they left empty-handed. Then, from a nearby appartment building came an offer to watch the game from the best spot in the stadium—a neighbor's first-floor balcony, lodged right between the north and east stands. A potential disaster turned to an incredible away day with numerous cups of tea and a 3–0 win for their team.

England / Europe

London Stadium
LONDON (WEST HAM UNITED FC)

Built for the 2012 London Olympics, the London Stadium has received criticism from home and traveling fans alike, due to the space separating the fans from the pitch, and the upper tier from the lower. Having said that, it is a stunning piece of architecture that has been home to West Ham United's success, and its best feature are the triangular floodlights that hang under the roof.

Loftus Road
LONDON (QUEENS PARK RANGERS FC)

Loftus Road, home to Queens Park Rangers, is one of London's many charming old football grounds. Set on the west side of town, but relatively central, it slots naturally into the city streets, with two short sharp tiers behind each goal giving some of the best away-day views in the country. The lower tier is so short that the upper tier feels like a balcony hanging right over the edge of the pitch.

Wembley Stadium
LONDON (NATIONAL TEAM)

Playing at Wembley is one of those deeply cherished childhood dreams of so many English players, be it representing England or experiencing the pinnacle of the world's oldest knockout competition, the FA Cup final. The previous Wembley, on the same site, had its iconic twin towers; this one has its arch. It doesn't quite have the same romanticism as the towers, but it is gaining iconic status.

The Den
LONDON (MILLWALL FC)

A visit in years gone by may have been a fearful experience. Millwall, a section of its fans, and the stadium itself were synonymous with the hooligan culture of the 1970s and 1980s. The old stadium was demolished in 1993 and a new all-seater Den was built nearby, bringing a more pleasant yet still rowdy vibe. One thing that hasn't changed is the infamous chant, "No one likes us, we don't care."

St. Paul's Sports Ground
LONDON (FISHER FC)

The home of Fisher FC sits by the River Thames and is overlooked by the skyscrapers of the Isle of Dogs. The imposing backdrop is in stark contrast to the humble nature of the ground. There is a small seating terrace, a clubhouse, and a low fence displaying a tongue-in-cheek banner suggesting "The Pond End." Fisher FC is a rare club in that it is named for a person— Saint John Fisher—and not a place

Cherry Red Records Stadium
LONDON (AFC WIMBLEDON)

In 2002, Wimbledon FC (relatively recent FA Cup winners) relocated 60 miles (96 km) away to Milton Keynes, becoming MK Dons. A number of loyal fans decided to keep the original club alive and started their own, AFC Wimbledon, at the Plough Lane ground. They began life in the ninth tier of English football. Promotions and a new stadium, just 250 yards (230 m) away from their former home, led the team to the third tier. In 2024 AFC Wimbledon hosted MK Dons (who had dropped down in the divisions) at their new home, and beat them.

GTech Community Stadium
LONDON (BRENTFORD FC)

Brentford's main stand has the effect of mechanical movement. It looks as though it has been unfurled from the rest of the stadium, like origami.

Bedfont Recreation Ground
BEDFONT (BEDFONT SPORTS FC)

The stadium lies directly under the flight path for airplanes landing at London's Heathrow Airport. They come frighteningly close, and little can be heard of fans or calls between players over the din of the jet engines.

Priestfield Stadium
GILLINGHAM (GILLINGHAM FC)

Gillingham can be considered poor hosts. Their ground has four stands, three of which are covered, while the away end remains completely uncovered. As one of the oldest stadiums in England, they've had plenty of time to protect their visitors from the wind and rain. They did, though, accommodate a homeless Brighton & Hove Albion for two years in the 1990s.

Broadfield Stadium
CRAWLEY (CRAWLEY TOWN FC / BRIGHTON & HOVE ALBION FC WOMEN'S TEAM)

Broadfield is one of those stadiums where the home fans sit in comfort while the away fans stand. It can come at a price, with a standing fan drinking a hot beef tea notoriously making more noise than a seated fan sipping champagne. Crawley is just up the A23 from the coastal city of Brighton and the seaside club's women's team call the Broadfield Stadium home.

Europe / **England**

Craven Cottage
LONDON (FULHAM FC)

Fulham's ground is a clash of worlds in more ways than one. The Johnny Haynes Stand was built in 1905 and is the oldest functioning stand in the football league today. Much like the old cottage at the corner of the stadium, its wooden seats have become football folklore. Yet, on the opposite side of the ground, Fulham has purchased part of the River Thames to enable it to expand the main stand and complete some jaw-dropping renovations. In stark contrast to the opposite side of the stadium, Fulham's new stand is huge and will even host a VIP zone and swimming pool on the roof.

← ↓ Craven Cottage

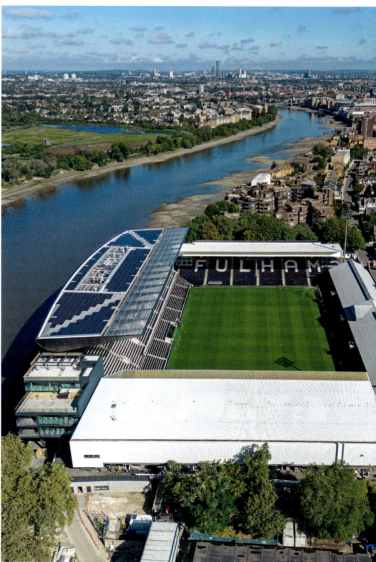

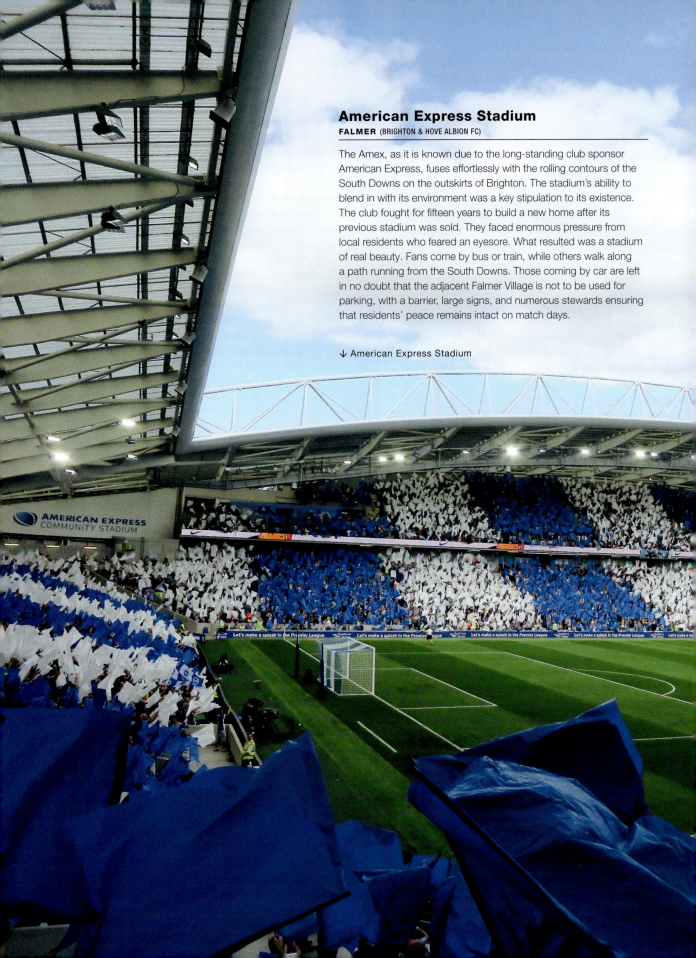

American Express Stadium
FALMER (BRIGHTON & HOVE ALBION FC)

The Amex, as it is known due to the long-standing club sponsor American Express, fuses effortlessly with the rolling contours of the South Downs on the outskirts of Brighton. The stadium's ability to blend in with its environment was a key stipulation to its existence. The club fought for fifteen years to build a new home after its previous stadium was sold. They faced enormous pressure from local residents who feared an eyesore. What resulted was a stadium of real beauty. Fans come by bus or train, while others walk along a path running from the South Downs. Those coming by car are left in no doubt that the adjacent Falmer Village is not to be used for parking, with a barrier, large signs, and numerous stewards ensuring that residents' peace remains intact on match days.

↓ American Express Stadium

Europe / **England**

The Enclosed Ground
BRIGHTON (WHITEHAWK FC)

The ethos of cult club Whitehawk can be seen on the stairs that lead fans to the terraces. Painted in bold black lettering on the toe of each of the yellow steps is an affirmation of what the club stands for: "Love, Peace, No Racism, No Sexism, No Violence, No Homophobia."

The Dripping Pan
LEWES (LEWES FC)

Like so many English clubs, Lewes FC was born out of a cricket club following plans that were drawn up in the local pub—in this case the Royal Oak. From that moment in 1885, the club has played its matches at the Dripping Pan. The club is owned by its fans, and in 2017 it was the first club in the world to offer equal pay to both its men's and women's teams. The friendly stadium has the unique feature of a tree growing from a cubicle in the men's restroom.

↓ The Dripping Pan

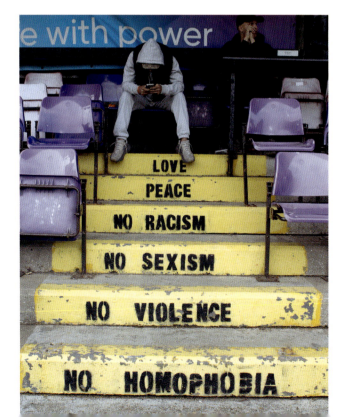

Woodside Road
WORTHING (WORTHING FC)

George Dowell was a promising youth player for Worthing FC when he was paralyzed in a car accident in 2010. He used the compensation he was paid to buy the club and saved it from extinction. With investment in the ground, the team now plays on a 5G artificial pitch. On match day mornings youth teams compete without fear of churning up the ground before the first team plays in the afternoon. Following a number of promotions, the club sits just below the professional leagues. The Mackerel Men play in an all-red kit with a badge that looks remarkably similar to that of Bayern Munich. If fans really squint, they might dream of a team playing in the Champions League in front of seventy thousand.

← The Enclosed Ground

England / Europe

Mill Road
ARUNDEL (ARUNDEL FC)

You can enjoy a prematch beer in an old English pub, then walk along the banks of the River Arun to the Mill Road stadium. As you watch the game you're surrounded by countryside and the shadows of an imposing eleventh-century castle.

Fratton Park
PORTSMOUTH (PORTSMOUTH FC)

The main entrance to Fratton Park is a Tudor-style facade, with big wooden beams and white stucco cladding, at the end of a street of suburban terraced houses. It is a charming throwback to when stadiums fused with the urban population from which they grew.

Vitality Stadium
BOURNEMOUTH (AFC BOURNEMOUTH)

The Vitality Stadium, previously known as Dean Court, sits in the breeze on the sunny south coast of England. It was built with the lower leagues in mind, but the club has been propelled into the big time of Premier League football, and it isn't showing any signs of going away. Fans can hear the players talk to each other here, in an arena one would imagine is too small for the most glamorous league in the world. Its intimacy is special, and its story is magical. Inside the stands are giant photos of Bournemouth's triumphs of yesteryear, their fairy-tale rise immortal in black and red.

Home Park
PLYMOUTH (PLYMOUTH ARGYLE FC)

The Mayflower Grandstand and the charming green-and-white walls of Plymouth's Home Park stadium are well off English football's beaten track. This port city of cobbled streets isn't known for its football prowess, but just like everywhere else, its people cannot help but be gripped by it. Plymouth Argyle's ground is a mix of old and new, set among rich green fields much like the color of the team's home jersey.

↑ Mill Road

Wellesley Recreation Ground →

↑ Kenilworth Road

The New Lawn
NAILSWORTH (FOREST GREEN ROVERS FC)

Forest Green Rovers lay claim to the title of "greenest club in the world." The entire match-day menu is vegan and waste cooking oil is recycled into biofuel. The pitch is organic, grown using no fertilizers and recycled rainwater. Even the player's jerseys are partially made from wooden fibers. The club's chairman is also the CEO of green energy supplier Ecotricity, and the stadium has large solar panels on one stand. There are plans for a fully sustainable club and stadium that will see a new ground, designed by Zaha Hadid, built of wood, and providing energy to the local area.

The Mesopotamia
ETON (ETON COLLEGE)

The Mespots is the oldest football-specific venue in the world, and within an institution where the first codes of football were written up in 1815. With a backdrop of the fifteenth-century Eton College and beside the Willowbrook, it is an impressive tree-lined site, albeit with a modern pavilion. The Mespots would have seen a dribbling style of football in those early days; forward passing was illegal.

Kenilworth Road
LUTON (LUTON TOWN FC)

The Kenny is so much a part of the community that the entrance to the Oak Road End sits within a row of terraced houses. As fans walk up the open stairwells into the ground, they can see the clotheslines and paving slabs of the locals' backyards.

Wellesley Recreation Ground
GREAT YARMOUTH (GREAT YARMOUTH TOWN FC)

The oldest wooden grandstand in the world can be found at the Wellesley Recreation Ground, home of Great Yarmouth Town in the east of England. The charming Victorian stand dates back to 1892, and it has recently been given a paint job, in traditional seaside green.

Carrow Road
NORWICH (NORWICH CITY FC)

Known as mini-Old Trafford, Carrow Road has gone through an almost identical series of "building-block" renovations with, among other elements, a large main stand and entrance, and additional curved terracing to fill the voids in each corner. Although hugely similar, the capacity is one-third of that of its famous counterpart.

England / Europe

John Smith's Stadium
HUDDERSFIELD (HUDDERSFIELD TOWN AFC)

Four swirling white structures that look like miniature Wembley arches cover the four stands of Huddersfield Town's home. The ground can be seen from the train passing through this West Yorkshire town. Blessed by a border of greenery, this stadium isn't the most hostile, and yet the Terriers have battled with the best the Premier League has to offer.

Elland Road
LEEDS (LEEDS UNITED FC)

Elland Road feels like it is home to the Leeds United national football team. It's unusual to visit a ground where every fan seems to be wearing their team's shirt, flag, or scarf. They are all there, proudly dressed in Yorkshire white, from head to toe. Songs are sung in unison, passion is fierce, and the atmosphere is electric even when their side isn't playing in the top division. Leeds is one of those clubs with a special fan base where loyalty is never questioned; rain or shine, they will be there. Record attendances in the Second Division have been smashed here. These old stands touch the turf and swallow up the opposition when it shows any sign of nerves. "Marching on together" is the famous rallying cry.

Vicarage Road
WATFORD (WATFORD FC)

Home to legends such as Elton John and Graham Taylor, Vicarage Road is a proper English football ground, steeped in history and located in the heart of the town. From the street beside the stadium you can peer through the turnstiles and see the pitch feet below, rows of yellow and red seats representing the famous colors of the former First Division runners-up and two-time FA Cup finalists. Watford is a club that has always punched above their weight. It is a town of a little over one hundred thousand people. One of their most famous moments came in 2013 when Troy Deeney incited a pitch invasion, scoring a crucial counterattack goal in the Championship playoffs. Few stadiums have witnessed such pandemonium.

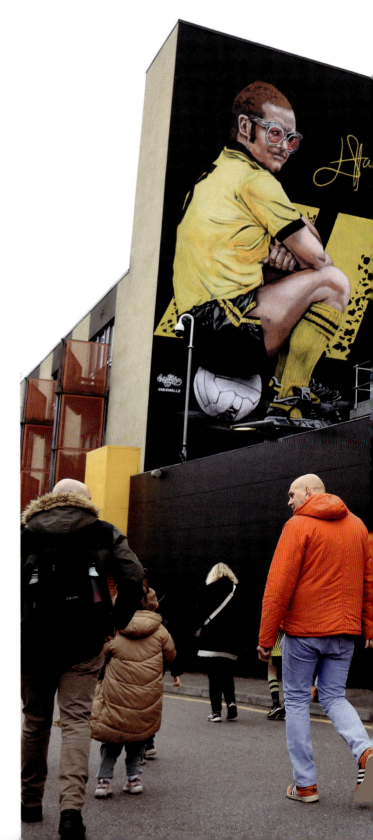

Vicarage Road →

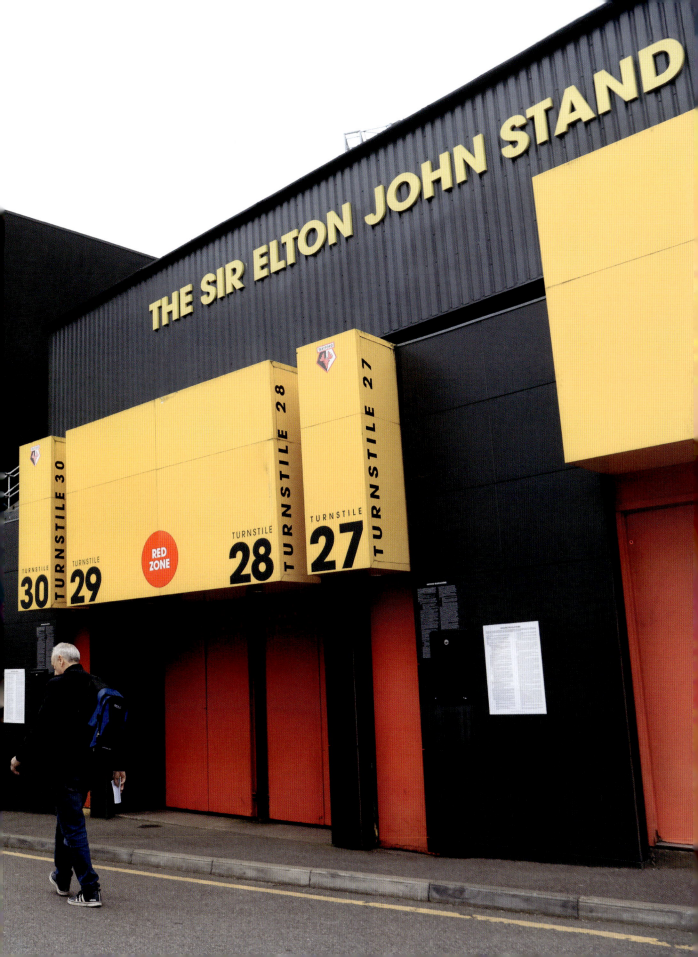

↑ The Home of Football Stadium

↑ Hillsborough

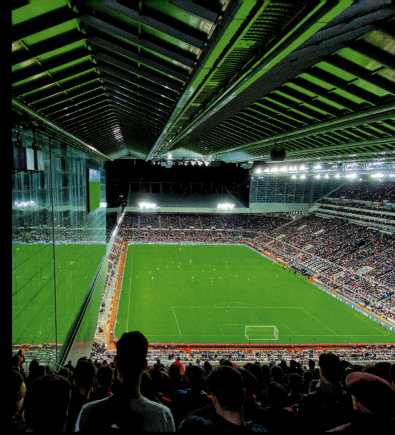

↑↓ St. James' Park

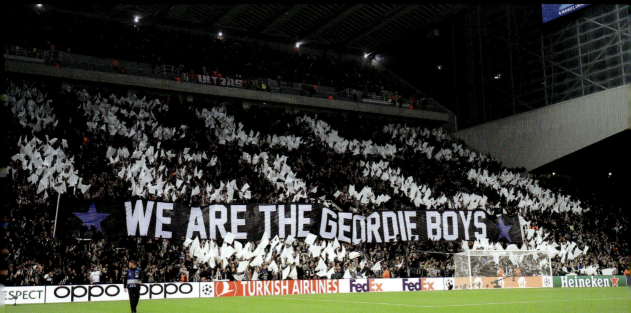

Europe / **England**

Bramall Lane
SHEFFIELD (SHEFFIELD UNITED FC)

Bramall Lane is the oldest football-specific stadium in the world. It opened in 1855 as a cricket stadium, and the first football match was played here in 1862. You can sip on a prematch ale at the Sheaf House pub, which was owned by the Bramall family who gave the road and the stadium their name. The home of Sheffield United has also hosted England internationals, the FA Cup final, the Women's Euro 2022, and the first-ever floodlit match in 1878.

The Home of Football Stadium
SHEFFIELD (SHEFFIELD FC)

Sheffield FC—the oldest club in the world—plays its football outside Sheffield in the village of Dronfield. The ground sits behind their own traditional English pub, the Coach & Horses, where fans can buy a pint of beer before the game and take it into the stadium. The club established and hosted the first Pioneers Cup here in 2013, with the oldest existing clubs from across Europe competing for the trophy. With England's former World Cup semifinalist Chris Waddle (by then fifty-two years old) turning out for Sheffield, they won the cup, defeating Genoa CFC and RC Recreativo de Huelva, Italy's and Spain's oldest clubs. The Pioneers champions' first-ever game was played in 1857 on Thomas Turner's field at East Bank; it is now a parking lot.

Sandygate
CROSSPOOL, SHEFFIELD (HALLAM FC)

Sandygate is the oldest football stadium in the world and the site of the first-ever interclub match when Hallam FC hosted Sheffield FC in 1860. The visitors won the game 2–0 in thick snow. The largest development since those early days has been an impressive two-hundred-and-fifty-seat grandstand and the 1860 Suite in the clubhouse. Apart from a small covered standing terrace, the rest of the ground is completely open. Hallam fans and away supporters can take a walk around the hallowed turf just as it was for that first-ever football derby.

Hillsborough
SHEFFIELD (SHEFFIELD WEDNESDAY FC)

Unfortunately, Sheffield Wednesday's traditional English stadium will forever be known as the place where the horrific events of the Hillsborough tragedy took place. In 1989 the stadium saw unimaginable suffering when ninety-six Liverpool fans lost their lives in a crush that changed football forever. They were there to witness an FA Cup clash with Nottingham Forest. This is a beautiful old stadium, but it will always be remembered for one of football's darkest hours.

Turnbull Ground
WHITBY (WHITBY TOWN FC)

A 10-foot-high (3-m) net runs around the ground to avoid off-target strikes and defensive clearances flying into neighboring yards. It doesn't always work; windows have been broken and balls can even end up in the waters of Whitby Bay. The stadium is a pebble's throw from the beach.

The Stadium of Light
SUNDERLAND (SUNDERLAND AFC)

Sunderland pioneered the modern process of ground relocation following the demolition of its iconic Roker Park stadium. It was replaced with the ultramodern Stadium of Light. Three decades later, Sunderland's new home is arguably more iconic than its predecessor. Its name is a tribute to the once-thriving coal mining industry, and the light of the Davy lamps, which kept miners safe from gas explosions in the dark of the coalpits.

St. James' Park
NEWCASTLE (NEWCASTLE UNITED FC)

Black-and-white flags stretch far into the sky as the Toon army sings, and the Toon army dreams. One of the top ten largest football stadiums in England, St. James' Park is home to Newcastle United. It is one of the few stadiums in the country where a look into the stands can find you stretching your neck up toward the heavens. This massive structure is no friend to the away fans, for they must climb what feels like a million staircases to look down on their traveling team from the visitors section. From such a distance, players appear like dots on a page. This ground has been built into the center of the city, in the same way that Newcastle United is built into the hearts of its people. When the Magpies sing it is loud, and the northern wind sends that message of passion and might far and wide.

WALES

Prince Moomin's Palace
LLANTWIT MAJOR (LLANTWIT MAJOR FC)

The Windmill Army plays in front of a nineteenth-century windmill decommissioned in 1846 and now, together with its adjacent barn, a house. In 2021 the seaside club held a lottery to rename the stadium in order to pay for a licence following promotion. It was won by a local who chose the name of her dog, and so the Windmill Ground became Prince Moomin's Palace.

The Racecourse Ground
WREXHAM (WREXHAM AFC)

The oldest international stadium in the world, it is also known as STōK Cae Ras. Wales played its first home match here in 1877.

Principality Stadium
CARDIFF (NATIONAL TEAM)

Previously known as the Millennium Stadium, after its grand opening in 1999, this perfect sports arena hosted the FA Cup final in 2006 (famous for Steven Gerrard's goal) and the Champions League final in 2017. It has been home to the Welsh national football and rugby teams in recent years. A ground with features ahead of its time, this stadium gained a reputation for outstanding acoustics as it became one of the first to have a retractable roof, keeping out the bad weather and keeping in the waves of passionate sound. The Welsh national anthem "Hen Wlad Fy Nhadau" is the soundtrack of this marvelous place where men, women, and children hold back the tears as they roar for their nation.

Cae Clyd
BLAENAU FFESTINIOG (BLAENAU FFESTINIOG FC)

The Blaenau Ffestiniog team plays amateur football in the North Wales Coast West Football League, yet their stadium is in the upper tier when it comes to beauty. The pitch is flanked by winding roads, old slate-mining cottages, and the River Clwyd valley.

↑→ Cwm Nant Y Groes

Llanelian Road
OLD COLWYN (COLWYN BAY FC)

Colwyn Bay FC plays in picturesque surroundings in Old Colwyn. You can take a seat under cover in the Shed End, erected in 1985, or stroll around the low brick wall enclosure, where you'll see the occasional dog, paws on wall, peeking over to watch the game. When the floodlights were first turned on in 1990, Colwyn Bay played Liverpool FC to mark the occasion.

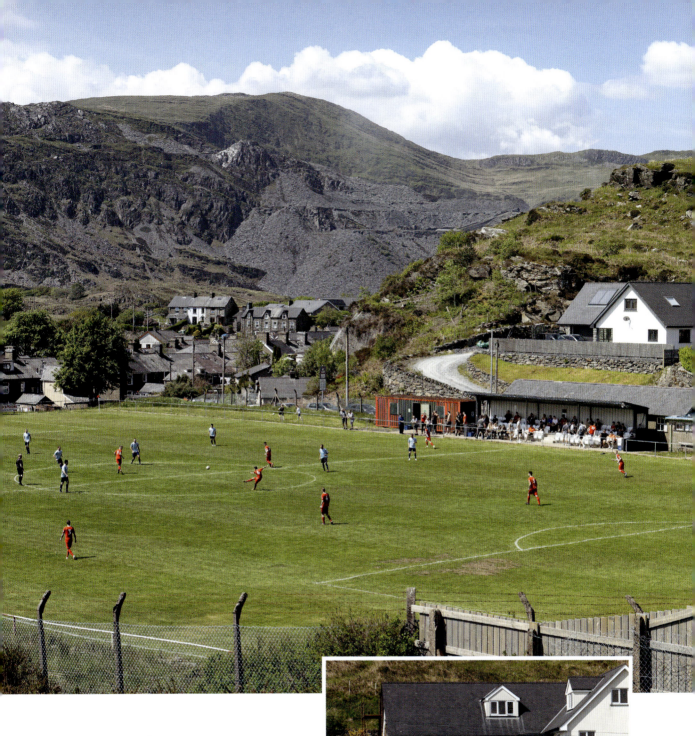

Cwm Nant Y Groes
ABERTILLERY (ABERTILLERY BLUEBIRDS FC)

A tree-filled backdrop in the Welsh valleys is home to Abertillery Bluebirds FC of the Cymru South, the second tier of Welsh football. A little clubhouse and covered seated stand house fans as valleys taper upward all around them. The club hails from the wonderfully named village of Six Bells.

SCOTLAND

Pittodrie
ABERDEEN (ABERDEEN FC)

Football coaches all over the world owe a debt of gratitude to Pittodrie, where dugouts were introduced for the first time in the 1920s. Aberdeen coach Donald Colman wanted to observe his players' footwork from ground level and take notes without losing the rain cover provided by the grandstand. In 1978 the stadium became the first all-seater in the United Kingdom. The extra seats launched a golden period under Alex Ferguson, culminating in a magical European night in 1983. Coming back from 2–1 down to Bayern Munich in the European Cup Winners' Cup, the Dons won 3–2, before defeating Real Madrid in the final. Pittodrie hasn't been touched since 1993, and offers a glimpse of the past. Its 1928 granite entrance at the Merkland Road end deserves a visit in itself.

Easter Road
EDINBURGH (HIBERNIAN FC)

One of the pearls of the Scottish Premiership, Easter Road has gone through a slow regeneration over the past three decades. The east stand was left single tiered to maintain its old charm and crowd vibe. The Holy Ground dances the tango of tradition and modern perfectly and with its emerald-green roof framework and white exterior, it has a clear identity. It is also known affectionately as the Leith San Siro.

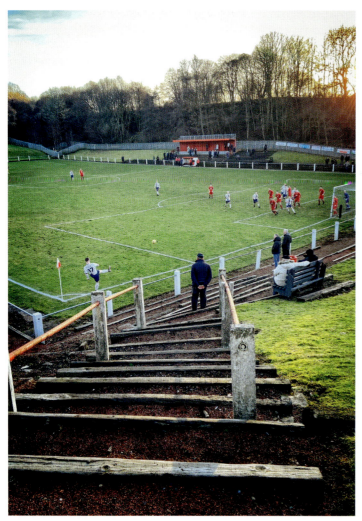

↑ Craighead Park

↑ Easter Road

Tynecastle
EDINBURGH (HEART OF MIDLOTHIAN FC)

Heart of Midlothian's Tynecastle is a short distance from the twelfth-century Edinburgh Castle, which sits on volcanic rock looming over the city. Within the stadium, floodlight roof supports arc over the pitch. The towers sit just 10 yards (9 m) from the corner flag and, if you sit in the front row, you can almost reach out and touch the byline.

Craighead Park
LESMAHAGOW (LESMAHAGOW JUNIORS FC)

The ground sits at the base of a grass-covered hill with stairs and seating made from soil, wood chippings, and lengths of wood.

Fir Park
MOTHERWELL (MOTHERWELL FC)

The east stand has the legendary "keep cigarettes away from the match" slogan displayed in bold letters on the rafters of the roof, facing the pitch.

Bayview Stadium
METHIL (EAST FIFE FC)

Bayview Stadium sits on the banks of Largo Bay, close to the mouth of the River Forth. The views are vastly improved since the Methil Power Station that overshadowed the ground was demolished. The single stand looks out to Leven Beach, the bay waters, and distant hills.

↓ Fir Park

Scotland / Europe

Stark's Park
KIRKCALDY (RAITH ROVERS FC)

Stark's Park is a fusion of old and new. The aging railway stand sits unused. The main stand curves toward the south stand. Its cast-iron seating and steel-framed panel windows could be in a museum. The architecture of the more modern north and south stands is sympathetic to the Victorian legacy, with paneled windows. When the light shines through, it is a wonderful sight. Raith Rovers fans lovingly refer to the ground as the "San Starko."

Dumbarton Football Stadium
DUMBARTON (DUMBARTON FC)

Known as the Rock (and for one season as Marbill Coaches Stadium), this stadium is located below the eighteenth-century Dumbarton Castle. The rock on which the castle sits is said to resemble an elephant, and an elephant adorns Dumbarton FC's crest. The stadium offers stunning views across the rivers Leven and Clyde. One building houses the stand, changing rooms, and offices. The rest of the ground is a paved walkway and standing area. The club formed in 1872 and only moved to the Rock in 2000, yet the stadium has an iconic and historic feel.

Netherdale
GALASHIELS (GALA FAIRYDEAN ROVERS FC)

Gala Fairydean Rovers's grandstand looks like a piece of concrete origami. Designed by Peter Womersley, it is a protected structure as it is considered to be of "special architectural importance." This may not be the most luxurious of fan experiences, with the seats formed of a single carved block of concrete, yet it is one of the most iconic from a wider architectural perspective—a modernist masterpiece.

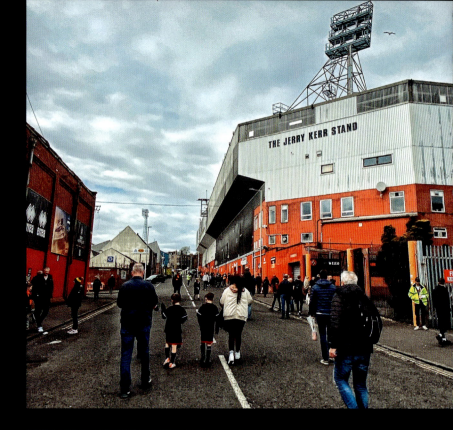

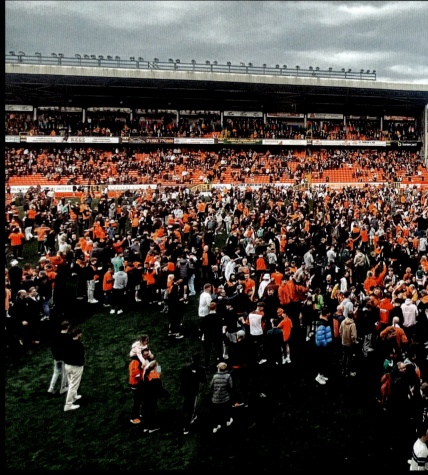

Europe / **Scotland**

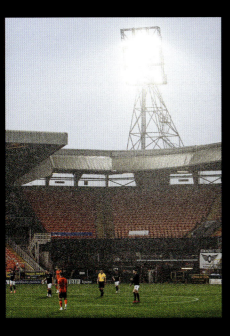

CalForth Construction Arena at Tannadice Park
DUNDEE (DUNDEE UNITED FC)

Much of Dundee United's fan noise reverberates from the Shed end, where the stand has its original 1957 roof. Like many old stands, history and tradition have built over generations. Families are often divided by the city's two teams, and Dundee FC's Dens Park is just across Tannadice Street. The teams are the closest neighbors in British football. When Edinburgh and Glasgow clubs are in town, the two sets of fans may come together as the "Dundee Utility" to "welcome" the visitors.

Falkirk Stadium
FALKIRK (FALKIRK FC)

You can smell the flares that have just been let off onto the pitch as you walk past the "Strictly no pyrotechnics permitted inside the ground" sign. The central lowlands of Scotland are not where you'd expect a pyro show, but it seems that every club has its ultras now, and Falkirk is no exception.

Gayfield Park
ARBROATH (ARBROATH FC)

Gayfield is the closest stadium to the sea in Europe, lying within 49 yards (45 m) of the North Sea. Waves have been known to come onto the pitch, and a player taking a corner is said to have been hit by a fish. There is seating for 861 fans in a single covered stand, with the rest enjoying the sea-salty winds in partially covered standing terraces. Fans can enjoy a famous smokie (smoked haddock) and the club even sells its own Arbroath FC wine to match the fish. Gayfield is the site of a British footballing record: In the 1885 Scottish Cup, Arbroath beat Bon Accord 36–0, the biggest ever victory in a senior British match.

Caledonian Stadium
INVERNESS (INVERNESS CALEDONIAN THISTLE FC)

In the Scottish Highlands, fans coming from the north cross the Kessock Bridge over the Beauly Firth. Inside the stadium, large gaps between the stands mean Inverness Caledonian Thistle fans can watch the game while casting a glance out to the Moray Firth if there is a lull in the action.

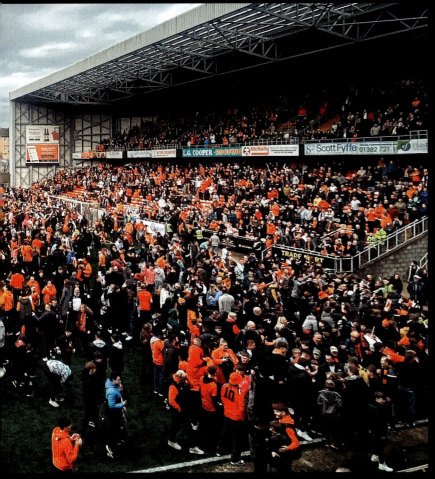

←↖ Tannadice Park

Scotland / Europe

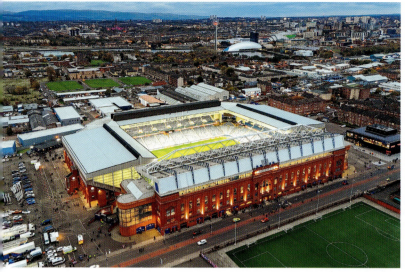

↑ Ibrox Stadium

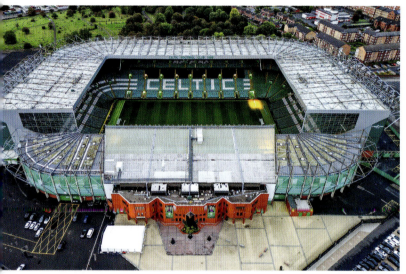

↑ Celtic Park

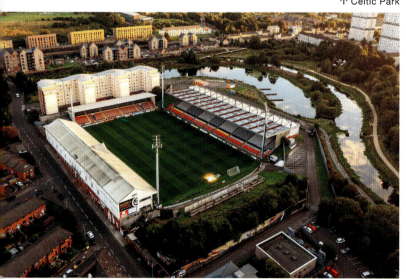

↑ Firhill Stadium

Ibrox Stadium
GLASGOW (RANGERS FC)

On the approach to Ibrox on match day, it's striking just how many people come from all different directions. The number of supporters can be incredible: back in 1939, 118,567 attended Ibrox—a record for a Scottish or English club game. Ranger's Old Firm derby with Celtic is one of the most heated in Europe with fans divided by religion, Protestant and Catholic. And all this from four teenage boys strolling through Kelvingrove Park in 1872 deciding to start a football team.

Celtic Park
GLASGOW (CELTIC FC)

Celtic Park has seen disappointment for Manchester United, Juventus, and Barcelona. This place is famous for its Champions League nights and uncanny ability to seemingly win a game on its own. Some of the greats have come here, fallen, and then carried the story with them forever; European football has many memorable stadiums, but few send a shiver down the spine as Celtic Park does. Home to the Celtic team known as the 1967 Lisbon Lions, history lives here, and it is an armor the Hoops wear every time they go into battle. With a strong football philosophy and a proud history of Irish identity, Celtic Park provides a unique atmosphere within British football that is famous around the world.

Firhill Stadium
GLASGOW (PARTICK THISTLE FC)

McParland Way is a steep, mural-lined walk up to Firhill Stadium. Taxis bearing the legend "People Make Glasgow" drive anyone struggling to make the walk up and down the hill for free on match day. It's a part of the community feel surrounding Partick Thistle FC. A large apartment building is integrated into the north stand and funded its construction. The historic facade on the west side ties in with the adjacent terrace houses.

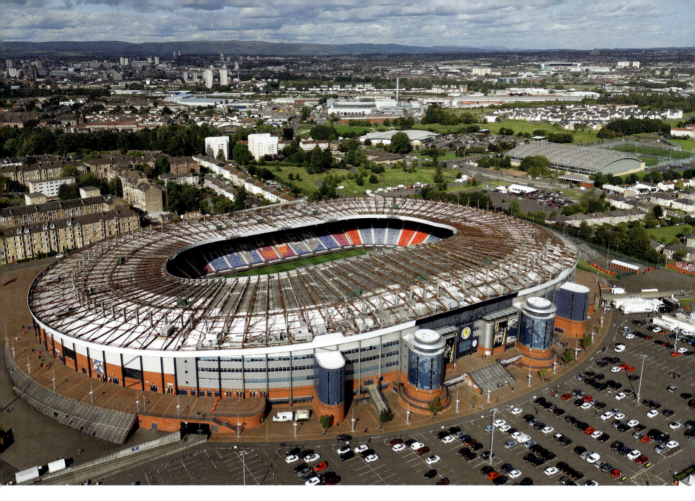

Hampden Park
GLASGOW (QUEEN'S PARK FC / NATIONAL TEAM)

There have been three Hampden Parks. The first incarnation is now Hampden Bowling Club, which has a large mural commemorating a 5–1 Scottish victory against England in 1885. It was demolished and moved a short distance away to make space for a rail track that would have cut through the east stand. The second stadium lasted less than twenty years as it lacked options for expansion. The stadium we see today is home to Queen's Park FC, one of the best teams in British and arguably world football in the nineteenth century, and now a smaller club playing in a huge venue. The stadium holds the record attendance for a European Cup final—127,621 watched Real Madrid beat Eintracht Frankfurt 7–3 in 1960.

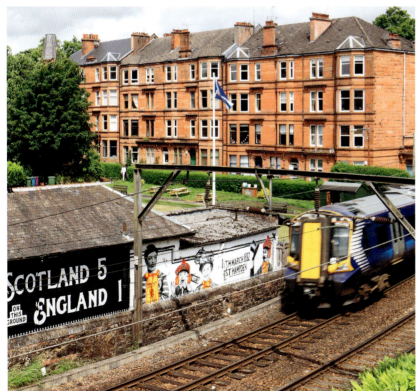

↑ Hampden Park

Northern Ireland / Europe

NORTHERN IRELAND

Windsor Park
BELFAST (LINFIELD FC)

Just like Liverpool FC's Anfield, the Kop is where die-hard Linfield FC and Northern Ireland fans congregate. The old terrace was demolished and replaced with a seated stand, which still maintains the slope and single tier that resembles the Spion Kop hillside in South Africa that gives every Kop its name.

The Oval
BELFAST (GLENTORAN FC)

The Oval has been home to Glentoran FC since 1892. The stadium was heavily damaged by bombing during World War II and still suffers from the legacy of that Belfast Blitz to this day. It was almost a decade until it was usable again and, other than a new stand in 2000, the ground remains as it was postwar, restricted to a safe capacity of 6,050. The record attendance was fifty-five thousand in 1966. What this brings is an intriguing journey into the past. You can sit in the main stand with almost three thousand Glentoran fans experiencing what it was like in 1953, when it was first built.

↓↗ The Oval

Europe / **Ireland**

IRELAND

The Showgrounds
SLIGO (SLIGO ROVERS FC)

The Showgrounds was bought by a Sligo Rovers fans' trust in 1968, and under the terms of the agreement, it can never be mortgaged, sold, or used for nonsport commercial purposes.

Dalymount Park
DUBLIN (BOHEMIAN FC)

This ground is like a charming old ruin that could be mistaken for a dormant stadium if it weren't for Bohemian's boisterous fans. The home to the black and red is also famous for its stadium-side graffiti. The club is known for its social and political activism, and its fabulous kits honoring music greats who played gigs on their very turf, including Bob Marley.

Ryan McBride Brandywell Stadium
DERRY (DERRY CITY FC)

A graveyard sits on the hill above this stadium. It is known by the locals as "skint hill," because those who couldn't afford to pay entry to the stadium used to watch games from there for free, in the company of friends and family who had moved on to a better place.

Tallaght Stadium
TALLAGHT, DUBLIN (SHAMROCK ROVERS FC)

Tallaght Stadium is built of four single stands and is home to both the Shamrock Rovers FC, one of Ireland's most heralded, and the Ireland women's national team. The stadium blends in with the rolling green hills on the horizon. Indisputably Irish in its appearance, it also regularly hosts the country's hottest derby between the Shamrock Rovers and Bohemian FC, their Dublin neighbors.

↑ Dalymount Park

Africa and the Middle East

CHAPTER 4

Morocco / Africa

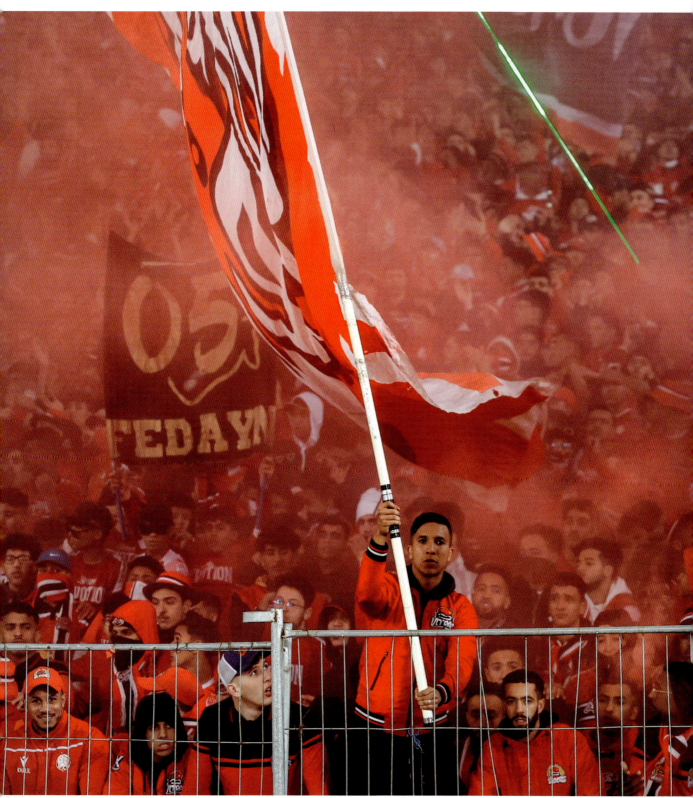

↑ Stade Mohammed V

Africa / **Morocco/Algeria**

MOROCCO

Stade Mohammed V
CASABLANCA (RAJA CLUB ATHLETIC / WYDAD AC / NATIONAL TEAM)

The Stade Mohammed V has hosted many of the national team's biggest home games, as well as numerous editions of the biggest club derby in the country between Raja and Wydad. The flares and tifos in the clubs' iconic green and red colors, as well as the incredible fervor of both sets of fans, make these games memorable spectacles even from afar, let alone within the curving stands. Frimija—the name used locally for the north stand—is home to Wydad supporters, while the southern stand—Magana—is where you'll find the most vocal Raja fans.

Stade Ibn Batouta
TANGIER (IR TANGER)

Less a complete football stadium, more a work in progress, the Ibn Batouta may look unfinished to some. If funds allow in the future, the single-tiered end zones have the footing for an upper tier, and the east stand has support structures for a roof. Despite the fact the pitch seems to be a long way from the fans, this is Tangier's major sports venue. Beware if you visit on a big match day—the roads surrounding the arena and the turnstiles can be congested.

Honneur Stadium
OUJDA (MC OUJDA)

The open stand that curves around three-quarters of the pitch helps to create the great match-day atmosphere that Moroccan fans are renowned for, but frustratingly the eight-lane running track around the edge pushes them far from the pitch. Oudja's largest sports venue offers a shaded stand and a large standing section behind one goal.

Grand Stade de Marrakech
MARRAKECH (KAC MARRAKECH)

Buildings with thick walls, towers, and minarets are a common sight in Marrakech, and this style of architecture is echoed in the design of the Grand Stade de Marrakech. Located beyond the outskirts of the city, its positioning in empty surroundings and sandy-brown hue mean it resembles a fort. However, its rectangular shape, wide running track, and covered stands make for a much more subdued fan atmosphere. Eating and drinking options are sparse outside the stadium, so it's best to eat before you leave the city.

ALGERIA

Stade Nelson Mandela
ALGIERS (NATIONAL TEAM)

You can't miss the roof of the Stade Nelson Mandela; a huge truss supported by four pillars, it completely covers the stands. If that weren't enough, the curved exterior features white bands and glazing. Inside you'll find a natural grass playing field surrounded by two-tier stands with pops of color provided by the seats. Algeria's first purpose-built football stadium, with its state-of-the-art design and infrastructure, opened in 2023 and is named in honor of the continent's greatest freedom fighter.

Stade du 5 Juillet
ALGIERS (MC ALGER / NATIONAL TEAM)

For the chance to experience the country's fervent fan culture, take your seat in the open and curved stands here for the Algiers derby between Mouloudia and USM. If nothing else you're sure to see some memorable tifos and feel the ground beneath your feet rumble to the roar of the tens of thousands of fans around you. Inaugurated in 1972, and named in honor of Algeria's independence day, this is one of the country's most historic stadiums.

Stade du 24 Février
SIDI BEL ABBÈS (USM BEL-ABBÈS)

Inside this bowl-shaped concrete arena, the breeze from the Alboran Sea washes over the open stands. There is a small covered section, but in this warm climate within a region of vineyards, market gardens, orchards, and grain fields, the match is best enjoyed in the open air. Local side USM Bel Abbès was one of the great teams of the French colonial period, and although its fortunes have slipped, fans can still enjoy flowing football from a team consistently negotiating the glory and sorrow of promotion and relegation between the top two divisions.

Algeria / Africa

Stade Mustapha Tchaker
BLIDA (USM BLIDA / NATIONAL TEAM)

To the west is a conventional covered grandstand, to the east a large open-air stand. From here, to the north and south, the arena becomes an intriguing formation of seating blocks, like wedges of cheese. The ten wedges allow the stands to follow the contours of the running track that surrounds the pitch without the prohibitive costs of a curved terrace. As with so many creative ideas, it results in something beautiful. You can take a seat in one of the wedge stands and enjoy some authentic lower-league Algerian football. The local team USM Blida play in the third tier. At the other end of the scale, you can watch the Algerian national team. Watching Les Fennecs play at the beguiling Mustapha Tchaker is to watch them in the closest thing to a spiritual home.

Stade Mohamed Hamlaoui
CONSTANTINE (CS CONSTANTINE / MO CONSTANTINE)

The Mohamed Hamlaoui is like an older, neat, and tidy sibling to the Mustapha Tchaker. It has similar wedge-like blocks in a circular concertina, but what elevates the ground to a vison of vibrancy and balance are the multicolored seating and stairs that fuse the blocks together. These encircle the entire stadium; a metal fence cups the pitch level; and giant flagpoles span the upper tier, adding to the wonderfully satisfying symmetry.

Stade Habib Bouakeul
ORAN (ASM ORAN / SCM ORAN)

A major highway runs along the east side of the stadium. At any time, someone in a passing car might be as close to the pitch as a fan in the upper row of the away end. The ground is squeezed into the end of a residential block. The main stand backs onto a row of houses. And when bouncing ASM Oran supporters trade chants with the away end, the stand moves a little and cups of ice mazagran shake on neighboring coffee tables on the Rue Zemoura.

Stade du 20 Août 1955
MOHAMED BELOUIZDAD (JS SAOURA)

The stadium is a wonderful collection of opposites. On one side is a sprawling nineteenth-century botanical garden, on the other a large residential high-rise block. Palm trees rise over the aging concrete west stand from the Hamma gardens. To the north, the Bay of Algiers leads to the Balearic Sea, and from within the stadium there's a view of the Algeria Hills. Being surrounded by such botanical marvels you may expect a luscious grass pitch, but this stadium rarely does the expected. In this dry climate an artificial pitch is preferred.

Stade Omar Hamadi
BOLOGHINE (USM ALGER)

Arguably the most picturesque stadium location in Algeria, if not the wider world, the Omar Hamadi (named after a hero of Algerian independence) rests on the edge of a rock face in the ancient city of Bologhine. Watching a top-flight match while taking in the hills of Saint Eugène, and feeling a breeze from the Mediterranean Sea, is a great footballing experience.

Stade du 1er Novembre 1954
TIZI OUZOU (JS KABYLIE)

Crowd energy is given over to politics, JS Kabylie club tifos, and positive support for the team here, but a single moment still haunts the stadium. A decade ago, a player was killed by a projectile thrown from the crowd. Algerian football was suspended, and the stadium closed for some time. Although the vibe has changed from those dark days, it still pays to be vigilant in and around the stadium.

Stade Hocine Aït Ahmed
TIZI OUZOU (JS KABYLIE)

After a thirteen-year delay JS Kabylie finally revealed their new home in 2023. Was it worth the wait? The answer is a resounding "yes." Sitting in the stands you feel like you're in the Emerald City from *The Wizard of Oz*. A huge steel-framed green roof compresses the noise and turns the light that shines through to emerald, eclipsing the stands. The seating tapers away from the pitch, creating a perfect oval surround. Sit in the first row to be within touching distance of the pitch, bathe in the green light, and soak up the vociferous atmosphere.

Stade du 19 Mai 1956
ANNABA (USM ANNABA)

Built to the contours of the land, the stands here are tiered and layered with the natural shelving of the hillside. It looks over the city of Annaba and out to sea.

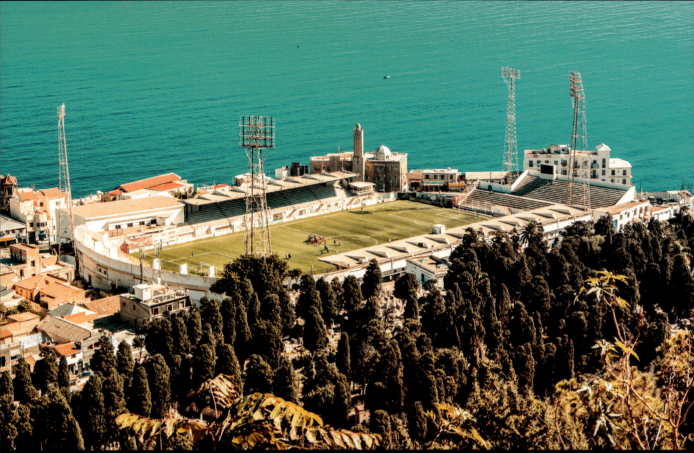
↑ Stade Omar Hamadi

↑ Stade du 1er Novembre 1954

245

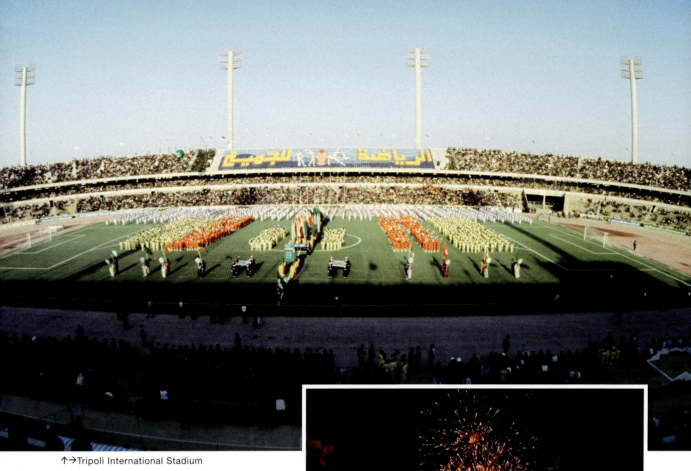

↑→Tripoli International Stadium

LIBYA

Tripoli International Stadium
TRIPOLI (AL-AHLI SAUDI FC / AL-ITTIHAD CLUB / AL-MADINA SC / NATIONAL TEAM)

Harnessing the long-standing relationship between Libya and Italy, this gigantic two-tiered concrete stadium hosted the 2002 Italian Super Cup between Juventus and Parma; Juventus won 2–1. It is home to the two most successful teams in Libyan football, Al-Ahli and Al-Ittihad, with more than thirty Premier League titles between them.

Africa / **Tunisia/Egypt**

TUNISIA

Hammadi Agrebi Stadium
RADÈS (ESPÉRANCE SPORTIVE DE TUNIS / CLUB AFRICAIN / NATIONAL TEAM)

During the 2004 African Cup of Nations, Tunisia took the idea of home advantage to the extreme, playing every game at their home venue on a run all the way to the final. That night the stadium witnessed its finest hour as fans packed the stands, heavily exceeding its capacity. Victory over Morocco gave rise to the team's nickname, the Eagles of Carthage. An eagle now adorns the team's crest. The Hammadi Agrebi was at the center of it all.

El Menzah Stadium
EL MENZAH (ESPÉRANCE DE TUNIS / CLUB AFRICAIN)

At first glance you see a classic African earring-style stadium: an open-air oval, with a single covered stand and a running track. Yet it jars as you get closer. The bowl-shaped stands appear to fan out like a blossoming flower in midbloom.

Sousse Olympic Stadium
SOUSSE (ÉTOILE SPORTIVE DU SAHEL)

A banner reads, "Born in Sousse, made in Sahel." Étoile Sportive du Sahel moved away from the stadium when it was closed for renovation in 2019, leading to a period of decline. They returned three years later, but their hearts now perhaps belong to the wider region of Sahel, rather than the historic city of what was once their spiritual home.

EGYPT

Borg El Arab Stadium
AMREYA (AL MASRY SC / PHARCO FC / NATIONAL TEAM)

Set within a dusty expanse beside the Borg El Arab Desert Road is one of the largest stadiums you'll find. It's so vast that there is an internal road system, airstrip, and helipad. For a night game expect one of the largest cell phone light shows in the world, as thousands of fans sing the national anthem. Then there's a moment of silence before the extraordinary din of vuvuzelas, like a thousand automobile horns.

Ghazl El Mahalla Stadium
EL MAHALLA EL KUBRA (BALADIYAT EL MAHALLA)

Four chimneys from the Misr Spinning and Weaving Company cast shadows over this aging stadium. A small group of fans bangs drums and chants songs for their favorite players in the covered stand, which is held up by iron scaffolding poles. The concrete is crumbling and a fence divides them from the pitch, but their smiles and energy are infectious. At this team training session, they make more noise than a thousand fans.

Al Salam Stadium
CAIRO (MULTIPLE TEAMS)

Should you be lucky enough to be in Cairo and plan to take in a game, you may want to check the fixture list first. Depending on which team you watch, you'll have a very different match-day experience. Al Ahly, the country's most successful team, has a huge fan base. Whereas Modern Sport FC, with its corporate beginnings as the team of Coca-Cola Egypt, doesn't bring with it the same fanfare or energy. And so, you can opt for tranquillity and empty space or electricity.

Mokhtar El-Tetsh Stadium
CAIRO (AL AHLY SC)

The historic original home of Al Ahly is well worth a visit. It is located on an island within the Nile River and under the shadow of the awe-inspiring Cairo Tower. The team uses the ground for training and friendly matches, so it's a great preseason destination. And prior to a game, a seat at the revolving restaurant at the top of the lotus-inspired tower offers an aerial view of the stadium and the Nile.

Egypt / Africa

30 June Stadium
CAIRO (PYRAMIDS FC)

The 30 June Stadium was built by the Egyptian Air Defence Force and is the jewel in the crown of the Air Defence Sport Village. You can take the new driverless Cairo Monorail direct to the village and watch the thriving Pyramids FC teams—men's and women's—here.

Cairo International Stadium
CAIRO (AL AHLY FC / ZAMALEK SPORTING CLUB / ZED FC)

Egypt's national stadium has served as a breeding ground for Al Ahly's and Zamalek's ultras factions, who in turn played a significant part in the 2011 Egyptian revolution. A Cairo derby is an intense experience. Both teams' fans are known to be among the most impassioned in the world, and a referee from abroad usually officiates the game. The stadium has unfortunately seen multiple instances of mass violence between the public and police since the revolution, leading to continuing attendance restrictions.

Moharam Bek neighborhood
MOHARAM BEK, ALEXANDRIA (AL FALAKI RAMADAN FOOTBALL TOURNAMENT)

Every day during Ramadan, teams from across the Moharam Bek neighborhood of Alexandria play football matches against one another, on pitches between residential buildings. The stands are the housing blocks and the terraces are the brick walls and the dusty edges of the pitch. Matches commence following afternoon prayer. Play continues until sundown and the start of iftar, the breaking of the daily fast.

Ismailia Stadium
ISMAILIA (ISMAILY SC)

What makes this stadium on the west bank of the Suez Canal unique is its east stand. The steep three-tier stand sits outside the parameters of the stadium, and is adorned with three large carved wooden reliefs that rise into the air. The artwork depicts Ismaily SC players in their Brazilesque kit mixed with Egyptian iconography.

↓ Cairo International Stadium

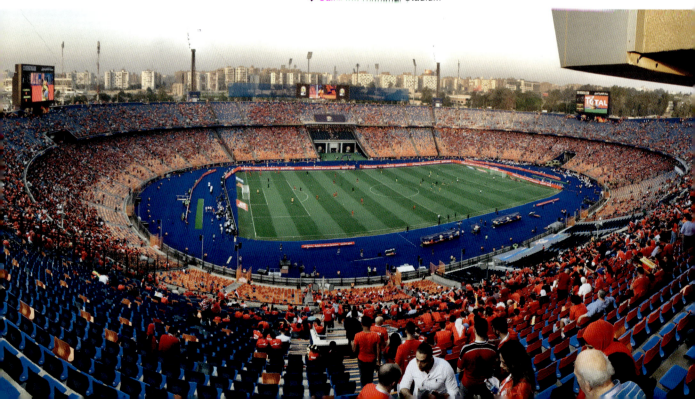

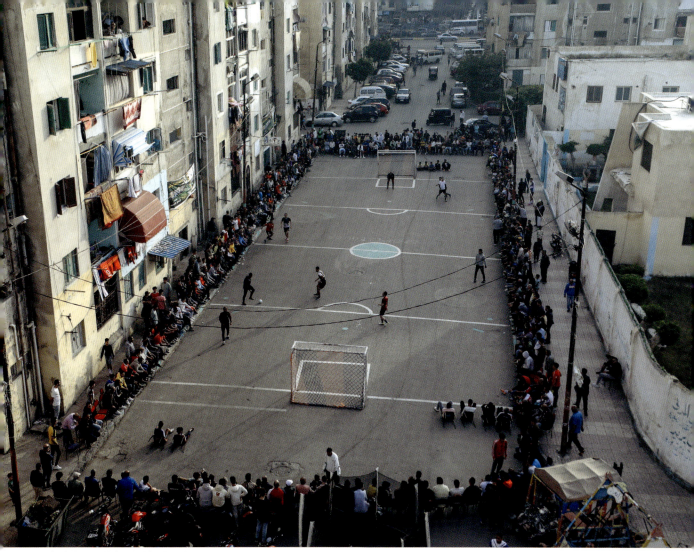

↑ Moharam Bek neighborhood

Alexandria Stadium
ALEXANDRIA (AL-ITTIHAD CLUB / SMOUHA SC)

The oldest stadium in Egypt has been described as a museum with a pitch and some stands. When the stadium was built, Alexandria was a melting pot of diversity with more Europeans living in the city than Egyptians. The entrance is in the style of a Greek temple; the grandstand of Venetian design; and beside it is a small tower, the remnants of a past fortress. The curved terraces take the form of a classic white sandstone Alexandrian amphitheater. The exterior wall features an art deco style of brickwork, white stucco beams, and repeating windows. As you pass the surrounding palm trees, it's worth reminding yourself that you're here to watch a game of football. The passion of the fans is to be experienced—but remain alert to volatility.

↑ Alexandria Stadium

Ethiopia / Africa

ETHIOPIA

Addis Ababa Stadium
ADDIS ABABA (NATIONAL TEAM / SAINT GEORGE SC / DEFENCE FORCE SC / ETHIOPIAN COFFEE SC)

If you want to experience the passion of African football, then take in the Shegar Derby between Saint George and Ethiopian Coffee. This is Derby della Madonnina in the Land of Thirteen Sunshines. Just like their famous Italian counterparts, this is two successful, historic teams, with superpassionate fans, sharing a stadium, and coming together to claim bragging rights in the streets of Addis Adaba, for a short time at least. Both sets of fans have their ultras, and clashes can be common. You'll want to avoid any areas that seem under the watch of military guards. The beautiful atmosphere comes from the thousands of fans singing high-tempo club anthems. These are more "songs" than chants and are accompanied by fans jumping or swaying in unison.

↓→ Addis Ababa Stadium

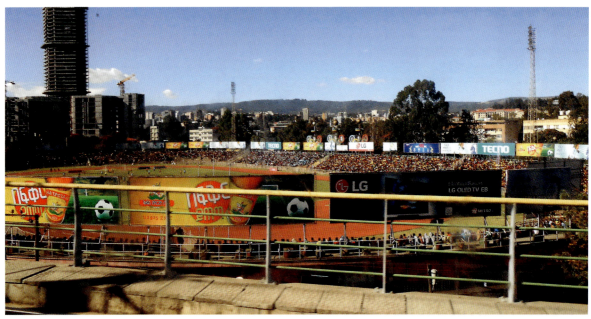

Woldiya Stadium
WELDIYA (WOLDIA SC / WOLDIA CITY)

This stadium shows what can be achieved when a community comes together—with a little help from a Saudi billionaire. But Sheik Mohammed Al Amoudi is no ordinary Saudi billionaire. He was born in Ethiopia, and when the chance came to give something back to it, he took it. The result is the first stadium in Ethiopia with an all-encompassing roof.

Tigray Stadium
MEKELE (MULTIPLE TEAMS)

Fans flocked to this concrete carcass before construction work was even complete, and that is how it remains to this day. In a region where children climb onto empty window frames in the ruins of local schools to watch a game on a dusty pitch, the people's desire to share football knows no ends. A visit should be taken with trepidation—this is the chance to experience football at its rawest. There are no facilities for food and drink, no restrooms, no infrastructure other than two huge tiers of standing-only terraces—just fans coming together to bask in the beautiful game.

TANZANIA

Benjamin Mkapa Stadium
TEMEKE DISTRICT, DAR ES SALAAM
(NATIONAL TEAM / SIMBA SC / YOUNG AFRICANS FC)

This venue is home to one of Africa's fastest-growing derbies—the Kariakoo between Young Africans and Simba, the dominant forces in the Tanzanian Premier League who share this stadium as their home. The stadium is hardly ever filled to the brim otherwise, but getting a ticket on derby day is a challenge as almost everyone in the city wants to be there.

SEYCHELLES

Stad Linité
VICTORIA (MULTIPLE TEAMS)

Stop at the brightly colored Victoria fish and fruit market to pick up lunch, take in the botanical gardens, then head toward the Indian Ocean on the rue Espoir for a rich, sensory walk to the Stad Linité. You can watch the national team or the Seychelles's most successful team, St Michel United FC.

Stade d'Amitié
PRASLIN (REVENGERS FC / CÔTE D'OR FC)

The stadium has benefited from the FIFA Goal Project. The grass pitch, a problem in the tropical climate, has been replaced with artificial turf. At the same time, terraces were constructed and facilities improved. The venue is home to two teams in the Premier League, so you can watch a richer brand of Seychelles football in comfortable tree-lined surroundings.

MADAGASCAR

Kianja Barea Mahamasina
ANTANANARIVO (NATIONAL TEAM)

Imagine a beer bottle crown cap pried off with a bottle opener and placed upside down on a table. That is what Madagascar's national stadium looks like. The upturned corner is a large semicircular grandstand, slightly separated from the rest of the stadium. The crown cap edge circles the entire ground in a series of white kite-shaped segments interspersed with images of famous Madagascans. Originally built by French colonials in 1897, it was reconstructed in 1960, and remodeled to the bottle top we see today in 2021.

↓ Kianja Barea Mahamasina

South Africa / Africa

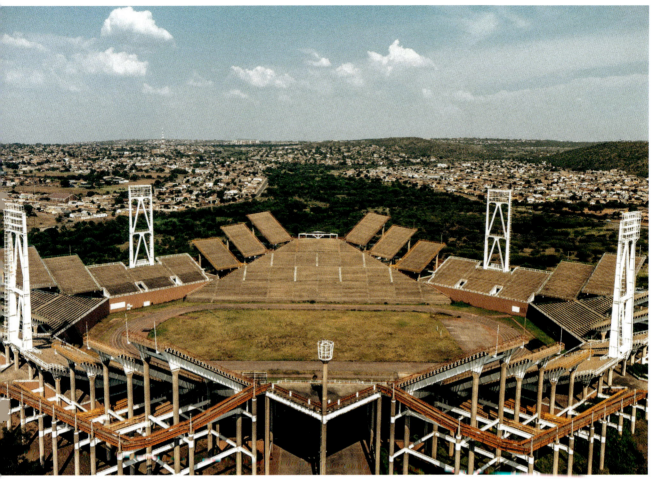

↑ Mmabatho Stadium

SOUTH AFRICA

Peter Mokaba Stadium
POLOKWANE (POLOKWANE CITY FC)

The Peter Mokaba Stadium, home of Polokwane City FC, hosted matches at the 2010 World Cup. It has a collection of distinctive but sporadic features. Four San Siro–style winding towers take you into the upper tiers. A large grandstand wears a tiara-like support frame with spot floodlights. The goal-side stands are painted with a mountainscape. Somehow it all comes together and it works.

Odi Stadium
MABOPANE (GARANKUWA UNITED FC)

You would be forgiven for thinking that the Odi Stadium, and its identical twin in Mahikeng, had flown in from outer space. The stadium consists of an uncovered grandstand, a secondary stand, four rectangular, two small triangular, and twenty floating stands. Now that it has been left to erode, many locals are calling for it to be demolished. Yet so far, the stadiums remain two white elephants with no money to either redevelop or demolish them. They are magnificent oddities that need to be visited before the chance has gone forever.

Mmabatho Stadium
MAHIKENG (MULTIPLE TEAMS)

This stadium is so unusual that, if it didn't have an identical twin in Mabopane, you'd say it must be a one-off. Sitting on one of the twenty-eight seemingly floating stands that "stack up" one upon the other to form a diamond shape around the pitch, it is a unique venue in world football.

Africa / **South Africa**

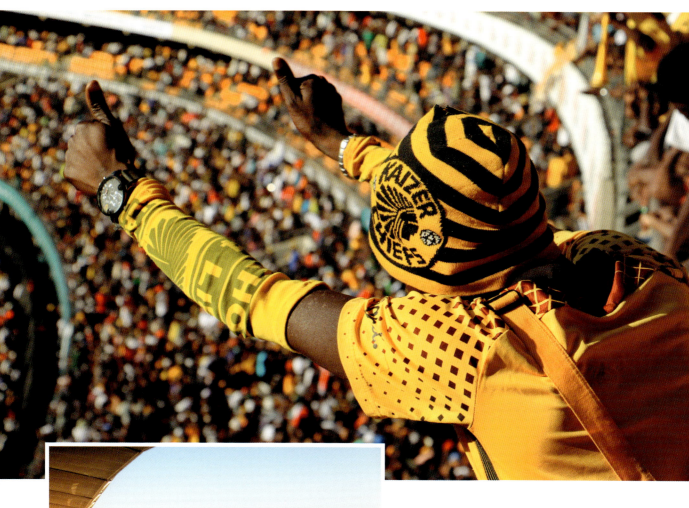

FNB Stadium
NASREC, JOHANNESBURG (NATIONAL TEAM / KAIZER CHIEFS FC)

With a design inspired by the calabash bowls traditionally used by women to carry water on their heads, and also used as musical instruments, FNB Stadium, also known as Soccer City, hosted the 2010 World Cup final between the Netherlands and Spain. The stadium mimics the warped shape of the bowl and its turned green wood. Its laminated fiber-reinforced concrete facade gives a magnificent sense of movement and texture. It is punctured with random openings that let in sunlight and emit glittering light onto the players and spectators when the sun goes down.

↑ FNB Stadium

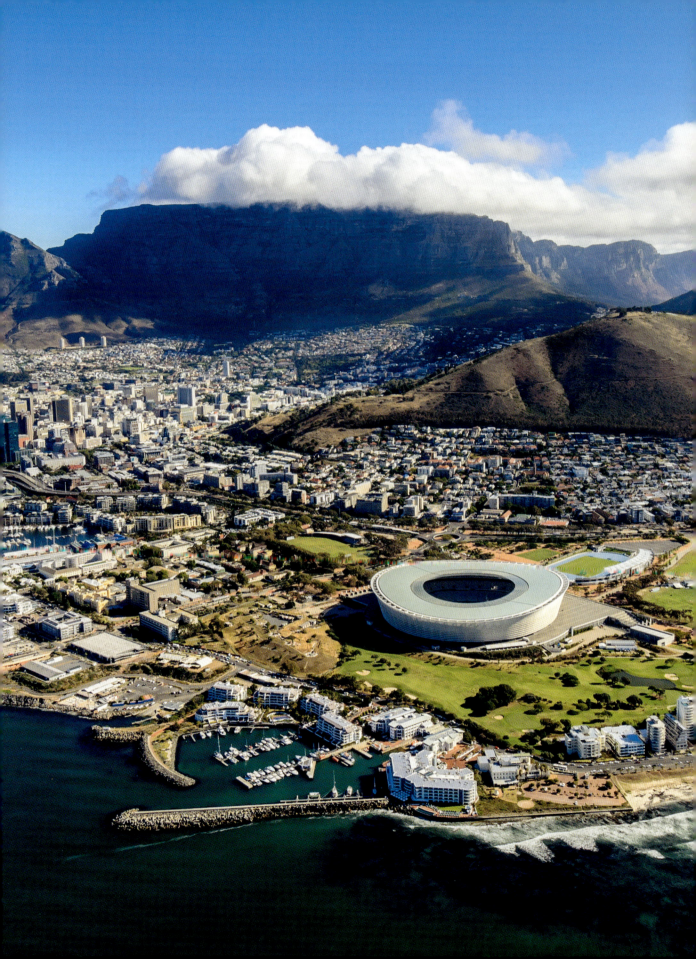

Africa / **South Africa**

DHL Stadium
CAPE TOWN (MULTIPLE TEAMS)

From the north you can walk along Beach Road with views of the South Atlantic Ocean and Signal Hill. From the south, you pass the previous incarnation of the stadium dating back to 1897. It's an intriguing view, seeing old and new resting beside each other. Inside, the undulating design of the stands mirrors the contours of the oceanic and mountainous surroundings. Secure a seat in the upper tier of the north stand for a glimpse of Table Mountain while watching play.

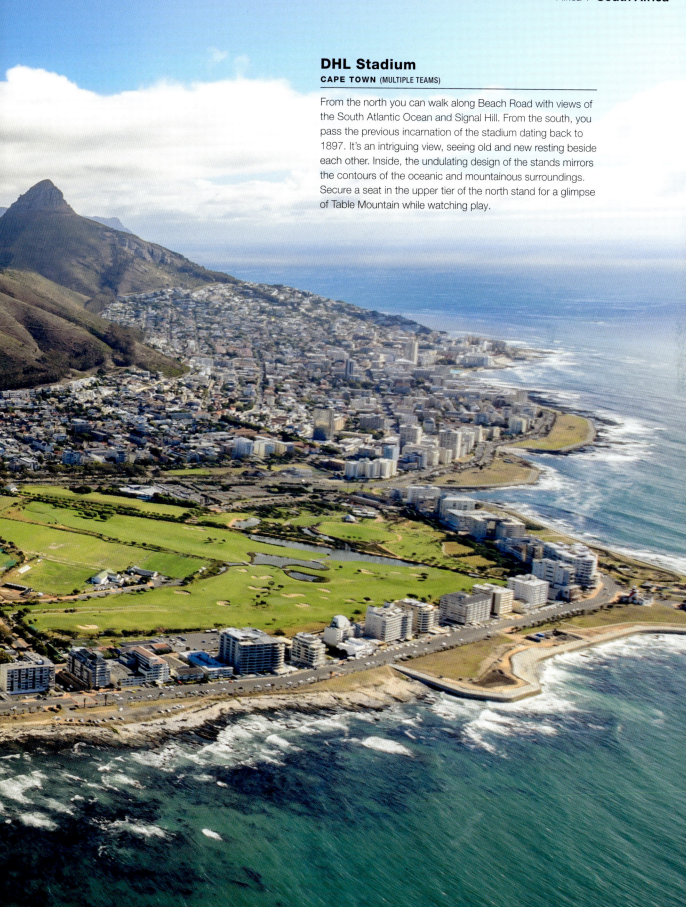

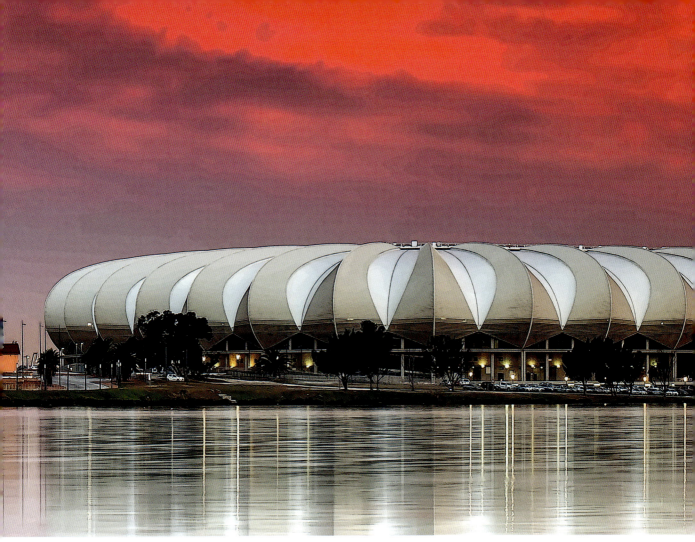

↑↗→ Nelson Mandela Bay Stadium

Moses Mabhida Stadium
DURBAN (AMAZULU FC)

If you're feeling intrepid, take a sky car across the archway that runs high above the center of the stadium, or if you're feeling energetic, walk up the five hundred stairs to a viewing platform that allows for views of Durban and the Indian Ocean. The views of the football are something to behold too. Every seat has uninhibited views of the match, thanks to the stadium's shallow bowl shape. The roof allows for an elliptical view of both the sky and the soaring arch. All of this is finished by industrial-style windows spanning the facade of the building.

Rand Stadium
JOHANNESBURG (NATIONAL TEAM)

Despite its relatively small capacity, Rand Stadium is regarded as one of the best playing surfaces in the country. It was rebuilt as an all-seater stadium and retained its old scoreboard for heritage purposes. Bafana Bafana uses it as a training ground.

Princess Magogo Stadium
KWAMASHU (NATHI LIONS FC / AMAZULU FC)

This stadium is steeped in Zulu culture. Named after a Zulu princess and home to AmaZulu FC, whose nickname Usuthu is a Zulu war cry.

Orlando Stadium
SOWETO (ORLANDO PIRATES FC)

Hearing the sound of *gwijo* from the stands is a wondrous experience. The South African collective singing takes the form of a call-and-response. When large sections of the crowd sing together it is incredibly rousing. An individual might sing "I don't care about my wounds," which is then repeated by the group. Then the response, "you will heal them," is repeated again. It brings fans together and feeds through to the players. Bafana Bafana players sing *gwijo* in the corridors of Orlando Stadium before a game.

Africa / **South Africa**

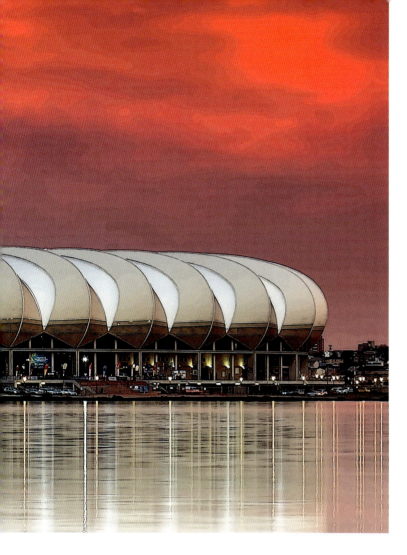

Mbombela Stadium
MBOMBELA (MBOMBELA UNITED FC)

Inspiration for the stadium comes from the surrounding game reserves. The seating is painted with zebra stripes, eighteen support frames look impressively like giraffes, and the gray roof mimics an elephant's skin.

Nelson Mandela Bay Stadium
GQEBERHA (CHIPPA UNITED FC)

One of South Africa's greatest and most beautiful sports venues. The cantilevered roof gives the impression of an unfolding flower, with alternating opaque and translucent sections that create stripes of light and shade. Uninterrupted stands, with seats just yards from the playing surface, form a natural bowl that traps the noise of the crowd. The combination gives you a sense of light and sound flowing down onto the pitch.

ANGOLA

Estádio da Cidadela
LUANDA (ASA / PROGRESSO DO SAMBIZANGA)

Known as the cathedral of Angolan sports, this stadium stands as a relic of better times. But as with so many Central African stadiums, this is perhaps its most intriguing facet. It has been replaced by the Estádio 11 de Novembro as the national team's home, but, like a coliseum, the Cidadela has an aging majesty to it. It bears all of its scars and glories in its slowly deteriorating concrete stands.

Ombaka National Stadium
BENGUELA (NATIONAL TEAM)

Grounds with open-ended structures are sometimes maligned, but here, close to the equator, it lets fans bathe in a welcome sea breeze from the nearby South Atlantic Ocean. If you approach the Ombaka National Stadium from a distance, across the Benguela plains, the stands look like hands cradling the pitch. The two main stands stop short of completing a full, classic bowl-like structure, leaving a void through the middle.

ZAMBIA

National Heroes Stadium
LUSAKA (NATIONAL TEAM)

The National Heroes Stadium is the largest in Zambia and a tribute to the players who died in the 1993 Gabon air disaster, when all but three of the talented national team died on their way to a World Cup qualifier against Senegal. The stadium sits beside the Heroes Acres Memorial, where the players are buried, and the deteriorating Independence Stadium. From a distance it looks impressive, with golden palm-tree-leaf elements spanning the white cantilevered roof, but get closer and you can see that is it starting to sink into decline. The dusty terrain close to the Great North Road is taking its toll. In 2022 part of the roof blew off, and from 2024 it has been used as a cholera center after a national surge in the disease.

Levy Mwanawasa Stadium
NDOLA (ZESCO UNITED FC)

Two colossal arched canopies cover each side of this impressive, bowl-like stadium. You'll find the overall feel to be open and expansive, thanks to the running track that creates a distance between players and fans. Fittingly, for the home of the Zambia women's national team—the Copper Queens—it sits in the heart of the country's copper mining belt.

DEMOCRATIC REPUBLIC OF THE CONGO

Stade Tata Raphaël
KINSHASA (DC MOTEMA PEMBE / AS VITA CLUB)

This huge stadium is most famous for 1974's Rumble in the Jungle boxing match between George Foreman and Muhammad Ali. It now hosts Linafoot, the Congolese top division. The stadium was named after Father Raphaël, the Belgian Catholic priest and missionary who was instrumental in its creation. He wanted to promote Catholicism through recreation and, with football being the largest global recreation of them all, a stadium was the perfect solution.

REPUBLIC OF THE CONGO

Stade Municipal de Kintélé
BRAZZAVILLE (NATIONAL TEAM)

If you were asked to imagine an alien craft from outer space, you might imagine the Stade Municipal de Kintélé. It is at its best when viewed from a drone shot, when the full wonder of the stadium's placement in the center of a collection of geometric shapes formed from roads, paths, stairways, and platforms becomes fully apparent.

GABON

Stade de l'Amitié
LIBREVILLE (NATIONAL TEAM)

The Stade de l'Amitié was entirely funded by China for the 2012 Africa Cup of Nations. The Friendship Stadium hosted the final, which gave the tournament its only goalless draw and its most magical moment, a sudden death penalty shootout with Zambia beating Ivory Coast 8–7.

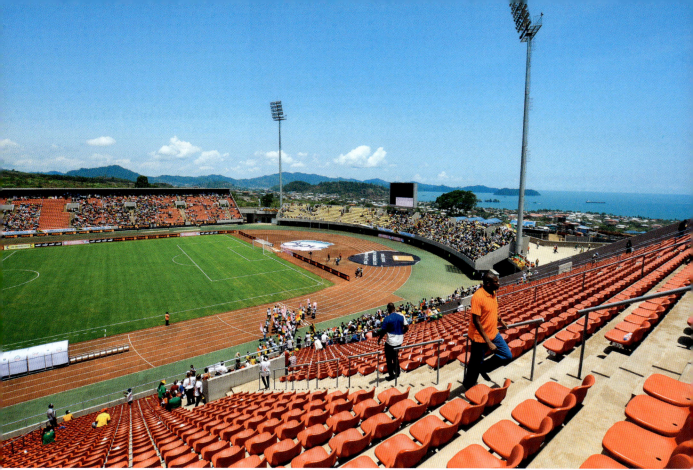
↑ Limbe Omnisport Stadium

EQUATORIAL GUINEA

Estadio de Bata
BATA (NATIONAL TEAM)

Originally built in 2007 with a capacity of twenty-two thousand in a single-tier precast concrete structure, the home of the Equatorial Guinea national team has since been expanded and hosted matches during the 2008 Women's African Football Championship.

CAMEROON

Stade Omnisport Paul Biya
YAOUNDÉ (NATIONAL TEAM)

The stadium is wrapped in a layer of small multicolored tiles. If you look at it long enough, it appears to be oscillating and shimmering.

Japoma Stadium
DOUALA (NATIONAL TEAM)

You'll find an energy in this district of Douala that may not have been there had the stadium not been built. The community was at the heart of the build, completed in time to host matches of the 2021 African Cup of Nations. The stadium has a classic African bowl shape, with full roof cover and seating patterned with abstract red, green, and yellow—an almost ever-present symbol of independence and democracy.

Limbe Omnisport Stadium
LIMBE (VICTORIA UNITED FC / NATIONAL TEAM)

The stadium sits on top of interconnecting levels like shelves; this allows the pitch to lie flat on top of a contoured hill. It makes for an interesting walk as you negotiate stairs and ramps, all the while taking in views of mountains, palm trees, and the South Atlantic Ocean. Victoria United plays many matches in the smaller training facility next door, leaving the main pitch to recover and making match-day logistics easier. With this in mind it is worth checking the match location if you want to ensure taking in a game at the main stadium.

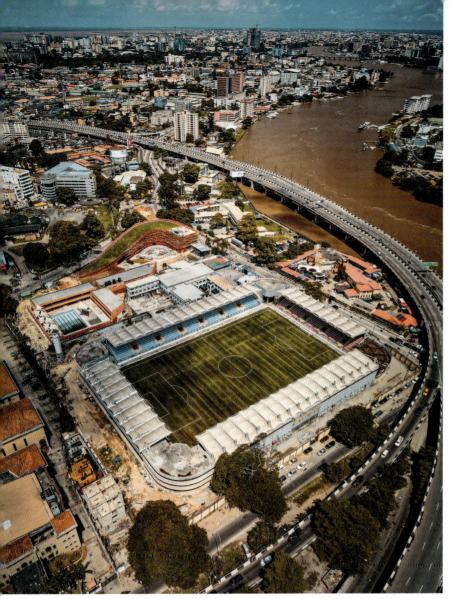

↑ Mobolaji Johnson Arena

NIGERIA

Mobolaji Johnson Arena
LAGOS (MULTIPLE TEAMS)

The Mobolaji Johnson Arena is Nigeria's oldest stadium and one of its busiest with ten teams calling it home, including Premier League side Sporting Lagos. The stadium has a superb waterside location on Lagos Island, and you can approach it via the impressive Tafawa Balewa Square with its four life-size statues of horses.

Moshood Abiola National Stadium
ABUJA (NATIONAL TEAM)

When the Super Eagles lost a World Cup qualification decider against Ghana at the Moshood Abiola, fans took their anger out on the stadium. They set fires, destroyed dugouts, and ripped out seats. But match day here can be a joyous experience with buoyant fans making their way to the stadium along the dozen or so tree-lined paths and roads that lead to the entrance. Just pick the game carefully.

Adamasingba Stadium
IBADAN (SHOOTING STARS SC)

With an ocean-blue running track, seating, and roofing all set against the green of the pitch, the stadium looks like a celestial representation of planet Earth.

NIGER

Stade Général Seyni Kountché
NIAMEY (NATIONAL TEAM / MULTIPLE TEAMS)

The main grandstand of the Stade Général Seyni Kountché—the largest stadium in the country—has an eye-catching exterior.

BENIN

Stade de l'Amitié
COTONOU (BENIN FOOTBALL FEDERATION)

Vuvuzelas are the first thing you hear as you join the crowd; the first indication you are visiting one of the continent's most quintessential African arenas. So many elements seen in the continent's stadiums can be found here: open-air, bowl-shaped, towering floodlights, large score display unit, bleachers separated from the pitch by a metal fence, and a mass of red, yellow, and green swathing across the stands to create a magnificent aesthetic. And when the Benin team scores, expect to see the players racing across the running track toward the crowd to share in the ecstasy.

Africa / **Ghana**

GHANA

Len Clay Stadium
OBUASI (ASHANTI GOLD SC / NATIONAL TEAM)

Two large floodlight pylons frame a backdrop of palm trees and nearby hills. A concrete ring for a future running track, metal fence, and coiled barbed wire stand between the fans and the pitch. It's raw football, but one the people of the local gold-mining community savor and flock to on match day.

Accra Sports Stadium
ACCRA (ACCRA GREAT OLYMPICS FC / ACCRA HEARTS OF OAK SC / ACCRA LIONS FC / NATIONAL TEAM)

The home to the oldest club in Ghana, Hearts of Oak, sits close to the South Atlantic Ocean. The sea breeze is a welcome comfort from the heat of the tropical climate. Unusually for a country's biggest team, Hearts of Oak was homeless in November 2023 so the stadium could be used to host Christmas events.

Sekondi-Takoradi Stadium
SEKONDI-TAKORADI (SEKONDI HASAACAS FC)

The story of the Sekondi is like so many African stadiums. It was built to host the African Cup of Nations, but funding dried up and it has fallen into disrepair. The roof, which created a magical light show on opening night, is in ruins. It has a strange charm, though, like visiting an abandoned building and seeing glimpses of its former glories. Only it isn't abandoned—the Sekondi hosts second-tier football, and you can share its story.

Baba Yara Sports Stadium
KUMASI (ASANTE KOTOKO SC / NATIONAL TEAM)

The Porcupine Tertiary floods the stadium in support of their team, Asante Kotoko. They are a "morale group," bringing gospel jama to the Baba Yara. The high-tempo, infectious songs and dance jams start outside the stadium. They work. Asante Kotoko is the most successful team in Ghana, and the national team is a force in world football. Both teams play to that same up-tempo, rhythmic beat on the pitch.

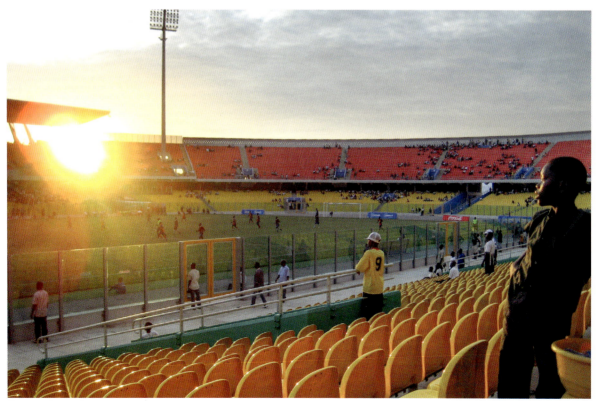

↑ Accra Sports Stadium

Burkina Faso/Côte d'Ivoire / Africa

BURKINA FASO

Stade du 4 Août
OUAGADOUGOU (NATIONAL TEAM / ÉTOILE FILANTE DE OUAGADOUGOU / COMMUNE FC / ASFA YENNEGA)

The largest stadium in Burkino Faso's capital was opened in 1984, a year after independence from France, and bears the date of the revolution. It is home to one of the nation's oldest teams, ASFA Yennenga. Founded in French colonial Burkino in 1947 as AS Jeanne d'Arc, their crest shows Joan of Arc on horseback in a revolutionary context holding an arrow and wearing a beret.

CÔTE D'IVOIRE

Alassane Ouattara Stadium
ABIDJAN (NATIONAL TEAM)

As you drive toward the stadium in a *gbaka* (minivan), the stadium's layers begin to unfold. The first is the outer skeleton of columns and arches, topped with stained glass windows in national colors. Through the arches the inner workings are revealed—the back of the stands and large flights of stairs. Beyond this is a faint view of the seating and pitch. On February 11, 2023, little of this would have even been visible as the Côte d'Ivoire fans poured from the stadium having beaten Nigeria to win the African Cup of Nations, which sparked wild celebrations.

Stade Félix Houphouët Boigny
ABIDJAN (NATIONAL TEAM / ASEC MIMOSAS)

An approach from the east, across the Pont Alassane Ouattara, offers superb views of this stadium that is reminiscent of a jewelry box. The former home of the national team sits close to the banks of the Cocody Bay in the heart of the capital, Abidjan.

↓ Alassane Ouattara Stadium

↑→ Stade Abdoulaye Wade

SENEGAL

Stade Abdoulaye Wade
DAKAR (NATIONAL TEAM)

The first thing that sets the beautiful new home of the Lions of Teranga apart from most African stadiums is the absence of a running track. If you can secure a seat in the front row, you'll be as close to the action as in any national stadium in the world.

MAURITANIA

Stade Municipal de Nouadhibou
NOUADHIBOU (FC NOUADHIBOU)

A simple pattern of alternating red, yellow, and green plastic seats creates a spectacular look.

Iran / Middle East

IRAN

Pars Stadium
SHIRAZ (FAJR SEPASI SHIRAZ FC)

Shiraz is one of Iran's most popular tourist destinations, a gateway to the ancient capital of Persepolis and to Persian Gulf Pro League football. The stadium sits on the edge of the city, and a walk through the City of Poets and Flowers on match day is well worth taking.

Imam Reza Stadium
MASHHAD (SHAHR KHODRO FC)

Fans of VfB Stuttgart might blink on a visit to the Imam Reza Stadium. It is almost identical to the home of the Bundesliga club. Both were constructed by the same German company. The roof also bears a striking resemblance to West Ham's London Stadium. Again, the roof was built by the same French company.

Fuladshahr Stadium
FULADSHAHR (ZOB AHAN ESFAHAN FC)

If you want to watch an intriguing match, the derby between two Isfahan steel company teams is the one to watch at the Fuladshahr Stadium. The rivalry between Zob Ahan and Sepahan SC harks back to the early days of football, when teams came from urban factories. Goals are celebrated with replica jerseys being swung above heads and ticker tape thrown onto the pitch.

Foolad Arena
AHVAZ (FOOLAD FC)

The Foolad Arena in Khuzestan province is arguably Iran's most remarkable stadium. While traditional venues in the country tend to be open arenas with curved stands around a running track, the Foolad Arena has a more rectangular shape and a gleaming white membrane roof.

Azadi Stadium
TEHRAN (PERSEPOLIS FC / ESTEGHLAL FC / NATIONAL TEAM)

The Azadi, Iran's largest stadium, has seating for almost eighty thousand. In 2023, it was the first Iranian stadium to welcome women to watch a men's game since the 1979 Islamic Revolution.

Shahid Kazemi Stadium
TEHRAN (PERSEPOLIS FC / ESTEGHLAL FC / NATIONAL TEAM)

Iran's most successful club, Persepolis, really flexed their muscles when they made the Shahid Kazemi Stadium their training ground. It is an impressive venue with a seating capacity bigger than the main home stadiums of about half of the teams in the Persian Gulf Pro League.

Takhti Stadium
TEHRAN (SAIPA FC)

The Takhti Tehran is a concrete, saddle-shaped stadium with a unique roof feature. Much of the 30,122 capacity is weighted to one enormous stand covered by a huge canopy. Similar to the Olympiastadion in Munich, the canopy is pitched by supporting towers and cables spanning across the arena.

Yadegar-e-Emam Stadium
TABRIZ (TRACTOR SC)

The city of Tabriz sits at the base of the massive—and now-extinct—Sahand volcano. However, its biggest venue, the Yadegar-e-Emam Stadium, certainly has the capacity to erupt when filled to the brim with fans of local club Tractor. And it is a great place to experience the country's passionate fan culture, with the stands turning red on the big days. The stadium's sweeping lower tier encircles a running track and was built using the natural topography on the slope of the land. With the addition of the two upper tiers along the sidelines, it is the third-largest stadium in the country.

Marzdaran Stadium
TABRIZ (MACHINE SAZI FC / SHAHRDARI TABRIZ FC)

The Marzdaran stands out among the surrounding sand dunes and desert mountains. A quaint clubhouse with a red roof and little chimney sits proud at the center of a small seated main stand.

Naghsh-e-Jahan Stadium
ISFAHAN (SEPAHAN SC)

Not all stadiums are welcomed by fans. The Naghsh-e-Jahan Stadium may be the second-largest stadium in Iran, but that counts for little to football fans in the city who view it as a waste of funds. To date, there have only been twelve occasions where even half of its capacity has been surpassed, so the public frustration is understandable. But it does mean that you'll find a seat to watch a match here. The stadium is named after the UNESCO World Heritage Site city square in the heart of Isfahan, the name of which translates to "image of the world."

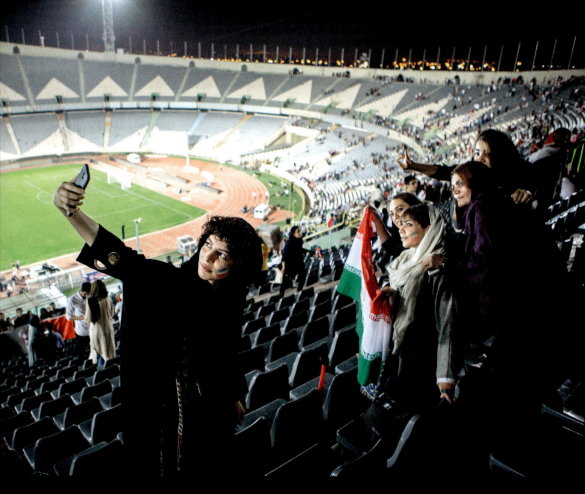
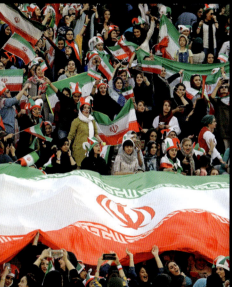

↑↗ Azadi Stadium

KUWAIT

Jaber al-Ahmad International Stadium
KUWAIT CITY (NATIONAL TEAM)

As you walk to the stadium, the heat hits you. In a climate where temperatures top 122°F (50°C), you must plan your journeys according to air-conditioning pit stops. The concourses of the Jaber al-Ahmad are a welcome cooling experience, but the stands can become sweltering. Here, friends play football in high heat and sandstorms. If you are equally acclimatized, then enjoy the match and make sure you look up at the roof to see the two interconnecting dove wings.

QATAR

Al Thumama Stadium
DOHA (NATIONAL TEAM)

At night the majestic Al Thumama Stadium looks like a crystal bowl. Following the 2022 World Cup, half of its seats were removed and donated to other countries, taking the capacity from 44,400 to 20,000.

Jassim bin Hamad Stadium
DOHA (NATIONAL TEAM / AL SADD SC)

You get a sense of heritage at Al Sadd's relatively compact arena thanks to the photos of their achievements, including some national team matches, that adorn parts of the wall behind the stands. Erected in 1975, the stadium is home to the most successful side in the country. Built in a residential area away from the glitz and glamour of the World Cup stadiums, the building itself stands out as its four towers are only just taller than the bungalows that surround it.

Doha Sports Stadium
DOHA (ASIAN COMMUNITIES FOOTBALL TOURNAMENT / QATAR AMATEUR LEAGUE)

In 1973, Pelé and his much-traveled Santos FC side played a friendly against Al-Ahli on the first grass pitch in the Arabian Gulf. Now, the arena hosts every match of the Qatar Amateur League and an annual tournament for Asian expats.

↓ Lusail Stadium

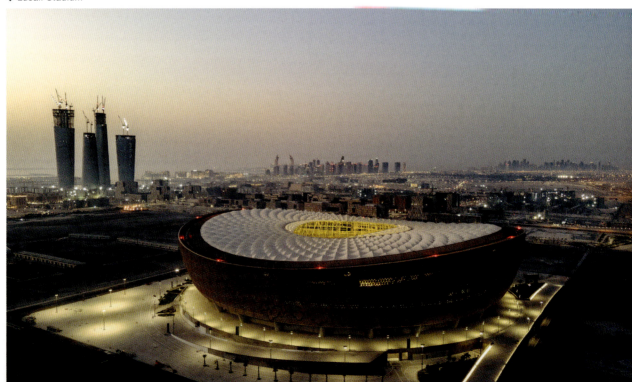

Lusail Stadium
LUSAIL (NATIONAL TEAM)

One of the greatest World Cup finals was played out here between France and Argentina in 2022. The classic end-to-end encounter saw a late French comeback in normal time, a hat-trick from Kylian Mbappé, an extra-time duel between the French star and Argentinean talisman Lionel Messi, and ultimate heartbreak for France, losing in a penalty shoot-out. Mbappé scored four goals in total and lost. All of this happened in front of 88,966 spectators in a stadium resembling a traditional woven wicker basket that, for one glorious night, became a cauldron.

Al Janoub Stadium
AL-WAKRAH (AL-WAKRAH SC)

One of the many stadiums built specifically for the 2022 World Cup, it stands out thanks to the curving patterns on its roof, which are designed to resemble the sail of a traditional Qatari dhow boat. The structure also serves to shade most spectators from the sharp Arab sun.

Ahmad bin Ali Stadium
RAWDAT AL JAHHANIYA (AL-RAYYAN SC)

Apart from its red and black seats, very little of this new stadium resembles the arena it replaced. The new arena, like many others, was built for the World Cup. It is more rectangular than curved and more closed at the top. Its exterior includes multiple multimedia screens that can make it glow at night. The color of the seats honors its home team, Al-Rayyan SC.

Al-Shamal SC Stadium
MADINAT ASH SHAMAL (AL-SHAMAL SC)

The home of Al-Shamal SC, in the top-tier Qatar Stars League, is a fortress. The stadium is an exact replica of the nearby Al Zubara Fort. The four corner turrets extend beyond the steep redbrick walls and hide floodlights that extend upward when needed. A word of warning—it can get very hot. The stands are open to the sun and an evening game under floodlights is perhaps the way to see a match here.

↑ Khalifa International Stadium

Khalifa International Stadium
AL RAYYAN (NATIONAL TEAM)

Whether you're inside or outside the Khalifa International, the imposing 984-foot (300-m) Aspire Tower forms part of the backdrop. The stadium underwent renovation in 2014 to expand its capacity in anticipation of the World Cup, though its iconic dual arches were left untouched as a reminder of its heritage. Before then, this was Qatar's largest stadium and it remains the most historic venue in the country, as well as being the predominant home of the national team. It has seen many a big game in its time, including the 2011 Asian Cup final when Japan lifted its record fourth title.

Education City Stadium
AL RAYYAN (MULTIPLE TEAMS / NATIONAL TEAM)

The vast size and grandeur of the Qatari arenas are expected, what perhaps is not are the sensory rooms for those with autism and audio commentary for the blind that fans can experience at the Education City Stadium.

Al Bayt Stadium
AL KHOR (MULTIPLE TEAMS / NATIONAL TEAM)

You might expect to see a traditional Bedouin tent in the deserts of Qatar but not one that holds 68,895 spectators and has a retractable roof. And ironically for a venue honoring the makeshift homes of the traditional nomadic people, the Al Bayt Stadium includes luxurious hotel suites and rooms with balcony views of the football field.

UNITED ARAB EMIRATES

Mohammed bin Zayed Stadium
ABU DHABI (AL-JAZIRA CLUB)

The main stand has a curved roof as well as hospitality areas behind the seats, which make its exterior resemble some sort of ship. The three other stands are open and rather steep, while two fifteen-story towers rise from the gaps between them. Opened in 1979, it is one of the older football stadiums in the country, but still stands as the biggest club venue as the home of Al Jazira.

Zayed Sports City Stadium
ABU DHABI (NATIONAL TEAM)

The exterior of the Sports City includes a series of sharply curved rolls that make up the roof, with the entrances to the stands following their pattern. The interior is bowl shaped, with a running track that pushes spectators away from the action at certain angles. Fittingly, as the United Arab Emirates's national stadium, it is also the country's biggest. Built as a part of a state-of-the-art sports complex in 1979, its national importance can be understood from the fact that it is featured on the AED 200 banknote.

Baniyas Stadium
ABU DHABI (FC BANIYAS)

This open venue has just one covered grandstand, which has a unique roof that is made to resemble the tents of the Bani Yas tribes, whom the club's name represents. The loudest fans can be heard in that stand with their voices amplified by the roof.

↑ Mohammed bin Zayed Stadium

Sharjah Football Stadium
SHARJAH (SHARJAH FC)

As well as the being the home of local team Sharjah FC, the stadium is a temporary sanctuary for the Palestinian national team. Close to the Persian Gulf, it is an oval arena with a small roof covering. The concrete supports on one side, which have the potential to house another tier of seating, protrude upward and resemble a rib cage.

Middle East / **Oman/Yemen**

OMAN

Al Hajar Mountains football field
AL HAJAR MOUNTAINS (MULTIPLE TEAMS)

Spectators can dream they're in the movies when they see a match on this pitch. It took two weeks to build for an Audi television commercial, and then a week to shoot the story of a boy from a local village dreaming of becoming a professional footballer. The crew and cars have long since left, but the playing surface in the heart of the Al Hajar Mountains remains. It is a trek to get to the pitch, but the lush grass pitch is available to intrepid players who want to play a match here.

YEMEN

Althawra Sports City Stadium
SAN'A' (NATIONAL TEAM)

Vibrant blocks of red, blue, and yellow seating, common in Asian and African stadiums, welcome visitors, while the luscious green pitch contrasts with the stadium's dusty surroundings. Having suffered bomb damage twice, the last time in 2016 at the hands of a Saudi Arabian air strike, the stadium has risen from the rubble.

↓ Al Hajar Mountains football field

Saudi Arabia / Middle East

↓ Al-Awwal Park (page 272)

Middle East / **Saudi Arabia**

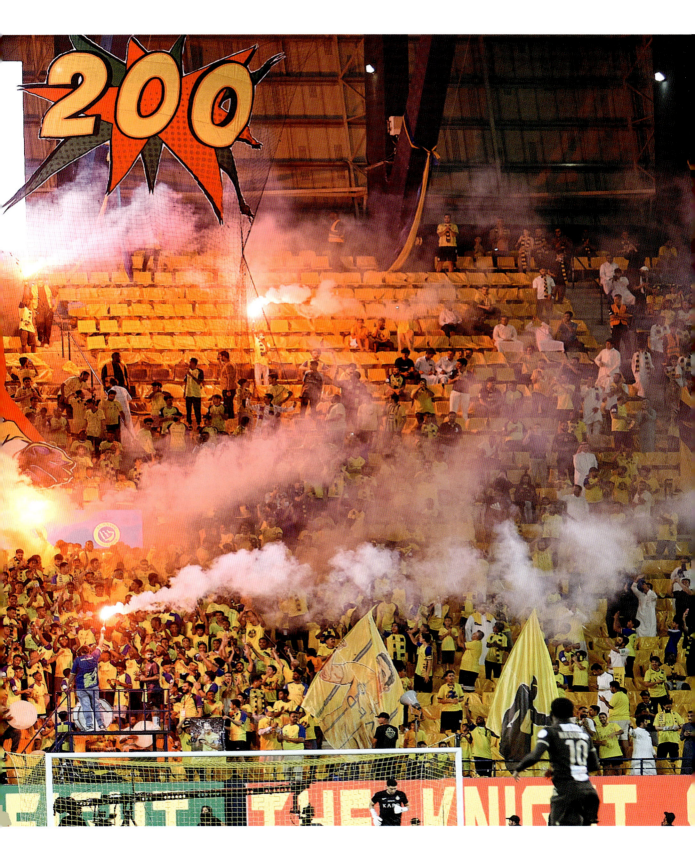

Saudi Arabia/Jordan/Israel / Middle East

SAUDI ARABIA

Al-Awwal Park
RIYADH (AL-NASSR FC)

When compared to the giant, gleaming arenas elsewhere in the country—as well as its neighbors such as Qatar and the United Arab Emirates—the King Saud University Stadium's design is rather unremarkable. It follows a rectangular shape with a simple roof, but its close stands enable the passionate Al-Nassr fans to create an imposing match-day atmosphere with their bright yellow flags and flares.

Prince Faisal bin Fahd Sports City
RIYADH (AL HILAL SFC)

If planned renovations go ahead, the oldest notable football stadium in Riyadh will be a cooler place to watch a match, thanks to a new roof and air-conditioning in the west stand. Match days will be even more electric with a doubling in its capacity and the removal of the running track, which will bring fans closer to the action.

Al-Shabab Club Stadium
RIYADH (AL-SHABAB FC)

Previously a multipurpose arena, the Al-Shabab Club Stadium has been converted to a football-specific venue thanks to the removal of the running track. This transformation reflects the rise in Saudi investment in football—not just on superstar international players but also in local infrastructure.

Alinma Stadium
JEDDAH (AL-AHLI SAUDI FC / AL-ITTIHAD CLUB / NATIONAL TEAM)

The main stadium sits in the center of Alinma Stadium, which looks like a giant crop circle. As well as the stadium, known as the Shining Jewel, the complex has six further pitches and a media center for match-day press and broadcasting.

JORDAN

Al-Hassan Stadium
IRBID (WOMEN'S NATIONAL TEAM / AL-HUSSEIN SC)

One of the major changes in world football in recent years is perhaps the lifting of FIFA's ban on headscarves. The Jordanian women's national football team and one of their biggest supporters, Prince Ali Bin Hussein, were instrumental in bringing about the change. Their home was one of the first stadiums to see the hijab worn at a major tournament, the 2017 Under-17 Women's World Cup.

Amman International Stadium
AMMAN (NATIONAL TEAM / AL-FAISALY SC)

The stadium, constructed at a time when Jordan did not have any state-of the-art sporting venues, has a wide running track, which means the curving stands are some way from the pitch— particularly behind the goals. Despite this, it has been the standout sporting venue in Jordan for over half a century. Located in the Sport City area of the capital, it remains the home of the national team as well as Al-Faisaly, by far the country's most successful club.

ISRAEL

Netanya Stadium
NETANYA (MACCABI NETANYA FC)

The sparkle at the Netanya, known as the Diamond Stadium, comes from the strips of spot floodlights spanning the edges of the two large curved stands. The stadium is close to the Mediterranean coast, and you can take in the colorful, aromatic markets and bazaars on the way to a match. Try a *bourekas*, a pastry topped with poppy seeds. In the stadium, it's sunflower seeds all the way.

Green Stadium
NOF HAGALIL (HAPOEL NOF HAGALIL FC)

The Green Stadium has two pitches tip to toe. The main pitch has three stands. At the away goal end, instead of a stand, there's a small divide between the pitches. Hapoel Nof HaGalil takes to the pitch in the same kit as Paris Saint-Germain.

Middle East / **Israel/Lebanon**

Bloomfield Stadium
TEL AVIV (MACCABI TEL AVIV FC / HAPOEL TEL AVIV FC / BNEI YEHUDA TEL AVIV FC)

Although not the biggest stadium in Tel Aviv, this is certainly the most eye-catching. Built in 1962, it has undergone four renovations including one recent reconstruction. Due to its constrained location, its expansion was achieved by adding a second tier to the east stand and more seats to the west stand, while the north and south stands remained as they were. As a result, it has an asymmetrical bowl shape with incredible views from the summit of the west stand.

Teddy Stadium
JERUSALEM (BEITAR JERUSALEM FC / HAPOEL JERUSALEM FC)

A huge tifo of a hooded druid cupping their hands around a crystal ball with the Beitar Menorah within it floats above supporters in the west stand. A section of seating between a sea of yellow flags and scarves on one side and red on the other, is left empty, telling its own story. This is the Jerusalem derby between the two teams that share Teddy Stadium. In a league that promotes inclusivity of all creeds and denominations, Beitar is notorious for its lack of inclusion and hate songs are rife. For this reason, you may want to check the fixture list and take in a Hapoel match. Or perhaps you're ready to experience the cauldron of the derby?

Sammy Ofer Stadium
HAIFA (MACCABI HAIFA FC / HAPOEL HAIFA FC)

The stands are compact, close to the pitch, and housed in a golden envelope. The acoustics are like an opera house. The golden stadium of Haifa's two largest clubs also hosted Maccabi Tel-Aviv's Champions League matches, with home fans driving an hour to get there, because it's that good. Located beside Mediterranean beaches and Mount Carmel, it benefits from the beauty of its surroundings. In the plaza outside is a 49-foot-high (15-m) *Statue of World Peace* by Chinese artist Yao Yuan. The same sculpture stands outside Beijing Olympic Stadium, the United Nations in New York, and on the Normandy coast in France.

LEBANON

Saida Municipal Stadium
SAIDA (AL AHLI SAIDA SCAL AHLI SAIDA SC / NATIONAL TEAM)

An amazing beachside location is the setting for Lebanon's gem of a football stadium. The grandstand is covered by a canopy roof based on a Phoenician sailing boat. Beneath the stand are archways with bridges to the seats and a walkway to the other side. The people of Saida get to watch their local team Al Ahli Saida SC and the Cedars at a great national stadium.

Camille Chamoun Sports City Stadium
BEIRUT (NATIONAL TEAM)

"Construction won over destruction, and peace over war," were the words used at the reopening of Lebanon's largest stadium in 1997, fifteen years after being destroyed during the country's civil war. It now lies in ruins again through neglect and the national team has moved out. Its narrative of the highs and lows of the nation's fortunes make it an absorbing relic to visit.

↓ Sammy Ofer Stadium

Lebanon/Syria/Iraq / Middle East

Beirut Municipal Stadium
BEIRUT (NOT IN USE)

Just a few hundred yards away from the new national stadium stands the Beirut Municipal Stadium. Built in 1935 by French colonists, it is a historic sporting venue. To this day, it pops out in an incredibly densely packed neighborhood of the Lebanese capital. It is absolutely suffocated by buildings that stand many times taller than it, to the point that there may well be more viewing spots from the balconies and windows than the stands.

SYRIA

Aleppo International Stadium
ALEPPO (AL ITTIHAD AHLI OF ALEPPO SC)

The largest sporting venue in Syria sits in the country's capital. Even today, the Aleppo International Stadium ranks in Asia's top fifty football stadiums by capacity, but back in the 1980s, when it was first planned, it was going to be a state-of-the-art facility. However, decades of financial issues delayed its completion to 2007, and soon thereafter, it required renovation after suffering damage from mortar fire during the Syrian Civil War.

IRAQ

Al-Najaf International Stadium
NAJAF (AL-NAJAF SC / AL-NAJAF-WASAT SC)

With incredibly high temperatures in the final months of the football season here, the stadium's magnet shape—with a large void on the south side—brings a gentle breeze from the Najaf Sea to the south. The white steel Islamic-mosaic exterior leads into the roof and creates shade for most of the stands. For comfort, avoid sitting in the south stand in July, although it will give you a wonderfully immersive experience.

Duhok Stadium
DUHOK (DUHOK SC)

Duhok SC players take to the pitch with blue mountain hawk wings across their shoulders over a yellow jersey. Yellow-and-blue checkered flags wave to the beat of drums. The Iraqi Kurdistan derby against Zakho FC brings a real passion to the Duhok Stadium. The stadium plays its part with 22,800 fans packed together under the shadow of mountains.

↓ Duhok Stadium

Basra International Stadium
BASRA (NATIONAL TEAM / AL-MINA'A SC / NAFT AL-JUNOOB SC)

From a distance the stadium looks like a woven basket. As you get closer you see the interwoven steel, a sculptural skin. The design is based on traditional Madan houses made from interwoven marsh reeds. One of the many bridges takes you across a large artificially made lake that surrounds the stadium, close to the Basra canal on the outskirts of the city. By the time you step inside, to the more expected football setup, you feel immersed in the landscape and culture.

Al-Minaa Olympic Stadium
BASRA (AL-MINAA SC)

The fusion of the contours of the football arena and the coastal location has become a firm favorite of stadium designers in recent years. The Al-Minaa, positioned close to the Persian Gulf and within the port city of Basra, is a beautiful example. The oval stands rise and fall like a wave, with the lowest points behind the goals. The roof feels like a tidal wave breaking above you, frozen in time.

Al-Sha'ab International Stadium
BAGHDAD (AL-SHORTA SC)

Iraq's oldest football stadium has come a long way since much of it was destroyed by US air strikes during the Battle of Baghdad in 2003. As well as a fully modernized stadium hosting top-flight football, it is home to the Real Madrid Academy Iraq, which nurtures local talent with dreams of lighting up the Bernabéu.

↑ Basra International Stadium

CYPRUS

Alphamega Stadium
LIMASSOL (AEL LIMASSOL / APOLLON LIMMASOL FC/ ARIS LIMMASOL FC)

Derby days are generally the best times to experience the atmosphere in this compact, rectangular venue. There had long been talk of a new stadium in Limassol as the city's three biggest clubs—AEL, Aris, and Apollon—had shared the old Tsirio Stadium since it opened in 1975. Plans finally came to fruition with the opening of the Limassol Stadium in 2022. The new arena is not quite as big as its predecessor, but boasts far superior facilities, which makes for a comfortable viewing experience.

GSP Stadium
NICOSIA (APOEL FC / AC OMONIA)

The GSP Stadium was constructed just before the turn of the century as the home of the city's three biggest clubs—APOEL, Omonia, and Olympiakos. It has also hosted many of the national team's matches over the past two decades, as it's the country's largest footballing venue. The passionate fans of the big three clubs, as well as the national team, can certainly create a memorable atmosphere on the big days— particularly in the open curved stands behind either goal.

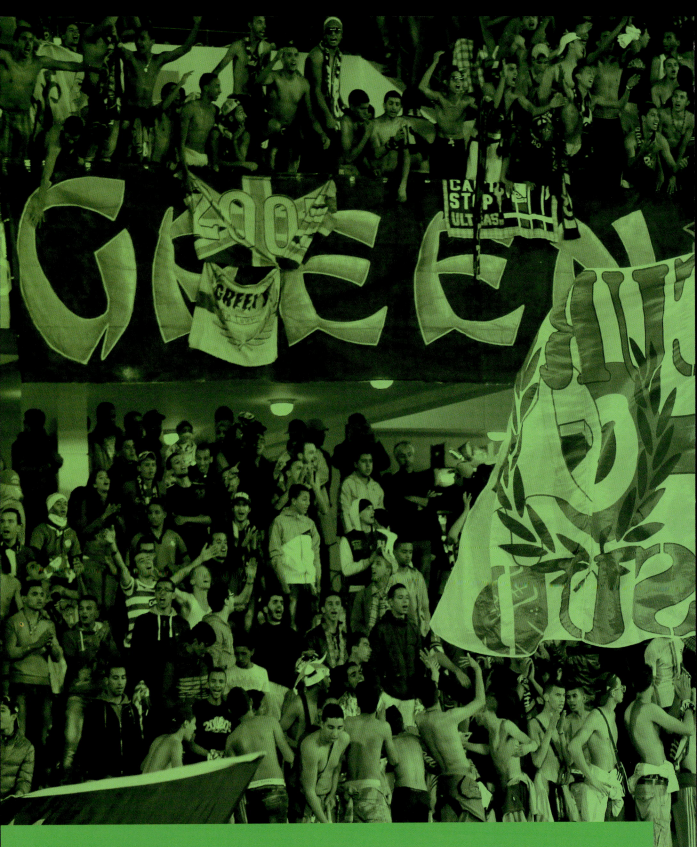

Asia

CHAPTER 5

↑ Koblandy Batyr Stadium

KAZAKHSTAN

Koblandy Batyr Stadium
AKTOBE (FC AKTOBE)

At almost fifty years old, the Koblandy Batyr Stadium is both a historic venue and one of the most popular stadiums in the country. While it does not have the largest capacity in Kazakhstan, it is one of the best-attended venues in the league as FC Aktobe has a large fan base, who create a great atmosphere.

UZBEKISTAN

Milliy Stadioni
TASHKENT (FC BUNYODKOR / NATIONAL TEAM)

When it opened in 2012, the Milliy Stadioni (Uzbek for "National Stadium") was an early emblem of the growth that Uzbek football experienced in the subsequent decade. To this day, it is the crowning jewel of the country's domestic football scene. Built in place of the old MHSK Stadium, it has two tiers of stands that run around the pitch while maintaining good proximity for all those in attendance. Its exterior is a vast series of arches that rise to a diamond shape before curving into the roof, which can be lit up to give the venue a dazzling appearance on big nights.

↓ Milliy Stadioni

Asia / **Uzbekistan/Mongolia**

Xorazm Stadium
URGENCH (XORAZM FK)

A small coliseum-like building. The two luscious green training pitches on the outside are arguably better than the main pitch inside.

MONGOLIA

My Mongolia Park Stadium
DARKHAN (DARKHAN CITY FC)

Although the vast majority of Mongolian football clubs hail from the capital Ulaanbaatar, the country's most notable stadium is arguably outside the city. Opened in 2022, and bearing the name of the neighboring amusement park, My Mongolia Park Stadium is indisputably the most modern in the country. Its stands are comfortable rather than remarkable, and its picture-perfect turf guarantees a good playing surface.

MFF Air Dome
NEW YARMAG (BAVARIANS FC / NATIONAL TEAM)

When an ice-cold wind is howling across a snow-covered plain, the place to be is indoors. For Bavarians FC that means being inside this FIFA-funded air dome. The dome hosted a 2022 World Cup qualifier where Mongolia defeated Brunei to progress to the next stage. It was the first qualifier in an air-inflated facility.

National Sports Stadium
ULAANBAATAR (DEREN FC)

The exterior of this oval ground resembles a nineteenth-century naval base; its redbrick walls are dotted with square windows and large arched doorways. It is unlike the facade of any other stadium.

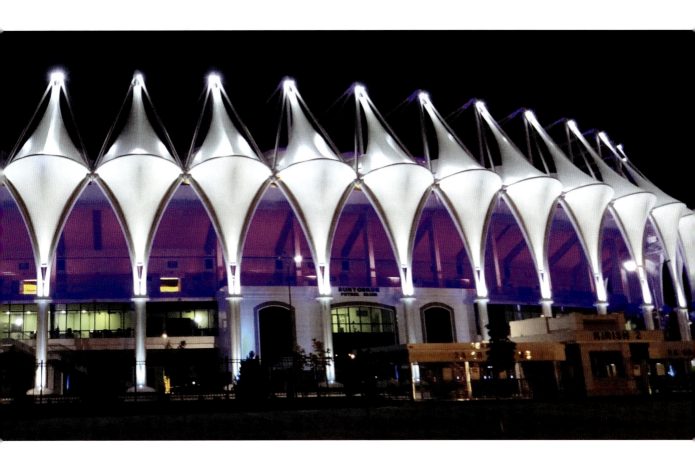

China / Asia

CHINA

Qingdao Tiantai Stadium
QINGDAO (QINGDAO HAINIU FC / QINGDAO RED LIONS FC)

This historic stadium is one of the oldest in China. It was opened in 1933 and the design is based on the Los Angeles Memorial Coliseum, which hosted the 1932 Olympics. Despite renovation, little has changed of the overall look, and the monumental entrance so reminiscent of its US counterpart remains. Watching Chinese Super League football surrounded by Egyptian, Spanish, and Mediterranean revival architecture is a unique experience.

Shanghai Stadium
SHANGHAI (SHANGHAI SHENHUA FC)

Under its saddle-shaped roof, up to eighty thousand fans can enjoy a match at the home of Shanghai Shenhua FC. The stadium is the largest footballing venue in China's biggest city. It was built for the 1997 National Games, and recent improvements include the eye-catching roof, a ring-shaped screen below the roof, and a third tier in the west stand, which offers a bird's-eye view of the pitch. A series of awnings can be extended over the ground to protect those below from the weather—be it too much rain or the heat of the sun.

Shenyang Pitch
SHENYANG (MULTIPLE TEAMS)

When space is at a premium, a pitch in the center of a circular overpass set in the Liaoning province traffic system is as good a place as any for a match.

↑ Shenyang Pitch

Longxing Football Stadium
CHONGQING (CHONGQING TONGLIANG LONG FC)

Never has the adage "if you build it, they will come" been more appropriate. This huge arena pushes the boundaries of modern stadium design, yet opened without a club to call it home. It is covered with LEDs and puts on a magical motion light show at night. It has retractable seating to increase capacity when needed, ultra-high-definition display screens, an underground training facility, a parking lot for two thousand vehicles, and is served by a rail link.

Qingdao Youth Football Stadium
QINGDAO (QINGDAO HAINIU FC / QINGDAO RED LIONS FC)

The new wave of Chinese stadiums all likes to play with a cultural narrative. Here it's the maritime culture of the Qingdao province. The undulating shapes of the stands and roof mimic the waves of the East China Sea. The speckled blue-and-white seating was inspired by sea spray.

Asia / **China**

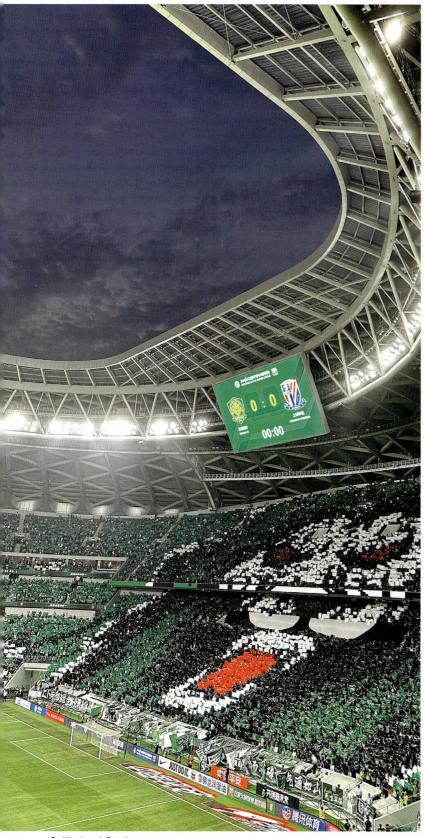

↑ Workers' Stadium

Phoenix Hill Sports Park Football Stadium
CHENGDU (CHENGDU RONGCHENG FC)

The chanting starts outside the stadium, raucous but orderly. Children are having their faces painted. *Guokui* (flatbreads) are being cooked and sold on the forecourts. The yellow and blue seats inside the stadium, designed to mimic wheat fields blowing in the wind, are filling with the red of Chengdu Rongcheng FC. Fans in the front row behind the home goal lift and drop their huge flags in unison as the players are introduced on the big screen. The chanting and flag waving continue unabated for ninety minutes. This perfectly orderly flamboyance carries through to the very essence of the stadium design. The incredible sprawling Phoenix Hill Sports Park is based on the gaiwan tea set used in the Sichuan tea-drinking ceremony. The football stadium is the porcelain bowl, the connecting eighteen-thousand-capacity all-seater sports arena the lid, and the platform on which they sit the saucer. The exterior facade of the interconnecting buildings is inspired by Shu Jin, the ancient Chengdu art of embroidery, with light gray aluminium strands and panels mimicking silk threads.

Workers' Stadium
BEIJING (BEIJING GUOAN FC)

The previous incarnation of the Workers' Stadium, built in 1959, was demolished in 2020 and a sparkling new arena built in its footprint. The almost identical concrete facade with eighty columns is a nod to its past. The awe-inspiring triangular-patterned domed roof is new, and the removal of the running track makes this a football-only venue.

Guangxi Sports Center
NANNING (GUANGXI HENGCHEN FC)

On every street corner within the "green city" of Nanning, you'll find subtropical foliage. It is like a city that has been left for nature to take over, yet it is vibrant and bustling with people. When the Guangxi Sports Centre comes into view, the incredible roof structure makes perfect sense—two giant leaves curved as if falling from the sky. It is one of the most remarkable stadium features in the world.

Hong Kong FC Stadium
HAPPY VALLEY, HONG KONG (HONG KONG FC)

The oldest club in Hong Kong (founded in 1886) plays inside the oval of Happy Valley Racecourse, known as the Jungle. The two roofed, seated stands flank the pitch, a rotunda sits between one of the goals and corner flags, and a racetrack runs along its side. Fans can enjoy wonderful views of the surrounding hills, Jardine's Lookout, and Causeway Bay while watching their team stroke the ball around on artificial turf in the HK Premier League.

Mong Kok Stadium
KOWLOON, HONG KONG (KITCHEE SC)

The Mong Kok Stadium is located in Kowloon, one of Hong Kong's most densely populated areas. Unsurprisingly, buildings make up its immediate vicinity from most angles, though its small stands allow spectators to spot the distant hills during daytime matches. There are open stands behind both goals, while a tented roof spans the grandstands. A recent revamp means that fans sit in individual seats rather than on shared benches. The hot water is heated using solar power and a rainwater recycling system reduces water consumption.

NORTH KOREA

Kim Il Sung Stadium
PYONGYANG (P'YŎNGYANG CITY SC / NATIONAL TEAM)

With tourism tightly controlled, a visit to this stadium needs to be part of an organized, sponsored trip. Check the fixture list on arrival if you want to watch a match. This will likely be one of the many Pyongyang teams that use the ground. The stadium is surrounded by trees and close to the Taedong River. A walkway leads you past statues celebrating Korean sports, to the coliseum-like entrance where images of Kim Il Sung and Kim Jong Un are on a concrete pedestal.

Asia / **North Korea/South Korea**

Rungrado 1st of May Stadium
PYONGYANG (NATIONAL TEAM / APRIL 25 SPORTS CLUB)

The largest football stadium in the world is in North Korea. It was the largest of any kind when it opened in 1989 with a capacity of 114,000, but has since been surpassed by the renovated Narendra Modi Stadium in India. The gleaming structure has a unique shape—the sixteen roof arches are assembled to resemble a magnolia flower. Inside, it has a turf pitch as well as a running track.

SOUTH KOREA

Daegu iM Bank Park
DAEGU (DAEGU FC)

Watching a game at the Daegu iM Bank Park should be the ultimate fan experience: It was designed to be a football-specific venue that prioritized the sport. The arena's compact stands are very close to the pitch and include a safe standing section where the most passionate Daegu FC fans can be seen and heard quite loudly.

Busan Asiad Main Stadium
BUSAN (BUSAN PARK)

As you approach the Busan Asiad Main Stadium, the numerous narrow arches on the outside of the building give it an almost shrine-like appearance—fittingly so as the people of Busan take their sports seriously. The arena's roof has an intriguing bowl-shaped construction thanks to its slightly sloping oval structure with patterns meant to resemble the waves of the sea in Korea's largest port city. The stadium is a multipurpose venue that was built for the 2002 Asian Games and was also used for the World Cup that year.

Daejeon World Cup Stadium
DAEJEON (DAEJEON HANA CITIZEN)

This purpose-built football stadium follows a rectangular shape that is meant to resemble a traditional Korean farmhouse. It has a partially retractable roof along its side, while the two-tiered stands behind the goals are open. Another one of the many stadiums in South Korea built for the 2002 World Cup, the Daejeon World Cup Stadium is now the home of Daejeon Hana Citizen and is known to their fans as the Purple Arena.

Ulsan Munsu Football Stadium
ULSAN (ULSAN HD FC)

For Ulsan HD's passionate fans, the Ulsan Munsu Football Stadium is the perfect venue. Its rectangular shape allows its two-tiered stands to be as close to the pitch as possible from all angles, creating a great match-day atmosphere. This is yet another venue built for the 2002 World Cup, and it has continued to see a good deal of huge matches as Ulsan HD has been one of the most successful teams in both South Korea and Asia as a whole.

Jeonju World Cup Stadium
JEONJU (JEONBUK HYUNDAI MOTORS)

Each of the Jeonju World Cup Stadium's four stands has a separate roof that resembles a *hapjukseon*, a hand fan native to Jeonju. The ground also has four tall columns in its corners, each one supported by twelve strings representing a *gayageum*, a traditional stringed instrument. It is also conducive to a great atmosphere, and it turns green and white on match days as the home to the K League's most successful club, Jeonbuk Hyundai Motors. The arena was built for the 2002 World Cup and continues to be the site of some of the biggest football matches in South Korea.

← Kim Il Sung Stadium

South Korea / Asia

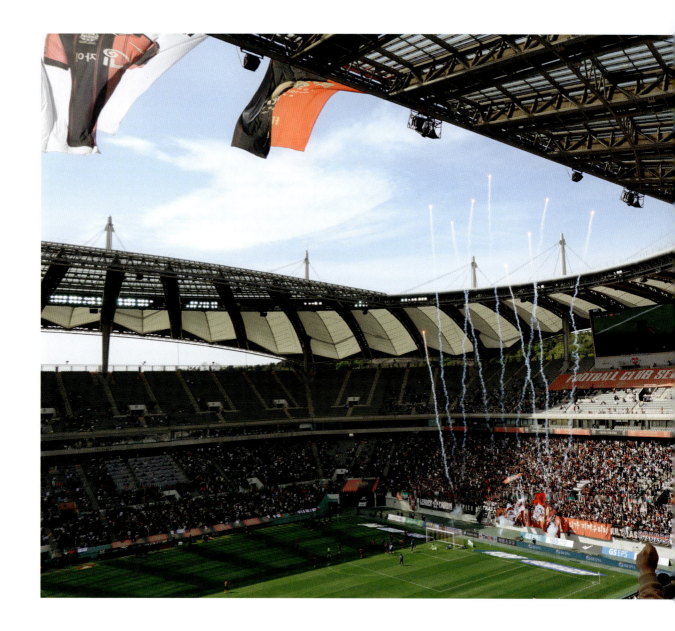

Seoul World Cup Stadium
SEOUL (FC SEOUL)

The South Korean capital is home to the country's two biggest sporting arenas: the Seoul Olympic Stadium and the Seoul World Cup Stadium. The latter, as its name suggests, was built for the 2002 World Cup and at the time was the largest purpose-built football stadium in the country and the second-largest of its kind in Asia. It has a striking roof that was designed to resemble a traditional Korean kite, and was constructed with materials that give it an appearance similar to traditional Korean paper. It can also be illuminated from the inside, often in the red of FC Seoul. As the best-attended stadium in the league, it regularly hosts some of the most vibrant atmospheres in the country.

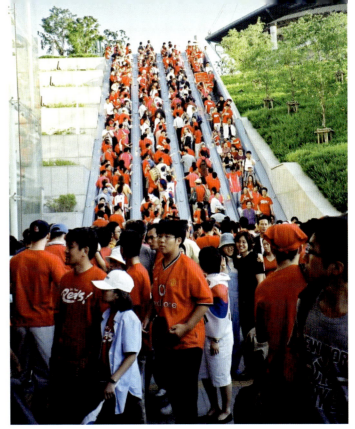

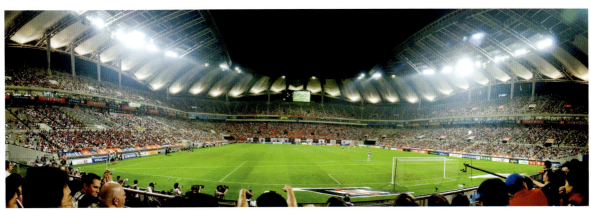

South Korea / Asia

Incheon Football Stadium
INCHEON (INCHEON UNITED FC)

The safe standing section behind the goal in the south stand is always filled with loud fans wearing blue-and-black jerseys. The arena's thin roof just about covers three stands, while the north stand is left open. It was built for local team Incheon United, so its twenty thousand capacity is just right for a side that found the Incheon Munhak Stadium too big.

Pohang Steel Yard
POHANG (POHANG STEELERS)

The Steel Yard is arguably the most historic and legendary football stadium in South Korea. Built in 1990 as the country's first football-specific arena, it has an unrivaled air of heritage and tradition. It also creates some of the best atmospheres in the country since there is nothing between the edge of the pitch and the seats, and its symmetrical two tiered stands have a good incline.

Alpensia Ski Jump Centre
PYEONGCHANG (NATIONAL TEAM)

The South Korean national team's stadium takes the idea of a multipurpose facility to a new level. The pitch sits at the end of an Olympic-sized ski jump, with three conventional stands completing the stadium. The 393-foot (120-m) jump appears like a fourth stand behind the goal.

Suwon World Cup Stadium
SUWON (SUWON SAMSUNG BLUEWINGS FC)

Known as the Big Bird, and home to the Suwon Samsung Bluewings, the stadium has a huge canopy roof on one side; it stretches well beyond the main structure of the building, giving the impression of gigantic soaring wings.

Gwangju World Cup Stadium
GWANGJU (GWANGJU FC)

Gwangju FC moved to the neighboring Gwangju Football Stadium in 2020. This arena is known as the Guus Hiddink Stadium after the manager who took South Korea to the semifinal of the 2002 World Cup.

Gwangju Football Stadium
GWANGJU (GWANGJU FC)

A stone's throw from the gleaming Gwangju World Cup Stadium that dominates the area, the Gwangju Football Stadium is its poor relative—a makeshift stadium built on a running track. The south stand is already abandoned for health and safety reasons, and the fold-up seats are deteriorating. When the ball is kicked into the cordoned-off stand, the ball boys are not allowed to retrieve it. The shiny adjacent stadium is considered too big to host the K League 2 team's games, and so they call this slowly dilapidating ground home.

Jeju World Cup Stadium
SEOGWIPO (JEJU UNITED FC)

Designed to fuse the volcanic environment of Jeju Island with the surrounding East China Sea, the structure mimics the mouth of a volcano, and the roof resembles the nets of traditional fishing boats.

Gimpo Solteo Football Field
GIMPO (GIMPO FC)

For such a small club and ground, this is an impressive facility with training pitches above the west stand of the main stadium. The pitches are surrounded by trees and green hills, with the white, high-rise apartment buildings of Gimpo in the distance.

Goyang Stadium
GOYANG (NATIONAL TEAM)

At Goyang Stadium the fans are separated from the pitch by an overly large running track, yet the atmosphere is electric. Two stands enjoy the cover of a modern Teflon-coated fiberglass membrane. It jars with the rest of the concrete structure, but helps to prevent some of the crowd noise from escaping. With the rise of K-pop fan culture within football, female spectators outnumber male, and there's a feeling of safety within the stadium. What could be a diluted atmosphere, with its separation from the pitch, becomes a wonderful fan experience.

↓Alpensia Ski Jump Centre ↓Suwon World Cup Stadium

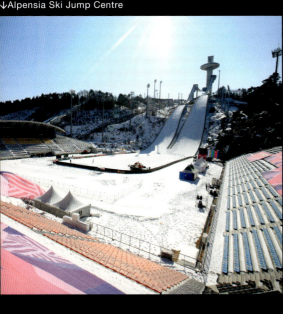
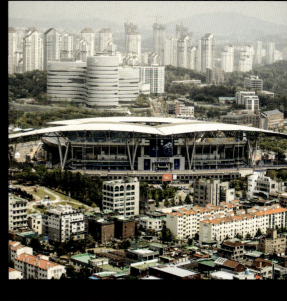
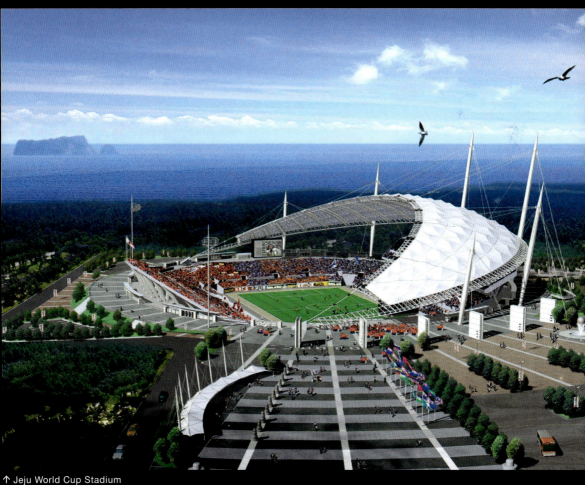

↑ Jeju World Cup Stadium

Japan / Asia

JAPAN

Toyota Stadium
TOYOTA (NAGOYA GRAMPUS)

Designed by one of Japan's most influential architects, Kisho Kurokawa, the Toyota Stadium is memorable from every angle. It looks eye-catching enough from the outside, thanks to its curved roof with a column protruding from each corner. But it is even more striking once you get inside. The four stands are imposing and, thanks to their incredibly steep gradient, almost offer an overhead view from the top row. The atmosphere becomes all the more dramatic when the retractable roof is closed, although that has not happened since 2016 because its one-of-a-kind system is too costly to operate.

Ajinomoto Stadium
TOKYO (FC TOKYO / TOKYO VERDY)

The pitch at Ajinomoto Stadium was reportedly sunk just below ground level to accommodate the fifty-thousand-capacity two-tiered stands while complying with the height regulations around the airport next door. This solution means that the stands can host almost fifty thousand people. The arena is home to the main football clubs in the Japanese capital, including FC Tokyo and Tokyo Verdy. FC Tokyo is one of the best-supported clubs in Japan and regularly enjoys brilliant match-day atmospheres here. This was the first stadium in Japan to sell its naming rights back in 2003 for what was initially a four-year deal worth $10 million.

Adidas Futsal Park
TOKYO (MULTIPLE TEAMS)

Even in Tokyo's bustling Shibuya commercial district there is space for a futsal pitch—on the rooftop of a department store.

Kashima Soccer Stadium
KASHIMA (KASHIMA ANTLERS)

Constructed in 1993, the Kashima Soccer Stadium was one of the first football-specific stadiums in Japan. It started life as a cozy, fifteen-thousand-seater venue. But a few years later, in preparation for the 2002 World Cup, a sweeping second tier was added on top of the four preexisting stands to increase its capacity to forty thousand. Since then, it has continued to enjoy life as the home of the Kashima Antlers, who are the most successful club in the history of the J1 League. Their fans certainly fill out the lower tiers, creating a vibrant match-day atmosphere close to the pitch.

Sankyo Frontier Kashiwa Stadium
KASHIWA (KASHIWA REYSOL)

The seating arrangement at the Sankyo Frontier Kashiwa Stadium makes for an excellent viewing experience. Unlike most of the large and gleaming stadiums in the league, this relatively modest arena is completely open with no roof, and has rectangular stands starting right at the very edge of the pitch, taking viewers very close to the action.

Todoroki Athletics Stadium
KAWASAKI (KAWASAKI FRONTALE)

The Todoroki Athletics Stadium has been home to many a big J1 League club over the years. Before the turn of the millennium, Verdy called it their home before moving back to Tokyo, and Toshiba SC also played there before moving to Sapporo and becoming Consadole Sapporo. Since 2000, Kawasaki Frontale's rise has ensured that the stadium remains a prominent venue in Japanese football, getting an expansion in 2015 to accommodate the club's growing fan base. The wide running track is not best suited for the football fan experience, although the blue-and-black-clad supporters do their best to create a great atmosphere. There are plans for another renovation that will see the track removed.

→ Adidas Futsal Park

Asia / **Japan**

↑ Edion Peace Wing Hiroshima

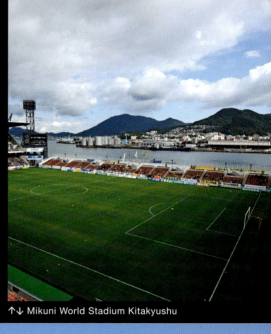
↑↓ Mikuni World Stadium Kitakyushu

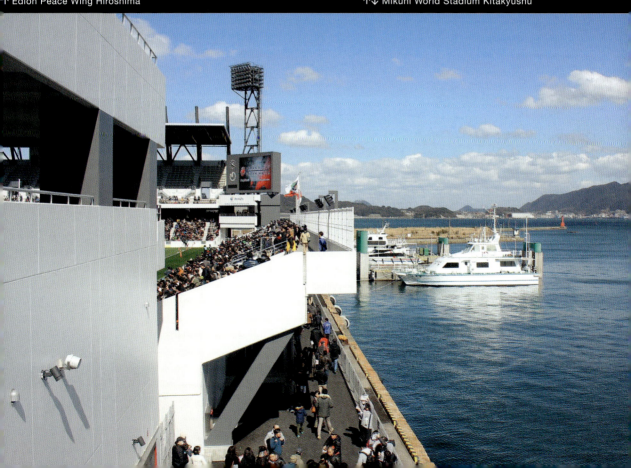

Asia / Japan

Mikuni World Stadium Kitakyushu
KITAKYUSHU (GIRAVANZ KITAKYUSHU)

Spectators on the top row of the east stand watch football as close to the water's edge as on any stand in the world, as the building hangs over the edge of Kitakyushu Bay. This is perhaps the only stadium with an official "no fishing" policy.

Sanga Stadium by Kyocera
KAMEOKA (KYOTO SANGA FC)

Because of the shape of the plot it is built on, the exterior of this stadium follows an octagonal outline, with eight sharp edges that make it look quite sleek. As a result, the seating is arranged in small sections across the edges of the pitch that provide a unique, angled yet close-up view of the action that few other stadiums can offer.

Saitama Stadium 2002
SAITAMA (URAWA RED DIAMONDS)

A visit to this stadium is bound to be memorable. Urawa Red Diamonds has one of the most passionate fan bases in the country and recorded the highest average attendance in the 2023 J1 League (the average attendance is 36,969). A two-tiered curved stand wraps around the pitch with open blocks behind each goal, where many a memorable tifo has been unfurled. The stands alongside the pitch are shaded with a third tier and a curved roof. This is the largest football-specific stadium in Japan, and the Reds was the first club in Asia to simultaneously hold continental crowns across men's and women's competitions.

Panasonic Stadium Suita
SUITA (GAMBA OSAKA)

Osaka club Gamba designed this state-of-the-art facility with an emphasis on efficiency, with a solar-power generation facility on its sleek roof. At the same time, the proximity of the stands to the field is conducive to a great home-crowd atmosphere, which fans certainly provide. This may be the second-largest football stadium in the region (it is 19 miies/30 km from Osaka city), but it was built by the club on a limited budget.

Best Denki Stadium
FUKUOKA (AVISPA FUKUOKA)

The die-hard supporters of Avispa, Fukuoka's prominent football club, create a good atmosphere in the open stands behind the goals, waving their flags and singing their chants with great fervor. The stadium was built predominantly for the football tournament at the 1995 Summer Universiade (World University Games).

Nagai Stadium
OSAKA (CEREZO)

The Nagai Stadium, also known as the Yanmar Stadium, has some surprises up its sleeve. The sports complex includes a botanical garden that is renowned for its beautiful cherry blossoms. Early in the season, you may think they resemble the scene inside the arena on big match days as its vast curved stands fill with the pink of Cerezo, for which it is the main home ground.

Denka Big Swan Stadium
NIIGATA (ALBIREX NIIGATA)

When viewed from the correct angle, the white curving panels on the roof of the Denka Big Swan Stadium make it look just like the body of a huge swan floating on Toyanogata Lake. Its eye-catching appearance is matched by its top-class infrastructure, making it a must-visit venue as the largest stadium on the Sea of Japan coast.

Edion Peace Wing Hiroshima
HIROSHIMA (SANFRECCE HIROSHIMA)

Wherever they sit, fans here are yards from the pitch, giving an incredible, immersive experience. The legacy of the atomic bomb is central to the design of the stadium, with the winglike roof construction seen as the wings of hope. There is a museum dedicated to the role of football in Hiroshima's rise from destruction. *Peace Wall* mural by manga artist Yōichi Takahashi rises high above the fan concourse. Traditional food from leagues across the world—from English pies to Argentinean *panchos*—is served in the food hall. Parents can enjoy match day with a view of the pitch while their kids have fun in the soft play area.

Indonesia / Asia

INDONESIA

Gelora Bung Karno Main Stadium
JAKARTA (PERSIJA JAKARTA / NATIONAL TEAM)

Expect Mexican waves, Poznańs, and orchestration from members of the Persija Ultras 1928. Crowds here can be huge for internationals as well as the Indonesian El Clásico between Persib Bandung and Persija Jakarta. A 2009 film captured this rivalry in a version of *Romeo and Juliet* featuring footage of the Persija Ultras from within the stadium. Look around you and imagine one hundred and fifty thousand fans packed into the stands. This was the scene for the 1985 Perserikatan final—the biggest amateur match in world football.

Jakarta International Stadium
JAKARTA (PERSIJA JAKARTA)

After years of planning and delays, Persija Jakarta—one of Indonesia's biggest clubs—finally got their new stadium in 2022. It is the only stadium with a retractable roof in Indonesia and was the biggest of its kind in the world when it opened. Its state-of-the-art infrastructure only facilitates the Persija fans' fervor, and its relatively closed nature magnifies the intensity of the atmosphere both in terms of volume and brightness of flares.

Stadion Maguwoharjo
YOGYAKARTA (PSS SLEMAN / RANS NUSANTARA)

The cylindrical towers in each corner of the stadium, with their open corkscrew walkways, are reminiscent of a certain famous Italian counterpart. It's no wonder then that the Maguwoharjo is known as the Little San Siro.

Kaharudin Nasution Rumbai Stadium
PEKANBARU (PSPS PEKANBARU)

The exterior of the two main opposing stands have an art nouveau–style decoration reminiscent of Gustav Klimt's painting *The Kiss*. The rest of the stadium is in the form of a generic bowl-like structure.

Stadion Batakan
BALIKPAPAN, BORNEO (BORNEO FC SAMARINDA / PERSIBA BALIKPAPAN)

Borneo's premier stadium hosts several local derbies. Borneo FC versus PS Mitra Kukar is known as the Mahakam derby since both teams are located on the same river. If you want a friendly encounter, then the Papadaan derby between Borneo FC and Barito Putera translates as the "brothers derby." For a more heated atmosphere try the Keltim derby between the teams that share the ground.

Aji Imbut Stadium
TENGGARONG (PS MITRA KUKAR)

If you want to soak up the atmosphere in this large arena that hosts lower league football, sit in the front rows. The local team has been in decline in recent seasons, but fans from Tenggarong still flock to the richly green bank of the Mahakam River where the stadium sits.

Kapten I Wayan Dipta Stadium
BALI (BALI UNITED FC)

You can watch matches from the Bali United Café, or join the spectators in the stands. Each area has its own fan contingent. The Semeton Dewata ultras (Brothers of the Island of Gods) and Lady Dewata fill the east stand; the Northsideboys 12 the north stand; and the Basudewa Curva Sud the south stand. Wherever you choose to enjoy the game, everyone comes together to sing the club anthem "Rasa Bangga," meaning "pride."

Lukas Enembe Stadium
PAPUA (PERSIPURA JAYAPURA)

Before matches, fans stroll down the long runway that leads to the entrance of the Lukas Enembe Stadium, which is set between the Cyclops Mountains and Lake Sentani. Unusually, there are four separate stands inside the concrete bowl structure. The exterior design consists of a series of perforated triangular shards imitating the traditional local carved shells. The pitch is a beautifully manicured, patterned playing surface.

Si Jalak Harupat Stadium
SOREANG (PERSIKAB BANDUNG / PSKC CIMAHI)

Football fans in the city of Bandung have to visit the remote village of Soreang to see a match at their "local" stadium. When they get there, the area's floodlights look like candles on a birthday cake as they curve around the west and east sides of the oval arena.

Asia / **Indonesia**

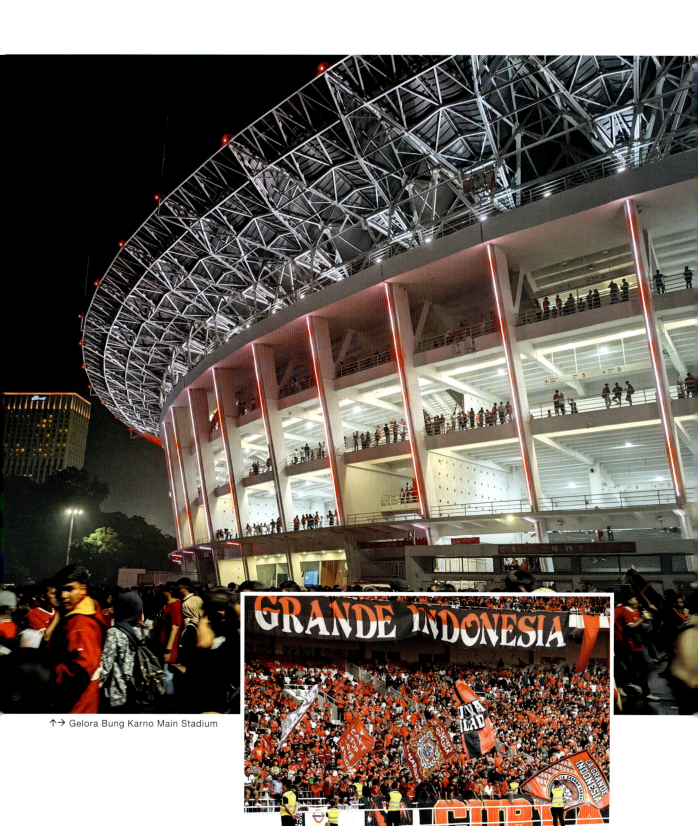

↑→ Gelora Bung Karno Main Stadium

293

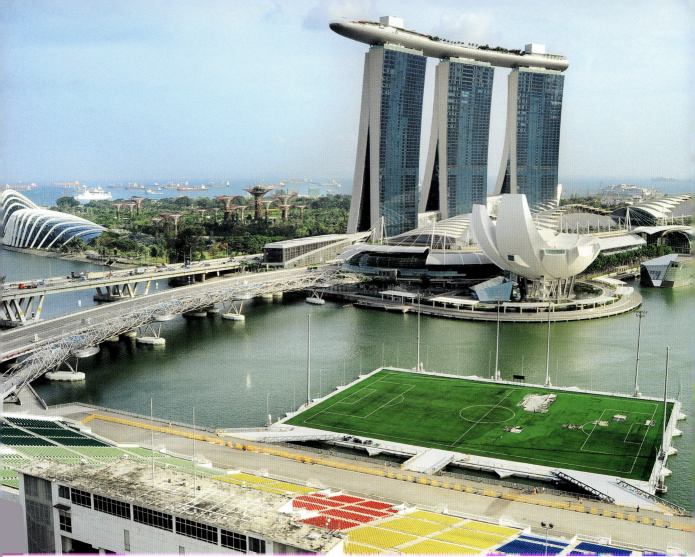

↑ The Float at Marina Bay

TIMOR-LESTE

Estádio Nacional de Timor-Leste
DILI (NATIONAL TEAM)

During the East Timor crisis of 1999, the stadium was used as a refugee camp and distribution point for emergency relief. Now enjoying better times, it hosted its first Timor-Leste international match in 2015 in a World Cup-qualifying victory against Mongolia.

SINGAPORE

The Float at Marina Bay
MARINA BAY (NATIONAL TEAM)

Singapore has the third-highest population density of any country in the world. That leaves little room for sporting venues. So making the most of the space within the harbor by building a floating stadium made sense. While the game unfolds on water, you can watch the action from a twenty-seven-thousand-seater grandstand on the mainland. The structure was temporary at first, but due to its popularity it has become a permanent fixture.

Singapore National Stadium
KALLANG (NATIONAL TEAM)

The anceint Baths of Agrippa, the second-century Pantheon in Rome, the dome of Florence Cathedral, and now the Singapore National Stadium. All of these have held the title of the world's biggest dome. The current holder and home to Singapore's national team also has the world's largest retractable roof. It has a long way to go to retain the title for a thousand years like the Pantheon.

MALAYSIA

Sultan Ibrahim Stadium
GELANG PATAH (JOHOR DARUL TA'ZIM FC)

The Sultan Ibrahim Stadium is the crown jewel that cements Johor Darul Ta'zim's status as the big dogs in Malaysia right now, having just completed a decade of dominance in the league. Its exterior was inspired by a banana leaf, though it can look like a piece of royal headgear, especially when lit up at night with JDT's logo shining at the top. Named after the ruler of Johor, it was effectively bankrolled by the royal family. Sultan Ibrahim's eldest son, Crown Prince Tunku Ismail Idris, is the man who turned JDT's fortunes from those of a lowly regional club to national giants, and his latest gift to the fans was this state-of-the-art arena in 2020.

Sarawak State Stadium
KUCHING (SARAWAK UNITED FC / KUCHING CITY FC)

The stadium is one of the closest in proximity to its rival in the world. Just 109 yards (100 m) separate the two Sarawak stadiums on the edge of Kuching City and Bako National Park. They are, though, yet to host rival teams. At present both teams call the smaller, older of the two "home."

Batu Kawan Stadium (State of Penang Stadium)
PENANG (PENANG FC)

On your way to a match, cross the Penang Second Bridge to the capital of Penang Island, George Town; sample a fragrant curry outside the stadium; and if you're struggling with the tropical rainforest climate, buy a cold milkshake at the Stadium Western Food Cafe. The stadium is completely open behind both goals, offering views of the surrounding forest from the semicircular west and east stands, and occasional cooling air from the Jawi River.

Perak Stadium
IPOH (PERAK FC / PERAK FC II)

Perak FC's stadium hosts the Malayan El Clasico against Selangor, the oldest rivalry in Malaysian football dating back to the 1920s. You can have two very different experiences depending on where you sit. The ultras of both sides parade their colors, bang drums, pack tightly together, and link arms for the Poznań. In contrast, you can enjoy plenty of space in the other stands where fans watch the match in a quieter, more relaxed manner.

Tuanku Abdul Rahman Stadium
SEREMBAN (NEGERI SEMBILAN FC / KSR SAINS FC / NATIONAL TEAM)

On days when there isn't a match, the parking lots become farmer's markets and a Ramadan bazaar. On match day the same vibe prevails, with food stalls and hawkers lining the outside of the stadium. The stadium became home to the Syrian national team during the civil war while also hosting local Malaysian Super League team Negeri Sembilan.

Hang Jebat Stadium
KRUBONG (MELAKA UNITED FC / NATIONAL TEAM)

A vibrant, colorful stadium with its framework fully on show is home to Melaka FC, and hosted the Syrian national team during their 2018 World Cup qualification campaign. With its open red framework, the white internal staircases can be seen from the outside much like the Centre Pompidou in Paris.

Malaysia / Asia

Bukit Jalil National Stadium
KUALA LUMPUR (NATIONAL TEAM)

The Malaysia Cup final takes place every June at the stadium and is an experience not to be missed. Thousands of Perak FC ultras, known simply as the Supporters, walk slowly toward the stadium wearing Star Wars stormtrooper masks, singing "Allez Allez Allez" to the beat of big bass drums. Inside they join their opponents Kedah FC in the biggest Viking clap of all time. The huge stadium traps the menacing sound of the slow clap and deep exhale as it builds to a crescendo, echoing around the oval arena.

↓ Bukit Jalil National Stadium

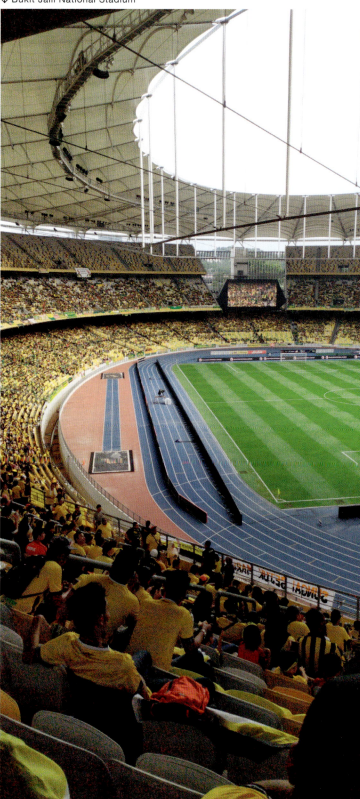

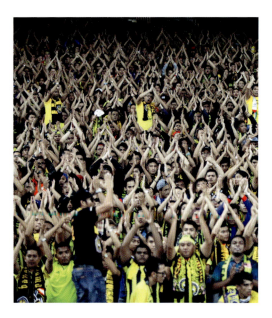

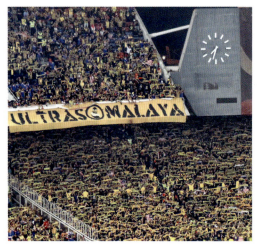

Asia / **Vietnam/Cambodia/Thailand**

VIETNAM

Mỹ Đình National Stadium
HANOI (NATIONAL TEAM)

The roof, which incorporates a tier of seating, appears to hover over two sides of the bowl-shaped stadium and is designed to mimic the Vietnamese national flower, the lotus. The flower represents purity, optimism, and commitment. Though the football here is often punctuated by diving and fakery, it is an experience to watch from the lotus stands.

CAMBODIA

RCAF Stadium
PHNOM PENH (NATIONAL DEFENSE MINISTRY FC / NATIONAL TEAM)

Since the stadium opened in 1920, it has been trumped by many modern stadiums, and its small open stands that sit in a densely packed area near the center of Phnom Penh are a living relic of a bygone era. The Royal Cambodian Air Forces Stadium has many names, including Tiffy Army Stadium (for sponsorship purposes following the name of its home club—National Defense Ministry FC), as well as simply Old Stadium.

National Olympic Stadium
PHNOM PENH (BOEUNG KET FC)

Cambodia's National Olympic Stadium has a dark past, having been used as an execution site during the regime of Pol Pot and the Khmer Rouge. But it also owns a slice of World Cup history. When North Korea was unable to host Australia for a crucial qualifying match for the 1966 competition, Cambodia allowed them to use their national stadium. North Korea qualified and famously went on to beat Italy to reach the quarterfinals, losing 5–3 to Portugal after having been 3–0 ahead.

Morodok Techo National Stadium
PHNOM PENH (NATIONAL TEAM)

The design is based both on the thirteenth-century sailing ships that first traveled from China to Cambodia, and the rumduol, Cambodia's national flower. A surrounding moat is a tribute to the largest religious monument in the world, the Hindu-Buddhist Angkor Wat temple.

↑ National Olympic Stadium

THAILAND

BG Stadium
BUENG YITHO (BG PATHUM UNITED FC)

When it opened in 2010, the BG Stadium was recognized as a unique venue not just in Thailand, but all over Asia due to its three-stand layout. It featured one shaded main stand on the west, an open single-tier north stand, and a three-tier south stand with safe standing sections. If you watch a match from the upper tiers, you can get a view of some buildings and residential complexes to the east side of the pitch. A fourth stand was added in 2024, increasing the stadium's capacity but robbing it of its uniqueness.

Thailand / Asia

↑ Chai Nat Provincial Stadium

Suphachalasai National Stadium
BANGKOK (MULTIPLE TEAMS)

Teams play at Thailand's original national stadium when their stadium doesn't meet the Asian Cup safety requirements. The entrance is reminiscent of a fortress, with towers at each end.

Rajamangala National Stadium
BANGKOK (NATIONAL TEAM)

Seventy thousand fans packed into the stadium to watch a match against a Liverpool side in 2001—a record attendance.

Chang Arena
BURIRAM (BURIRAM UNITED FC)

The largest football-specific stadium in Thailand is based on the Thai-owned King Power Stadium of England's Leicester City. It is known as the Thunder Castle after the ancient Khmer stone castle of the region, and a lightning bolt graphic finishes off what has become an intimidating venue.

700th Anniversary of Chiang Mai Stadium
CHIANG MAI (CHIANGMAI FC)

On the northern edge of Chiang Mai and set among the hills, waterfalls, and pagodas of Doi Inthanon National Park, sits this classic earring-shaped stadium. What better way to end a trek around the famous Golden Triangle than by relaxing into a football match and cheering on Chiangmai United FC?

Chai Nat Provincial Stadium
KHAO THA PHRA (CHAINAT HORNBILL FC)

In Thailand, pink is considered to be a lucky color, and so fans enter the Chai Nat Provincial Stadium with a spring in their step. The building is pink inside and out, including the seating and exterior paintwork, and the color runs all the way through to the team kit. The shade was also the favorite of Thai King Bhumibol the Great who started a craze for pink shirts and was the ruler when the Chainat Hornbill FC was inaugurated. The color also echoes the pink that can appear on a hornbill's white plumage.

Koh Panyee Floating Football Field
KOH PANYEE (KOH PANYEE FC)

Even living on a floating village with no land for a pitch is no barrier to the beautiful game. Inspired by Maradona and the 1986 World Cup, the first floating pitch here was built using fish cages covered with wooden planks. The pitch is now made from floating pontoons, rubber, and reinforced turf. When the ball is kicked into the water, players dive in to retrieve it. The village youth team Koh Panyee FC practices on the water before taking boats to play tournaments on the mainland.

↓ Koh Panyee Floating Football Field

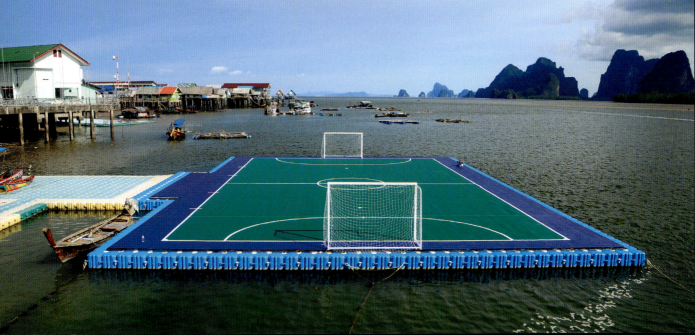

NEPAL

Pokhara Rangasala
POKHARA (SAHARA CLUB (POKHARA) / POKHARA THUNDERS / NATIONAL TEAM)

What better team to play football in the lake city of Pokhara, with views of the snowcapped Nepalese Annapurna mountain range, than Sahara Club? Like the size, style, and history of the stadium, it is unexpected and wonderful in equal measure.

Narayani Stadium
BIRGUNJ (BIRGUNJ UNITED FC)

The third-largest football venue in Nepal is probably not the most comfortable venue in the world to watch a match, but it certainly offers a unique experience. Built in 1981, it was renovated in 2015, at which point it was nearly derelict. While the main stand has been improved, the rest of the field is encircled by what are essentially a series of large steps.

Dasharath Rangasala
KATHMANDU (NATIONAL TEAM)

Named after Dasharath Chand, one of Nepal's four great martyrs, the stadium has been plagued with misfortune. In 1988, ninety-three people died fleeing a hailstorm during a game when fans surged toward the only covered stand. When they were beaten back by police, a crush ensued as they tried to escape through a tunneled exit. In 2018 the stadium was heavily damaged by an earthquake. Now reconstructed, it is trying to forge ahead. All the stands are covered with canopy roofing, while the main stand has a solid roof. The seating is arranged in vibrant blocks of yellow, red, green, and blue.

BHUTAN

Changlimithang Stadium
THIMPHU (TRANSPORT UNITED FC / NATIONAL TEAM)

The national stadium of Bhutan looks like a palace. It was built on the site of a key battle in the unification of Bhutan in 1885, and so its construction tapped into the feeling of celebration and national pride. The stands are ornate arched vestries. The VIP grandstand is palatial and overlooked by the nearby hills. It is a wondrous site. In 2002 the stadium hosted an historic match known as the Other Final. On the same day that Brazil and Germany contested the World Cup final, the two lowest ranked teams in the world played at the Changlimithang Stadium, Bhutan versus Montserrat. Bhutan won 4–0. It was their first-ever victory. Brazil won the other final 2–0.

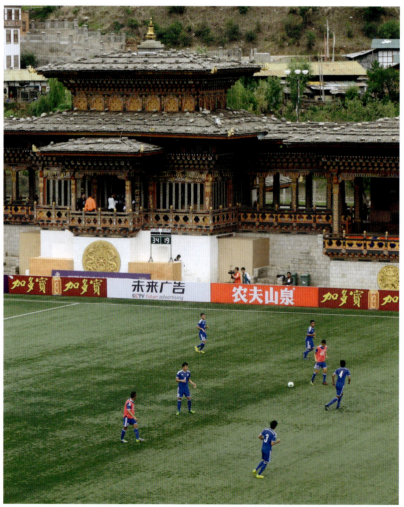

↑ Changlimithang Stadium

Asia / **India**

INDIA

Fatorda Stadium
MARGAO (FC GOA)

The Fatorda is the only international stadium in the tiny football-mad state of Goa. It boasts a rich history as the occasional home of many of the state's most storied clubs, such as Salgaocar FC, Dempo SC, and Churchill Brothers, and the host of some national team games. Since its renovation in 2014, it has been the home of Indian Super League club FC Goa, whose fans produce a good atmosphere despite their distance from the action due to the venue's capacity to double as a cricket stadium.

Bhaichung Bhutia Stadium
NAMCHI (UNITED SIKKIM FC)

Hope for good weather if you plan to watch a match at this stadium, high in the mountains—when the mist descends, viewing the match becomes tricky. On days like that, fans are thankful that the entire north stand is covered with a flat turquoise roof and the east side is partially covered. The backdrop to the stadium is breathtaking: thick forest surrounds the stands, with the mountainside tapering away on the east side. You can also watch the game from grass slopes on the south and west sides. The stadium is named after Bhaichung Bhutia, the first Indian footballer to reach one hundred international caps.

↓ Bhaichung Bhutia Stadium

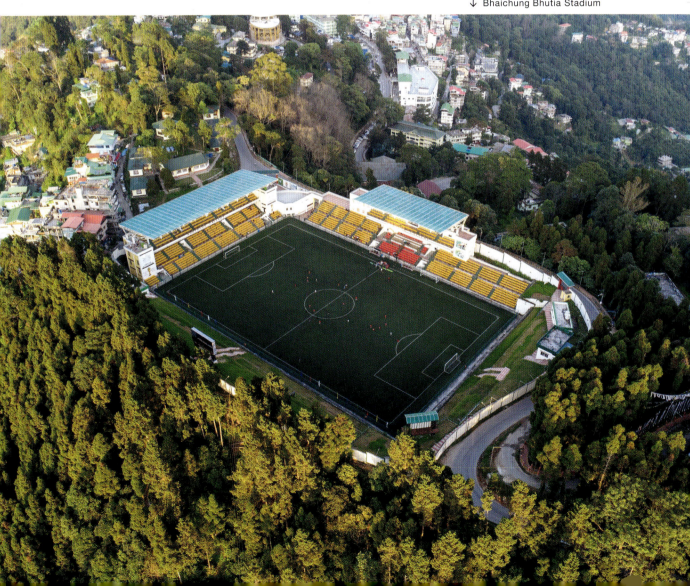

India / Asia

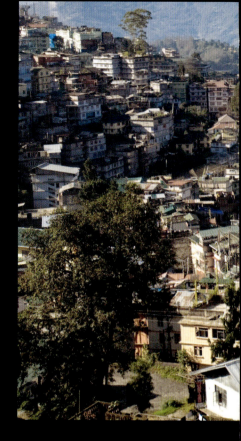

Ladakh Stadium
LADAKH (LADAKH FC)

At 11,000 feet (3,353 m) above sea level, Ladakh Stadium is unlikely to host too many away fans. It is located in a desert terrain surrounded by mountains. You can access it by bus and train, but the best way to arrive is by plane. Delhi to Leh is arguably the most spectacular flight in India, with awe-inspiring views of snowcapped peaks as you fly over the Himalayas.

Salt Lake Stadium
KOLKATA (NATIONAL TEAM / WEST BENGAL FOOTBALL TEAM / MOHUN BAGAN SUPER GIANT)

The Salt Lake Stadium was the site of one of India's best-remembered football matches; 134,000 people packed the stands to watch local giants East Bengal and Mohun Bagan battle it out in a cup semifinal, setting the record for the highest attendance at a football match in Asia that stands to this day. Recent renovations have significantly improved the quality of its facilities, and its capacity has been capped at under seventy thousand for safety purposes. That will hardly stop the football-mad public of Kolkata from creating an incredible atmosphere around the stadium, as well as in the city, on derby day, when everything is green and maroon or red and yellow.

Paljor Stadium
GANGTOK (UNITED SIKKIM FC)

High in the Bengalese mountains is the home of United Sikkim FC. The stadium was built in 1943, and houses an incredible thirty thousand spectators on the edge of a mountain. The east stand offers a stunning view of the valley, but gets the full force of the mountain mist as it

Mumbai Football Arena
MUMBAI (MUMBAI CITY FC / NATIONAL TEAM)

If you're in India, and you want to watch a football match, then Mumbai Football Arena may offer the best views. Although it is far from the largest venue in the country, this arena is one of the few purpose-built football stadiums in the country. This means that its seating layout is far more conducive to a better viewing experience thanks to its proximity to the pitch, which is also one of the best in the country.

Rajiv Gandhi Stadium
AIZAWL (AIZAWL FC)

The stadium's sloping, open stands make this one of the best venues in the region to watch a match, and their lack of height means a good punt to the east could clear the stand and go all the way down the slope of the hill. Located in a picturesque setting in the northeastern state of Mizoram, with nothing but lush green hills, blue skies, and white clouds in the background, the stadium is the home of one of the region's most historic clubs, Aizawl FC.

EKA Arena
AHMEDABAD (ARA FC)

There is always a lot going on at the EKA Arena, one of India's most modern sporting venues. It was inaugurated in 2016 as the only convertible stadium in the country, fit to host as many as fourteen different sports, as well as suites that overlook the football pitch and lounges on the upper levels that offer a view of the nearby lake. If you make your booking for the right day, you could be treated to a unique match-viewing experience.

Nongpathar Stadium
NONGSTOIN (UNKNOWN)

The Nongpathar Stadium—if we can call it that—is well worth a visit. Not necessarily for the football on show, but certainly for its beautiful backdrop. The stands do not take up much space in your field of vision: its seating is predominantly a set of steps, some of them covered by a corrugated metal roof. That leaves you to appreciate the lush green hills in the background while a typically cool and misty breeze further enrichens the setting.

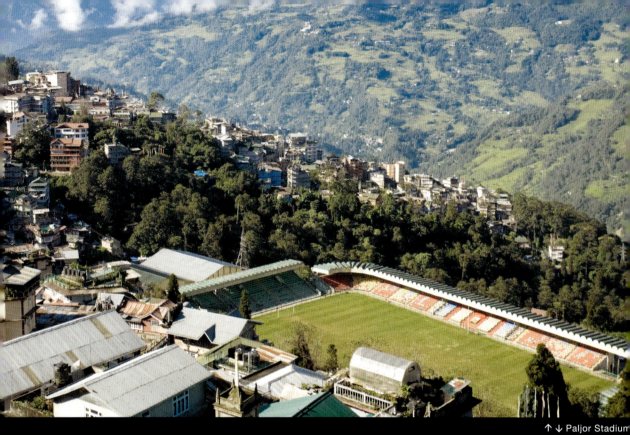

↑ ↓ Paljor Stadium

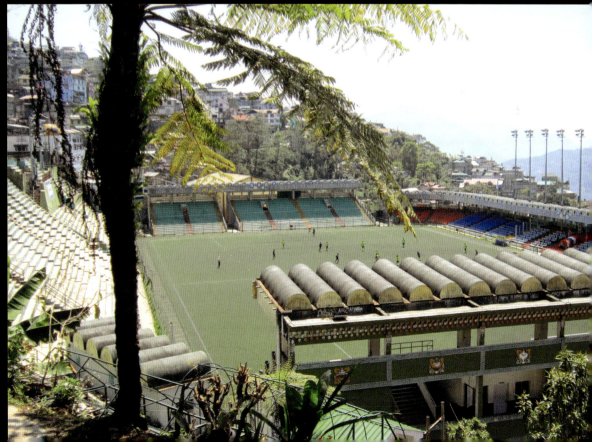

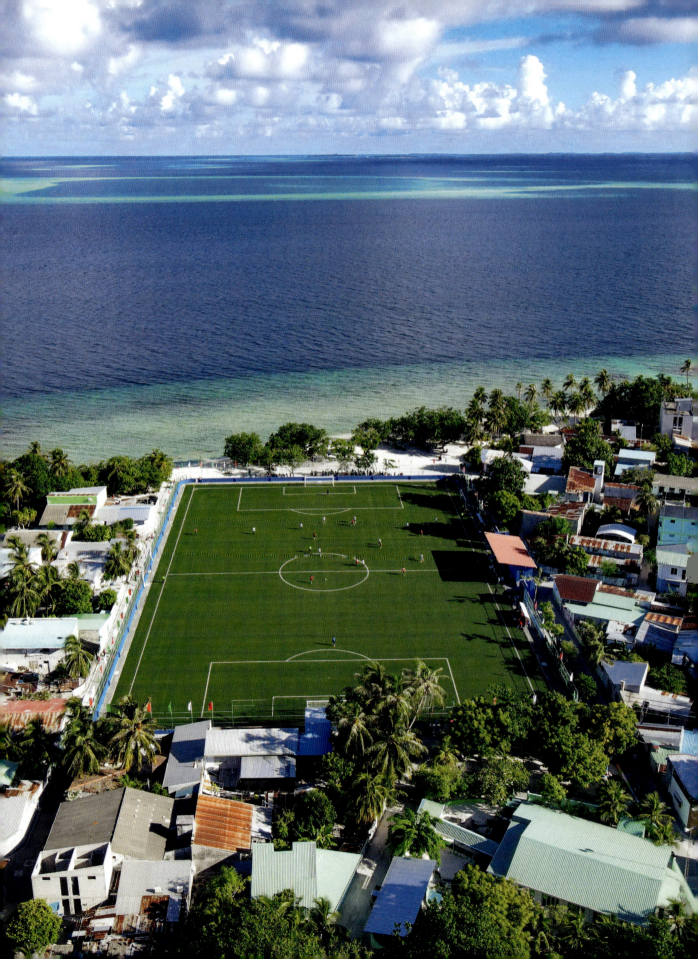

Asia / **Maldives**

MALDIVES

Baa Eydhafushi Football Ground
EYDHAFUSHI (NATIONAL TEAM)

As the Maldives Dhiraagu Dhivehi Premier League grows, the atolls of the archipelago are providing some of the most stunning football locations in the world. They are always set against the backdrop of the Indian Ocean and never far from white, sandy beaches and rows of palm trees. The Baa Eydhafushi is one of them.

Maafushi turf stadium
MAAFUSHI (UNKNOWN)

A presidential pledge stated that one hundred turf stadiums would be created on the islands within the archipelago, and the Maafushi turf stadium kick-started the push. And what a beauty it is. The smooth, lush surface is perfect for developing some rhythmic passing *Boduberu* football.

Pelé Stadium Maldives
MAHIBADHOO (NATIONAL TEAM / MAHIBADHOO SPORTS CLUB)

FIFA president Gianni Infantino suggested that all member associations name a stadium after Pelé, and the Maldives did just that, making Pelé Stadium the home of their national team.

National Football Stadium
MALÉ (NATIONAL TEAM / BURU SPORTS CLUB)

Seen on its own, the National Football Stadium in the Maldivian capital does not seem to be particularly remarkable; it looks about right for an average forty-five-year-old venue. But a glance above the pitch reveals its uniqueness—it is situated in a crowded residential area in one of the most densely populated cities in the world. It is one of the few stadium complexes anywhere whose area can be expressed as a proportion of the city they are located in, at roughly one-quarter of a percent of the 3.2 square miles (8.3 sq km) of Malé.

← Pelé Stadium Maldives

Kandima Maldives Football Pitch
KANDIMA (UNKNOWN)

Among palm trees, white sands, and clear turquoise waters, perhaps the only thing that could improve on paradise is a football pitch. And you can stay at the Kandima Maldives hotel too. The ground is mainly used for training camps, including the Maldives youth teams.

Kurendhoo Football Ground
KURENDHOO (KURENDHOO FC)

Sitting on the edge of the white sand and turquoise waters of a coral ring must be one of the most breathtaking locations to watch the beautiful game. Players from the nine small football clubs on the island contributed three hundred dollars each to build the stadium. And they constructed it themselves, laying the pitch with their bare hands.

↓ Kandima Maldives Football Pitch

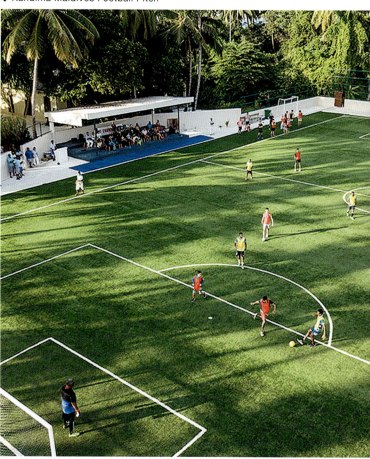

Pakistan/Afghanistan / Asia

PAKISTAN

Jinnah Sports Stadium
ISLAMABAD (NATIONAL TEAM)

When Pakistan ended a twenty-two-year wait to register their first-ever win in a World Cup qualifier, the players were backed by a boisterous crowd, who may well remember the day as a turning point in the nation's footballing history. Named after the country's founder, the Jinnah Sports Stadium is the largest sporting venue in Pakistan. It is a multipurpose stadium with a running track, but is best known and used for football.

Karachi Port Trust Stadium
KARACHI (KARACHI PORT TRUST FC)

Fans are promised maximum shade and cooling air at this stadium, thanks to the unique corrugated roof of the main stand. The structure is formed from a series of interconnected, open-ended half cylinders that extend over the seating area and to the edge of the pitch. The half cylinders act like a series of wind tunnels, which allow fans to sit on the sandstone tiers in relative comfort to watch Karachi Port Trust, Pakistan's oldest club, founded in 1887.

People's Football Stadium
KARACHI (NATIONAL TEAM)

Thanks to the national team reaching the second round of the World Cup qualifiers, the future's looking bright for Pakistan's biggest football-specific venue. While at the moment its infrastructure and facilities are rather dilapidated, the Pakistan Football Federation is considering making it their main stadium in the future.

Punjab Stadium
LAHORE (WAPDA FC / WOHAIB FC / NATIONAL TEAM)

The Punjab is nicknamed the Ian Rush Stadium following a visit from the former Liverpool, Juventus, and Wales striker to help promote football in the area.

AFGHANISTAN

Marshal Fahim Sports Stadium
PANJSHIR VALLEY (UNKNOWN)

Deep in the Panjshir Valley, within the Hindu Kush mountain range, lies a wonderful little football stadium. The open, oval arena on the banks of the Panjshir River brings the beautiful game to the one hundred thousand inhabitants of the valley.

↓ Marshal Fahim Sports Stadium

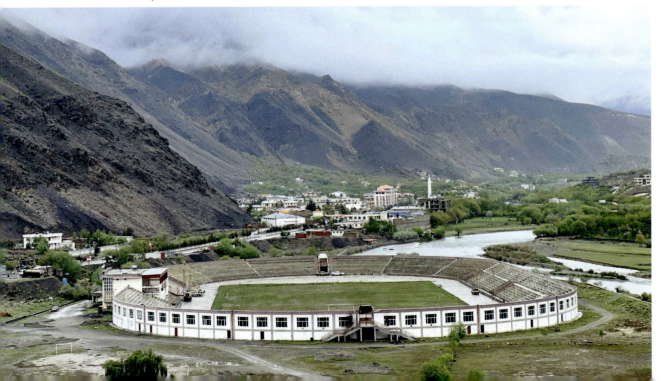

← ↑ Rams Park

Rams Park
ISTANBUL (GALATASARAY SK)

Visitors playing Galatasarayty may hope for a warmer reception than Manchester United when they played the team at their former ground—Ali Sami Yen Stadium—in a Champions League game in 1993. They were famously welcomed with large banners reading "Welcome to Hell." The level of intimidation that night was something the Red Devils had never experienced. Fast-forward thirty years and a repeat fixture saw the levels heavily ramped up with a well-choreographed Galatasaray tifo covering the entire east stand and referencing those infamous words. The high-voltage atmosphere isn't the only electricity produced here; the stadium roof holds a world-record 10,500 solar panels. They produce an incredible 4.3 megawatts of power per year and make Rams Park completely energy self-sufficient.

TÜRKIYE

Tüpraş Stadyumu
ISTANBUL (BEŞIKTAŞ JK)

Beşiktaş was the last of Istanbul's big three clubs to get their own home; construction of their stadium began in 2013 and was completed three years later. Located close to the bank of the Bosphorus River, on the site of the old İnönü Stadium (some parts of which were preserved)—once the home of all three Istanbul giants—it had to be built in a rather compact manner. Its capacity is generally not enough for the big local derbies, but those who do get into the stadium are sure to find an unforgettable atmosphere.

Atatürk Olympic Stadium
ISTANBUL (FATIH KARAGÜMRÜK SK)

Planned as the crowning jewel of Turkey's ultimately unsuccessful Olympics bids, the Atatürk Olympic Stadium is partially covered with asymmetrically curved roofs on either side of the pitch, with the one on the west larger and at a greater height. With an Olympic track wrapped around the pitch, it effectively has one unified bowl-shaped stand capable of holding close to eighty thousand spectators. It can undoubtedly be an imposing venue on the big match days, as one large swarm of fans pretty much encircles the field.

Türkiye / Asia

Şükrü Saracoğlu Stadium
ISTANBUL (FENERBAHÇE SK / NATIONAL TEAM)

The home of Turkish giants Fenerbahçe SK sits between a major road network and a water inlet of the Marmara Sea. The Sarı Kanaryalar (the Yellow Canaries) tifos project wonderful sentiments in their displays: "The Rising Sun Over Europe," "Peace at Home, Peace in the World," and "Fly High to Glory" are just a few.

Türkiye / Asia

Şenol Güneş Spor Kompleksi Papara Park
TRABZON (TRABZONSPOR)

Far from the capital Istanbul, and past the Pontic Alps in the northeast of Turkey, sits the city of Trabzon. It has a rich footballing heritage through its namesake football club. Trabzonspor was in the news in 2022 when they ended a thirty-eight-year title drought; the stadium was the scene of wild celebrations. A picturesque venue on the edge of the Black Sea, it was built on reclaimed land and features a striking exterior with white panels against a blue backdrop.

Antalya Stadium
ANTALYA (ANTALYASPOR)

The structure of the Antalya is a unique mix of a rectangular seating configuration on a circular plot. Its roof is certainly curved, with the majority of it covered in solar panels, while its four base tiers are at perfect right angles. The upper tiers along the pitch are also parallel, but three small and sharply curved higher tiers behind both goals provide unique seating angles. It is a marker of the recent new stadium boom that Turkey has experienced.

↑ Vazgen Sargsyan Republican Stadium

Konya Büyükşehir Stadium
KONYA (KONYASPOR)

At night the stadium puts on a light show like a high-voltage plasma ball in a science museum. By day the exterior pattern mimics both moving bicycle spokes, representing the Cycle City of Konya, and the whirling dervish dance, resembling spinning white and green robes.

↓ Konya Büyükşehir Stadium

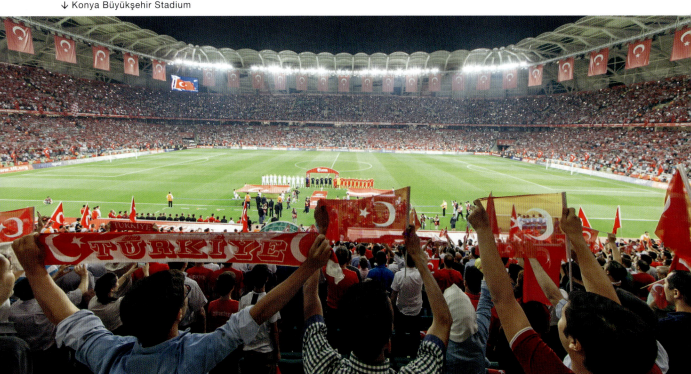

New Adana Stadium
ADANA (ADANA DEMIRSPOR / ADANASPOR)

The open interior skeleton of the New Adana Stadium's roof makes for a stunning aesthetic. Hundreds of steel ropes covered with white membranes hang down into the stadium while steel standing-terrace rails rise up from the ground to greet them. The interior is finished with a red-flame design covering half the seating. The other half has blue flames. The flames represent Adana Demirspor and Adanaspor—the teams that share the stadium.

Centennial Atatürk Stadium
BURSA (BURSASPOR)

Bursaspor's nickname is the Green Crocodiles, and their stadium design takes this literally. The exterior is constructed from green glass, and overlapping membranes mimic the body of a crocodile. But the coup de grâce is the stadium's entrance—a huge crocodile's head, its open mouth welcoming in fans.

Samsun 19 Mayıs Stadium
SAMSUN (SAMSUNSPOR)

Try to make the Old derby between two of the biggest teams of the Black Sea region—Samsunspor and Trabzonspor. This is when fans pack the stands, and you get the full, intense experience the stadium can bring. Other fixtures outside of the visiting Big Three can be quiet, but the arena design is worth a trip in itself. A huge covered outer promenade flows from the body of the stadium, reaching an apex on the southern side.

Eryaman Stadium
ANKARA (GENÇLERBİRLİĞİ SK / MKE ANKARAGÜCÜ)

Both of Ankara's teams—Gençlerbirliği and Ankaragücü—play at the Eryaman. The main stand seats are red and black for Gençlerbirliği, the rest yellow and blue for Ankaragücü. So, you may find yourself joining fans of one team in the seats of their rivals. As the atmosphere builds, you will feel close to the action in the compact, single-tier stands.

New Hatay Stadium
ANTAKYA (HATAYSPOR)

Hatayspor formed in 1967 and played in the lower leagues of Turkish football until they were promoted to the top flight in 2020. With the team's success came a brand-new stadium: an eco-conscious marvel with a unique roof construction of two overlapping J-shaped forms in the club colors, maroon and white. The new stadium was built to withstand earthquakes. But when COVID–19 hit, the opening was delayed, and the first match played behind closed doors. Then, just as football was returning, Antakya was devastated by the biggest earthquake to hit Turkey since 1939. At least fifty-nine thousand people died, including Hatayspor's Ghanaian winger Christian Atsu. The club pulled out of the Süper Lig and the New Hatay Stadium, which had withstood the earthquake, was used for emergency accommodation. The Süper Lig reinstated the club for the 2023–24 season, and fans were finally able to watch their team in their new home. The earthquake's scars are everywhere—there's a makeshift graveyard not far from the stadium, and rebuilding is ongoing—but it is a positive focal point for a grieving city.

Kocaeli Stadium
IZMIT (KOCAELISPOR / NATIONAL TEAM)

At first glance, Kocaeli Stadium looks fit to host some of the biggest games. It comes as a surprise then that, when it opened, its home club Kocaelispor was down in the fourth tier. While they did not have the capacity to build this state-of-the-art venue themselves, the project was publicly funded because despite their struggles on the pitch, Kocaelispor is one of the best-supported teams in Turkey, having set the fifth-tier attendance record at over twenty thousand. They climbed to the second tier after the stadium opened, so the occupants of the green-filled stands have enjoyed a good few years.

Kadir Has Stadium
KAYSERI (KAYSERISPOR)

Strips of steel "fold in" from the ground up and extend over the seating areas to create a steel cradle.

ARMENIA

Vazgen Sargsyan Republican Stadium
YEREVAN (FC ARARAT YEREVAN / FC PYUNIK / NATIONAL TEAM)

Football experiences don't come much better than this. First, entrance to the stadium is free. And second, you may find yourself watching the game on a carpet of discarded sunflower seed shells. The snack is a delicacy in the region, and devoured in large quantities at matches. The stadium is a beautiful oval of brickwork, archway entrances, and Greek Doric columns. Inside, the stands are surrounded by neoclassical colonnades.

Australasia

CHAPTER 6

Palau/Marshall Islands/Papua New Guinea / Australasia

↑ Majuro Track and Field Stadium

PALAU

Palau National Stadium
KOROR CITY (NATIONAL TEAM)

On the outer fringes of the football world, in the Micronesian Western Pacific, Palau is attempting to grow the game with the national football stadium at its center. All Palau Soccer League matches take place here. As the league consists of 340 islands, players come from far and wide.

MARSHALL ISLANDS

Majuro Track and Field Stadium
MAJURO (NATIONAL TEAM)

This sublime beachside location is more than just a new stadium, it offers hope for the future of football on the "final frontier." The Marshall Islands is the last country in the world without a national football team. The grass pitch, so normal to footballing nations across the world, is like a pitch made from solid gold to the people of this collection of volcanic islands and coral atolls. Grassroots football is ready to blossom.

PAPUA NEW GUINEA

Sir John Guise Stadium
PORT MORESBY (PORT MORESBY STRIKERS FC / PRK GULF KOMARA / NATIONAL TEAM)

The open framework of the main stand fuses with the main entrance building, and its layered roof juts out like the wings of a bird taking flight. It was the main venue for the 2016 U-20 Women's World Cup and the occasional home of the nomadic men's national team. Check the fixture list to watch PNG Premier League football here—it's limited to a few games each season.

Sir Hubert Murray Stadium
PORT MORESBY (NATIONAL TEAM)

Considering that the site at Konedobu was once shoreline mangroves, this stadium is impressive. Its location beside the yachts at Port Moresby Harbour and Newtown Hills—and its open-air stands—make it a sumptuous venue. The harborside main stand is part of a large clubhouse with members' lounge, corporate boxes, conference rooms, and yacht club vibes.

Australasia / **Papua New Guinea/Nauru**

PNG Football Stadium
PORT MORESBY (HEKARI UNITED FC / UNIVERSITY INTER FC / BESTA PNG UNITED / NATIONAL TEAM)

What looks like a giant sail from a traditional Papuan outrigger canoe hangs above the grandstand. This is a perfectly put together stadium. The pitch is close to the fans, with a thin white border dividing it from the stands. Four all-seater stands and four floodlight towers in each corner complete the tidy arrangement. The sail adds panache.

NAURU

Meneng Stadium
MENENG (ASYLUM SEEKERS)

Meneng Stadium was once Nauru's national stadium, but the Australian government converted it into a containment area for asylum seekers under the Pacific Solution. Today, a section of the immigration center has been given over to a small football field for detainees to play on.

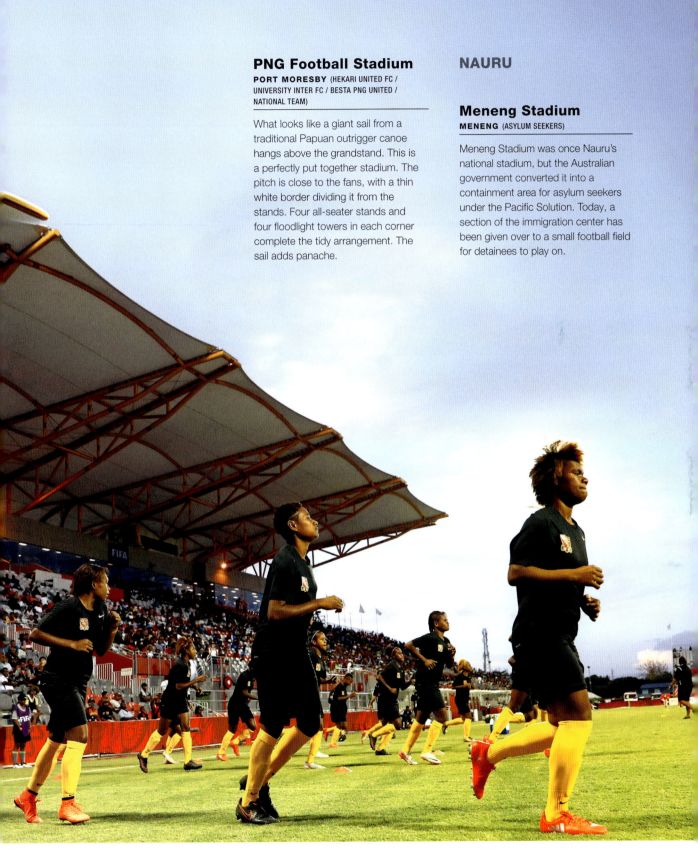

↑ PNG Football Stadium

↑ Solomon Islands National Stadium

↑ Lawson Tama Stadium

SOLOMON ISLANDS

Solomon Islands National Stadium
HONIARA (NATIONAL TEAM)

The Chinese-built stadium in the capital city of Honiara has what might be described as a traditional Melanesian/Polynesian design, with a cantilevered roof in the form of traditional fishing boat sails, running track, and two all-seater stands inscribed with "Solomon" on the east and "Islands" on the west.

↑→ Bairiki National Stadium

Lawson Tama Stadium
HONIARA (NATIONAL TEAM / HONIARA RANGERS FC / MULTIPLE TEAMS)

The match-day experience here is a laid-back affair. You can sit on a hillside to watch the game, park your car behind the goal, and enjoy the shade of the trees lining three sides of the stadium. There's just one main stand here, but who needs the grandeur of the higher echelons of international football when you can see the game played with passion?

KIRIBATI

Bairiki National Stadium
BAIRIKI (NATIONAL TEAM)

Join joyful fans who line the pitch and pack into the covered pavilion to watch their local heroes—some playing in trainers and others with bare feet. Kiribati plays its football on a sand pitch, and they are yet to play a home international. Dreams of a grass pitch and FIFA membership remain. For now.

Australasia / **Vanuatu**

VANUATU

Freshwater Stadium
PORT VILA (NATIONAL TEAM)

This modern stadium produces solar energy and has a water recirculation system to maintain the standard of the playing surface. It hosts every game of the second-tier South Efaté League, and hosted the 2023 Oceania Football Confederation Champions League within months of opening.

Port Vila Municipal Stadium
PORT VILA (PORT VILA FOOTBALL LEAGUE)

The Vanuatu capital has its own three-tiered football league, separate from the rest of the archipelago and considered to be the highest level. Every match takes place at the Municipal Stadium, which makes for a highly active fixture list. The most dominant team in recent years is Ifira Black Bird who, at more than one hundred years old, highlight the rich culture of football in Vanuatu.

Luganville Soccer City Stadium
LUGANVILLE (WOMEN'S EAST SANTO AREA LEAGUE)

The main stadium of Espiritu Santo island hosts the Women's East Santo Area League. Three matches are played in a single day. Luganville Football Association's Freda Warsal has said, "It is time the feminine population of Vanuatu bring their power and love for football to the pitch."

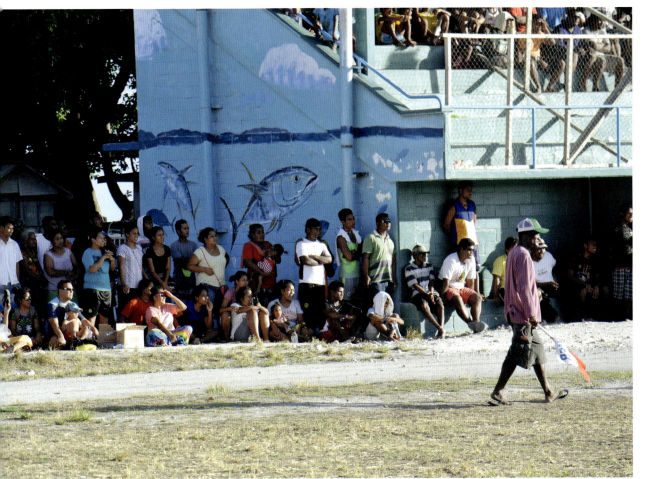

Tuvalu/Samoa/Fiji/Tonga / Australasia

TUVALU

Tuvalu Sports Ground
FUNAFUTI (NATIONAL TEAM / MULTIPLE TEAMS)

To create the pitch, river clay was shipped in from Fiji and laid on a coral base to form a flat surface and a terrain on which grass could grow. Solar panels make the stadium self-sustainable and were the first large-scale renewable energy system in Tuvalu. But despite these innovations, the pitch remains relatively hard and uneven, and the stands are built largely from wood. Still, the very presence of a stadium is a victory for this small nation.

SAMOA

National Soccer Stadium
APIA (NATIONAL TEAM / SAMOA NATIONAL LEAGUE)

Overlooked by the jungle hillsides of Apia, this small but well put together stadium with two all-seater stands hosts every match of the Samoa National League. Lupe o le Soaga SC has been the most dominant team of the past decade, but recent champions Vaipuna SC is also one to watch.

FIJI

Churchill Park
LAUTOKA (LAUTOKA FC)

Once you've tried some *palusami* and coconut bread at Lautoka Market, and walked along Natara Parade to take in the views of the Indian Ocean, you can settle down to watch Lautoka FC in the Fiji Premier League. Churchill Park offers shade within two small stands with newly fitted bucket seats.

↑ Tuvalu Sports Ground

Lawaqa Park
SIGATOKA (NADROGA FC)

Lawaqa Park is as laid-back a football venue as you can wish for. The single covered concrete terrace often has its own party going on, with music playing from a personal speaker. Beside the stand is a traditional Fijian house, the stadium headquarters. Mobile food carts sell fruit, orange juice, and corn on the cob. Everything is some distance from the players as the pitch is encircled by a grass running track. Tall palm trees surround the stadium.

HFC Bank Stadium
SUVA (SUVA FC / NATIONAL TEAM)

In the early days of Fijian football, local clubs used to play teams made up of sailors from visiting ships. A Suva team beat the crew of HMS *Powerful* 3–1 and HMS *Torch* 2–0. It was from these beginnings that Fiji's oldest club, Suva FC, was formed in 1928. Since 1951 they have proudly called this stadium home. It is a wonderful venue, next to the Indian Ocean and the Maritime Academy.

Govind Park
BA (BA FC)

Govind Park is home to Ba FC, the Men in Black. The main stand has the words "BA BA BA BA" written large across it. Located next to the Ba River, the pride in the name is clear to see. The Park has hosted the Fiji FACT (FA Cup Tournament) and the Battle of the Giants, Fiji's version of the UEFA Champions League.

TONGA

Teufaiva Sport Stadium
NUKU'ALOFA (NATIONAL TEAM)

You can enjoy the shade in the large main stand, but take a cushion for comfort on the concrete seating. The rest of the stadium is encircled by a grass verge with palm trees offering some respite from the sun. Some fans take to the roofs of the small buildings dotted around the ground, but if you join them, take a parasol.

Australasia / **New Zealand**

NEW ZEALAND

Forsyth Barr Stadium
DUNEDIN (SOUTHERN UNITED FC)

The stadium known affectionately by locals as the Glasshouse was the first enclosed stadium with natural turf when it opened in 2011. It hosted six matches during the 2023 Women's World Cup. Attendances were relatively small until the Football Ferns played Switzerland to a capacity crowd.

Bluewater Stadium
NAPIER (NAPIER CITY ROVERS)

The skylights in the grandstand are a hint at the wonder of the city of Napier, and the walk to the stadium is one of its highlights. Start on the beach side, stroll along the tree-lined esplanades and marvel at the architecture. Known as the art deco capital of the world, the city was destroyed by an earthquake in the 1930s and completely rebuilt in the style of the time. When you reach Park Island, where the stadium is located, you can relax in the shade, watching the amateur league Napier City Rovers.

Mount Smart Stadium
AUCKLAND (AUCKLAND FC)

The stadium sits within the quarried site of built-up lava flow from an ancient volcanic eruption. It's an important spiritual, ancestral site for local Māori, and the stadium is sympathetic to this, molding into the contours of the land. The north side has been left completely open. The three British-style covered stands hold thirty thousand fans, now enjoying A-League football with their team Auckland FC.

↓ Forsyth Barr Stadium

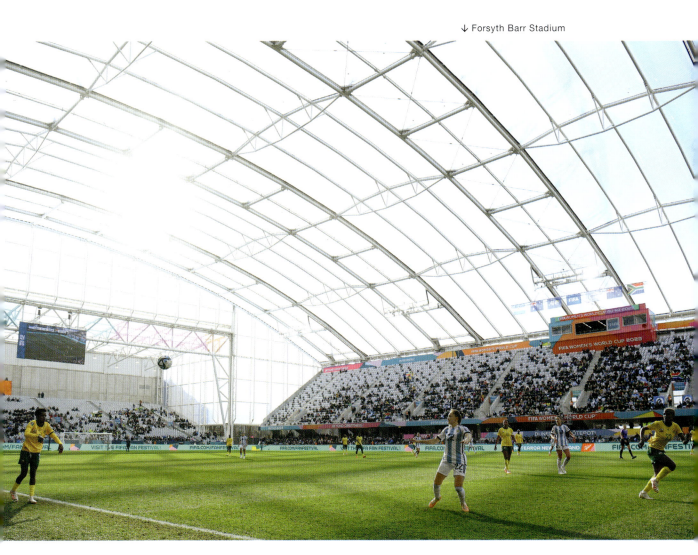

New Zealand / Australasia

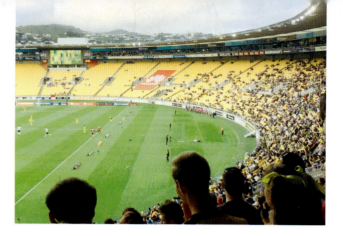

Sky Stadium
WELLINGTON (NATIONAL TEAM)

For a variation on the Australian A-League experience, head for aisles 21 and 22—the Fever Zone. The Phoenix supporters group Yellow Fever loves tradition. If Phoenix is leading in the eightieth minute, they discard their jerseys. If you're there at Christmas and you like a pub crawl, you might like to get involved in the 12 Pubs of Lochhead. To give you a flavor of this, the last crawl, named after defender Tony Lochhead, got an early start at Bin 44, stopped at Rosie's for lunch, took in the last home match of the season, and ended at the Moustache at 11:30 pm. Check the Yellow Fever website for the itinerary.

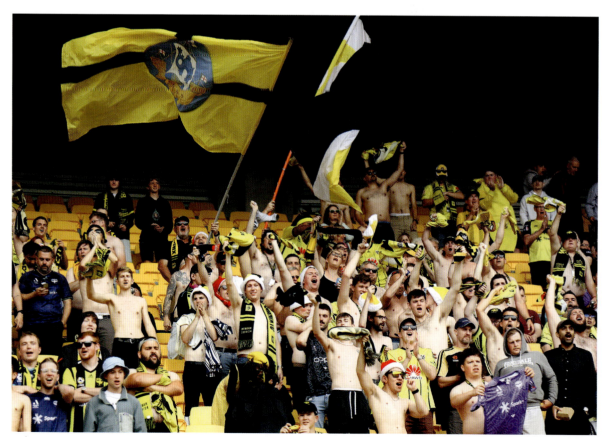

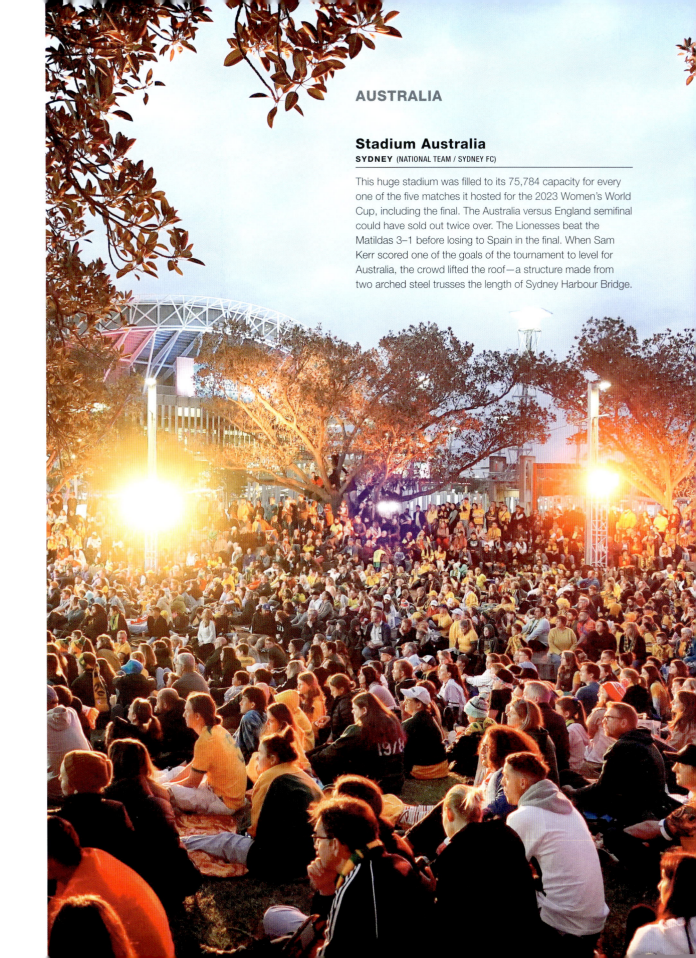

AUSTRALIA

Stadium Australia
SYDNEY (NATIONAL TEAM / SYDNEY FC)

This huge stadium was filled to its 75,784 capacity for every one of the five matches it hosted for the 2023 Women's World Cup, including the final. The Australia versus England semifinal could have sold out twice over. The Lionesses beat the Matildas 3–1 before losing to Spain in the final. When Sam Kerr scored one of the goals of the tournament to level for Australia, the crowd lifted the roof—a structure made from two arched steel trusses the length of Sydney Harbour Bridge.

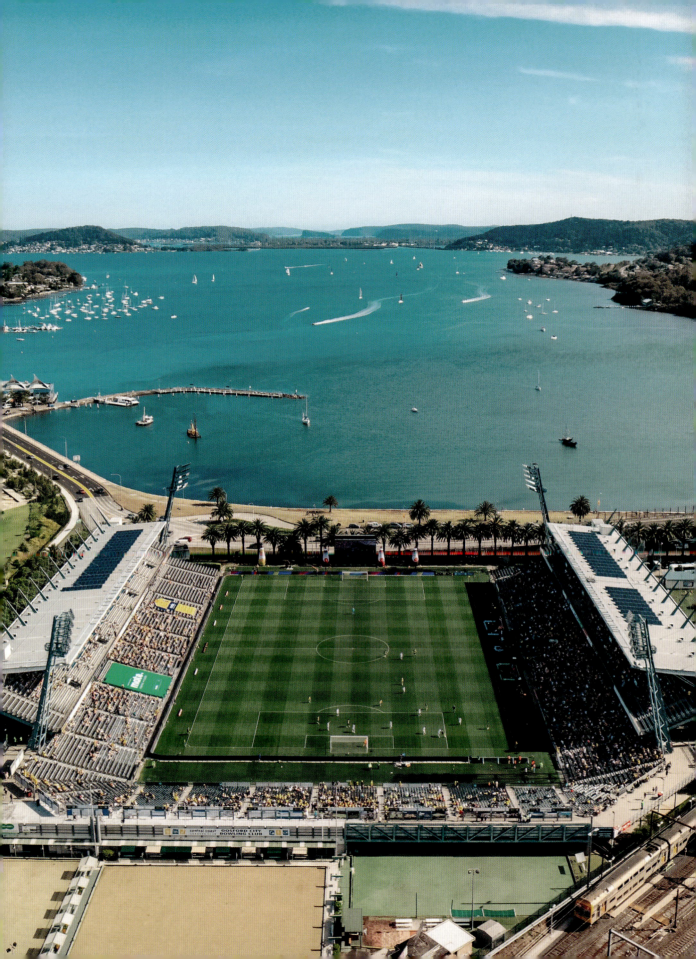

Australasia / **Australia**

Allianz Stadium
SYDNEY (SYDNEY FC)

The stadium is a part of the impressive Moore Park sports precinct close to Sydney Harbour. The large, bicycle-seat-shaped ground hosted matches during the 2023 Women's World Cup.

Commbank Stadium
PARRAMATTA, SYDNEY (WESTERN SYDNEY WANDERERS FC / NATIONAL WOMEN'S TEAM)

On match day, the Red and Black Bloc marches through the streets of Parramatta with megaphone-led call-and-responses, strong language, and smoke bombs. As they make their way to the banks of the Parramatta River where the stadium sits, they are joined by thousands of locals who watch on. Inside, the steep grandstands create a wall of noise and are at their loudest for derbies against Sydney FC and for the Matildas, who call the stadium home.

Suncorp Stadium
BRISBANE (BRISBANE ROAR FC)

Nicknamed the Cauldron, this stadium is home to the Brisbane Roar, which comes from a small but vocal set of die-hard fans. Football here dates to the 1930s. The seats are rarely filled for A League games, but for eight matches during the 2023 Women's World Cup, the stands were packed.

Industree Group Stadium
GOSFORD (CENTRAL COAST MARINERS FC)

Sitting on the banks of the Brisbane Water estuary where the Narara and Coorumbine Creeks meet is arguably Australia's most picturesque football stadium. You'll want to sit in the north stand to get the most breathtaking views while watching the game. The south side is completely open, leaving a palm-tree-lined view of the waters. The corner where the north stand meets the west is cut away to make way for the Gosforth railroad line, breaking the symmetry, but it allows away-day vibes if you arrive by train.

Judy Masters Oval
BALGOWNIE (BALGOWNIE RANGERS FC)

You might not expect to find one of the oldest clubs in the world in a country that has taken a long time to truly embrace the beautiful game. With a backdrop of the Illawarra Hills, on the southeast coast just outside Sydney, is the Judy Masters Oval, named after a Socceroo's legend and Balgownie local. The team plays in the seventh tier on a playing field with a single covered wooden stand, clubhouse, and wonderfully quaint team dugouts. Harking back to 1883, it is a slice of football history.

Coopers Stadium
ADELAIDE (ADELAIDE UNITED FC)

As a venue for both the 2000 Olympic Games and the 2023 Women's World Cup, the stadium has benefited from injections of investment. Until the Olympics, the 1960 wooden-benched grandstand was still in place. The stadium still has a feel of tradition about it. The four stands are in the classic early British style, with voids between them housing floodlights. And it's during an evening game, in the calm breezy dusk, that the stadium really reveals its historic charm.

AAMI Park
MELBOURNE (MELBOURNE CITY FC / MELBOURNE VICTORY FC / WESTERN UNITED FC)

The stadium has a bio-frame design you might expect to house an artificial tropical climate project. Instead, it hosts A League football. The geodesic interlocking domed roof means no pillars or walls, so every seat has an uninterrupted view. And when the Victory fans sing "Take me home, Victory Road" to the tune of John Denver's "Take Me Home, Country Roads," it echoes around every one of the lattice-patterned panels.

HBF Park
PERTH (PERTH GLORY FC)

For one of the best experiences in Australian football, enter the stadium via the northern gate, an art deco entrance from the 1930s. This will take you to that rare thing in modern football—a standing terrace. The Shed is over-eighteens only and it's where the die-hard fans congregate. Join the Glory Shed Supporters Club with a beer from the west brick bar. In the summer heat, there is a subtle breeze from the Swan River. Perfect.

← Industree Group Stadium

Index

INDEX

Includes team name(s), capacity and year built, where known

Afghanistan

Marshal Fahim Sports Stadium 306
Unknown
• Unknown • Unknown

Albania

Air Albania Stadium 145
KF Tirana / National team
• 22,500 • 2019

Algeria

Stade de 19 Mai 1956 244
USM Annaba
• 56,000 • 1987

Stade de 5 Juillet 243
MC Alger / National team
• 64,000 • 1972

Stade du 1er Novembre 1954 244
JS Kabylie
• 25,000 • 1978

Stade du 20 Août 1955 244
JS Saoura
• 20,000 • 1953

Stade du 24 Fevrier 243
USM Bel-Abbès
• 45,000 • 1981

Stade Habib Bouakeul 244
ASM Oran / SCM Oran
• 20,000 • 1927

Stade Hocine Ait Ahmed 244
JS Kabylie
• 50,766 • 2023

Stade Mohamed Hamlaoui 244
CS Constantine / MO Constantine
• 22,000 • 1973

Stade Mustapha Tchaker 244
USM Blida / National team
• 25,000 • 2001

Stade Nelson Mandela 243
National team
• 40,784 • 2023

Stade Omar Hamadi 244
USM Alger
• 10,000 • 1919

Andorra

Estadi Comunal d'Andorra la Vella 174
National team / Multiple teams
• 1,300 • 1990

Estadi Nacional d'Andorra 174
FC Andorra / National Team
• 3,306 • 2014

Angola

Estádio da Cidadela 258
ASA / Progresso do Sambizanga
• 40,000 • 1972

Ombaka National Stadium 258
National team
• 35,000 • 2009

Argentina

Complejo Pedro Pompilio 90
Boca Juniors Women's team
• 1,000 • 1995

El Monumental 86
CA River Plate
• 84,567 • 1938

El Nuevo Gasómetro 90
San Lorenzo
• 47,964 • 1993

Estadio 15 de Abril 82
CA Unión
• 27,358 • 1929

Estadio Alberto José Armando 85
CA Boca Juniors
• 54,000 • 1940

Estadio Alfredo Terrera 92
Club Atlético Central Córdoba
• 14,000 • 1946

Estadio Anselmo Zingaretti 92
Gutierrez Sport Club
• 5,000 • Unknown

Estadio Ciudad de Lanús 90
Club Atlético Lanús
• 47,090 • 1929

Estadio Ciudad de Vicente López 86
CA Platense
• 28,530 • 1979

Estadio Claudio Chiqui Tapia 86
Barracas Central
• 4,400 • 1916

Estadio de Argentino de Quilmes 88
Atlético Argentino de Quilmes
• 5,000 • 1906

Estadio de Chacarita Juniors 94
Club Atlético Chacarita Juniors
• 13,600 • 2011

Estadio Diego Armando Maradona 88
Argentinos Juniors
• 26,000 • 1939–1940, 1995–2003

Estadio Doctor Osvaldo Baletto 83
CA San Telmo
• 10,500 • 1929

Estadio Eva Perón 90
Sarmiento
• 22,000 • 1951

Estadio Feliciano Gambarte 92
Godoy Cruz
• 11,000 • 1959

Estadio Florencio Sola 88
CA Banfield
• 1940 • 1940

Estadio Francisco Cabasés 83
CA Talleres
• 18,000 • 1931

Estadio Gigante de Arroyito 93
Club Atlético Rosario Central
• 46,955 • 1926

Estadio Guillermo Laza 86
Deportivo Riestra
• 3,000 • 1993

Estadio Jorge Luis Hirschi 89
Estudiantes de La Plata
• 32,530 • 2019

Estadio José Amalfitani 90
Vélez Sarsfield
• 49,540 • 1951

Estadio José Dellagiovanna 90
Club Atlético Tigre
• 26,282 • 1936

Estadio Juan Carmelo Zerillo 88
Gimnasia La Plata
• 27,618 •1982

Estadio Juan Domingo Perón 82
Instituto ACC
• 55,000 • 1951

Estadio Julio César Villagra 82
CA Belgrano
• 30,500 • 1929

Estadio Libertadores de América 90
Club Atlético Independiente
• 42,069 • 2009

Estadio Liga Mercedina 88
Club Mercedes
• 5,000 • 1942

Estadio Marceloa Bielsa 94
Newell's Old Boys
• 42,000 • 1911

Estadio Mario Alberto Kempes 82
National team / Multiple teams
• 57,000 • 1978

Estadio Monumental José Fierro 93
Club Atlético Tucumán
• 35,200 • 1922

Estadio Norberto "Tito" Tomaghello 90
Defensa y Justicia
• 20,000 • 1978

Estadio Presidente Perón 90
Racing Club
• 55,000 • 1950

Estadio Saturnino Moure 87
CA Victoriano Arenas
• 1,500 • 1963

Estadio Tomás Adolfo Ducó 86
CA Huracán
• 48,314 • 1949

Estadio Único de Villa Mercedes 82
Club Jorge Newbery (Villa Mercedes)
• 28,000 • 2017

Estadio Único Madre de Ciudades 92
National team
• 30,000 • 2021

Armenia

Vazgen Sargsyan Republican Stadium 311
FC Ararat Yerevan / FC Pyunik / National team
• 14,403 • 1935

Australia

AAMI Park 323
Melbourne City FC / Melbourne Victory FC / Western United FC
• 30,050 • 2010

Allianz Stadium 323
Sydney FC
• 44,000 • 2022

Commbank Stadium 323
Western Sydney Wanderers FC / National women's team
• 30,000 • 2019

Coopers Stadium 323
Adelaide United FC
• 13,327 • 1960

HBF Park 323
Perth Glory FC
• 20,500 • 1910

Industree Group Stadium 323
Central Coast Mariners FC
• 20,059 • 1999

Judy Masters Oval 323
Balgownie Rangers FC
• 1,000 • Early 1900s

Stadium Australia 321
Canterbury-Bankstown Bulldogs / South Sydney Rabbitohs
• 75,784 • 1999

Suncorp Stadium 323
Brisbane Roar FC
• 52,500 • 1934

Austria

FavAC-Platz 164
Favoritner Athletik Club
• 5,000 • 1910

Hohe Warte Stadium 164
First Vienna FC
• 5,500 • 1921

Wörthersee Stadion 164
SK Austria Klagenfurt
• 29,863 • 2007

Belarus

Boisov Arena 128
FC Bate Borisov
• 13126 • 2014

Belgium

AFAS Stadion Achter de Kazerne 192
KV Mechelen
• 16,672 • 1911

Bosuilstadion 193
Royal Antwerp FC
• 16,144 • 1923

Edelhart de Lille Stadion 192
FC Sobemei
• 1,000 • 1973

Edmond Machtens Stadium 192
RWD Molenbeek
• 12,266 • 1920

Gemeentelijk Sportpark Molenbaan 193
KVV Dosko Baarle-Hertog
• 1,500 • Unknown

Jan Breydelstadium 192
Club Brugge KV / Cercle Brugge KSV
• 29,062 • 1975

Joseph Marien Stadium 193
Royale Union Saint-Gilloise
• 9,400 • 1919

King Baudouin Stadium 192
National team
• 50,093 • 1930

Legrand Stadium 193
Royale Football Club de Huy
• 500 • 2020

Stade Maurice Dufrasne 192
Royal Standard de Liège
• 27,670 • 1909

Stade Trois Tilleuis 193
RC Boitsfort
• 40,000 • 1948

Benin

Stade de l'Amitié 260
Benin Football Federation
• 35,000 • 1983

Bhutan

Changlimithang Stadium 300
Transport United FC / National team
• 15,000 • 1974

Bolivia

Estadio de Villa Ingenio 98
Always Ready / Club Deportivo FATIC
• 22,000 • 2017

Estadio Hernando Siles 98
National team / Multiple teams
• 41,143 • 1930

Bosnia and Herzegovina

Koševo Stadium 140
FK Sarajevo
• 34,500 • 1946

Stadion Grbavica 140
FK Željezničar Sarajevo / National team
• 13,146 • 1953

Stadion Rođeni 140
FK Velež Mostar /ŽF / NK Emina Mostar
• 7,000 • 1995

Brazil

Allianz Parque 69
Sociedade Esportiva Palmeiras
• 43,713 • 2014

Almeidão 77
Botafogo
• 25,800 • 1975

Amigão 77
Treze FC / Campinense Clube
• 35,000 • 1975

Arena Castelão 66
Fortaleza EC
• 63,903 • 1973

Arena Condá 66
Associação Chapecoense de Futebol
• 20,089 • 1976

Arena da Baixada 66
Club Athletico Paranaense
• 42,372 • 1999

Arena das Dunas 69
América Futebol Clube RN
• 31,375 • 2014

Arena de Amazonia 64
EC Iranduba Femino
• 46,000 • 2014

Arena do Grêmio 77
Grêmio FBPA
• 55,225 • 2012

Arena Independência 78
América Futebol Clube MG
• 23,018 • 1950

324

Index

Arena MRV 78
Clube Atlético Mineiro
• 44,892 • 2023

Arena Pantanal 77
Cuiabá Esporte Clube
• 44,000 • 2014

Colosso da Lagoa 65
Ypiranga FC
• 22,000 • 1970

Estádio Adelmar da Costa Carvalho 67
Sport Club do Recife
• 26,418 • 1937

Estadio Alfredo Jaconi 74
EC Juventude
• 19,924 • 1975

Estádio Antônio Accioly 78
Atlético Goianiense
• 12,500 • 2018

Estádio Atilio Maroti 74
Serrano FC
• 10,000 • 1951

Estadio Beira-Rio 77
SC Internacional
• 50,128 • 1969

Estadio Brinco de Ouro 69
Guarani FC
• 29,130 • 1953

Estádio Carlos Zamith 64
Amazonas FC
• 6,500 • 2014

Estadio Couto Pereira 66
Coritiba FC
• 40,502 • 1932

Estádio da Gávea 73
CR Flamengo
• 4,000 • 1938

Estádio da Ressacada 74
Avaí FC
• 17,826 • 1983

Estádio da Serrinha 78
Goiás EC
• 14,450 • 1995

Estádio de Laranjeiras 73
Fluminense FC
• 8,000 • 1919

Estádio do Café 65
Londrina EC
• 36,000 • 1976

Estadio do Morumbi 69
São Paulo FC
• 72,039 • 1960

Estadio dos Afitos 66
Clube Náutico Capibaribe
• 19,800 • 1939

Estádio Doutor Jorge Ismael de Biasi 64
Grêmio Novorizontino
• 16,000 • 1987

Estádio Estadual Jornalista Edgar Augusto Proença 64
Paysandu SC / Clube do Remo / SC Belém
• 53,635 • 1978

Estádio Fonte Luminosa 66
Ferroviária
• 20,600 • 1951

Estádio Germano Krüger 64
Operário Ferroviário
• 10,632 • 1941

Estádio Governador João Castelo 78
Sampaio Corrêa FC / Moto Club / Maranhão
• 40,149 • 1982

Estádio Janguito Malucelli 65
J Malucelli Futebol
• 6,000 • 2007

Estádio José Maria de Campos Maia 64
Mirassol FC
• 15,000 • 1925

Estádio Kléber Andrade 73
Rio Branco AC
• 21,152 • 1983

Estadio Manoel Barradas 74
EC Vitória
• 34,535 • 1986

Estádio Morro da Mineira 71
Multiple teams
• Unknown • 2014

Estádio Nabi Abi Chedid 74
Red Bull Bragantino
• 17,128 • 1949

Estadio Novelli Júnior 64
Ituano FC
• 18,560 • 1947

Estadio Olímpico Nilton Santos 73
Botafogo de Futebol e Regatas
• 44,661 • 2007

Estádio Orlando Scarpelli 73
Figueirense FC
• 19,584 • 1960

Estádio Passo D'Areia 64
São José
• 16000 • 1940

Estadio Presidente Vargas 66
Multiple teams
• 20,268 • 1941

Estádio Primeiro de Maio 78
São Bernardo FC
• 12,578 • 1968

Estádio Proletário Guilherme da Silveira Filho 73
Bangu AC
• 9,024 • 1947

Estádio Rei Pelé 77
Clube de Regatas Brasil / Centro Sportivo Alagoano
• 17,126 • 1970

Estádio Ronaldo Luis Nazário de Lima 73
São Cristóvão de Futebol e Regatas
• 8,000 • 1916

Estadio São Januário 71
CR Vasco da Gama
• 24,584 • 1927

Estadio Urbano Caldeira 69
Santos FC
• 16,068 • 1916

Estadio Moisés Lucarelli 69
Associação Atlética Ponte Preta
• 19,728 • 1948

Frasqueirão 69
ABC Futebol Clube
• 24,000 • 2006

Itaipava Arena Fonte Nova 74
EC Bahia
• 47,907 • 2013

Maracanã 71
Multiple teams
• 78,838 • 1950

Mineirão 78
Cruzeiro EC
• 61,927 • 1965

Neo Química Arena 69
Sport Club Corinthians Paulista
• 47,605 • 2014

Tavares Bastos Favela pitch 72
Multiple teams
• Unknown • Unknown

Bulgaria

Georgi Asparuhov Stadium 142
PFC Levski Sofia
• 18,000 • 1963

Vasil Levski National Stadium 142
PFC CSKA Sofia / National team
• 42230 • 1953

Burkina Faso

Stade du 4-août 262
National team / Étoile Filante de Ouagadougou / Commune FC / ASFA Yennega
• 29,800 • 1984

Cambodia

Morodok Techo National Stadium 297
National team
• 60,000 • 2021

National Olympic Stadium 297
Boeung Ket FC
• 50,000 • 1962

RCAF Stadium 297
National Defense Ministry FC / National team
• 10,000 • 1920s

Cameroon

Japoma Stadium 259
National team
• 50,000 • 2020

Limbe Omnisport Stadium 259
Victoria United FC / National team
• 20,000 • 2016

Stade Omnisport Paul Biya 259
National team
• 60,000 • 2021

Canada

ATCO Field 12
Cavalry FC
• 5,000 • 1976

BC Place 13
Vancouver Whitecaps FC
• 54,500 • 1983

BMO Field 12
Toronto F.C
• 40,000 • 2007

King George V Park 13
National Stadium / Memorial Sea-Hawks
• 6,400 • 1925

Olympic Stadium 12
CF Montréal
• 56,040 • 1976

York Lions Stadium 12
York United FC
• 4,000 • 2015

Chile

Estadio Carlos de Apoquindo 95
Universidad Católica
• 20,000 • 1988

Estadio Carlos Dittborn 96
San Marcos de Arica / Deportivo Universidad de Tarapacá
• 9,746 • 1962

Estadio El Cobre 96
Cobresal
• 12,000 • 1980

Estadio El Teniente 94
O'Higgins Fútbol Club
• 14,087 • 1947

Estadio Elías Figueroa Brander 96
Santiago Wanderers
• 20,575 • 1931

Estadio Monumental 94
Colo-Colo
• 47,347 • 1975

Estadio Municipal Joaquín Muñoz García 96
Deportes Santa Cruz
• 6000 • 1920

Estadio Nacional Julio Martínez Prádanos 96
National team / Multiple teams
• 48,665 • 1938

Estadio Regional de Antofagasta 95
Multiple teams
• 21,178 • 1964

Estadio Regional de Chinquihue 96
Deportes Puerto Montt
• 10,000 • 1982

Estadio Rubén Marcos Peralta 96
Provincial Osorno
• 10,000 • 1940

Estadio Sausalito 96
CD Everton
• 23,423 • 1929

Estadio Zorros del Desierto 95
CD Cobreloa / National team
• 13,000 • 1952

Estudio Hanga Roa 96
CF Rapa Nui
• 1,000 • 1996

Santa Laura Universidad SEK 96
Unión Española
• 19,887 • 1923

China

Guangxi Sports Centre 282
Guangxi Hengchen FC
• 60,000 • 2010

Hong Kong FC Stadium 282
Hong Kong FC
• 2,750 • 1886

Longxing Football Stadium 280
Chongqing Tongliang Long FC
• 60,000 • 2022

Mong Kok Stadium 282
Kitchee SC
• 6,664 • 1961

Phoenix Hill Sports Park Football Stadium 281
Chengdu Rongcheng FC
• 50,695 • 2021

Qingdao Tiantai Stadium 280
Qingdao Hainiu FC / Qingdao Red Lions FC
• 20,525 • 1933

Qingdao Youth Football Stadium 280
Qingdao Hainiu FC / Qingdao Red Lions FC
• 52,800 • 2023

Shanghai Stadium 280
Shanghai Shenhua FC
• 72,000 • 1997

Shenyang Pitch 280
Multiple teams
• 60,000 • 2007

Workers' Stadium 281
Beijing Guoan FC
• 68,000 • 2023

Colombia

Estadio Américo Montanini 58
Atlético Bucaramanga
• 25,000 • 1941

Estadio Atanasio Giradot 58
Atlético Nacional / Independiente Medellín
• 44,863 • 1953

Estadio Centenario de Armenia 58
Deportes Quindío SA
• 23,500 • 1988

Estadio Deportivo Cali 58
Deportivo Cali
• 42,000 • 2010

Estadio Metropolitano Roberto Melendez 59
National team
• 46,692 • 1986

Estadio Nemesio Camacho El Campin 60
Millonarios FC/ Santa Fe
• 39,512 • 1938

Estadio Olímpico Pascual Guerrero 59
América de Cali / Atlético / Boca Juniors
• 38,588 • 1937

Estadio Sierra Nevada 59
Unión Magdalena
• 16,162 • 2017

Costa Rica

Estadio National de Costa Rica 57
National Team
• 30,052 • 2011

Côte d'Ivoire

Alassane Ouattara Stadium 262
National team
• 60,012 • 2020

Stade Félix Houphouët Boigny 262
National team / ASEC Mimosas
• 40,000 • 1964

Croatia

Igralište Batarija 148
HNK Trogir
• 160 • 1912

325

Index

Stadion Gospin dolac 148
NK Imotski
• 4,000 • 1989

Stadio Graqdski vrt 148
Zrinski Osječko 1664
• 18,856 • 1980

Stadion Hvar 146
NK Hvar
• 1,000 • 2013

Stadion Kantrida 146
ŽNK Rijeka
• 10,600 • 1913

Stadium Maksimir 147
GNK Dinamo
• 35,123 • 1912

Stadion Poljud 147
HNK Hajduk Split
• 33,987 • 1979

Stadion Rujevica 146
HNK Rijeka
• 8,279 • 2015

Cuba

Estadio La Bombonera 52
FC Pinar del Río
• 8,000 • 1978

Estadio Luis Pérez Lozano 53
FC Cienfuegos
• 4,000 • Unknown

Estadio Pedro Marrero 53
National team
• 28,000 • 1929

Cyprus

Alphamega Stadium 275
AEL Limassol / Apollon Limmasol FC / Aris Limmasol FC
• 11,000 • 2022

GSP Stadium 275
APOEL FC / AC Omonia
• 22,859 • 1999

Czechia

Andrův stadion 134
SK Sigma Olomouc
• 12,483 • 1940

Ďolíček Stadium 134
Bohemians Praha 1905
• 6,300 • 1932

epet ARENA 134
AC Sparta Prague
• 18,944 • 1917

Fortuna Arena 134
SK Slavia Prague
• 19,370 • 2006

Na Stínadlech 134
FK Teplice
• 18,221 • 1973

Stadion u Nisy 134
FC Slovan Liberec
• 9,900 • 1933

Denmark

Aalborg Portland Park 116
Aalborg Boldspilklub
• 13,800 • 1920

Brøndby Stadion 117
Brøndby IF
• 31,400 • 1965

Eioi Stadium 119
National team
• 700 • 1916

Frederiksberg I P Opvisning 119
Kjøbenhavns Boldklub
• 30 • Unknown

Horsens Idrætspark 119
AC Horsens
• 10,400 • 2009

Inni í Vika 119
Argja Bóltfelag
• 2,000 • 1983

Parken 119
FC Copenhagen / National team
• 38,065 • 1911

Qeqertarsuaq Football Pitch 116
G-44 Qeqertarsuarmi timersoqatigiiffik
• 500 • 2016

Roskilde Idrætspark 119
Football Club Roskilde
• 6,000 • 2004

Svangaskarð 119
Tofta Ítróttarfelag, B68 / National team
• 6,000 • 1980

Tasiilaq Field 116
ATA 1960
• 500 • 1960

Tórsvøllur 119
National team
• 6,500 • 1999

Við Djúpumýrar 119
KÍ Klaksvík
• 2,500 • 1910

DR Congo

Stade Tata Raphaël 258
DC Motema Pembe / AS Vita Club
• 80,000 • 1952

Ecuador

Estadio Bellavista 105
Club Deportivo Macará / Mushuc Runa / Técnico Universitario
• 16,467 • 1945

Estadio George Capwell 105
Club Sport Emelec
• 40,020 • 1945

Estadio Jorge Andrade Cantos 104
Deportivo Azogues / Gualaceo SC
• 14,000 • 1984

Estadio Monumental Banco Pichincha 105
Barcelona SC / National team
• 59,283 • 1987

Estadio Olympico de Atahualpa 104
Club Deportivo El Nacional
• 32,258 • 1951

Estadio Rodrigo Paz Delgado 104
LDU Quito / National team
• 41,575 • 1997

Egypt

30 June Stadium 248
Pyramids FC
• 30,000 • 2012

Al Salam Stadium 247
Multiple teams
• 30,000 • 2009

Alexandria Stadium 249
Al-Ittihad Club / Smouha SC
• 13,660 • 1929

Borg el-Arab Stadium 247
Al Masry SC / Pharco FC / National team
• 86,000 • 2009

Cairo International Stadium 248
Al Ahly FC / Zamalek Sporting Club / ZED FC
• 75,000 • 1960

Ghazl El Mahalla Stadium 247
Baladiyat El Mahalla
• 20,000 • 1947

Ismailia Stadium 248
Ismaily SC
• 30,000 • 2009

Moharam Bek neighbourhood 248
Al Falaki Ramadan Football Tournament
• Unknown • 1976

Mokhtar El-Tetsh Stadium 247
Al Ahly SC
• 15,000 • 1917

England

Academy Stadium 211
Manchester City women's team / Manchester City FC EDS
• 7,000 • 2014

American Express Stadium 222
Brighton & Hove Albion FC
• 31,800 • 2011

Anfield 212
Liverpool FC
• 53,394 • 1884

Barbican Football Field 216
Multiple teams
• 100 • 1982

Bedfont Recreation Ground 220
Bedfont Sports FC
• 3,000 • 1960

Bet365 Stadium 209
Stoke City FC
• 30,089 • 1997

Bramall Lane 229
Sheffield United FC
• 31,884 • 1855

Broadfield Stadium 220
Crawley Town FC / Brighton & Hove Albion FC women's team
• 6,134 • 1997

Broadhurst Park 211
FC United of Manchester
• 4,700 • 2015

Cadbury Recreation Ground 214
Cadbury Athletic FC
• 200 • 1896

Carrow Road 225
Norwich City FC
• 27,359 • 1935

Champion Hill 219
Dulwich Hamlet FC
• 3000 • 1931

Cherry Red Records Stadium 220
AFC Wimbledon
• 9,215 • 2020

Craven Cottage 221
Fulham FC
• 25,700 • 1896

Deepdale Stadium 215
Preston North End FC
• 23,408 • 1878

Deva Stadium 212
Chester FC
• 6,500 • 1992

Dripping Pan 223
Lewes FC
• 3,000 • 1885

Earls Orchard 209
Richmond Town FC
• 500 • 1975

Elland Road 226
Leeds United FC
• 37,792 • 1897

Emirates Stadium 217
Arsenal FC
• 60,704 • 2006

Etihad Stadium 211
Manchester City FC
• 53,400 • 2003

Everton Stadium 212
Everton FC
• 39,414 • 1892

Field Mill 208
Mansfield Town FC
• 9,186 • 1861

Fratton Park 224
Portsmouth FC
• 21,100 • 1899

Gaughan Group Stadium 219
Leyton Orient FC
• 9,271 • 1890s

Gtech Community Stadium 220
Brentford FC
• 17,250 • 2020

Highbury Stadium 214
Fleetwood Town FC
• 5,327 • 1939

Hillsborough Stadium 229
Sheffield Wednesday FC
• 39,732 • 1899

Home Park 224
Plymouth Argyle FC
• 16,388 • 1893

John Smith's Stadium 226
Huddddersfield Town AFC
• 24,500 • 1994

Kenilworth Road 225
Luton Town FC
• 10,356 • 1905

King Power Stadium 209
Leicester City FC
• 32,261 • 2002

Kingsmeadow 215
Chelsea FC Women's team / Chelsea Development Squad
• 4,850 • 1989

Leigh Sports Village 210
Manchester United women's team
• 12,000 • 2,008

Loftus Road Stadium 220
Queens Park Rangers FC
• 18,439 • 1904

London Stadium 220
West Ham United FC
• 62,500 • 2011

Mill Road 224
Arundel FC
• 2,200 • 1970s

Millmoor 209
Multiple youth teams
• 8,300 • 1920

Molineux 208
Wolverhampton Wanderers FC
• 31,750 • 1889

New York Stadium 209
Rotherham United FC
• 12,021 • 2012

Old Trafford 210
Manchester United FC
• 74,310 • 1910

Peninsula Stadium 212
Salford City FC
• 5,106 • 1978

Prenton Park 212
Liverpool FC Women / Tranmere Rovers FC
• 16,587 • 1912

Priestfield Stadium 220
Gillingham FC
• 11,582 • 1893

Queen Elizabeth II Stadium 215
Enfield Town FC
• 2,500 • 1953

Riverside Stadium 209
Middlesbrough FC
• 34,742 • 1995

Sandygate 229
Hallam FC
• 1,300 • 1804

Selhurst Park 218
Crystal Palace FC
• 25,486 • 1924

St James' Park 229
Newcastle United FC
• 52,305 • 1892

St. Andrew's 214
Birmingham City FC
• 29,409 • 1906

St. Paul's Sports Ground 220
Fisher FC
• 2,500 • 2016

Stamford Bridge 217
Chelsea FC
• 40,343 • 1877

The City Ground 208
Nottingham Forest FC
• 30,332 • 1898

The Den 220
Millwall FC
• 20,146 • 1993

The Enclosed Ground 223
Whitehawk FC
• 3,126 • 1945

The Hawthorns 208
West Bromwich Albion FC
• 26,688 • 1900

The Home of Football Stadium 229
Sheffield FC
• 2,000 • 2001

The Menace Arena 219
Peckham Town FC
• 1,000 • 2003

The Mesopotamia 225
Eton College
• Unknown • 1766

The New Lawn 225
Forest Green Rovers FC
• 5,147 • 2006

The Old Spotted Dog Ground 216
Clapton Community FC
• 2,000 • 1888

326

Index

The Stadium Of Light 229
Sunderland AFC
• 48,707 • 1997

Tottenham Hotspur
Stadium 217
Tottenham Hotspur FC
• 62,850 • 2019

Turf Moor 214
Burnley FC
• 21,944 • 1883

Turnbull Ground 229
Whitby Town FC
• 3,500 • 1929

Vicarage Road 226
Watford FC
• 21,577 • 1922

Villa Park 214
Aston Villa FC
• 2,000 • 1897

Villa Park (Ray Parker
Stadium) 212
Ashville FC
• 2,000 • 1962

Vitality Stadium 224
AFC Bournemouth
• 11,307 • 1910

Walton Hall Park 212
Everton FC women's team
• 2,200 • 2019

Wellesley Recreation
Ground 225
Great Yarmouth Town FC
• 3,600 • 1888

Wembley Stadium 220
National Team
• 90,000 • 2007

Woodside Road 223
Worthing FC
• 3,250 • 1937

Equatorial Guinea

Estadio de Bata 259
National team
• 35,700 • 2007

Estonia

Pärnu Rannastaadion 122
Pärnu JK Vaprus / Pärnu Jalgpalliklubi
• 1,501 • 1929

Ethiopia

Addis Ababa Stadium 250
*National team / Saint George SC /
Defence Force SC / Ethiopian
Coffee SC*
• 35,000 • 1940

Tigray Stadium 251
Multiple teams
• 60,000 • 2017

Woldiya Stadium 251
Woldia SC / Woldia City
• 25,155 • 2017

Fiji

Churchill Park 318
Lautoka FC
• 18,000 • Unknown

Govind Park 318
Ba FC
• 13,500 • 1976

HFC Bank Stadium 318
Suva FC / National team
• 15,000 • 1951

Lawaqa Park 318
Nadroga FC
• 12,000 • 1998

France

Allianz Riviera 172
OGC Nice
• 35,624 • 2013

AS Monaco Performance
Centre 165
AS Monaco FC
• 283 • 2023

Decathlon Arena - Stade
Pierre-Mauroy 172
LOSC Lille
• 50,186 • 2009

Groupama Stadium 172
Olympique Lyonnais
• 59,186 • 2016

Matmut Atlantique 172
FC Girondins de Bordeaux
• 42,115 • 2015

Parc des Princes 166
Paris Saint-Germain FC
• 48,583 • 1967

Roazhon Park 168
Stade Rennais FC
• 29,778 • 1912

Stade Auguste Delaune 168
Stade de Reims
• 21,684 • 1935

Stade Bauer 167
Red Star FC
• 9,750 • 1909

Stade Bollaert-Delelis 172
RC Lens
• 37,705 • 1933

Stade de la Beaujoire 168
FC Nantes
• 35,322 • 1984

Stade de la Licorne 172
Amiens SC
• 12,097 • 1999

Stade de Roudourou 172
En Avant Guingamp
• 18,378 • 1990

Stade des Alpes 172
Grenoble Foot 38
• 20,068 • 2008

Stade Di Giovanni 168
US Marseille Endoume Catalans FC
• 1,500 • 2000s

Stade du Fort Carré 168
FC Antibes
• 7,000 • 1935

Stade du Hainaut 168
Valenciennes FC
• 25,172 • 2008

Stade du Moustoir 168
FC Lorient
• 18,890 • 1959

Stade Émile Anthoine 166
Multiple teams
• 55,000 • 1999

Stade Francis-Le Blé 168
Stade Brestois 29
• 15,931 • 1922

Stade Geoffroy-Guichard 167
AS Saint-Étienne
• 42,000 • 1930

Stade Gérard Houllier 172
*Olympique Lyonnais women's
team*
• 1,524 • 2017

Stade Jean-Bouin 166
FC Versailles
• 19,904 • 1925

Stade Michel-Moretti 168
AC Ajaccio
• 10,446 • 1969

Stade Océane 168
Le Havre AC
• 25,178 • 2010

Stade Paul-Lignon 167
Rodez AF
• 5,955 • 1940s

Stade Raymond Kopa 172
Angers SCO
• 18,752 • 1912

Stade Sébastien-Charléty 167
Paris FC
• 19,151 • 1939

Stade Vélodrome 171
Olympique de Marseille
• 67,394 • 1937

Gabon

Stade de l'Amitié 258
National team
• 40,000 • 2011

Georgia

Adjarabet Arena 129
FC Dinamo Batumi
• 20,383 • 2020

Boris Paitchadze Dinamo
Arena 128
FC Dinamo Tbilisi
• 54,202 • 1976

Kvarlis Tsentraluri Stadioni 129
Kvareli Duruji FC
• 500 • 1987

Germany

Allianz Arena 197
FC Bayern Munich
• 75,000 • 2005

AOK Stadion 200
VfL Wolfsburg women's team
• 5,200 • 2015

BayArena 206
Bayer 04 Leverkusen
• 30,210 • 1958

Borussia-Park 206
Borussia Mönchengladbach
• 54,057 • 2004

Europa-Park Stadion 199
SC Freiburg
• 34,700 • 2021

Fritz-Walter-Stadion 199
1. FC Kaiserslautern
• 49,780 • 1920

Gazi-Stadion auf der
Waldau 204
*Stuttgarter Kickers / VFB
Stuttgart II*
• 11,410 • 1915

Heinz von Heiden Arena 200
Hannover 96
• 49,000 • 1954

Holstein-Stadion 206
Holstein Kiel
• 15,034 • 1911

Max-Morlock-Stadion 204
1. FC Nürnberg
• 49,923 • 1928

Merck-Stadion am
Böllenfalltor 204
Darmstadt 98
• 17,650 • 1921

Merkur Spiel-Arena 204
Fortuna Düsseldorf
• 54,600 • 2004

Mewa Arena 199
1. FSV Mainz 05
• 33,305 • 2011

Millerntor-Stadion 203
FC St. Pauli
• 29,546 • 1963

Neckarstadion 204
VfB Stuttgart
• 60,449 • 1933

New Tivoli 204
Alemannia Aachen
• 32,960 • 2009

Olympiastadion 204
Hertha BSC
• 74,649 • 1936

PreZero Arena 199
TSG 1899 Hoffenheim
• 30,150 • 2007

Red Bull Arena 206
RB Leipzig
• 47,069 • 2004

RheinEnergieStadion 206
1. FC Köln49,
• 698 • 2004

Schwabenstadion 206
FC Gundelfingen
• 8,000 • Unknown

Signal Iduna Park 198
Borussia Dortmund
• 81,365 • 1974

Sportanlage
Heiligengeistfeld 200
SC Hansa Hamburg
• 1039 • Unknown

Sportplatz an der
Götzstrasse 206
BFC Germania 1888
• 1,000 • Unknown

Stadion An der Alten Försterei
205
1. FC Union Berlin
• 22,012 • 1920

Veltins-Arena 206
FC Schalke 04
• 62,271 • 2001

Voith-Arena 197
1. FC Heidenheim
• 15,000 • 1972

Volksparkstadion 200
Hamburger SV
• 57,000 • 1953

Volkswagen Arena 200
VfL Wolfsburg
• 30,000 • 2002

Vonovia Ruhrstadion 206
VfL Bochum
• 27,599 • 1979

Waldstadion 199
Eintracht Frankfurt
• 58,000 • 1925

Waldstadion an der
Kaiserlinde 204
SV Elversberg
• 10,000 • 1983

Weserstadion 199
SV Werder Bremen
• 42,100 • 1947

Wildparkstadion 206
Karlsruher SC
• 34,302 • 1955

WWK Arena 197
FC Augsburg
• 30,660 • 2009

Ghana

Accra Sports Stadium 261
*Accra Great Olympics FC / Accra
Hearts of Oak SC / Accra Lions
FC / National team*
• 40,000 • 1961

Baba Yara Sports Stadium 261
Asante Kotoko SC / National team
• 40,528 • 1959 / 1971

Len Clay Stadium 261
Ashanti Gold SC / National team
• 20,000 • 1990

Sekondi-Takoraqdi Stadium 261
Sekondi Hasaacas FC
• 20,000 • 2008

Gibraltar

Europa Point Stadium 188
National team
• 8,066 • 2016

Greece

AEL FC Arena 142
SAE Larissa FC
• 16,118 • 2010

Agia Sophia Stadium 143
AEK Athens FC
• 31,100 • 2022

Diagoras Stadium 142
PAE GS Diagoras 1905 / AS Rodos
• 3,693 • 1932

Georgios Karaiskakis
Stadium 143
Olympiacos FC
• 32,115 • 1895

Grigoris Lambrakis Stadium 144
Kallithea FC
• 6,300 • 1970

Nea Smyrni Stadium 145
Panionios GSS
• 11,700 • 1939

Sochora Stadium 145
*Neos Asteras Rethymno FC / Star
Women*
• 2,500 • Unknown

Theodoros Vardinogiannis
Stadium 145
Asteras Tripolis FC
• 7,442 • 1979

Theodorus Kolokotronis
Stadium 142
Asteras Tripolis FC
• 7,442 • 1979

Toumba Stadium 142
PAOK FC
• 28,701 • 1957

327

Index

Guatemala

Estadio Bella Vista 57
San Pedro La Laguna
• 18,000 • 1945

Estadio Dr. Óscar Monterroso Izaguirre 57
Deportivo Reu
• 8,000 • 1948

Estadio Julián Tesucún 57
Heredia Jaguares de Peten
• 8,000 • 1930

Estadio Mario Camposeco 57
Xelajú MC
• 11,220 • 1950

Estadio Municipal Sampedrano 57
Deportivo San Pedro
• 4,000 • 1992

Hungary

Bozsik Aréna 138
Budapest Honvéd FC
• 8,200 • 2021

Pancho Aréna 137
Puskás Akadémia FC
• 3,500 • 2014

Puskás Aréna 138
National team
• 67,215 • 2019

Iceland

Akranesvöllur 109
ÍA Akranes
• 5,550 • 1935

Hásteinsvöllur 108
Íþróttabandalag Vestmannaeyja
• 2,300 • 1912

Olafsvikurvollur 109
Vikingur Olafsvik FC
• 1,130 • 1999

India

Bhaichung Bhutia Stadium 301
United Sikkim FC
• 7,500–15,000 • (disputed) 2019

EKA Arena 302
ARA FC
• 35,000 • 2016

Fatorda Stadium 301
FC Goa
• 19,000 • 1989

Ladakh Stadium 302
Ladakh FC
• 30,000 • 2023

Mumbai Football Arena 302
Mumbai City FC / National team
• 6,600 • 1988

Nongpathar Stadium 302
Unknown
• 30,000 • 1923

Paljor Stadium 302
United Sikkim FC
• 30,000 • 1943

Rajiv Gandhi Stadium 302
Aizawl FC
• 20,000 • 2016

Salt Lake Stadium 302
National team / West Bengal football team / Mohun Bagan Super Giant
• 68,000 • 1984

Indonesia

Aji Imbut Stadium 292
PS Mitra Kukar
• 35,000 • 2008

Gelora Bung Karno Main Stadium 292
Persija Jakarta / National team
• 77,193 • 1962

Jakarta International Stadium 292
Persija Jakarta
• 82,000 • 2022

Kaharudin Nasution Rumbai Stadium 292
PSPS Pekanbaru
• 30,000 • 2011

Kapten I Wayan Dipta Stadium 292
Bali United FC
• 18,000 • 2003

Lukas Enembe Stadium 292
Persipura Jayapura
• 40,263 • 2017

Si Jalak Harupat Stadium 292
Persikab Bandung / PSKC Cimahi
• 27,000 • 2005

Stadion Batakan 292
Borneo FC Samarinda / Persiba Balikpapan
• 40,000 • 2017

Stadion Maguwoharjo 292
PSS Sleman / RANS Nusantara
• 31,700 • 2007

Iran

Azadi Stadium 264
Persepolis FC / Esteghlal FC / National team
• 78,116 • 1971

Foolad Arena Stadium 264
Foolad FC
• 30,655 • 2018

Fuladshahr Stadium 264
Zob Ahan Esfahan FC
• 15,000 • 1998

Imam Reza Stadium 264
Shahr Khodro FC
• 27,700 • 2017

Marzdaran Stadium 264
Machine Sazi FC / Shahrdari Tabriz FC
• 5,000 • 2014

Naghsh-e-Jahan Stadium 264
Sepahan SC
• 75,000 • 2003

Pars Stadium 264
Fajr Sepasi Shiraz FC
• 50,000 • 2017

Shahid Kazemi Stadium 264
Persepolis FC / Esteghlal FC / National team
• 15,000 • 2013

Takhti Stadium 264
Saipa FC
• 30,122 • 1973

Yadegar-e-Emam Stadium 264
Tractor SC
• 66,833 • 1996

Iraq

Al-Minaa Olympic Stadium 275
Al-Minaa SC
• 30,000 • 2022

Al-Najaf International Stadium 274
Al-Najaf SC / Al-Najaf-Wasat SC
• 30,000 • 2018

Al-Sha'ab International Stadium 275
Al-Shorta SC
• 35,700 • 1966

Basra International Stadium 275
National team / Al-Mina'a SC / Naft Al-Junoob SC
• 65,227 • 2013

Duhok Stadium 274
Duhok SC
• 22,800 • 1986

Ireland

Dalymount Park 239
Bohemian FC
• 4,500 • 1901

Ryan McBride Brandywell Stadium 239
Derry City FC
• 3,700 • 1928

Tallaght Stadium 239
Shamrock Rovers FC
• 8,000 • 2009

The Showgrounds 239
Sligo Rovers FC
• 3,873 • 1928

Israel

Bloomfield Stadium 273
Maccabi Tel Aviv FC / Hapoel Tel Aviv FC / Bnei Yehuda Tel Aviv FC
• 30,000 approx • 1962

Green Stadium 272
Hapoel Nof HaGalil FC
• 5,200 • 1965

Netanya Stadium 272
Maccabi Netanya FC
• 13,610 • 2012

Sammy Ofer Stadium 273
Maccabi Haifa FC / Hapoel Haifa FC
• 30,942 • 2014

Teddy Stadium 273
Beitar Jerusalem FC / Hapoel Jerusalem FC
• 31,733 • 1991

Italy

Allianz Stadium 153
Juventus
• 41,507 • 2011

Arena Civica 151
Brera Calcio
• 10000 • 1807

Campo di Calcio San Costanzo 157
Racing Capri FC
• 1,000 • 2019

Campo Gerini 153
Procalcio Italia
• 100 • Unknown

Campo Pio XI 153
Vatican City national teams
• 500 • 2006

Centro Sportiva Agostino Cascella 151
AS Velasca / US Triestina 1946
• 300 • 1989

Gewiss Stadium 151
Atalanta BC
• 15,222 • 1927

Mapei Stadium (Città del Tricolore) 157
US Sassuolo Calciol
• 21,515 • 1995

Piazza Santa Croce 160
Santa Croce, Azzurri / Santa Maria Novella, Rossi / Santo Spirito, Bianchi / San Giovanni, Verdi
• Approx. 2,000 • 1580

San Siro 150
AC Milan / Inter Milan
• 75,710 • 1926

Stadio "Valerio Bacigalupo" di Taormina 157
ACR Messina
• 1,000 • 1959

Stadio Alberto Braglia 157
Modena FC 2018
• 21,151 • 1936

Stadio Alberto Picco 160
Spezia Calcio
• 11,968 • 1919

Stadio Antonio Riciniello 156
Gaeta Calcio 1931
• 2,055 • 1931

Stadio Arechi 158
US Salernitana 1919
• 29,739 • 1990

Stadio Armando Picchi 150
US Livorno 1915
• 14,267 • 1935

Stadio Artemio Franchi 160
ACF Fiorentina
• 43,118 • 1931

Stadio Benito Stirpe 159
Frosinone Calcio
• 16,227 • 1974

Stadio Brianteo 152
AC Monza
• 15,039 • 1988

Stadio Carlo Castellani 160
Empoli FC
• 16,167 • 1965

Stadio Communale San Vito "Gigi Marulla" 158
Cosenza Calcio
• 20,987 • 1964

Stadio del Conero 152
US Ancona
• 23,967 • 1992

Stadio Diego Armando Maradona 154
SSC Napoli
• 54,732 • 195

Stadio Druso 157
FC Südtirol
• 5,539 • 1930

Stadio Ennio Tardini 156
Parma Calcio 1913
• 22,352 • 1923

Stadio Friuli 159
Udinese Calcio
• 25,155 • 2016

Stadio Giovanni Mari 156
AC Legnano
• 5000 • 1921

Stadio Giovanni Zini 157
US Cremonese
• 15,191 • 1919

Stadio Giuseppe Sinigaglia 158
Como 1907
• 13,602 • 1927

Stadio Libero Liberati 157
Ternana Calcio
• 22,000 • 1969

Stadio Luigi Ferraris 153
Genoa CFC / UC Sampdoria
• 33,205 • 1911

Stadio Marcantonio Bentegodi 160
Hellas Verona FC
• 31,713 • 1963

Stadio Mario Rigamonti 159
Brescia Calcio
• 19,500 • 1959

Stadio Nereo Rocco 152
US Triestina Calcio 1918
• 24,500 • 1992

Stadio Nicola Ceravolo 157
US Catanzaro 1929
• 14,650 • 1919

Stadio Olimpico 152
AS Roma / SS Lazio
• 67,585 • 1953

Stadio Olimpico Grande Torino 153
Torino FC
• 28,177 • 1933

Stadio Pier Cesare Tombolato 158
AS Cittadella
• 7,623 • 1981

Stadio Pier Luigi Penzo 152
Venezia FC
• 11,150 • 1913

Stadio Renato Dall'Ara 162
Bologna FC 1909
• 36,532 • 1927

Stadio Renzo Barbera 157
Palermo FC
• 36,365 • 1932

Stadio Rigamonti-Ceppi Stadio Euganeo 152
Calcio Lecco 1912
• 4,997 • 1922

Stadio San Nicola 160
SSC Bari
• 58,270 • 1990

Stadio Sant'Elia 160
Cagliari Calcio
• 16,000 • 1917

Stadio Teofilo Patini 151
ACD Castel di Sangro Cep 1953
• 7,220 • 1996

Stadio Via del Mare 152
US Lecce
• 30,354 • 1966

Stadio Vittorio de Sica 150
ASD San Vito Positano 1956
• 600 • 1990s

Trampolino Olimpico 156
SG Cortina
• 40,000 • 1955

Japan

Adidas Futsal Park 288
Multiple teams
• 2,200 • 2001

Ajinomoto Stadium 288
FC Tokyo / Tokyo Verdy
• 63,700 • 2001

Index

Best Denki Stadium 291
Avispa Fukuoka
• 22,563 • 1995

Denka Big Swan Stadium 291
Albirex Niigata
• 42,300 • 2001

Edion Peace Wing
Hiroshima 291
Sanfrecce Hiroshima
• 28,520 • 2023

Kashima Soccer Stadium 288
Kashima Antlers
• 40,728 • 1993

Mikuni World Stadium
Kitakyushu 291
Giravanz Kitakyushu
• 15,300 • 2017

Nagai Stadium 291
Cerezo
• 50,000 • 1964

Panasonic Stadium Suita 291
Gamba Osaka
• 41,484 • 2015

Saitama Stadium 2002 291
Urawa Red Diamonds
• 30,132 • 2001

Sanga Stadium by Kyocera 291
Kyoto Sanga FC
• 21,600 • 2020

Sankyo Frontier Kashiwa
Stadium 288
Kashiwa Reysol
• 15,349 • 1985

Todoroki Athletics Stadium 288
Kawasaki Frontale
• 26,232 • 1962

Toyota Stadium 288
Nagoya Grampus
• 44,692 • 2001

Jordan

Al-Hassan Stadium 272
Women's national team /
Al-Hussein SC
• 12,301 • 1990

Amman International
Stadium 272
National team / Al-Faisaly SC
• 17,619 • 1968

Kazakhstan

Koblandy Batyr Stadium 278
FC Aktobe
• 13,200 • 1975

Kiribati

Bairiki National Stadium 316
National team
• 2,500 • 2011

Kuwait

Jaber al-Ahmad International
Stadium 266
National team
• 60,000 • 2010

Lebanon

Beirut Municipal Stadium 274
Not in use
• 18,000 • 1935

Camille Chamoun Sports
City Stadium 273
National team
• 49,500 • 1957

Saida Municipal Stadium 273
Al Ahli Saida SCAI Ahli Saida SC /
National team
• 22,600 • 1999

Libya

Tripoli International Stadium 246
Al-Ahli Saudi FC / Al-Ittihad Club /
Al-Madina SC / National team
• 80,000 • 1970

Liechtenstein

Rheinpark Stadion 194
National team
• 7,584 • 1998

Lithuania

Darius and Girénas
Stadium 123
National team / FK Kauno Žalgiris
• 15,315 • 1925

Luxembourg

Stade de Luxembourg 194
National team
• 9,386 • 2021

Stade du Thillenberg 194
FC Differdange 03
• 7,150 • 1922

Madagascar

Kianja Barea
Mahamasina 251
National team
• 40,880 • 1960

Malaysia

Batu Kawan Stadium (State
of Penang Stadium) 295
Penang FC
• 40,000 • 2000

Bukit Jalil National
Stadium 296
National team
• 87,411 • 1998

Hang Jebat Stadium 295
Melaka United FC / National team
• 40,000 • 2004

Perak Stadium 295
Perak FC / Perak FC II
• 42,500 • 1965

Sarawak State Stadium 295
Sarawak United FC / Kuching City FC
• 26,000 • 1991

Sultan Ibrahim Stadium 295
Johor Darul Ta'zim FC
• 40,000 • 2020

Tuanku Abdul Rahman
Stadium 295
Negeri Sembilan FC / KSR Sains
FC / National team
• 45,000 • 2004

Maldives

Baa Eydhafushi Football
Ground 305
National team
• 11,000 • 2019

Kandima Maldives Football
Pitch 305
Unknown
• Unknown • 2017

Kurendhoo Football
Ground 305
Kurendhoo FC
• 500 • 2018

Maafushi turf stadium 305
Unknown
• 1,000 • 2021

National Football Stadium 305
National team / Buru Sports Club
• 11,850 • 1979

Pele Stadium Maldives 305
National team / Mahibadhoo
Sports Club
• 500 • 2023

Malta

Grawnd Nazzjonali 149
National team / Maltese Premier
League
• 16,997 • 1981

Kerċem Ajax Stadium 149
Multiple teams
• 1,000 • 2014

Luxol Stadium 149
St. Lucia FC / St. Andrews FC /
National Amateur League
• 800 • 2006

Marshall Islands

Majuro Track and Field
Stadium 314
National team
• 2,000 • 2024

Mauritania

Stade Municipal de
Nouadhibou 263
FC Nouadhibou
• 10,300 • 2020 renovated

Mexico

Estadio BBVA 51
CF Monterrey
• 53,500 • 2015

Estadio Akron 45
CD Guadalajara
• 45,364 • 2010

Estadio Alfonso Lastras 44
Atlético San Luis
• 25,111 • 2002

Estadio Azteca 45
Club América
• 87,523 • 1966

Estadio Caliente 48
Club Tijuana
• 27,333 • 2007

Estadio Ciudad de los
Deportes 44
Cruz Azul / Tazón México / Atlante
• 33,000 • 1946

Estadio Corona 48
Santos Laguna
• 30,000 • 2009

Estadio Corregidora 48
Querétaro FC
• 33,162 • 1985

Estadio Cuauhtémoc 47
Club Puebla
• 51,726 • 1968

Estadio de Mazatlán 48
Mazatlán FC
• 25,000 • 2020

Estadio El Hogar 48
Gavilanes de Matamoros FC
• 22,000 • 2016

Estadio Hidalgo 47
CF Pachuca
• 30,000 • 1993

Estadio Jalisco 45
Atlas FC
• 56,713 • 1960

Estadio León 46
Club León FC
• 31,297 • 1967

Estadio Nemesio Díez 48
Deportivo Toluca FC
• 30,000 • 1935

Estadio Olímpico Benito
Juárez 47
FC Juárez
• 19,703 • 1981

Estadio Olímpico Universitario 44
Club Universidad Nacional
• 72,000 • 1952

Estadio Universitario 48
UANL
• 42,000 • 1967

Estadio Universitario Alberto
"Chivo" Córdoba 48
Potros
• 32,000 • 1964

Estadio Victoria 47
Club Necaxa
• 25,500 • 2003

Teoca volcano football pitch 45
Multiple teams
• 50 • 1950s/1960s

Moldova

Sheriff Arena 132
FC Sheriff Tiraspol
• 12,746 • 2002

Monaco

Stade Louis II 165
AS Monaco FC
• 18,523 • 1985

Mongolia

MFF Air Dome 279
Bavarians FC / National team
• 600 • 2024

My Mongolia Park Stadium 279
Darkhan City FC
• 1,700 • 2022

National Sports Stadium 279
Deren FC
• 12,500 • 1958

Montenegro

Podgorica City Stadium 145
National team / FK Budućnost
Podgorica
• 11,050 • 1945

Morocco

Grande Stade de
Marrakech 243
KAC Marrakech
• 41,356 • 2011

Honneur Stadium 243
MC Oujda
• 19,000 • 1976

Stade Ibn Batouta 243
IR Tanger
• 65,000 • 2002

Stade Mohammed V 243
Raja Club Athletic / Wydad AC /
National team
• 45,891 • 1955

Nauru

Menang Stadium 315
Asylum seekers
• 3500 • 2006

Nepal

Dasharath Rangasala 300
National team
• 15000 • 1956

Narayani Stadium 300
Birgunj United FC
• 15000 • 1981

Pokhara Stadium 300
Sahara Club (Pokhara) / Pokhara
Thunders / National team
• 16500 • 1980

Netherlands

AFAS Stadion 195
AZ Alkmaar
• 17,023 • 2006

Euroborg 196
FC Groningen
• 22,525 • 2006

GelreDome 195
SBV Vitesse
• 34,000 • 1998

Johan Cruyff ArenA 196
AFC Ajax
• 53,490 • 1996

Kras Stadion 195
FC Volendam
• 7000 • 1975

Parkstad Limburg Stadion 195
Roda JC
• 19,979 • 2000

Sparta Stadion 196
Sparta Rotterdam
• 11,026 • 1916

Stadion Feijenoord 196
Feyenoord / National team
• 51,177 • 1937

New Zealand

Bluewater Stadium 319
Napier City Rovers
• 5000 • 1985

Forsyth Barr Stadium 319
Southern United FC
• 25,947 • 2011

Mount Smart Stadium 319
Auckland FC
• 30,000 • 1967

329

Index

Sky Stadium 320
National team
• 31,089 • 2000

Nicaragua

Estadio Carlos Fonseca
Amador 57
Matagalpa FC
• 5,000 • 2021

Estadio Independencia 57
Real Esteli Fútbol Club
• 5,000 • 1961

Estadio Nacional de Fútbol 57
Multiple teams
• 20,000 • 2011

Niger

Stade Général Seyni
Kountché 260
National Team / Multiple teams
• 35,000 • 1989

Nigeria

Adamasingba Stadium 260
Shooting Stars SC
• 10,000 • 1988

Mobolaji Johnson Arena 260
Multiple teams
• 10,000 • 1930

Moshood Abiola Stadium 260
National team
• 60,491 • 2003

North Korea

Kim Il Sung Stadium 282
P'yŏngyang City SC/ National team
• 50,000 • 1969

Rungrado 1st of May
Stadium 283
National team / April 25 Sports Club
• 114,000 • 1989

North Macedonia

Petar Miloševski Stadium 146
FK Pelister
• 10,000 • 1937

Sports Center Pandev 146
FC AP Brera
• 1,500 • 2020

Northern Ireland

The Oval 238
Glentoran FC
• 26,556 • 1892

Windsor Park 238
Linfield FC
• 18,500 • 1905

Norway

Aker Stadion 112
Molde FK
• 11,249 • 1998

Aspmyra Stadion 114
FK Bodø / Glimt / Grand Bodø
• 8,270 • 1966

Fosshaugane Campus 111
Sogndal Fotball
• 5,622 • 2006

Henningsvær Stadion 114
Henningsvær IL
• 500 • 1927

Intility Arena 110
Vålerenga
• 16,556 • 2017

Lerkendal Stadium 110
Rosenborg BK
• 21,423 • 1947

Romssa Arena 111
Tromsø IL
• 8,585 • 1987

Skagerak Arena 111
Odds Ballklubb
• 11,767 • 1923

Vallhall Arena 110
Vålerenga Fotball
• 5,500 • 2001

Viking Stadion 111
Viking FK
• 15,900 • 2004

Oman

Al Hajar Mountains football
field 269
Multiple teams
• Unknown • 2016

Pakistan

Jinnah Sports Stadium 306
National team
• 48,820 • 1970s

Karachi Port Trust Stadium 306
Karachi Port Trust FC
• 20,000 • 2010

People's Football Stadium 306
National team
• 40,000 • 1995

Punjab Stadium 306
WAPDA FC / Wohaib FC / National team
• 15,000 • 2003

Palau

Palau National Stadium 314
National team
• 4,000 • 1998

Panama

Estadio Olímpico Rommel
Fernández Gutiérrez 57
National team / Tauro FC
• 32,000 • 2009

Papua New Guinea

PNG Football Stadium 315
Hekari United FC / University Inter FC / Besta PNG United / National team
• 15,000 • 1975

Sir Hubert Murray Stadium 314
National team
• 20,000 • 1969

Sir John Guise Stadium 314
Port Moresby Strikers FC / PRK Gulf Komara / National team
• 15,000 • 1991

Paraguay

Estadio Antonio Aranda 80
Club Atlético 3 de Febrero
• 23,500 • 1972

Estadio Defensores del
Chaco 80
National team / Club Guaraní / Club Olimpia
• 42,354 • 1917

Estadio Feliciano Cáceres 80
Sportivo Luqueño
• 24,000 • 1999

Estádio General Pedro Rojas 80
Cerro Porteño
• 18,000 • 1977

Estadio Tigo La Huerta 80
Club Libertad
• 10,100 • 2005

Estadio Villa Alegre 80
Encarnación FC / Deportivo Itapuense
• 16,000 • 2022

Monumental Río Parapití 80
Club du 2 Mayo
• 18,000 • 1977

Peru

Aguas Calientes Football
Pitch 101
Club Tijuana FC
• 33,333 • 2007

Estadio 25 de Noviembre 103
Sport Huancayo / Sport Aguila
• 20,000 • 1962

Estadio Alejandro
Villanueva 100
Club Alianza Lima
• 33,938 • 1974

Estadio Daniel Alcides
Carrion 103
Union Minas
• 8,000 • Unknown

Estadio de la UNSA 102
Alfonso Ugarte de Puno
• 30,000 • 2022

Estadio Enrique Torres
Belon 102
Alfonso Ugarte
• 20,000 • Unknown

Estadio Garcilaso 103
Cienciano / Garcilaso / Cusco FC
• 42,056 • 1958

Estadio Max Agustín 103
Comerciantes FC
• 24,576 • 1942

Estadio Melgar 102
Multiple teams
• 15,000 • 1954

Estadio Monumental 100
Club Universitario de Deportes
• 80,093 • 2000

Estadio Municipal de
Amantaní 102
Multiple teams
• 8,000 • Unknown

Estadio Nacional del Perú 102
National team
• 43,086 • 1952

Estadio Unión Tarma 100
ADT Tarma
• 9,000 • 1980

Poland

Kazimierz Górski National
Stadium 125
National team
• 58,580 • 2012

Opole Stadium 126
Odra Opole
• 3,300 • 1930

Polsat Plus Arena
Gdańsk 123
Lechia Gdańsk
• 43,615 • 2011

SOSiR Stadium 126
Polonia Słubice
• 7,000 • 1927

Spodek Arena 126
Spodek Super Cup
• 11,036 • 1971

Stadion Cracovii im. Józefa
Piłsudskiego 126
KS Cracovia / Puszcza Niepołomice
• 15,016 • 2010

Stadion im. Czesława
Kobusa 123
Chemik Bydgoszcz
• 15,000 • 1977

Stadion im. Ernesta Pohla 125
Górnik Zabrze
• 24,563 • 2016

Stadion im. mjr. Mieczysława
Słabego 123
Czuwaj Przemyśl
• 2,200 • 1923

Stadion Jagiellonii Białystok 123
Jagiellonia Białystok
• 22,432 • 2014

Stadion Miejski im. Henryka
Reymana 126
LKS Pogon Lebork
• 35,000 • 1953

Stadion Orzel Kozy 126
Orzel Kozy
• 500 • Unknown

Stadion Poznań 126
KKS Lech Poznań
• 43,269 • 1980

Stadion Promienia
Opalenica 126
KS Promień Opalenica
• 1,015 • 1960

Stadion RKS Marymont 125
Marymont Warszawa
• 10,000 • 1955

Stadion Wielofunkcyjny
OSIR w Łowiczu 126
MUKS Pelikan Łowicz
• 4,840 • 1999

Stadion Wojska Polskiego 123
Legia Warszawa
• 31,800 • 1930 / 2011

Tarczyński Arena Wrocław 123
Śląsk Wrocław
• 45,105 • 2011

Zagłębiowski Park
Sportowy 123
Zagłębie Sosnowiec SSA
• 11,600 • 2023

Zimowit Rzeszow Stadion 126
Zimowit Rzeszów
• 100 • 1955

Portugal

Estádio Algarve 190
Louletano DC
• 30,305 • 2003

Estádio de São Miguel 190
CD Santa Clara
• 13,277 • 1930

Estádio do Bessa 191
Boavista FC
• 28,263 • 1911

Estádio do Dragão 191
FC Porto
• 50,033 • 2003

Estádio do Marítimo 188
CS Marítimo
• 10,932 • 1957

Estádio do Sport Lisboa e
Benfica 190
SL Benfica
• 64,642 • 2003

Estádio Dom Afonso
Henriques 190
Vitória SC
• 30,000 • 1965

Estádio José Alvalade 189
Sporting Clube de Portugal
• 50,095 • 2001

Estádio José Gomes 191
CF Estrela da Amadora
• 9,288 • 1957

Estádio Municipal de Arouca 191
FC Arouca
• 5,000 • 2006

Estádio Municipal de Braga 191
SC Braga
• 30,286 • 2003

Estádio Municipal Eng.
Manuel Branco Teixeira 191
GD Chaves
• 8,400 • 1949

Estádio Nacional 188
Casa Pia AC
• 37,593 • 1944

Qatar

Ahmad bin Ali Stadium 267
Al-Rayyan SC
• 45,032 • 2020

Al Bayt Stadium 267
Multiple teams / National team
• 68,895 • 2019

Al Janoub Stadium 267
Al-Wakrah SC
• 44,325 • 2019

Al Thumama Stadium 266
National team
• 44,400 • 2021

Al-Shamal SC Stadium 267
Al-Shamal SC
• 5,000 • 2011

Doha Sports Stadium 266
Asian Communities Football Tournament / Qatar Amateur League
• 2,000 • 1962

Education City Stadium 267
Multiple teams / National team
• 44,667 • 2020

Jassim bin Hamad Stadium 266
National team / Al Sadd SC
• 1,500 • 1975

Khalifa International Stadium 267
National team
• 45,857 • 1976

Lusail Stadium 267
National team
• 88,966 • 2021

330

Index

Republic of the Congo

Stade Municipal de Kintélé 258
National team
•60,000 • 2015

Romania

Arena Națională 139
FCSB
• 55,634 • 2011

Cacica Salt Mine 138
Multiple teams
• 50 • Unknown

Sepsi Arena 139
Sepsi OSK Sfântu Gheorghe
• 8,400 • 2021

Russia

Ekaterinburg Arena 132
FC Ural Yekaterinburg
• 35,000 • 1957

Krasnodar Stadium 130
FC Krasnodar
• 35,179 • 2016

Krestovsky Stadium 132
FC Zenit
• 67,800 • 2017

Luzhniki Stadium 132
FC Torpedo Moscow
• 81,000 • 1956

Meshchersky Park 132
Multiple teams
• 100 • Unknown

Mordovia Arena 132
FC Mordovia Saransk
• 44,442 • 2018

Nizhny Novgorod Stadium 129
FC Pari Nizhny Novgorod
• 44,899 • 2017

Petrovsky Stadium 132
FC Leningradets Leningrad Oblast
• 20,985 • 1925

Rostov Arena 129
FC Rostov
• 45,000 • 2018

Volgograd Arena 132
FC Rotor Volgograd
• 45,568 • 2018

Saint Barthélemy

Stade de Saint-Jean 53
National team
• 1,000 • 1970s

Samoa

National Soccer Stadium 318
National team / Samoa National League
• 3,500 • 2011

Saudi Arabia

Al-Awwal Park 272
Al-Nassr FC
• 25,000 • 2015

Al-Shabab Club Stadium 272
Al-Shabab FC
• 15,000 • 1984

Alinma Stadium 272
Al-Ahli Saudi FC / Al-Ittihad Club / National team
• 62,345 • 2014

Prince Faisal bin Fahd Sports City 272
Al Hilal SFC
• 22,188 • 1971

Scotland

Bayview Stadium 233
East Fife FC
• 1,980 • 1998

Caledonian Stadium 235
Inverness Caledonian Thistle FC
• 7,512 • 1996

CalForthConstruction Arena at Tannadice Park 235
Dundee United FC
• 14,209 • 1882

Celtic Park 236
Celtic FC
• 60,411 • 1892

Craighead Park 233
Lesmahagow Juniors FC
• 18,128 • 1932

Dumbarton Football Stadium 234
Dumbarton FC
• 2,020 • 2000

Easter Road 232
Hibernian FC
• 20,421 • 1893

Falkirk Stadium 235
Falkirk FC
• 7,937 • 2004

Fir Park 233
Motherwell FC
• 13,742 • 1895

Firhill Stadium 236
Partick Thistle FC
• 10,887 • 1909

Gayfield Park 235
Arbroath FC
• 6,600 • 1880

Hampden Park 237
Queen's Park FC / National team
• 52,025 • 1903

Ibrox Stadium 236
Rangers FC
• 50,817 • 1899

Netherdale 234
Gala Fairydean Rovers FC
• 2,000 • 1912

Pittodrie Stadium 232
Aberdeen FC
• 22,199 • 1899

Stark's Park 234
Raith Rovers FC
• 8,867 • 1891

Tynecastle Park 233
Heart of Midlothian FC
• 20,099 • 1886

Senegal

Diamniadio Olympic Stadium 263
National team
• 50,000 • 2022

Serbia

Marakana 141
FK Crvena Zvezda
• 53,000 • 1963

Stadiim Voždovac 141
FK Voždovac/FK IMT
• 5,200 • 2011

Stadion Dubočica 141
GFK Dubočica
• 8,136 • 2023

Stadion Partizan 141
FK Partizan
• 29,755 • 1951

Seychelles

Stad Linité 251
Multiple teams
• 10,000 • 1992

Stade d'Amitié 251
Revengers FC / Côte d'Or FC
• 2,000 • Not in use

Singapore

Singapore National Stadium 294
National team
55,000 2014

The Float at Marina Bay 294
National team
• 27,000 • 2007

Slovakia

TJ Tatran Cierny Balog Stadium 135
TJ Tatran Cierny Balog
• 800 • 1980s

Slovenia

Stadion Pod Obzidjem 139
NK Portoroz Piran
• 750 • 1925

Solomon Islands

Lawson Tama Stadium 316
National team / Honiara Rangers FC / Multiple teams
• 20,000 • 1964

Solomon Islands National Stadium 316
National team
• 10,000 • 2023

South Africa

DHL stadium 255
Multiple teams
• 55,000 • 2009

FNB Stadium 253
National team / Kaizer Chiefs FC
• 94,736 • 2009

Mbombela Stadium 257
Mbombela United FC
• 40,929 • 2009

Mmabatho Stadium 252
Multiple teams
• 59,000 • 1981

Moses Mabhida Stadium 256
AmaZulu FC
• 55,000 • 2009

Nelson Mandela Bay Stadium 257
Chippa United FC
• 48,459 • 2009

Odi Stadium 252
Garankuwa United FC
• 60,000 • 1988

Orlando Stadium 256
Orlando Pirates FC
• 40,000 • 2008

Peter Mokaba Stadium 252
Polokwane City FC
• 41,733 • 2010

Princess Magogo Stadium 256
Nathi Lions FC / AmaZulu FC
• 12,000 • 2009

Rand Stadium 256
National team
• 30,000 • 1951

South Korea

Alpensia Ski Jump Centre 286
National team
• 13,500 • 2008

Busan Asiad Main Stadium 283
Busan Park
• 53,769 • 2001

Daejeon World Cup Stadium 283
Daejeon Hana Citizen
• 40,535 • 2001

DGB Daegu Bank Park 283
Daegu FC
• 12,419 • 2019

Gimpo Solteo Football Field 286
Gimpo FC
• 5,076 • 2015

Goyang Stadium 286
National team
• 41,311 • 2003

Gwangju Football Stadium 286
Gwangju FC
• 10,007 • 2020

Gwangju World Cup Stadium 286
Gwangju FC
• 40,245 • 2001

Incheon Football Stadium 286
Incheon United FC
• 20,891 • 2012

Jeju World Cup Stadium 286
Jeju United FC
• 29,791 • 2001

Jeonju World Cup Stadium 283
Jeonbuk Hyundai Motors
36,781 2001

Pohang Steel Yard 286
Pohang Steelers
• 17,443 • 1990

Seoul World Cup Stadium 284
FC Seoul
• 66,704 • 1984

Suwon World Cup Stadium 286
Busan IPark
• 44,031 • 2001

Ulsan Munsu Football Stadium 283
Ulsan HD FC
• 37,897 • 2001

Spain

Camp de Futbol Municipal La Satàlia 174
Unió Esportiva Poble Sec / Atlètic la Palma / CE Apa Poble Sec
• 1,000 • 1936

Camp Nou 175
FC Barcelona
• 105,000 • 1957

Estadi Ciutat de València 177
Levante UD
• 26,354 • 1969

Estadi Johan Cruyff 174
FC Barcelona Atlètic
• 6,000 • 2019

Estadi Olímpic Lluís Companys 175
FC Barcelona / Catalonia national team
• 49,472 • 1929

Estadio Abanca Balaídos 186
RC Celta de Vigo
• 29,000 • 1928

Estadio Alfredo Di Stéfano Stadium 182
Real Madrid CF Femenino / Real Madrid Castilla
• 6,000 • 2006

Estadio Benito Villamarín 178
Real Betis Balompié
• 60,721 • 1929

Estadio Carlos Belmonte 184
Albacete Balompié
• 17,524 • 1960

Estadio Carlos Tartiere 185
Real Oviedo
• 30,500 • 2000

Estadio Coliseum 184
Getafe CF
• 16,500 • 1998

Estadio de la Cerámica 177
Villarreal CF
• 23,008 • 1923

Estadio de Vallecas 182
Rayo Vallecano
• 14,708 • 1976

Estadio El Molinón 177
Real Sporting de Gijón
• 29,371 • 1908

Estadio El Sardinero 184
Real Racing Club
• 22,222 • 1988

Estadio Gran Canaria 186
UD Las Palmas
• 31,250 • 2003

Estadio Heliodoro Rodríguez López 186
CD Tenerife
• 22,824 • 1925

Estadio José Rico Pérez 177
Hércules CF
• 24,704 • 1974

Estadio La Romareda 182
Real Zaragoza
• 33,608 • 1957

Estadio Mallorca Son Moix 186
RCD Mallorca
• 23,142 • 1999

Estadio Mestalla 176
Valencia CF
• 49,430 • 1923

Estadio Municipal Butarque 179
CD Leganés
• 12,454 • 1998

Estadio Municipal Cartagonova 186
FC Cartagena
• 15,105 • 1988

Estadio Municipal de Chapín 177
Xerez CD
• 20,523 • 1988

331

Index

Estadio Municipal de El Plantío 186
Burgos CF
• 12,194 • 1963 / 2018

Estadio Municipal de Riazor 174
RC Deportivo de La Coruña
• 32,490 • 1944

Estadio Municipal de Santo Domingo 179
AD Alcorcón
• 5,100 • 1999

Estadio Nuevo Colombino 177
Recreativo de Huelva
• 21,670 • 2001

Estadio Nuevo Mirandilla 184
Cádiz CF
• 20,724 • 1955

Estadio Nuevo Silvestre Carrillo 186
CD Mensajero
• 4,000 • 1977

Estadio Ramón Sánchez-Pizjuán 179
Sevilla FC
• 43,883 • 1958

Estadio Santa María de Lezama 184
Athletic Club
• 53,289 • 1971

Estadio Santiago Bernabéu Stadium 181
Real Madrid CF / Real Madrid CF Femenino
• 83,186 • 1947

Estadio Virgen de las Nieves 186
SD Tenisca
• 5,500 • 2001

Ipurua Municipal Stadium 184
SD Eibar
• 8,164 • 1947

José Zorrilla Stadium 184
Real Valladolid CF
• 27,618 • 1982

Reale Arena 179
Real Sociedad
• 39,500 • 1993

Riyadh Air Metropolitano 182
Club Atlético de Madrid
• 70,460 • 2017

San Mamés 186
Athletic Club Bilbao
• 53,289 • 2013

UD Almería Stadium 179
UD Almería
• 15,000 • 2004

Suriname

Clarence Seedorf Stadium 63
SV Brothers
• 3,500 • 2001

Sweden

3Arena 120
Djurgårdens IF / Hammarby IF
• 30,000 • 2013

Borås Arena 121
IF Elfsborg
• 16,200 • 2005

Eleda Stadion 120
Malmö FF
• 22,500 • 2009

Malmö Stadion 120
IFK Malmö

• 26,500 • 1958

Stockholm Olympic Stadium 120
Djurgårdens IF Women's team / FC Stockholm Internazionale
• 14,417 • 1912

Strandvallen 120
Mjällby AIF
• 6,500 • 1953

Strawberry Arena 120
National team / AIK Fotboll
• 50,000 • 2012

Tunavallen 120
AFC Eskilstuna / Eskilstuna City FK / IFK Eskilstuna/Eskilstuna United DFF
• 7,800 • 1924

Ullevi 120
IFK Göteborg
• 43,000 • 1958

Switzerland

Ottmar Hitzfeld Stadium 165
FC Gspon
• 200 • 1984

St. Jakob-Park 164
FC Basel
• 38,512 • 2001

Stade de la Tuilière 165
FC Lausanne Sport
• 12,544 • 2020

Stadion Wankdorf 164
BSC Young Boys
• 32,000 • 2005

Swissporarena 164
FC Luzern
• 16,800 • 2011

Syria

Aleppo International Stadium 274
Al Ittihad Ahli of Aleppo SC
• 53,200 • 2007

Tanzania

Benjamin Mkapa Stadium 251
National team / Simba SC / Young Africans FC
• 60,000 • 2007

Thailand

700th Anniversary of Chiang Mai Stadium 298
Chiangmai FC
• 17,909 • 1995

BG Stadium 297
BG Pathum United FC
• 10,114 • 2010

Chai Nat Provincial Stadium 298
Chainat Hornbill FC
• 12,000 • 2011

Chang Arena 298
Buriram United FC
• 32,600 • 2011

Koh Panyee Floating football field 299
Koh Panyee FC
• Unknown • 1986

Rajamangala National Stadium 298
National team
• 51,552 • 1998

Suphachalasai National Stadium 298
Multiple teams
• 19,793 • 1938

Timor-Leste

Estádio Nacional de Timor-Leste 294
National team
• 5,000 • 1980

Tonga

Teufaiva Sport Stadium 318
National team
• 10,000 • 2017

Tunisia

El Menzah Stadium 247
Espérance de Tunis / Club Africain
• 39,858 • 1967

Hammadi Agrebi Stadium 247
Espérance Sportive de Tunis / Club Africain / National team
• 60,000 • 2001

Sousse Olympic Stadium 247
Étoile Sportive du Sahel
• 50,000 • 1973

Türkiye

Antalya Stadium 310
Antalyaspor
• 32,537 • 2015

Atatürk Olympic Stadium 307
Fatih Karagümrük SK
• 74,753 • 2002

Centennial Atatürk Stadium 311
Bursaspor
• 45,000 • 2010

Eryaman Stadium 311
Gençlerbirliği SK / MKE Ankaragücü
• 20,560 • 2019

Kadir Has Stadium 311
Kayserispor
• 32,864 • 2017

Kocaeli Stadium 311
Kocaelispor / National team
• 34,712 • 2018

Konya Büyükşehir Stadium 310
Konyaspor
• 42,000 • 2014

New Adana Stadium 311
Adana Demirspor / Adanaspor
• 33,543 • 2021

New Hatay Stadium 311
Hatayspor
• 25,000 • 2021

Rams Park 307
Galatasaray SK
• 52,280 • 2011

Samsun 19 Mayıs Stadium 311
Samsunspor
• 33,919 • 2017

Senoi Gunes Spor Kompleski Papara Park 310
Trabzonspor
• 40,782 • 2016

Şükrü Saracoğlu Stadium 308
Fenerbahçe SK / National team
• 47,834 • 1908

Tüpraş Stadyumu 307
Beşiktaş JK
• 42,590 • 2016

Tuvalu

Tuvalu Sports Ground 318
National team / Multiple teams
• 1500 • 2004

Ukraine

Olimpiyskiy National Sports Complex 128
National team / Dynamo Kyiv / Shakhtar Donetsk
• 70,050 • 1923

Valeriy Lobanovskyi Dynamo Stadium 128
Dynamo Kyiv / Olimpik Donetsk
• 16,873 • 1933

United Arab Emirates

Baniyas Stadium 268
FC Baniyas
• 6,927 • 2009

Mohammed bin Zayed Stadium 268
Al-Jazira Club
• 37,000 • 1979

Sharjah Football Stadium 268
Sharjah FC
• 12,000 • 1982

Zayed Sports City Stadium 268
National team
• 43,206 • 1979

United States

Al Lang Stadium 28
Tampa Bay Rowdies
• 7,227 • 1947

Allianz Field 15
Minnesota United FC
• 19,400 • 2019

Alumni Stadium 18
Notre Dame Fighting Irish
• 44,500 • 1957

America First Field 36
Real Salt Lake
• 20,213 • 2008

American Legion Memorial Stadium 24
Charlotte Independence / Carolina Ascent FC
• 10,500 • 1934

Applejack Stadium 22
Black Rock FC / VT Fusion
• 1,000 • 2021

Audi Field 23
DC United / Washington Spirit / DC Power FC
• 20,000 • 2018

Bank of America 25
Charlotte FC
• 74,867 • 1996

Belson Stadium 20
St. John's Red Storm
• 2,168 • 2001

Bill Armstrong Stadium 18
Indiana Hoosiers
• 6,500 • 1981

BMO Stadium 41
Los Angeles FC / Angel City FC
• 22,000 • 2018

Boxer Stadium 43
El Farolito SC
• 3500 • 1953

Breese Stevens Field 17
Forward Madison FC
• 5,000 • 1926

Cadet Soccer Stadium 36
Air Force teams
• 1,000 • 1995

Cagan Stadium 41
Stanford Cardinals
• 2,000 • 1973

Cardinale Stadium 42
Monterey Bay FC
• 6,000 • 2022

Cashman Field 36
Las Vegas Lights FC
• 9,334 • 1983

Championship Soccer Stadium 42
Orange County SC
• 5,000 • 2017

Chase Stadium 28
Inter Miami CF
• 21,000 • 2019

CHI Memorial Stadium 31
Chattanooga Red Wolves SC
• 5,500 • 2020

Children's Mercy Park 35
Sporting Kansas City /Kansas City Current
• 18,467 • 2011

City Stadium 24
Richmond Kickers
• 6,000 • 1929

City Stadium 26
City of Greer Youth Team
• 3,000 • 1938

CPKC Stadium 16
Kansas City Current
• 11,500 • 2024

Cubberley Community Centre Turf Field 41
Pickup
• 200 • 2008

Dignity Health Sports Park 39
Los Angeles Galaxy / LA Galaxy II
• 27,000 • 2003

Dorrance Field 25
North Carolina Tar Heels
• 5,025 • 2019

Elizabeth Lyle Robbie Stadium 15
Minnesota Golden Gophers
• 1,000 • 1999

Elmore Field 20
Hartwick Hawks
• 3,000 • 1956

Energizer Park 17
St. Louis City SC
• 22,423 • 2022

ESPN Wide World of Sports Complex 28
Youth teams
• 6,000 • 1997

Eugene E. Stone III Stadium 27
South Carolina Gamecocks / Furman Paladins
• 5,000 • 1981

FAU Soccer Stadium 28
Florida Atlantic Owls
• 1,000 • 1980

Fifth Third Stadium 30
Kennesaw State Owls
• 8,300 • 2010

Index

Gaelic Park 20
Manhattan SC
• **2,000** • **1926**

Geodis Park 30
Nashville SC
• **30,000** • **2022**

Harder Stadium 41
UC Santa Barbara Gauchos
• **17,000** • **1966**

Heart Health Park 43
Sacramento Republic FC
• **11,242** • **2014**

Hermann Stadium 17
St Louis Billikens
• **6,050** • **1999**

Highmark Stadium 19
Pittsburgh Riverhounds SC
• **5,000** • **2013**

Historic Riggs Field 26
Clemson Tigers
• **6,500** • **1915**

Hoops Family Field 24
Marshall Thundering Herd
• **1,006** • **2013**

Inter&Co Stadium 28
Orlando City SC / Orlando Pride
• **25,500** • **2017**

Jordan Field 22
Harvard Crimson
• **4,100** • **2010**

Keyworth Stadium 17
Detroit City FC
• **7,933** • **1936**

Kezar Stadium 43
San Francisco City FC
• **10,000** • **1925**

Kino North Stadium 36
FC Tuscon
• **3,200** • **2013**

Lower.com Field 18
Columbus Crew
• **20,371** • **2021**

Lumen Field 14
Seattle Sounders FC / Seattle Reign FC
• **37,722** • **2002**

Lusitano Stadium 22
Western Mass Pioneers
• **3,000** • **1918**

Lynn Family Stadium 18
Racing Louisville FC/Louisville City FC
• **11,700** • **2021**

Macpherson Stadium 24
North Carolina Fusion U23
• **7,000** • **2002**

Martin Family Stadium (Albert-Daly Field) 24
William & Mary Tribe
• **1,000** • **2004**

Maryland SoccerPlex 24
Maryland Bobcats FC
• **5,000** • **2000**

Mayfield Soccer Complex 41
Pickup
• **500** • **2006**

Mercedes-Benz Stadium 30
Atlanta United FC
• **71,000** • **2017**

MetLife Stadium 22
Multiple teams
• **82,500** • **2010**

Metropolitan Oval 20
Youth Academy
• **1,500** • **1925**

Morrison Stadium 15
Creighton Bluejays
• **6,000** • **2003**

Morrone Stadium 22
Connecticut Huskies
• **5,100** • **1969**

National Sports Center 15
Minnesota United FC
• **5,500** • **1990**

Ole Miss Soccer Stadium 31
Ole Miss Rebels
• **1,500** • **1997**

One Spokane Stadium 14
Spokane Velocity FC / Spokane Zephyr FC
• **5,100** • **2023**

Orange Beach Sportsplex 31
Multiple teams
• **1,500** • **2001**

Paladin Stadium 27
Greenville Triumph SC
• **16,000** • **1981**

Paradise Coast Sports Complex 28
FC Naples
• **3,500** • **2020**

Patriots Point Soccer Complex 27
Charleston Battery
• **3,500** • **2000**

PayPal Park 43
San Jose Earthquakes
• **18,000** • **2015**

Phoenix Rising Soccer Stadium 36
Phoenix Rising FC
• **10,000** • **2023**

Pier 40 @Hudson Park 20
Multiple teams
• **500** • **1998**

Pier 5 20
Multiple teams
• **1,200** • **2012**

Playa Vista Sports Park 39
Pickup
• **200** • **2014**

Providence Park 14
Portland Timbers / Portland Thorns FC
• **25,218** • **1926**

Q2 Stadium 34
Austin FC
• **20,738** • **2021**

Razorback Field 31
Arkansas Razorbacks
• **1,500** • **1992**

Red Bull Arena 23
New York Red Bulls / NY Gotham FC
• **25,000** • **2010**

Regal Stadium 30
One Knoxville SC
• **3,000** • **1996**

Riverfront Stadium 28
Tampa Bay Suns FC
• **5,000** • **2024**

Roberts Stadium 22
Princeton Tigers
• **2,356** • **2008**

Rocco B. Commisso Soccer Stadium 20
Columbia Lions
• **3,500** • **1985**

Rochester Community Sports Complex 20
Flower City Union
• **13,768** • **2006**

Rose Bowl 39
UCLA
• **94,542** • **1922**

Santa Monica Airport Soccer Field 41
Pickup
• **200** • **2018**

Santa Monica Civic Center Multipurpose Sports Field 41
Pickup
• **200** • **2020**

SeatGeek Stadium 17
Chicago Red Stars
• **20,000** • **2006**

Segra Field 24
Loudoun United FC
• **5,000** • **2019**

Shell Energy Stadium 33
Houston Dynamo FC / Houston Dash
• **22,039** • **2012**

Snapdragon Stadium 38
San Diego Wave FC / San Diego FC
• **35,000** • **2022**

SoFi Stadium 39
Hosts major fixtures
• **70,240** • **2020**

Starfire Sports stadium 14
Tacoma Defiance / OSA Seattle FC/OSA XF
• **4,500** • **2002**

Stevens Stadium 41
Santa Clara University
• **7,000** • **1962**

SU Soccer Stadium 20
Syracuse Orange
• **1,500** • **1996**

Subaru Park 19
Philadelphia Union
• **18,500** • **2010**

The Ground 20
Multiple teams
• **12,021** • **2021**

Tormenta Stadium 30
South Georgia Tormenta FC
• **5,300** • **2022**

Toyota Field 35
San Antonio FC
• **8,296** • **2013**

Toyota Stadium 35
FC Dallas
• **19,096** • **2005**

TQL Stadium 18
FC Cincinnati
• **26,000** • **2021**

Trinity Health Stadium 22
Hartford Athletic
• **5,500** • **1960**

UC Riverside Soccer Stadium 41
UC Riverside Highlanders / Club Xolos USA U-23
• **1,000** • **2007**

Uihlein Soccer Park 17
MSOE Raiders
• **7,000** • **1994**

UNCG Soccer Stadium 24
University of North Carolina at Greensboro
• **3,540** • **1990**

University of Denver Soccer Stadium 36
Denver Pioneers
• **2,000** • **2009**

Virtue Field 22
Vermont Green FC
• **2,600** • **2015**

Vista Hermosa Sports Park 42
Pickup
• **200** • **2012**

Waipi'o Peninsula Soccer Stadium 36
Hawai'i Rainbow Wahine
• **4,500** • **2000**

WakeMed Soccer Park 25
North Carolina Courage / North Carolina FC
• **10,000** • **2002**

Wallis Annenberg Stadium 41
UCLA Bruins teams
• **2,145** • **2018**

Weidner Field 36
Colorado Springs Switchbacks
• **8,000** • **2021**

WRAL Soccer Park 24
CASL teams
• **3,200** • **1990**

Yankee Stadium 20
New York City FC
• **28,743** • **1928**

Yurcak Field 22
Rutgers Scarlet Knights
• **5,000** • **1994**

Zions Bank Stadium 36
Real Monarchs
• **5,000** • **2018**

Uruguay

Campeón del Siglo 81
Club Atlético Peñarol
• **40,005** • **2016**

Estadio Centenario 80
National team
• **60,235** • **1930**

Estadio Gran Parque Central 80
Club Nacional de Football
• **38,000** • **1900**

Estadio Profesor Alberto Suppici 80
Plaza Colonia
• **6,500** • **1977**

Uzbekistan

Milliy Stadioni 278
FC Bunyodkor / National team
• **33,834** • **2012**

Xorazm Stadium 279
Xorazm FK
• **25,000** • **1983**

Vanuatu

Freshwater Stadium 317
National team
• **6,500** • **2022**

Luganville Soccer City Stadium 317
Women's East Santo Area League
• **6,000** • **2013**

Port Vila Municipal Stadium 317
Port Vila Football League
• **10,000** • **2009**

Venezuela

Centro Total de Entretenimiento Cachamay 62
Mineros de Guayana / Minervén de Bolívar / National team
• **41,600** • **1980**

Cocodrilos Sports Park 63
Caracas FC Femenino
• **3,500** • **2005**

Estadio Metropolitano de Cabudare 62
ACD Lara
• **47,913** • **2007**

Estadio Olímpico Metropolitano de Mérida 63
Estudiantes de Mérida FC
• **42,200** • **2007**

Estadio Polideportivo de Pueblo Nuevo 62
Deportivo Táchira FC
• **38,755** • **1976**

Vietnam

Mỹ Đình National Stadium 297
National team
• **40,192** • **2003**

Wales

Cae Clyd 230
Blaenau Ffestiniog FC
• **7,920** • **1934**

Cwm Nant Y Groes 231
Abertillery Bluebirds FC
• **1,000** • **Unknown**

Llanelian Road 230
Colwyn Bay FC
• **3,000** • **1984**

Prince Moomin's Palace 230
Llantwit Major FC
• **250** • **Unknown**

Principality Stadium 230
National team
• **74,500** • **1999**

The Racecourse Ground 230
Wrexham AFC
• **10,771** • **1807**

Yemen

Althawra Sports City Stadium 269
National team
• **30,000** • **1986**

Zambia

Levy Mwanawasa Stadium 258
ZESCO United FC
• **49,800** • **2012**

PICTURE CREDITS

The publisher would like to thank the following for the permission to reproduce copyright material.

Key: (T) Top; (B) Bottom; (L) Left; (R) Right; (C) Center; (IN) Inset; (BG) Background.

ALAMY: 31 Associated Press, 44 Zoonar GmbH, 50 Luis Gutierrez/NortePhoto, 79T SPP Sport Press Photo, 85B Canon2260, 95 Esteban Felix/Associated Press, 98–99 Arterra Picture Library, 121R Sipa US/Alamy Live News, 128 Ruslan Lytvyn, 136 Sandor Szabo, 137T Associated Press, 150–151 David Khelashvili, 158–159B Eugenio Pingo, 174–175 Sergi Boixader, 192 Christophe Ketels, 203T Zoonar GmbH, 209T PA Images, 212 PA Images, 213B PA Images, 213TR horst friedrichs, 221R Tom McAtee, 224B Clynt Garnham, 232B Colin McPherson, 236B John Carroll Photography, 237B PA Images, 239 Liam McBurney, 239IN Colin McPherson, 259 Xinhua, 265T Xinhua, 278 dpa picture alliance archive, 289 jeremy sutton-hibbert, 290TL Naoya Azuma/Associated Press, 290TR Aflo Co. Ltd., 302–303 Jon Arnold Images Ltd, 309T PA Images, 310T Lewis Mitchell, 321 PA Images,

ALEX WEBBER: 127TL,TR & B.

GROUNDHOPPING MERSEBURG: 135T, 245B.

GLEN POKORNY–CENTRAL COAST MARINERS: 2–3, 322.

DANNY LAST: 4B, 117BL & R, 134, 142–143, 143, 154T, 162–163, 163BL & BR, 167, 173BL & BR, 173T, 185B & T, 198T, 211, 221LC & LT, 222, 223T.

DAVE HARRY: 108–109, 140, 148–149, 194, 200, 230–231, 231IN.

DREAMSTIME: 63 Rommel Gonzalez, 161TL & 161TR Gianni Pasquini, 245T Yacer Seksaoui, 253IN C West-Russell, 253T Graham Montanari, 296R Azim Ariffin, 320T Alexpirie10.

FLICKR: 34B Ralph Arvesen, 42 waltarrrrr, 68T Edson Lopes Jr/A2 FOTOGRAFIA, 102–103 David Fisher, 135B Paul Braybrook, 261 vickisee.com, 285B Mark Zastrow, 285T curoninja, 318 Public.Resource.Org.

GETTY IMAGES: 4T Jeremy Olson/ISI Photos, 5C Matthew Ashton, 5T AFP, 7 Shaun Botterill, 10–11 Robyn Beck, 12B Olga Matveeva, 12–13T DeFodi Images, 14 Steve Dykes, 15 Jeremy Olson/ISI Photos, 16B, C & T Jamie Squire, 21CR Mike Stobe, 23 Al Bello, 25B & C Andy Mead/ISI Photos, 25T Erik Perel/Allsport, 26 (both) David Jensen/USSF, 27T David Jensen/USSF, 29BL Carmen Mandato, 29CR Thaddaeus McAdams, 29T Simon M Bruty, 30 Carmen Mandato, 33B & C Icon Sportswire, 33T Houston Chronicle/Hearst Newspapers 34C & T Gary Miller, 35 Erin Chang/ISI Photos, 38B Harry How, 38C Denis Poroy, 38T Mike Janosz/ISI Photos/USSF, 40CL Patrick T. Fallon, 43 Erin Chang/ISI Photos, 46C Jam Media, 46T Leopoldo Smith, 47 Jam Media, 49B & TL Jam Media, 51 Jam Media, 53 Sven Creutzmann/Mambo Photo, 58 Freddy Builes, 65 Luciano Mendes, 67B Renato Spencer, 70 Yasuyoshi Chiba, 72B Carl De Souza, 72C Yasuyoshi Chiba, 72T Christopher Pillitz, 92 Alexis Lloret, 93 Gabriel Rossi, 100T Eurasia Sport Images, 101 ullstein bild Dtl, 111 Gary M. Prior, 112–113 DjelicS, 117CL Philip Davali, 147 Jurij Kodrun, 152 Fabrizio Villa, 153 Claudio Villa, 161B Guido Cozzi/Atlantide Phototravel, 171B & T Nicolas Tucat, 178–179 Aitor Alcalde, 181T Nawi Films, 182 Gonzalo Arroyo Moreno, 184 Juan Manuel Serrano Arce, 194–195 Soccrates Images, 196 ANP, 198BL Stuart Franklin, 199 Neil Baynes, 203C Martin Rose, 205B Atlantide Phototravel, 205C Maja Hitij, 208 Tom McAtee, 213TL Robbie Jay Barratt-AMA, 215 Adrian Dennis, 216T Henry Nicholls, 218LB Michael Regan-The FA, 218RB Adrian Dennis,

221LCB Serena Taylor, 225 Justin Setterfield, 226–227 Stephen Pond–The FA, 228B Daniel Chesterton/Offside, 228RC Ed Sykes, 235 Craig Williamson–SNS Group, 236T Robbie Jay Barratt–AMA, 237T Michael Regan, 239 Ramsey Cardy, 240–241 AFP, 242 Fadel Senna, 246B Anadolu, 249T NurPhoto, 250C Anadolu, 250T Zacharias Abubeker, 262 Franck Fife, 263T Seyllou, 264–265 Atta Kenare, 265BR Atta Kenare, 266 David Ramos, 268 David Cannon, 270–271 Adam Nurkiewicz, 274 Reza, 276–277 Matthew Ashton, 280 AFP, 282–283 Carl Court, 285C Chung Sung-Jun, 287B FIFA/AFP, 287TR Lars Baron–FIFA, 293IN Robertus Pudyanto, 300 Diptendu Dutta, 306 AFP, 307T Yagiz Gurtug, 308BL Anadolu, 308TL VI-Images, 315 Maddie Meyer–FIFA, 316TL Saeed Khan, 316TR Cameron Spencer, 319 Joe Allison–FIFA, 320B & C Hagen Hopkins.

GRENZENLOS GROUNDHOPPING: 110, 176B, 205T, 284–285.

ISTOCK: 32 Art Wager, 139 Wirestock, 260 Kehinde Temitope Odutayo.

JOSEPH O'SULLIVAN: 60T, 83, 85C, 89C & T, 94, 97B & TL 177, 181B, 183.

JOSEPH SWIDE: 52B, C & T.

KIERAN PENDER: 316B, 317.

LIAM HEWITT: 218LT & RT, 228R, 232L, 233, 234T, 234–235.

SAM MCARDLE: 84, 91BL, BR & T, 118RC & RT, 121LB, LC, & LT, 169, 170, 198BR, 207TR

SHUTTERSTOCK: 21B RyanZi, 21T Domingo Saez, 29BR YES Market Media, 39B FiledIMAGE, 39T Marcus E Jones, 40TL Marcus E Jones, 40TR Michael Vi, 45 Aberu.Go, 46B Ramiro Loyola Pacheco, 54–55 lazyllama, 56BG & B Luis Alvarado Alvarado, 59L & R JOCA_PH, 60B Jess Kraft, 68BR Mauricio Fernandes, 71

Picture Credits

marchello74, 79C Edson Michalick, 85T Cavan-Images, 86 Sobrevolando Patagonia, 88 Sobrevolando Patagonia, 100B Christian Inga, 106–7 Skyshark Media, 114 James Marsh, 114–115 ju.hrozian, 116 Oliver Foerstner, 117TL Zakariaa El Mikdam, 118B uslatar, 118TL Sergiy Vovk, 124–125 Zbigniew Dziok, 130–131 Budilnikov Yuriy, 133 Nick Ledzinskiy, 141 Nenad Nedomacki, 145 Wirestock Creators, 146 giocalde, 147IN uslatar, 148 mairu10, 154BL Francesca Sciarra, 154BR Paky Cassano, 155 PhotoLondonUK, 156 Pyty, 162 Luca Lorenzelli, 165B PhotoLondonUK, 166 PhotoLondonUK, 176C LEVANTEMEDIA, 176T BearFotos, 180–181 Oscar Gonzalez Fuentes, 187BL & BR Ismael Juan, 187TL Edu del Fresno, 187TR Ruben Becerra, 188 vladivlad, 189 Cherkasov, 191 Oscar Gonzalez Fuentes, 197 uslatar, 201 uslatar, 203B Thomas Persson, 207B & TL uslatar, 209B Shanae Ennis-Melhado, 214 Bruce Alan Bennett, 224T sussexdronepilot, 228RT Michael715, 232TR Michael715, 236C 4kclips, 254–255 Deyan Denchev, 256–257 Leonard Hugo, 257B & TR South Africa Stock Video, 263IN Pierre Laborde, 267 SLSK Photography, 273 Luciano Santandreu, 275 Mohammed_Al_Ali, 287TL KoreaKHW, 293 Brunohitam, 294–295 joyfull, 296TL feelphoto, 297 Melie Nasr, 299 SP rabbito, 299INB Cat Box, 299INT Alexandre.ROSA, 303B Arpan Chaudhuri, 308–309 Berkomaster, 310B mehmetcan.

UNSPLASH: 9, 68BL Mariana Fernandes, 190 Sernadas Pica (rp_ts_), 210IN Nat Callaghan (callacrap), 210L Joe Yong (jxeyong), 251.

WIKIMEDIA: 4C Jimmy Baikovicius, 5B Phillip Capper, 13B GoToVan, 17 Arturo63, 18L Rick Dikeman, 19 Jamie Smed, 37 Ray Terrill, 40B Mike Godwin, 49TR Chiko elektriko, 56T Terran21, 61 123Hollic, 62 Rei2Rey, 75 Faquini Produção Fotográfica; Fotógrafo David Campbell, 76

Eduardo Alex Soares Vergara, 79B Boaventuravinicius, 81 Jimmy Baikovicius, 83 TitiNicola, 89B Germanramos2, 94–5 PitchdGroundhopping, 97TR Meik.ch 104–105 Sageo, 122 Mikey 111, 129 Discoverynn, 137B Christo, 138 OD Pictures, 158–159T Emiliano Francone,164 H. Raab, 165T Christophe95, 202 el_loko, 217 Bluejam, 246T Ben Taher, 248, 249B Harby6020, 250B Joehawkins, 269 albinfo, 281 IDontHaveSkype, 290B, 296B L Mohd Fazlin Mohd Effendy Ooi, 298 www.thai-fussball.com, 307B Antoloji, 312–313 Phillip Capper.

ALSO: 21CL James Evans, 87 Marina and Fernando @groundspotters, 144B Alex Grymanis, 144T Rafael Manders, 193 Nico Dewaele, 216B © [2023] [Ryan Wong - @ryn.lens & rystudio.co.uk], 219 Mike Urban/Brixton Buzz, 223B John Gillard, 252 Silver Works, 278–279 Michael Höller, 301 ek_khoj, 304 Mohamed Naushad @natea23mv, 305 Shafraz Hafiz/Visit Kandima, 314 Jojo Kramer/PII Majuro.

All reasonable efforts have been made to trace copyright holders and obtain their permission for use of copyright material. The publisher would like to apologize should there have been any omissions or errors, and would be pleased to make the appropriate correction for future editions of the book if notified.

AUTHOR BIOGRAPHIES

John Gillard

Throughout his travels around the world, John Gillard has experienced the rich culture of world football—from the Ground in New York to La Bombonera in Buenos Aires, the Dripping Pan in rural England to the Estadio Nacional in industrial Peru.

Gillard has a long history of working in the football industry. He has worked creatively with English Premier League club Brighton & Hove Albion, Bundesliga's Union Berlin, A.S. Velasca of Milan, Adidas, COPA90, NSS Sports, *Mundial*, and is a feature writer for *NPLH* magazine.

Joseph O'Sullivan

Joseph O'Sullivan grew up falling in and out of love with Liverpool FC and the Ireland national team. That passion led him to write for Forbes.com and other media outlets. He has focused on Italian and South American football in recent years, and visited some of the most incredible stadiums that world football has to offer—from the historic and gargantuan San Siro in Milan to the more humble sites of the Argentinean second division in the form of CA San Telmo and Chacarita Juniors.

O'Sullivan has reported on Champions League football in Europe, and worked creatively with the likes of COPA90 while on tour in South America. Keep in touch with his football travels on Instagram @footballtravelman.

Neel Shelat

Neel Shelat is a freelance football journalist and analyst who has been covering the game for nearly five years. He is a self-styled missionary of the religion of football, spreading the word about the game from all corners of the world. His features and analyses have been published in various reputed outlets, such as Al Jazeera, *FourFourTwo*, *World Soccer*, and Analytics FC.